𝕿𝖍𝖊 𝕹𝖊𝖜

Traveler's

Art Museum
Exhibitions
2002

The New York Times
Traveler's Guide To

Art Museum Exhibitions 2002

Edited by Susan Mermelstein

The New York Times
New York, New York

Distributed by Harry N. Abrams Inc., Publishers

Please send all comments to:
artguide@nytimes.com

Published by:
The New York Times
229 W. 43d St.
New York, NY 10036

ISBN 0-8109-6746-4
Printed and bound in the United States of America
First Printing 1999
10 9 8 7 6 5 4 3 2 1

For the New York Times: Mitchel Levitas, Editorial Director, Book Development; Thomas A. Carley, President, News Services Division; Nancy Lee, Director of Business Development

Editor: Susan Mermelstein

Associate Editor: Mark Yawdoszyn

Photo Editor: Anna Bahney

Contributors: Pamela Kent (London); Ladka Bauerova (Paris); Marina Harss (Rome); Benjamin Jones (Madrid); Dasha Klimenko (Moscow); Katka Fronk (Prague); Chieko Mori (Tokyo); Graham Gori (Mexico City); Nina Galanternick (Rio de Janeiro); Victor Homola (Berlin); Sarah A. Kass (Scandinavia); Winnie Pang (Hong Kong); P.J. Anthony (New Delhi); Susan Gotthelf (Buenos Aires); Nicole Turner (Johannesburg)

Design and Production: John W. Wright (Production); Gregory Hamlin (Production); G&H SOHO, Hoboken, N.J.: Jim Harris, Ian Wright, Gerald Wolfe, Mary Jo Rhodes

Cover Design: Barbara Chilenskas, Bishop Books

Cover Art: Detail from *The Soothsayer's Recompense,* 1913, by Giorgio de Chirico. Philadelphia Museum of Art: The Louise and Walter Arensberg Collection. Featured in the exhibition "Giorgio de Chirico and the Myth of Ariadne" at the museum from November 3, 2002, through January 5, 2003.

Distributed by Harry N. Abrams, Incorporated, New York

Harry N. Abrams, Inc.
100 Fifth Avenue
New York, N.Y. 10011
www.abramsbooks.com

Table of Contents

Editor's Note

In this third edition of The New York Times Travelers' Guide, we continue to make small improvements so that the guide is as useful a resource as possible for the art lover. Most notably, in addition to our popular list of Traveling Exhibitions, we have compiled a list of individual artists and where you can find exhibitions devoted to their work in 2002. Moreover, we have added several museums to the more than 350 already included in past editions.

While we aim to be as comprehensive and accurate in our exhibition listings as possible, we are constrained by the need to gather information from museums far in advance. We therefore urge you to contact the museum before you go to confirm exhibition dates.

You'll see that once again this year we are using handy icons to indicate what services are offered by the museums. Here is the key to what they mean:

 — Recorded tours only; guided and group tours are generally available.

 — Programs for children, including workshops, lectures and family activities.

 — Food and drink, ranging from vending machines to restaurants.

 — Museum shop, including gifts, posters and artifacts.

 — Handicapped accessible.

If you have any suggestions for further additions or improvements to this guide, please write to: artguide@nytimes.com.

Susan Mermelstein

List of Illustrations

x

Whatever Happened to the Avant-Garde?

By Ken Johnson

One of the jobs of art is to help us keep our bearings in an era of constant flux, in a world in which the pace of technological and social change threatens to put us into what a best-selling book of the 60's called "future shock." To keep from becoming dazed and confused, you can anchor yourself to the art of the old masters, an enduring bedrock of tradition and quality. Or, if you're adventurous, you might turn to the artists of the avant-garde who lead the way to a brave new world of aesthetic clarity and creative freedom.

Take, for example, "The New York Earth Room," a gallery in New York's Soho containing nothing but a two-foot-deep, wall-to-wall carpet of dark brown soil. Conceived in 1968 by Walter De Maria, the "Earth Room" is permanently maintained by the Dia Foundation, an institution dedicated to the care and feeding of seriously advanced art. In light of all that has happened in art over the past three decades, you might not find the "Earth Room" very shocking. But imagine yourself a traditionalist for whom Impressionist painting is as radical as it gets. Expected to view a roomful of dirt as a work of art, you could just walk away thinking, "This is not art; this must be some kind of a hoax."

Alternatively, you might begin seriously to entertain the idea that if a roomful of dirt could be art, then art could be almost anything. It could be an entirely empty room or a thought typed on a piece of paper or a man in a gallery being shot in the arm by a friend with a rifle. And if art can be anything, then maybe some of the other categories assumed for millennia to be hard-wired into existence — categories like sex, class, God, the speed of light and so on — are not so fixed. Maybe it is only the imagination that decides what is and what is not for all time. Treated to safe, homeopathic doses of newness by avant-garde shock therapists, your psyche may learn the flexibility it needs to gladly surf the waves of 21st century change.

That's the idea, anyway.

The problem today is that the avant-garde is not so easy to

define or locate. Absorbed into the mainstream, it's become just another style, one of many options available to artists living under the reign of pluralism. Paul McCarthy, for example, whose extremist performances and videos devoted to sexual and scatological themes would have guaranteed a strictly underground currency a few decades ago, enjoys one of the most celebrated, ubiquitously visible of international careers. And while painters like Brice Marden or Terry Winters, whose purely abstract canvases once would have been thought radical, are honored for their traditional values, young upstarts like Lisa Yuskavage or John Currin revive representational techniques from the Renaissance and focus on that most venerable of motifs, the female nude, to give painting new, controversial life.

Lovers of contemporary art revel in the free-for-all this new regime affords; skeptics see in the panoply of contemporary art little more than a novelty-addicted fashion show. Either way, it seems we can no longer look to the avant-garde for a clear sense of direction and cultural purpose.

At exactly what point it became clear that the avant-garde had outlived its usefulness — assuming it has — depends on how you define it. One way is in terms of the history of style. The history of painting, for example, can be read as the story of a 100-year march from realism to pure abstraction. Beginning with Manet, who, to an unprecedented degree, made paint itself part of the picture, we advance through the Impressionism of Monet to the Post-Impressionism of Cézanne to the Cubism of Picasso and Braque to the flattened grids of Mondrian to the all-over dripping of Jackson Pollock. Finally we arrive at the striped or single-color or shaped paintings of the 60's — painting reduced to its most basic elements — and it seems there is nowhere new to go, no uncharted territory left to explore. Around 1970 people began to speak of the death of painting. Painting didn't really die — lots of artists continued to paint. But the idea of painting continuing to progress in some historically meaningful way no longer seemed viable.

For there to be progress in art at this point, then, some believed, art would have to break "Out of the Box," as the critic Carter Ratcliff puts it in the title of his new book about avant-garde art in the 1960's. Freed from containment by traditional mediums, art began to proliferate into a bewildering array of new forms: conceptualism, performance art, installation art, earthworks, video and so on, continuing up to the pre-

sent with digital art and art on the World Wide Web. But this didn't solve the problem either. For if art is expanding in all directions at once, then it's not really going anywhere in particular.

The other way to view the avant-garde is as a program of increasing freedom — social as well as artistic. This doesn't mean just the overthrow of old-fashioned Puritanical or Victorian restraints. It's important to remember that the avant-garde emerged at a time when the Industrial Revolution was going full steam and to recall how the effects of industrialization — rigid scheduling, mechanization of labor, labyrinthine bureaucracies — could entrap people's souls and depress their spirits. So the visions of a more richly sensual life in the South Pacific that Paul Gauguin painted give a glimpse of another way of being — a life free from modernized monotony, more in touch with instinctive energies and authentic feelings. Later, that sly provocateur Marcel Duchamp would present an inverted urinal as a work of sculpture, opening the door for the "Earth Room" and countless other works that would challenge and loosen the usual categories of art and life.

But here again, the avant-garde may have succeeded too well. When every day is dress-down Friday and every ad on television urges immediate gratification of every desire, what greater freedom can the avant-garde possibly lead to? Freedom from consumerism? Maybe, but for now, at least, it's hard to see even the most fiercely anti-capitalist kind of art, like the mock-billboards of Barbara Kruger, as anything more than just another choice — along with sliced up animals in formaldehyde-filled tanks, video tape of satyrs wrestling in the back of a limousine and paintings of pneumatic women inspired by pictures in Playboy — on the art supermarket shelf.

How do museums deal with this situation? Some bastions of tradition, The Metropolitan Museum of Art in New York being one, don't try to keep up with the latest developments, reasoning that museums are not by nature quick enough afoot. By the time the new new thing appears in a museum, chances are it's already old news. That's aside from the question whether museums can know what in contemporary art is truly worth saving. Better to leave it to the smaller and nimbler commercial galleries to do the initial sorting.

But given that even the paintings of Vermeer had to start out contemporary, many museums feel it's worth trying to

keep track of the new — institutions like the New Museum in New York, the Los Angeles Museum of Contemporary Art, the Tate Modern in London or the Pompidou Center in Paris, to name just a few. If you don't get out to the galleries as often as you'd like, you could do worse than check out the Whitney Biennial, an exhibition at New York's Whitney Museum of American Art that every two years takes the pulse of contemporary art. (This year's model opens in April.)

Whether the avant-garde lives on or not, the Biennial regularly proves that Ezra Pound's famous dictum "Make it new" still fires the imagination of almost every contemporary artist with a master of fine arts degree. If you go, prepare to be annoyed, outraged and, quite possibly, amazed. It might not tell you where we are going, but it could give your brain an invigorating stretch.

Ken Johnson is a critic who reviews art regularly for The New York Times.

[An essay by Alan Riding on where to find avant-garde art in Europe appears on page 317.]

Major Traveling Exhibitions

Aelbert Cuyp

National Gallery of Art, Washington: Through January 13
National Gallery, London: February 13–May 12
Rijksmuseum, Amsterdam: June 8–September 1

Against the Modern: Jean Dagnan-Bouveret and the Transformation of the Academic Tradition

Dahesh Museum of Art, New York City: September 10–December 7
Society of the Four Arts, Palm Beach, Fla.: January 3–February 9, 2003

An American Anthem: 300 Years of Painting From the Butler Institute of Art

The John and Mable Ringling Museum of Art, Sarasota, Fla.: June 11–August 14
Yellowstone Art Museum, Billings, Mont.: March 23–June 30

American Impressionism: Treasures From the Smithsonian American Art Museum

Norton Museum of Art, West Palm Beach, Fla.: Through January 20
The Springfield Museum of Fine Arts, Springfield, Mass.: February 17–April 14
High Museum of Art, Atlanta: June 8–September 1
Chrysler Museum of Art, Norfolk, Va.: October 4–January 5, 2003

American Spectrum: Painting and Sculpture From the Smith College Museum of Art

Memorial Art Gallery of the University of Rochester, Rochester, N.Y.: Through January 13
Tucson Museum of Art and Historic Block: February 16–April 28

Andreas Gursky

Museum of Modern Art, George Pompidou Center, Paris: March 13–May 8
Chicago Museum of Contemporary Art: June 22–September 22

Courtesy of the Memorial Art Gallery of the University of Rochester.
Edwin Romanzo Elmer, *Mourning Picture*, 1890.

Anne Vallayer-Coster: Still-Life Painting in the Age of Marie Antoinette

National Gallery of Art, West Building, Washington: June
30–September 25
Dallas Museum of Art: October 13–January 5, 2003

Ansel Adams at 100

The San Francisco Museum of Modern Art:
Through January 13
Art Institute of Chicago: February 23–June 2
Hayward Gallery, London: July–September
Art Library, Berlin: October 10–January 5, 2003
Los Angeles County Museum of Art: February 2–April 27, 2003
Museum of Modern Art, New York City: Summer 2003

The Art of Nathan Oliveira

San Jose Museum of Art, San Jose, Calif.: February 8–May 12
Neuberger Museum of Art, Purchase, N.Y.: June
16–September 8
Palm Springs Desert Museum, Palm Springs, Calif.: October
5–January 5, 2003
Orange County Museum of Art, Newport Beach, Calif.: April
5–June 15, 2003
Tacoma Art Museum, Tacoma, Wash.: July–November 2003

The Artist's Landscape: Photographs by Todd Webb

Orange County Museum of Art, South Coast Plaza, Costa
Mesa, Calif.: Through January 6
Georgia O'Keeffe Museum, Santa Fe, N.M.: May 24–
September 21

Arte Latino: Treasures From the Smithsonian American Museum of Art

The Art Museum at Florida International University, Miami:
Through January 27
Palm Springs Desert Museum, Palm Springs, Calif.: February 27–
May 26
Museum of Fine Arts, Santa Fe, N.M.: June 28–September 22
Oakland Museum of California: November 2–January 26, 2003

Barnett Newman

Philadelphia Museum of Art: March 24–July 7
Tate Modern, London: September 19–January 5, 2003

Bartolomé Esteban Murillo (1617–1682): Paintings From American Collections

Kimbell Art Museum, Fort
Worth: March 10–June 2
Los Angeles County
Museum of Art: July
14–October 6

A Brush With History: Paintings From the National Portrait Gallery

The Speed Art Museum,
Louisville, Ky.: Through
January 27
Montgomery Museum of
Fine Arts, Montgomery,
Ala.: February 23–May 5
New Orleans Museum of
Art: June 1–August 11
National Portrait Gallery,
London: October 4–
January 5, 2003

Courtesy of the National Portrait Gallery.
John Alexander, *Samuel Langhorne Clemens*,
1902.

Carrie Mae Weems: The Hampton Project

The Nelson-Atkins Museum of Art, Kansas City, Mo.:
Through January 6
University Museum, California State, Long Beach, Calif.:
January 29–April 27
Hood Museum, Dartmouth College, Hanover, N.H.:
September 14–December 1

Central European Avant-Gardes: Exchange and Transformation

Los Angeles County Museum of Art: March 10–June 2
Art House, Munich: July 8–October 6

Chic Clicks: Creativity and Commerce in Contemporary Fashion Photography

Institute of Contemporary Art, Boston: January 23–April 7
Winterthur Museum, Switzerland: Summer
Wolfsburg Art Museum, Germany: Fall
National Photography Center, Paris: Spring 2003
Kobe Fashion Museum, Japan: Summer 2003

Contemporary Folk Art: Treasures From the Smithsonian American Museum of Art

The Cummer Museum of Art and Gardens, Jacksonville, Fla.:
Through January 20
High Museum of Art, Folk Art and Photography Galleries,
Atlanta: February 16–April 13
Fort Wayne Museum of Art: September 7–November 3
Senator John Heinz Pittsburgh Regional History Center,
Pittsburgh: November 29–January 30, 2003

Corot to Picasso: European Masterworks From the Smith College Museum of Art

Marion Koogler McNay Art Museum, San Antonio:
Through January 20
Phillips Collection, Washington: February 16–May 12
Seattle Art Museum: June 20–September 15

Dancer: Photographs by Irving Penn

Whitney Museum of American Art, New York City: January
12–May 12
The Museum of Fine Arts, Houston: March 17–June 16

Desire and Devotion: Indian and Himalayan Art From the John and Berthe Ford Collection

The Walters Art Gallery, Baltimore: Through January 13
Santa Barbara Museum of Art: March 2–May 26
Birmingham Museum of Art, Birmingham, Ala.: November 3–January 26, 2003

Empire of the Sultans: Ottoman Art From the Khalili Collection

Milwaukee Art Museum: Through April 28
North Carolina Museum of Art: May 18–July 28

Eternal Egypt: Masterworks of Ancient Art From the British Museum

Brooklyn Museum of Art, New York City: Through February 24
The Nelson-Atkins Museum of Art, Kansas City, Mo.: April 12–July 7
Fine Arts Museums of San Francisco, California Palace of the Legion of Honor: August 10–November 3
Minneapolis Institute of Arts: December 22–March 16, 2003
The Field Museum of Natural History, Chicago: April 26–August 10, 2003
The Walters Art Gallery, Baltimore: September 21–January 4, 2003

European Masterpieces: Six Centuries of Paintings From the National Gallery of Australia

Portland Art Museum, Portland, Ore.: Through January 6
Birmingham Art Museum, Birmingham, Ala.: February 10–April 14

Fauvism to Impressionism: Albert Marquet From the Pompidou

Museum of Art, Fort Lauderdale, Fla.: January 20–April 7
Georgia Museum of Art, Athens: April 28–July 8
Marion Koogler McNay Art Museum, San Antonio: October 8–January 5, 2003

The Gentileschi: Father and Daughters

Venice Palace Museum, Rome: Through January 6
The Metropolitan Museum of Art, New York City: February 14–May 12
Saint Louis Art Museum: June 15–September 15

George Romney Retrospective

Walker Art Gallery, Liverpool, England: February 7–April 28
National Portrait Gallery, London: May 30–August 18
The Huntington Library, Art Collections and Botanical
Gardens, San Marino, Calif.: September 15–December 1

Gerhard Richter: Forty Years of Painting

Museum of Modern Art,
New York City: February
21–May 21
Art Institute of Chicago:
June 22–September 15
San Francisco Museum of
Modern Art: October
11–January 14, 2003
Hirshhorn Museum and
Sculpture Garden,
Washington: February
12–May 11, 2003
High Museum of Art,
Atlanta: Summer 2003

Courtesy of the Art Institute of Chicago.
Gerhard Richter, *Ice 1(Eis)*, 1989.

The Gilded Age: Treasures From the Smithsonian American Art Museum

Mint Museum of Art, Charlotte, N.C.: January 26–April 21
The Long Island Museum of American Art, History and
Carriages, Stony Brook, N.Y.: May 17–July 14
Crocker Art Museum, Sacramento, Calif.: August 10–October 6
Dallas Museum of Art: November 2–January 12, 2003

Giorgio de Chirico and the Myth of Ariadne

Philadelphia Museum of Art: November 3–January 5, 2003
Estorick Collection, London: January 22–April 13, 2003

Goya: Images of Women

Prado Museum, Madrid: Through January 27
National Gallery of Art, West Building, Washington: February
24–May 19

The Grandeur of Viceregal Mexico: Treasures From the Franz Mayer Museum

Museum of Fine Arts, Houston: March 31–August 4

Winterthur Museum, Winterthur, Del.: Fall 2002
San Diego Museum of Art: March–June 2003

Grandma Moses in the Twenty-First Century

Brooklyn Museum of Art, New York City: Through January 27
Gilcrease Museum, Tulsa, Okla.: February 27–April 14
Columbus Museum of Art, Columbus, Ohio: May 10–July 28
Portland Museum of Art, Portland, Ore.: August 27–December 1

H.C. Westermann

Hirshhorn Museum and Sculpture Garden, Washington:
February 14–May 12
Museum of Contemporary Art, Los Angeles: June 9–September 8
The Menil Collection, Houston: October 4–January 5, 2003

Impressionism Transformed: The Paintings of Edmund C. Tarbell

Delaware Art Museum: February 15–April 28
Terra Museum of American Art, Chicago: May 11–July 20

Impressionist Still Life

The Phillips Collection,
Washington: Through
January 13
Museum of Fine Arts,
Boston: February
17–June 9

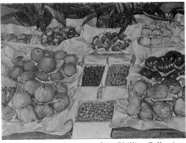

Courtesy of the Phillips Collection.
Gustave Caillebotte, *Fruit Displayed*,
ca. 1881–1882.

The Impressionists and Their Masters: Three Centuries of French Painting From the State Pushkin Museum of Fine Arts, Moscow

Museum of Fine Arts, Houston: December 15–March 9, 2003
High Museum of Art, Atlanta: April 16–June 29, 2003
Los Angeles County Museum of Art: July 17–October 12, 2003

Indivisible: Stories of American Community

The North Carolina Museum of Art, Raleigh: Through January 6
Museum of Contemporary Art, San Diego: January 27–April 21
Philadelphia Museum of Art: August 10–October 6
Anchorage Museum of History and Art: October 28–December 31

In Response to Place: Photographs From the Nature Conservancy's Last Great Places

Houston Museum of Natural Science: February–April
Ansel Adams Center for Photography, San Francisco: May–July
Minnesota Museum of Art, St. Paul: August 31–October 6
High Museum of Art, Atlanta: August–December
Field Museum, Chicago: January–April 2003

Innovation/Imagination: Fifty Years of Polaroid Photography

Knoxville Museum of Art: August 16–November 17
Spencer Museum of Art, Lawrence, Kan.: December 17–March 15, 2003

Jasper Johns to Jeff Koons: Four Decades of Art From the Broad Collections

Los Angeles County Museum of Art: Through January 6
Corcoran Gallery of Art, Washington: March 16–June 3
Museum of Fine Arts, Boston: July 21–October 20

Juan Muñoz

Hirshhorn Museum and Sculpture Garden, Washington: Through January 13
Museum of Contemporary Art, Los Angeles: April 21–July 28
Art Institute of Chicago: September 14–December 8
Contemporary Art Museum, Houston: January 24–March 30, 2003

The Lawrence Gussman Collection of African Art

Neuberger Museum of Art, Purchase, N.Y.: Through January 13
Philbrook Museum, Tulsa, Okla.: February 10–April 7
National Museum of African Art, Washington: June 9–August 14

Leonardo da Vinci and the Splendor of Poland

The Milwaukee Art Museum: September 12–November 24
The Museum of Fine Arts, Houston: December 8–February 17, 2003
Fine Arts Museums of San Francisco, California Palace of the Legion of Honor: March 8–May 18, 2003

Light Screens: The Leaded Glass of Frank Lloyd Wright

Grand Rapids Art Museum: Through January 6
High Museum of Art, Atlanta: June 8–September 1

Louis Faurer Retrospective

Museum of Fine Arts, Houston: January 20–April 14
Addison Gallery of American Art, Andover, Mass.: May 4–July 31
Philadelphia Museum of Art: Summer 2003

Lure of the West: Treasures From the Smithsonian American Art Museum

Museum of Art at Brigham Young University, Provo, Utah: January 17–May 19
Knoxville Museum of Art: June 14–September 8
Lyman Allyn Art Museum, New London, Conn.: October 4–December 1

Masterworks From the Albertina

The Frick Art and Historical Center, Pittsburgh: Through March 3
The Speed Art Museum, Louisville, Ky.: March 16–May 12

Matières des Rêves/The Stuff of Dreams

Portland Art Museum, Portland, Ore.: February 2–April 28
Wadsworth Atheneum Museum of Art, Hartford, Conn.: June 1–August 11
Birmingham Museum of Art: September 20–January 5, 2003

Matta in America: Paintings and Drawings of the 1940's

Museum of Contemporary Art, Los Angeles: Through January 6
Miami Art Museum: March 22–June 2

Courtesy of the Museum of Contemporary Art, Los Angeles.
Roberto Sebastian Matta, *Untitled*, 1938.

Michiel Sweerts

Rijksmuseum, Amsterdam: March 8–May 12
Fine Arts Museums of San Francisco, California Palace of the
Legion of Honor: June 8–August 25
Wadsworth Atheneum Art Museum, Hartford, Conn:
September 20–December 1

Milton Avery: The Late Paintings

Milwaukee Art Museum: Through January 27
Norton Museum of Art, West Palm Beach, Fla.: February
16–April 14

Modernism and Abstraction: Treasures From the Smithsonian American Museum of Art

Worcester Art Museum, Worcester, Mass.: Through January 6
Museum of the National Academy of Design, New York City:
February 6–April 7
Des Moines Art Center: May 4–June 30

Modigliani and the Artists of Montparnasse

Albright-Knox Art Gallery, Buffalo, N.Y.: October
19–January 12, 2003
Kimbell Art Museum, Fort Worth, Tex.: February 9–May 25,
2003
Los Angeles County Museum of Art: June 29–September 28,
2003

Northern Renaissance Painted Prints

Baltimore Museum of Art: October 2–January 5, 2003
Saint Louis Art Museum: April–May 2003
Armand Hammer Museum of Art and Cultural Center, Los
Angeles: Opening June 2003

O'Keeffe's O'Keeffes: The Artist's Collection

Georgia O'Keeffe Museum, Santa Fe: Through January 13
Louisiana Museum of Modern Art, Denmark: February 8–
May 20

Open City: Street Photographs Since 1950

The Lowry, Manchester, England: Through January 3
Bilbao Fine Arts Museum, Spain: January 21–April
Hirshhorn Museum and Sculpture Garden, Washington:
June 13–September 8

Over the Line: The Art and Life of Jacob Lawrence

Whitney Museum of American Art, New York City: Through February 3
Detroit Institute of the Arts: February 24–May 19
The Museum of Fine Arts, Houston: October 6–January 5, 2003

Paris: Capital of the Arts, 1900–1968

Royal Academy, London: January 26–April 12
Guggenheim Museum, Bilbao, Spain: Opening in September

Perfect Acts of Architecture

The Heinz Architectural Center, Carnegie Museum of Art, Pittsburgh: Through January 6
San Francisco Museum of Modern Art: March 2–May 26
AXA Gallery, New York City: August 14–October 19

Pierre Bonnard: Early and Late

The Phillips Collection, Washington: September 21–January 19, 2003
Denver Art Museum: March 1–May 25, 2003

Pop Impressions Europe/USA: Prints and Multiples From the Museum of Modern Art

Chrysler Museum of Art, Norfolk, Va.: Through January 13
Glenbow Museum, Calgary, Alberta: February 23–June 2

Primal Visions: Albert Bierstadt "Discovers" America

The Montclair Art Museum, New Jersey: Through February 3
Columbus Museum of Art: February 7–April 28
Crocker Art Museum, Sacramento, Calif.: June 1–July 22

Red Grooms: Selections From the Complete Graphic Work, 1956–2000

Montgomery Museum of Fine Arts, Montgomery, Ala.: May 18–September 1
Museum of Fine Arts, St. Petersburg, Fla.: September 29–January 5, 2003

Scenes of American Life: Treasures From the Smithsonian American Museum of Art

Dayton Art Institute, Dayton, Ohio: January 12–March 24

Arkansas Arts Center, Little Rock: April 25–July 7
Westmoreland Museum of American Art, Greensburg, Pa.:
August 4–October 13

The Sport of Life and Death: The Mesoamerican Ballgame

New Orleans Museum of Art: February 16–April 28
Joslyn Art Museum, Omaha: June 8–September 1
The Newark Museum, Newark, N.J.: October 1–December 29

The Stamp of Impulse: Abstract Expressionist Prints

Cleveland Museum of Art: Through January 27
Amon Carter Museum, Fort Worth: March 2–May 12

Star Wars: The Magic of Myth

Toledo Museum of Art, Toledo, Ohio: Through January 5
Brooklyn Museum of Art, New York City: April 5–July 7

Thomas Eakins

Musée d'Orsay, Paris: February 3–May 12
Metropolitan Museum of Art, New York City: June 18–
September 15

Treasury of the World: The Jeweled Arts in the Age of the Mughals

Metropolitan Museum of Art, New York City: Through
January 13
Cleveland Museum of Art,
February 17–April 28
Museum of Fine Arts,
Houston: June 30–October 27
Los Angeles County Museum
of Art: November–February
2003

Treasures From a Lost Civilization: Ancient Chinese Art From Sichuan

Kimbell Art Museum, Fort
Worth: Through January 13
Metropolitan Museum of Art,
New York City: March 6–June
16

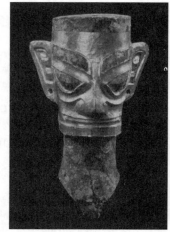

Courtesy of the Kimbell Art Museum.
Bronze with gold foil, China, *Head*,
12th century B.C.

MAJOR TRAVELING EXHIBITIONS

The Tumultuous 50's: A View From The New York Times

Albright-Knox Art Gallery, Buffalo, N.Y.: January 26–April 7
The New York Historical Society: April 30–July 21
Michael C. Carlos Museum, Atlanta: August 10–October 6
Tang Teaching Museum and Art Gallery, Skidmore College, Saratoga Springs, N.Y.: November–January 2003
CU Art Galleries, University of Colorado, Boulder: January 23–March 23, 2003
Museum of Art, Fort Lauderdale, Fla.: May 2–July 13, 2003
University Gallery, University of Massachusetts, Amherst: September 13–October 26, 2003
Terra Museum of America Art, Chicago: December 12, 2003–February 8, 2004

Van Gogh and Gauguin: "The Studio of the South"

Art Institute of Chicago: Through January 13
Van Gogh Museum, Amsterdam: February 9–June 2

UltraBaroque: Aspects of Post-Latin American Art

Art Gallery of Ontario, Toronto: January–April
Miami Art Museum: June 21–August 25
Walker Art Center, Minneapolis: October 13–January 5, 2003

Vital Forms: American Art in the Atomic Age, 1940–1960

Walker Art Museum, Minneapolis: February 17–May 12
Frist Center for the Visual Arts, Nashville: Summer
Los Angeles County Museum of Art: Fall/winter 2002–2003

William Kentridge

Museum of Contemporary Art, Chicago: Through January 20
Contemporary Arts Museum, Houston: March 1–May 5
Los Angeles County Museum of Art: July 21–October 6
South African National Gallery, Capetown: December 7–March 23, 2003

Women Who Ruled: Queens, Goddesses, Amazons, 1500–1650

The University of Michigan Museum of Art, Ann Arbor: February 17–May 5
Davis Museum and Cultural Center, Wellesley, Mass.: September 17–December 8

Young America: Treasures From the Smithsonian American Art Museum

The Ackland Art Museum, The University of North Carolina at Chapel Hill: Through February 17
Albany Institute of History and Art: March 15–May 19
Terra Museum of American Art, Chicago: August 10–October 20

Zero to Infinity: Arte Povera, 1962–1972

Walker Art Center, Minneapolis: Through January 13
Museum of Contemporary Art, Los Angeles: March 10–August 11
Hirshhorn Museum and Sculpture Garden, Smithsonian Institution, Washington: October 17–January 12, 2003

Courtesy of the Walker Art Center.
Giulio Paolini, *Preto (III)*, 1971.

Artists on View

Below is a listing of artists who have exhibitions focusing on their work in 2002.

ADAMS, ANSEL

Ansel Adams in the University of California Collection
University of California, Berkeley Art Museum and Pacific Film Archive: Through March 10

Ansel Adams at 100
The San Francisco Museum of Modern Art: Through January 13
Art Institute of Chicago: February 23–June 2
Hayward Gallery, London:
July–September
Art Library, Berlin: October 10–January 5, 2003
Los Angeles County Museum of Art: February 2–April 27, 2003
Museum of Modern Art, New York City: Summer 2002

Ansel Adams in Hawaii
The Honolulu Academy of Arts: July 18–August 25

Courtesy of the Art Institute of Chicago.
Ansel Adams, *Autumn Tree Against Cathedral Rocks, Yosemite*, ca. 1944.

Ansel Adams, a Legacy: Masterworks From the Friends of Photography Collection
Gibbes Museum of Art, Charleston, S.C.: May 11–August 4

AVERY, MILTON

Milton Avery: Paintings From the Collection of the Neuberger Museum of Art
Lowe Art Museum, Coral Gables, Fla.: Through January 20

Milton Avery: The Late Paintings
Milwaukee Art Museum: Through January 27

Norton Museum of Art, West Palm Beach, Fla.: February 16–April 14

BIERSTADT, ALBERT

Primal Visions: Albert Bierstadt "Discovers" America
Crocker Art Museum, Sacramento, Calif.: June 1–July 22
Columbus Museum of Art: February 7–April 28
The Montclair Art Museum, New Jersey: Through February 3

BONNARD, PIERRE

Pierre Bonnard: Early and Late
The Phillips Collection, Washington: September 21–January 19, 2003

BRAQUE, GEORGES

Georges Braque
Museo Thyssen-Bornemisza, Madrid: February 5–May 19

CARAVAGGIO, MICHELANGELO DA

Caravaggio
National Fine Arts Museum, Rio de Janeiro: March–April

CHAGALL, MARC

Marc Chagall: Worlds of Fable and Fantasy
Edmonton Art Gallery: Through January 14

Chagall: Dream Images
Musée Nacional Marc Chagall, Nice, France: Through January 7

Master and Apprentice: Marc Chagall and Yehuda Pen
The State Russian Museum, St. Petersburg: Spring

CHIHULY, DALE

Dale Chihuly: Installations
Phoenix Art Museum: March 30–June 23

CUYP, AELBERT

Aelbert Cuyp
National Gallery of Art, Washington: Through January 13
National Gallery, London: February 13–May 12
Rijksmuseum, Amsterdam: June 8–September 1

DA VINCI, LEONARDO

Leonardo da Vinci and the Splendor of Poland
The Milwaukee Art Museum: September 12–November 24
The Museum of Fine Arts, Houston: December 8–February 17, 2003
Fine Arts Museums of San Francisco, California Palace of the Legion of Honor: March 8–May 18, 2003

DE CHIRICO, GIORGIO

Giorgio de Chirico and the Myth of Ariadne
Philadelphia Museum of Art: November 3–January 5, 2003

DE KOONING, WILLEM

Tracing the Figure: Drawing by Willem de Kooning
Museum of Contemporary Art, Los Angeles: February 10–May 5

DIEBENKORN, RICHARD

Richard Diebenkorn
Norton Simon Museum, Pasadena, Calif.: Through April 8

Richard Diebenkorn: Clubs and Spades
The Fine Arts Museums of San Francisco: January 19–April 14

DINE, JIM

Jim Dine and Roy Lichtenstein: Selected Prints
Corcoran Gallery of Art, Washington, D.C.: Through February 4

Jim Dine Prints, 1985–2000
Minneapolis Institute of Art: May 12–August 4

DÜRER, ALBRECHT

Albrecht Dürer and His Influence: The Graphic Work of a Renaissance Artist
British Museum: December 6–March 23, 2003

Engravings and Woodcuts by Albrecht Dürer
Montgomery Museum of Fine Arts: September 15–October 21

The Print in the North: The Age of Albrecht Dürer and Lucas van Leyden
Bass Museum of Art, Miami Beach: July 6–September 29
The Currier Gallery of Art, Manchester, N.H.: March 22–June 16

EAKINS, THOMAS

Thomas Eakins
Musée d'Orsay, Paris:
February 3–May 12
Metropolitan Museum of
Art, New York City:
June 18– September 15

FAURER, LOUIS

Louis Faurer Retrospective
Museum of Fine Arts,
Houston:
January 20– April 14
Addison Gallery of American
Art, Andover, Mass.:
May 4– July 31

Courtesy of the Metropolitan Museum of Art.
Thomas Eakins, *The Artist's Wife and His
Setter Dog*, 1884–89.

GAUGUIN, PAUL

Gauguin in New York Collections
The Metropolitan Museum of Art: June 18–October 20

Van Gogh and Gauguin: The Studio of the South
Art Institute of Chicago: Through January 13
Van Gogh Museum, Amsterdam: February 9–June 2

GIACOMETTI, ALBERTO

Alberto Giacometti
Museum of Modern Art, New York: Through January 8
Fondation de L'Hermitage, Lausanne, Switzerland: February 1–
May 12

GIORDANO, LUCA

Luca Giordano
Los Angeles County Museum of Art: Through January 20

GOYA, FRANCISCO

Goya: Images of Women
Museo del Prado, Madrid: Through January 27
National Gallery of Art and Sculpture Garden, Washington,
D.C.: March 10–June 2

Francisco Goya and Jake and Dinos Chapman: Disasters of War
The Montreal Museum of Fine Art: Through January 27

Goya: The Family of the Infante Don Luis
The National Gallery, London: Through March 3

GROOMS, RED

Red Grooms: Bus
Herbert F. Johnson Museum of Art, Ithaca, N.Y.: Through
March 17

Red Grooms: Selections From the Complete Graphic Work,
1956–2000
Montgomery Museum of Fine Arts, Montgomery, Ala.: May
18–September 1
Museum of Fine Arts, St. Petersburg, Fla.: September 29–
January 5, 2003

GURSKY, ANDREAS

Andreas Gursky
Museum of Modern Art, George Pompidou Center, Paris:
March 13–May 8
Chicago Museum of Contemporary Art: June 22–September 22

HOCKNEY, DAVID

David Hockney: Paintings, 1960–2000
Louisiana Museum of Modern Art, Denmark: Through January 27

Cavafy's World: Hidden Things
The University of Michigan Museum of Art: February 21–May 5

HOMER, WINSLOW

Casting a Spell: Winslow Homer, Artist and Angler
The Fine Arts Museums of San Francisco: December
7–February 9, 2003

Winslow Homer and His Contemporaries: American Prints From the
Metropolitan Museum of Art
Munson-Williams-Proctor Institute, Utica, N.Y.: March 9–
April 28

JOHNS, JASPER

Robert Motherwell and Jasper Johns: Poetic Works as Metaphor
Montgomery Museum of Fine Arts: June 23–August 19

KELLY, ELLSWORTH

Ellsworth Kelly in San Francisco
The San Francisco Museum of Modern Art: July 13–January 5,
2003

Eye of the Beholder: The Photography of Ellsworth Kelly
Grand Rapids Art Museum: Opening in October

KIEFER, ANSELM

Anselm Kiefer
The Astrup Fearnley Museum of Modern Art, Oslo: April–June

KLEE, PAUL

Paul Klee
Hayward Gallery, London: January 17–April 1
Kunstmuseum Basel: March 23–July 28

LAWRENCE, JACOB

Over the Line: The Art and Life of Jacob Lawrence
Whitney Museum of American Art, New York City: Through
February 3
Detroit Institute of the Arts: February 24–May 19
The Museum of Fine Arts, Houston: October 6–January 5, 2003

LICHTENSTEIN, ROY

Jim Dine and Roy Lichtenstein: Selected Prints
Corcoran Gallery of Art, Washington, D.C.:
Through February 4

MANET, EDOUARD

Manet and the Impressionists
Staatsgalerie Stuttgart: September 21–February 9, 2003

MIRÓ, JOAN

The Shape of Color: Joan Miró's Painted Sculpture
Corcoran Gallery of Art, Washington, D.C.: September 21–
January 6, 2003

Joan Miró: Metamorphosis of Form
Bass Museum of Art, Miami: February 8–June 9

MONDRIAN, PIET

Piet Mondrian
Musée d'Orsay, Paris: March–June

MOORE, HENRY

Henry Moore
National Gallery of Art and Sculpture Garden, Washington,
D.C.: Through January 27

MORISOT, BERTHE

Berthe Morisot
Fondation Pierre Gianadda, Martigny, Switzerland: June 20–November 19

MOSES, GRANDMA

Grandma Moses in the 21st Century
Brooklyn Museum of Art, New York City: Through January 27
Gilcrease Museum, Tulsa, Okla.: February 27–April 14
Columbus Museum of Art, Columbus, Ohio: May 10–July 28
Portland Museum of Art, Portland, Ore.: August 27–December 1

MOTHERWELL, ROBERT

Robert Motherwell and Jasper Johns: Poetic Works as Metaphor
Montgomery Museum of Fine Arts: June 23–August 19

MUNCH, EDVARD

Edvard Munch: The Sick Child
Hamburger Kunsthalle: March 1–May 19

After "The Scream": The Late Work of Edvard Munch
High Museum of Art, Atlanta: February 9–May 5

MUÑOZ, JUAN

Juan Muñoz
Hirshhorn Museum and Sculpture Garden, Washington, D.C.: Through January 13
Museum of Contemporary Art, Los Angeles: April 21–July 28
Art Institute of Chicago: September 14–December 8

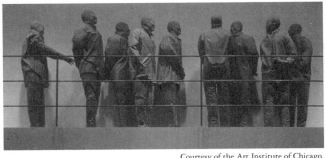

Courtesy of the Art Institute of Chicago.

Juan Muñoz, *Many Times*, 2000.

The Unilever Series: Juan Muñoz
Tate Modern, London: Through March 10

MURILLO, BARTOLOMÉ ESTEBAN

Bartolomé Esteban Murillo (1617–1682): Paintings From American Collections
Kimbell Art Museum, Fort Worth: March 10–June 2
Los Angeles County Museum of Art: July 14–October 6

NEWMAN, BARNETT

Barnett Newman
Philadelphia Museum of Art: March 24–July 7
Tate Modern, London: September 19–January 5, 2003

O'KEEFFE, GEORGIA

O'Keeffe's O'Keeffes: The Artist's Collection
Georgia O'Keeffe Museum, Santa Fe: Through January 13
Louisiana Museum of Modern Art, Denmark: February 8–May 20

Georgia O'Keeffe and the Landscape Tradition
Mississippi Museum of Art: March 2–June 30

PICABIA, FRANCIS

Francis Picabia, Retrospective
Musée d'Art Moderne de la Ville de Paris: October–February 2003

PICASSO, PABLO

Picasso Under the Sun of Mithra
Musée Picasso, Paris: Through March 4

Erotic Picasso
Museo Picasso, Barcelona: Through January 25

Picasso: Classicism
Baltimore Museum of Art: Through February 3

Picasso: The Artist's Studio
The Cleveland Museum of Art: Through January 6

PRENDERGAST, MAURICE

Maurice Prendergast: Learning to Look
Addison Gallery of American Art, Andover, Mass.: January 20–March 14

REDON, ODILON

Odilon Redon
Kröller-Müller Museum, The Netherlands: February 2–July 7

RENOIR, PIERRE-AUGUSTE

Idol of the Moderns: Pierre-Auguste Renoir and American Painting
San Diego Museum of Art: June 29–September 15

RIVERS, LARRY

Paris, New York, Hollywood: The Art of Larry Rivers
Corcoran Gallery of Art, Washington, D.C.: May 18–July 22

RODIN, AUGUSTE

Rodin: A Magnificent Obsession
National Gallery of Australia: Through February 10

ROMNEY, GEORGE

George Romney Retrospective
Walker Art Gallery, Liverpool, England: February 7–
April 28
National Portrait Gallery, London: May 30–August 18
The Huntington Library, Art Collections and Botanical
Gardens, San Marino, Calif.: September 15–December 1

RUSCHA, ED

Ed Ruscha
Museum of Modern Art, Oxford, England: Through January 13

SIGNAC, PAUL

The Watercolors of Paul Signac
The Society of Four Arts, Palm Beach, Fla.: January 12–
February 12

SISKIND, AARON

Aaron Siskind: Expression Through Abstraction
Museum of Contemporary Art, Los Angeles: Through January 6

STIEGLITZ, ALFRED

The Photography of Alfred Stieglitz: Georgia O'Keeffe's Enduring Gift
Davenport Museum of Art, Iowa: Through January 27

STRUTH, THOMAS

Thomas Struth: A Retrospective
Museum of Contemporary Art, Los Angeles: September 15–
January 5, 2003

SWEERTS, MICHIEL

Michiel Sweerts: Painter of Silence and Secrets
Rijksmuseum, Amsterdam: March 8–May 12

Michiel Sweerts
The Fine Arts Museums of San Francisco: June 8–August 25

Michiel Sweerts, 1624–1664
Wadsworth Atheneum Museum of Art, Hartford, Conn.:
September 20–December 1

TARBELL, EDMUND C.

Impressionism Transformed: The Paintings of Edmund C. Tarbell
Delaware Art Museum: February 15–April 28
Terra Museum of American Art, Chicago: May 11–July 20

J.M.W. TURNER

Late Turner: The Legacy of the Liber Studiorum
Yale Center for British Art, New Haven, Conn.: September 26–
November 30

*Reflections of Sea and Light: Paintings and Watercolors by J.M.W.
Turner*
The Baltimore Museum of Art: February 17–May 26

The Turner Watercolors
National Gallery of Ireland: Through January 31

VAN GOGH, VINCENT

Van Gogh and Gauguin: The Studio of the South
Art Institute of Chicago: Through January 13
Van Gogh Museum, Amsterdam: February 9–June 2

Vincent van Gogh
Hamburger Kunsthalle: March 29–June 16

Vincent Van Gogh Drawings: Antwerp and Paris, 1885–1888
Van Gogh Museum, Amsterdam: Through January 6

Van Gogh
Kröller-Müller Museum, The Netherlands: December
21–January 11, 2004

Warhol, Andy

Andy Warhol: Retrospective
Veletrzni Palace, Prague: January 10–March 17

Possession Obsession: Objects From Andy Warhol's Personal Collection
The Andy Warhol Museum, Pittsburgh: March 2–May 19

Westermann, H.C.

*See America First: The Complete Graphic Works of H.C.
Westermann*
Laguna Art Museum: April 27–July 7
Contemporary Arts Museum, Houston: October 4–December 1

H.C. Westermann
Hirshhorn Museum and Sculpture Garden, Washington:
February 14–May 12
Museum of Contemporary Art, Los Angeles: June
9–September 8
The Menil Collection, Houston: October 4–January 5, 2003

Weston, Edward

Edward Weston: The Last Years in Carmel
San Francisco Museum of Modern Art: March 1–July 9

A Passionate Collaboration: Edward Weston and Margrethe Mather
Santa Barbara Museum of Art: April 13-June 23

Edward Weston: Photography and Modernism
Georgia O'Keeffe Museum, Santa Fe: January 24–May 12
The Phillips Collection, Washington, D.C.: June 1–August 18

Whistler, James McNeill

Whistler in Venice: The First Set of Etchings
Freer Gallery of Art, Washington, D.C.: Through January 6

James McNeill Whistler
Freer Gallery of Art, Washington, D.C.: Continuing

The Lithographs of James McNeill Whistler
Lowe Art Museum, Coral Gables, Fla.: June 13–July 28

Wright, Frank Lloyd

Light Screens: The Leaded Glass of Frank Lloyd Wright
High Museum of Art, Atlanta: June 8–September 1
Grand Rapids Art Museum: Through January 6

WYETH FAMILY

One Nation: Patriots and Pirates Portrayed by N.C. Wyeth and James Wyeth
The John and Mable Ringling Museum of Art, Sarasota, Fla.: Through January 6

Andrew Wyeth Selections
Farnsworth Art Museum, Rockland, Me.: Through May 19

N.C. Wyeth in Maine
Farnsworth Art Museum, Rockland, Me.: Continuing

N.C. Wyeth Arrives in Wilmington
Brandywine River Museum, Chadds Ford, Pa.: September 13–November 24

Andrew Wyeth: The Greenville Collection
The Greenville County Museum of Art, Greenville, S.C.: Continuing

Photographs Get Bigger

By Sarah Boxer

Does size matter in photography? Last summer a friend and I were walking through The Metropolitan Museum of Art in New York City looking at an exhibition of Bauhaus photographs from the 1920's. "Why are they so small?" she asked. Good question. And a rare one these days.

Photographs are getting bigger and bigger. Think of Nan Goldin. Think of Jeff Wall. Chuck Close. Rineke Dijkstra. Hiroshi Sugimoto. Joel Sternfeld. Thomas Struth. Sally Mann. Richard Avedon. And especially Andreas Gursky, the biggest of the big, whose retrospective exhibition, beginning at New York's Museum of Modern Art, is traveling the world: Madrid, Paris, Chicago.

Why bigness? In his 1998 book, "S, M, L, XL," the architect Rem Koolhas quoted Donald Trump: "I like thinking big. I always have. To me it's very simple: if you're going to be thinking anyway, you might as well think big." Bill Clinton made a similar remark in his second inaugural address: "Nothing big ever came from being small." And Koolhas himself wrote an apology for bigness in architecture. "The best reason to broach Bigness is the one given by climbers of Mount Everest: 'because it is there.' Bigness is ultimate architecture." It is "inflexible, immutable, definitive, forever there, generated through superhuman effort." Could it be that bigness is ultimate photography?

Maybe there are other reasons why photographs keep growing. The Edwynn Houk Gallery in New York City, in a recent exhibition called "Size Matters," proposed that photographs first got big when they moved from album pages to exhibition walls: "A case in point is the work of Ansel Adams, whose belated artistic recognition in the 1970's was due in part to his production of large exhibition prints from earlier images." That is, Adams became a big name when his photographs got big enough to put up on walls. (Since then, photography books have also grown unreasonably large. "Earth from Above," "Inferno" and "Century" are all unliftable, doorstopper testaments to the idea that photography belongs not in books but on the walls.)

Can the move from album to gallery wall explain every

supersize-it impulse in photography? Take the case of Gursky, the deadpan German artist who photographs stock exchange floors, factories, shipping docks and dance clubs. Katy Siegel pondered Gursky's bigness in Artforum magazine. "Why does he do it? The answer seems obvious: to see the big picture, things too vast to take in with either the human eye or a camera fixed at a particular viewpoint," she wrote. "We need these big brilliant photos to show us our big bland, dense world."

But big subjects don't always get a big picture. Sebastiao Salgado's grand cinematic scenes of refugees moving across a landscape are not so very large. And plenty of big photographs have no global scope. Take, for example, Nan Goldin's work that was recently shown at Matthew Marks's gallery in Manhattan. Do we really need to see these intimate photographs — Goldin's friends in bed, in the tub — as big as life? Does it make them more real? More unreal? More impressive? More expressive?

How about just more visible? The point was driven home at the opening of Goldin's show. The crowd was massive. You couldn't get anywhere near the photographs. And the great thing was, you didn't have to.

There is anonymity and speed in bigness. In the age of the funhouse gallery, bigness means that more people can come and go, without having to get too close. It is a self-perpetuating phenomenon. Big works of art need big museums and big museums need big works of art. Take the huge crowds and yawning spaces of the Tate Modern in London. What kind of photographs will stand up in a place like this? Big photographs, naturally.

Chuck Close, an artist who is known for making huge paintings based on photographs of himself and his friends, said he likes the aggression of big pictures "that you can see from a block away." Why? "The longer they take to walk by, the harder they are to ignore," he said. And the added attraction is that in big photographs "there is a level of information about other people's faces that is embarrassing." In other words, big photographs are not only anonymous but intimate too.

Maybe bigness is a question of money. "There is an acreage issue," Close said. Although a photograph that is four times as big is not four times as expensive, it may be three times as expensive. But then again, he added, it is more expensive to produce too.

According to Peter MacGill, of the Pace/MacGill gallery in Manhattan, big contemporary photographs go for more money than small ones, but, he added, you can't, in general, say that there is a relationship between the size and value of a photograph. He mentioned a vintage Man Ray that went for more than $1 million. It was 11 by 14 inches. "No big pictures have gone for that," he said. And a recent 8-by-10-inch Richard Serra maquette brought $140,000.

Maybe it comes down to respect. Photography wants to be loved like art. The artist Duane Michals said, "Photographs are mimicking the art of the moment." And the art of the moment is big. "Big photographs fulfill the art world's idea of what art looks like."

"Gigantic, life-size and larger-than-life-size prints have become the equivalent of painting's grand compositions," the Edwynn Houk gallery observed. Which raises a question: Does bigness confer art status on a photograph? Or does the status come indirectly, because photographs, now big, can hang with paintings? Whatever the case, photographs have achieved a kind of parity with paintings. In one of its millennial exhibitions, New York's Museum of Modern Art exhibited Paul Cézanne's monumental *Bather* next to an equally big Rineke Dijkstra photo of a guy in swim trunks.

This is not the first time or the first way that photographs have strived to be more like "fine art." In the late 19th and early 20th century, pictorialist photographers, under the influence of Clarence White and Alfred Stieglitz, started making photographs that would actually look like the Impressionist and Symbolist paintings of their day. And in the 1950's, Michals noted, Aaron Siskind made photographs that looked like Franz Kline's black and white Abstract Expressionist paintings.

This time around things are different. First, photography now seems to be imitating not the style so much as the scale of contemporary paintings. As Michals put it, "Photographers are making giant pictures that can only hang on the walls of museums of bank lobbies."

The second difference is that photography now is competing not only with painting but also with video art. Video is, of course, a lot like photography except that it is moving, it is often projected onto a very large screen and it is inexplicably mesmerizing. Photography, caught between the majesty of

painting and the magnetism of video, is becoming more like both by magnification. "Look at me! I'm huge!"

Of course there are countercurrents: galleries showing small pictures, even tiny pictures. The retrospective of Ansel Adams, beginning at the San Francisco Museum of Modern Art, highlights his smaller, quieter works. "No Big Pictures," a recent show at Pace/MacGill in New York, was an overt counterreaction to the bigness craze, with small prints by Jacques Henri Lartigue, Andre Kertesz, Paul Outerbridge and Joel-Peter Witkin, and even contact sheets from Robert Frank's "Americans."

What is the counterreaction about? Size is off-putting. Smallness is inviting. Recently two Chuck Close photographs were visiting neighboring galleries in New York. One was a humongous close-up of Close himself. The other was a delicate portrait of a girl named Leslie. Getting up close to the big Close wasn't fun. The pores were scary. But Close's small photograph of the girl, a maquette for a painting, was a different matter. Over her delicate freckles and perspiration, Close had drawn a grid in ballpoint, presumably to prepare for enlargement and painting. Her face was so small behind the grid that you felt for it, locked in its prison of ink and tape. You wanted to examine everything about it.

Despite occasions like this, bigness is still big. Bigness is overdetermined. Everything in the world points to bigness in photography. Big museums. Heavy books. Crowds. Globalism. The art market. Giant Polaroid cameras. And the Mount Everest effect: simply because bigness is there to be conquered.

How big will big get? "Because there is no theory of Bigness," Koolhas wrote, "we don't know what to do with it, we don't know where to put it, we don't know when to use it, we don't know how to plan it. Big mistakes are our only connection to Bigness."

Sarah Boxer is an arts reporter and photography critic for The New York Times. Her first book, "In the Floyd Archives: A Psycho-Bestiary," has just been published by Pantheon.

Exhibition Schedules for Museums in the United States

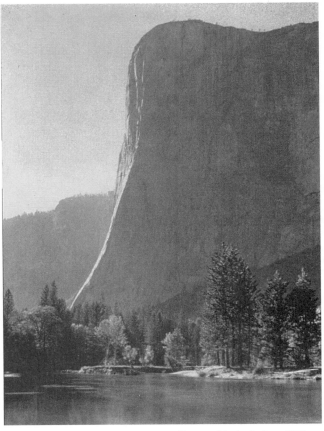

Ansel Adams, *El Capitan, Merced River, Against Sun*, Yosemite, California, ca. 1950.

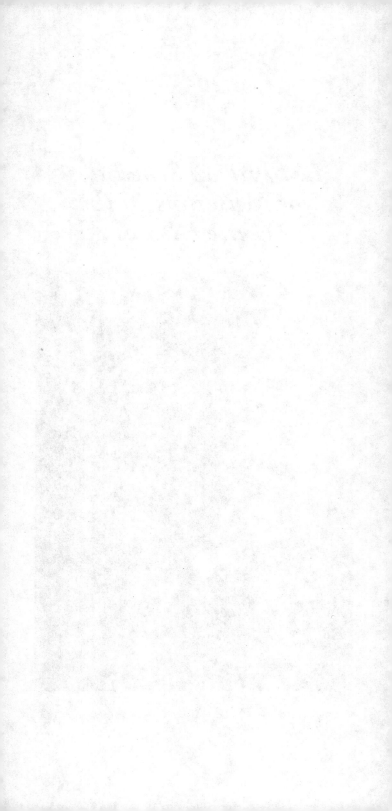

Alabama

Birmingham Museum of Art

2000 Eighth Avenue North, Birmingham, Ala. 35203
(205) 254-2566
www.artsBMA.org

2002 EXHIBITIONS

Through January 6
Gracious Splendor: The Bequest of Susan Mabry and William Hansell Hulsey
More than 20 Marie Laurencin works, plus art by Edgar Degas, Maurice de Vlaminck and other Europeans.

Through January 6
In the Presence of Spirits: Selections From the National Museum of Ethnology, Lisbon
Approximately 140 objects from Angola, Mozambique and Guinea-Bissau, including masks; intricately carved combs, pipes and staffs used during initiation rituals; and chairs commissioned for tribal chiefs.

Through June 2
Perspectives 6: Lawrence Weiner
A text-based site-specific installation: "A Basic Assumption."

January 20–April 7
Methods and Media: Drawings From the Birmingham Museum of Art
Works by George Bellows, Thomas Cole, Sol LeWitt, Jan Liss, Adriaen van Ostade and others, including watercolors, gouaches and ink, chalk, charcoal and graphite drawings.

February–April 9
European Masterpieces: Six Centuries of Painting From the National Gallery of Victoria, Australia

Courtesy of the Birmingham Museum of Art. Rembrandt, *Portrait of a White-Haired Man*, 1667.

Birmingham/Montgomery

Dozens of paintings from the 14th to the 20th century, including works by Gainsborough, El Greco, Hockney, Monet, Picasso, Pissarro and Rembrandt.

May 5–July 14
Glass of the Avant-Garde from Vienna Secession to Bauhaus: The Torsten Bröhan Collection from the Museo Nacional de Artes Decorativas, Madrid

May 26–August 11
China Chic

PERMANENT COLLECTION

More than 18,000 paintings, drawings, textiles and sculpture from ancient to modern times; growing collections of African, pre-Columbian and Native American art; the Charles W. Ireland Sculpture Garden. **Highlights:** Kress Collection of Renaissance art; Beeson Collection of Wedgwood; *Birmingham Persian Wall,* a glass installation by Dale Chihuly. **Architecture:** International Style building, 1959; additions by Warren, Knight and Davis; expansion and renovation by Edward Larrabee Barnes, 1993.

Admission: Free.
Hours: Tuesday through Saturday, 10 a.m.–5 p.m.; Sunday, noon–5 p.m. Closed Monday, New Year's Day, Thanksgiving and Christmas Day.

Montgomery Museum of Fine Arts

One Museum Drive, Blount Cultural Park,
 Montgomery, Ala. 36117
(334) 244-5700
www.mmfa.org

2002 EXHIBITIONS
Through January 6
The Art of the Goldsmith: Masterworks From the Buccellati Foundation

Finely crafted objets d'art and jewelry made by the Buccellati family of designers in Italy since the mid-18th century.

Through February 3
ARTNOW: Keiji Shinohara
Prints focusing on the beauty of individual natural elements, such as tree branches, floating leaves and water ripples.

January 12–February 10
Robert Rivers
Graphic and ceramic works by the artist.

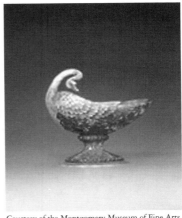

Courtesy of the Montgomery Museum of Fine Arts.
Cup of Euphoric Bliss, 1978, from collection of Gianmaria Buccellatti.

February 23–May 5
Brush With History: Paintings From the National Portrait Gallery
Seventy-five paintings drawn from the National Portrait Gallery's permanent collection.

May 18–August 4
Hubert Shuptrine
About 50 watercolors by this abstract painter, who gained a national reputation in 1974 with the publication of *Jericho: The South Beheld,* featuring his representational watercolor paintings alongside text by the writer James Dickey.

May 18–September 1
Red Grooms: Selections From the Complete Graphic Work, 1956–2000
Retrospective of the graphics work of Red Grooms, a native of the South who migrated to New York and became a fixture in the world of contemporary art. (Travels)

September 15–October 21
Engravings and Woodcuts by Albrecht Dürer
Thirty impressions of prints by the Germany artist Albrecht Dürer (1471-1528), renowned in his own time as both a painter and printmaker.

PERMANENT COLLECTION

More than 3,000 works, including 19th- and 20th-century American paintings and sculpture; Southern regional and folk art; European Old Master and contemporary works on paper; decorative art objects.

Admission: Free.
Hours: Tuesday through Saturday, 10 a.m.–5 p.m.; Thursday, until 9 p.m.; Sunday, noon–5 p.m. Closed Monday, New Year's Day, Independence Day, Thanksgiving and Christmas Day.

Anchorage Museum of History and Art

121 West Seventh Avenue, Anchorage, Alaska 99501
(907) 343-4326; (907) 343-6173 (recording)

2002 EXHIBITIONS

January 7–March 5
Recent Acquisitions
Objects collected during the previous year.

January 14–March 18
Sam Kimura Retrospective
Works by a longtime photography teacher at the University of Alaska, Anchorage.

January 14–March 18
All Alaska Juried
Juried exhibition of works by Alaska artists.

March 10–April 24
Jane Terzis Solo Exhibition
Works by an innovative portraitist who lives in Alaska.

April 22–September 16
Sharkabet: *By Ray Troll*
Exhibition of original drawings used in *Sharkabet: A Shark Infested ABC Book.*

October 6–December 31
Looking Both Ways: Heritage and Identity of the Alutiiq People

Art, archaeology, history and oral tradition of the Alutiiq people of Alaska's southcentral coast.

October 28–December 31
Indivisible: Stories of American Community
Nearly 200 photographs depicting life in 12 U.S. communities.

PERMANENT COLLECTION

The history of Alaska, featuring subsistence life styles before contact with Europeans; whaling; gold mining; building of the railroad; statehood; and contemporary Alaska.

Admission: Adults, $6.50; seniors, $6; children, free.
Hours: Sunday through Thursday, 9 a.m.–9 p.m.; Friday and Saturday, 9 a.m.–6 p.m. Slightly shorter hours during the winter. Closed New Year's Day, Thanksgiving and Christmas Day.

The Heard Museum — Native Cultures and Art

2301 North Central Avenue, Phoenix, Ariz. 85004
(602) 252-8840; (602) 252-8848 (recording)
www.heard.org

2002 EXHIBITIONS

Through March 3
Hold Everything! Masterworks of Pottery and Basketry From the Heard Museum
First exhibition in a series highlighting the more than 32,000 examples of Native American fine art and cultural art in the museum's collection.

Through May
Fine Art: Recent Acquisitions From the Heard Museum Collection
Native American paintings and sculptures recently given to the museum.

February 16–January 2003
8th Native American Fine Art Invitational
Works by eight cutting-edge Native American artists from the United States and Canada.

Phoenix

March 23–September
Be Dazzled! Masterworks of Jewelry and Beadwork From the Heard Museum Collection
Second in a series highlighting Native American artwork from the museum's collection.

Heard Museum North

34505 Scottsdale Road, North Scottsdale, Ariz. 85262
(602) 488-9817

2002 EXHIBITIONS
January 26–June
Fabric, Wood and Clay: The Diverse World of Navajo Art

PERMANENT COLLECTION

Founded in 1929 by Dwight B. and Maie Bartlett Heard to house their collection of primarily Native American artifacts, the museum now has more than 32,000 objects of Native American art. More than 3,600 paintings, prints and sculpture that document the 20th-century development of the Native American Fine Art Movement. **Highlights:** The Barry Goldwater collection of 437 Hopi katsina dolls.

Admission: Adults, $7; seniors, $6; children 4–12, $3; children under 4 and Native Americans with proof of tribal enrollment, free.
Hours: Daily, 9:30 a.m.–5 p.m. Closed New Year's Day, Easter Sunday, Memorial Day, Independence Day, Labor Day, Thanksgiving and Christmas Day.

Phoenix Art Museum

1625 North Central Avenue, Phoenix, Ariz. 85004
(602) 257-1880; (602) 257-1222 (recording)
www.phxart.org

2002 EXHIBITIONS

Through January 27
The Art of Eugene Grigsby
A retrospective of the Phoenix artist's work, including
paintings, woodcuts and lithographs.

Through April 7
*Secret World of the Forbidden City: Splendors From China's Imperial
Palace*
More than 300 objects, including gold, silver, gems, jade,
silks, inlaid metals, paintings, portraits, ceramics, furniture
and robes, plus personal possessions of Xuantong and other
Qing dynasty emperors. Separate admission charge.

January 26–May 27
Gwynn Popovac Fantasy Masks
Masks made of bamboo, silk, stones, beads, bark, bone, shells,
fossils and other natural materials.

February 9–May 12
Reminders of Invisible Light: Beth Ames Swartz, 1960-2000
A retrospective of the Arizona artist's work, including
watercolors and mixed-media paintings.

March 30–June 23
Dale Chihuly: Installations
Large-scale glass works.

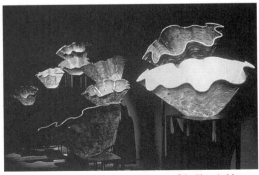

Courtesy of the Phoenix Museum.
Dale Chihuly, *Macchia Forest*, 1994.

October 19–November 17
Cowboy Artists of America Exhibition
More than 100 new works in the 37th annual CAA event.

PERMANENT COLLECTION

More than 16,000 works of American, Asian, contemporary,
European, Latin American and Western American art, and
fashion design. The Thorne Miniature Rooms offer historic
interiors.

Admission: Adults, $7; seniors and students, $5; ages 6–17,
$2; children under 6, free. Free on Thursday.
Hours: Tuesday through Sunday, 10 a.m.–5 p.m.; Thursday,
until 9 p.m. Closed Monday and major holidays.

Tucson Museum of Art and Historic Block

140 North Main Avenue, Tucson, Ariz. 85701
(520) 624-2333
www.tucsonarts.com

2002 EXHIBITIONS

Through January 13
*Iron Maidens: Cast Metal and Welded Steel Sculpture by Bellay
Feldman, Mary Bates-Neubauer and Kim Cridler*
Contemporary works by women who cast their own iron and
weld their own steel.

Through January 13
Barbara Rogers: Natural Facts/Unnatural Acts
Paintings that explore the classic garden themes of decay,
death, rebirth and renewal.

Through March 31
El Nacimiento
A traditional Mexican nativity scene, recreated each year by
Maria Luisa Tena, featuring hundreds of miniature subjects
depicting the life of Christ.

January 12–March 16
Shu-Min Lin: Holographic Installations
Contemporary works that explore the disparity of belief
systems between the artist's home in Taiwan and his current
residence in New York.

February 16–April 21
Threads of the World: Folk Costumes
Garments, jewelry and accessories from Asia and South
America, made and worn predominantly by women.

February 16–April 28
*American Spectrum: Paintings and Sculptures From the Smith
College Museum of Art*
Works from the 18th century to the 20th, including examples
by Albert Bierstadt, Alexander Calder, Willem de Kooning,
Arthur Dove and Winslow Homer.

February 24–March 24
Western Artists of America: Branding Iron Show
Works by 12 members of the newly formed national
association, plus examples by eight other artisans.

Admission: Adults, $2; seniors and students, $1; children,
free. Free on Sunday.
Hours: Monday through Saturday, 10 a.m.–4 p.m.; Sunday,
noon–4 p.m. Closed Monday from Memorial Day through
Labor Day and major holidays.

The University of Arizona Museum of Art

Speedway Boulevard, Tucson, Ariz. 85721
(520) 621-7567
artmuseum.arizona.edu

2002 EXHIBITIONS

Through January 13
Between a Poem and a Tree: Vera Klement
Recent paintings.

ARIZONA

Tucson

Through January 13
Drawings by Jim Waid
Works the Arizona painter drew during the past 30 years.

Through February 24
New Old Prints: Recent Acquisitions of 16th- Through 19th-Century Prints
Works by Francisco José de Goya, Jacob van Ruisdael, Giovanni Tiepolo and others.

January 27–March 24
Bruce McGrew: A Retrospective
Paintings and works on paper from the three-decade career of the artist and teacher, who died in 1999.

March 3–April 21
DeSoto and Mexico: The Second Part
Prints by Tucson native Ernest DeSoto, plus works by Mexican artists with whom he collaborated.

April 7–May 5
Master of Fine Arts Exhibition

April 28–June 2
Tamblyn Collages

PERMANENT COLLECTION

The more than 4,000 paintings, sculptures, drawings and prints in the museum include works by Hopper, Picasso, O'Keeffe and Zuniga. On display are the 26 panels of the 15th-century Spanish altarpiece of Ciudad Rodrigo and 61 clay and plaster models by the 20th-century sculptor Jacques Lipchitz.

Admission: Free.
Hours: Monday through Friday, 9 a.m.–5 p.m.; Sunday, noon–4 p.m.; slightly shorter hours during the summer. Closed Saturday and university holidays.

The Arkansas Arts Center

Tenth and Commerce Streets, Little Rock, Ark. 72202
(501) 372-4000
www.arkarts.com

2002 EXHIBITIONS

Through January 13
Carl Milles: Sculptor
Forty-two sculptures by a Swedish-born artist who created
many large public fountains in the United States.

Through January 13
Magic Vision
Works by contemporary artists whose images alter reality.

January 17–March 10
Baskets: A National Survey
Works by 50 basket makers, organized in cooperation with the
newly formed National Basket Organization.

January 18–March 3
A Strong Night Wind: The Art of Donald Roller Wilson
Surreal works by an Arkansas artist, such as chimpanzees
dressed in court attire playing cards.

January 18–March 3
Benjamin Krain: From the Streets of Cuba
Street photography in Havana by a photojournalist at the
Arkansas Democrat-Gazette.

March 15–April 21
32nd Annual Mid-Southern Watercolorists
Juried show organized by the Mid-Southern Watercolorists.

March 17–April 14
Above and Below
Explores the evolution of New York City from the 1900s to
the 1930s through the eyes of printmakers.

March 17–April 14
*Tale of Two Cities: Eugene Atget's Paris and Berenice Abbott's
New York*
Works by two photographers documenting the changes to the
two cities.

April 26–July 7
Scenes From American Life: Treasures From the Smithsonian Museum of American Art
Sixty-two paintings exploring the 20th century by artists such as Thomas Hart Benton, Edward Hopper and Jacob Lawrence.

PERMANENT COLLECTION

Paintings by Rembrandt, Picasso, Pollock, de Kooning, Mondrian, Wyeth, O'Keeffe, Bellows and others; drawings in all media; contemporary crafts. The museum also operates the Decorative Arts Museum in a historic home nearby.

Admission: Free.
Hours: Monday and Wednesday through Saturday, 10 a.m.–5 p.m.; Thursday and Friday, until 9 p.m.; Sunday, 11 a.m.–5 p.m. Closed Tuesday and Christmas Day.

Decorative Arts Museum

East Seventh and Rock Streets, Little Rock, Ark. 72202

2002 EXHIBITIONS

Through January 6
29th Annual Toys Designed by Artists
Juried exhibition of toys designed and made by artists across the United States.

Through January 6
The Wonderful Wacky World of Bill Reid
Exhibit of creations by this toymaker.

January 13–February 17
Baskets From the Permanent Collection
Contemporary baskets from one of the nation's largest museum collections of baskets.

February 24–March 31
Kreg Kallenberger: Glass Series
Glass works from the 1980s and 1990s.

April 7–May 12
Embellished With Gold

Works in various craft media with gold embellishment.

PERMANENT COLLECTION

The center has 10 to 12 exhibitions a year by nationally recognized craftspeople.

Admission: Free.
Hours: Monday through Saturday, 10 a.m.–5 p.m.; Sunday, noon–5 p.m. Closed Christmas Day.

California

University of California, Berkeley Art Museum and Pacific Film Archive

2626 Bancroft Way, Berkeley, Calif. 94720
(510) 642-0808
www.bampfa.berkeley.edu

2002 EXHIBITIONS

Through January 13
Thomas Scheibitz/MATRIX 195
Colorful paintings by this East German artist.

Through late January
The Lady at the Window: Figure Painting in the Qing Dynasty (1644–1911)
Explores how Chinese painters — including Huang Shen, an 18th-century Yangzhou artist, and Gao Qipei, who painted with his long fingernails — depicted the human figure.

Through March 10
Ansel Adams in the University of California Collection
Celebrating the centennial of the photographer's birth, an exhibition including scenes of the California wilderness and the Berkeley campus as well as commercial photography.

January 16–March 24
Migrations: Photographs by Sebastião Salgado
Works by this Brazilian photographer showing people, often the victims of war and oppression, who leave their homeland.

January 27–March 24
Sowon Kwon/MATRIX 196
Works in digital media by a Manhattan-based artist.

February 6–August 25
MicroPainting: The Practice of Portrait Miniature in England and France
Sixteenth- to 19th-century British and French portrait miniatures, including ones of Queen Elizabeth I and Napoleon.

February–June
The Work of a Lifetime: Highlights From the Cahill Family Collections
More than 60 paintings, particularly by Chinese artists, spanning 800 years. (Travels)

March 20–May 26
Marion Brenner: The Subtle Life of Plants and People
Works by a widely published Berkeley photographer, including botanical images and large-format portraits.

April 7–June 2
Sanford Biggers/MATRIX 197
Works reflecting African-American culture and history, race politics, world religions and hip-hop.

April 10–July 14
Komar & Melamid's Asian Elephant Art and Conservation Project
An exhibition of paintings created by elephants formerly used in the Thai logging industry, raising questions of what art is.

June 16–July 28
T.J. Wilcox/MATRIX 198
Films mixing vintage and new clips and animation.

August 11–October 6
Vince Fecteau/MATRIX 199
Miniature sculptures made from materials such as aluminum foil, cardboard and paper clips by a San Francisco artist.

October 20–December 29
Yehudit Sasportas/MATRIX 200
An installation titled *The Carpenter and the Seamstress* based on the floor plan of the Israeli apartment of the artist's family.

October 23–December 29
Beyond Preconceptions: The Sixties Experiment
Works by 21 artists from three continents whose art reflects the political and cultural change of the 1960's.

PERMANENT COLLECTION

Western art from the Renaissance to the 20th century, with particular strengths in contemporary and conceptual art; Asian art, especially Japanese prints and paintings and Chinese painting and ceramics; work by the Abstract Expressionist Hans Hofmann.

Admission: Adults, $6; children, students and seniors, $4. Free on Thursday.
Hours: Wednesday through Sunday, 11 a.m.–5 p.m.; Thursday, until 9 p.m. Closed Monday and Tuesday.

Laguna Art Museum

307 Cliff Drive, Laguna Beach, Calif. 92651
(949) 494-8971
www.lagunaartmuseum.org

2002 EXHIBITIONS

Through January 13
Representing LA: Pictorial Currents in Southern California Art
Explores the varied representational paintings, drawings, printmaking and sculpture of more than 80 Southern California artists since 1990.

Through January 13
Erotic Abstraction From the Collection
Paintings, drawings and sculpture by 15 artists exploring the fine line between abstraction and sensual imagery.

Through January 13
Women Artists in California
Works by Anna Hills, Donna Schuster, Marion Wachtel and Julia Wendt.

January 20–April 7
Some Fuzzy Logic: The Joan Simon Menkes Gift
Group exhibition focusing on artists who came to prominence in the 1980s and who question the certainties of daily life through their works.

January 27–April 7
California Holiday: E. Gene Crain Collection
Works from 1930 to 1990 by the California School as well as later generations of watercolor painters.

April 27–July 7
See America First: The Complete Graphic Works of H.C. Westermann

Nearly 50 lithographs, linoleum cuts, woodblock prints and related drawings by this postwar American artist who was influential in the Figurative and Pop Art movements.

April 28–July 7
The Chances of Andy Wing: A Retrospective
A survey of 43 years of work by the Laguna artist who uses chance in creating his images.

July 29–October 14
Surf Culture
Explores surfboard design from 1900 to the present and links between surfing and art, culture and technology.

November–January
In and Out of California: Travels of American Impressionists
Works by California artists who also had careers elsewhere and East Coast artists who worked for periods in California.

PERMANENT COLLECTION

A 300-piece collection including works by 19th-century Californian Impressionists and contemporary Southern California artists.

Admission: Adults, $5; students and seniors, $4.
Hours: Tuesday through Sunday, 11 a.m.–5 p.m.; the first Thursday of each month, until 9 p.m. Closed Monday, New Year's Day, Thanksgiving and Christmas Day.

The Getty Center

The J. Paul Getty Museum, 1200 Getty Center Drive,
 Los Angeles, Calif. 90049
(310) 440-7300; (310) 440-7305 (for the deaf)
www.getty.edu

2002 EXHIBITIONS

Through January 20
Posing for Posterity: Portrait Drawings From the Collection
Thirty portraits, spanning the Renaissance through the 19th century, including preparatory drawings for large-scale portraits as well as finished works.

Los Angeles

Through February 3
Devices of Wonder: From the World in a Box to Images on a Screen
Optical games, toys, prints, scientific instruments, rare natural history books, trompe l'oeil paintings, trick furniture and other items from the Getty Research Institute's collection.

Through February 17
Manuel Alvarez Bravo: Optical Parables
Works by the Mexican photographer, including images with surreal undertones.

Through March 10
Artful Reading in Medieval and Renaissance Europe
Fifteen medieval manuscripts from the museum's collection, plus a papyrus roll, two early printed books and a photograph by Walker Evans. Explores how the written word in the Middle Ages opened minds, and examines how technology has influenced communication since then.

January 8–August 11
Rome on the Grand Tour
Paintings, pastels, drawings, sculpture, artists' sketchbooks, antiquities, books and prints.

February 5–May 12
Viewing Italy in the 18th Century
Landscapes and cityscapes that became popular travel souvenirs — the predecessors of modern-day postcards.

March 5–June 23
Railroads in Photography
Works by Édouard-Denis Baldus, O. Winston Link and others. Explores the relationship between photography and railroads, which grew up together in the 1830's.

March 26–July 7
Violence in the Medieval World
Sixteen European manuscripts and leaves, from the 13th century to the 16th.

April 16–July 7
The Sacred Spaces of Peter Saenredam
Drawings and paintings of churches by the Dutch artist and architectural draftsman (1597-1665).

Continuing
Ancient Art from the Permanent Collection

Greek and Roman antiquities, including a fifth-century B.C. statue thought to be of Aphrodite.

Continuing
Statue of an Emperor: A Conservation Partnership
A behind-the-scenes look that highlights changes in restoration and conservation practices since the 18th century.

PERMANENT COLLECTION

An international cultural and philanthropic institution devoted to the visual arts that includes an art museum as well as programs for education, scholarship and conservation. Features European paintings, drawings, illuminated manuscripts, sculpture, decorative arts and American and European photographs. **Highlights:** Van Gogh, *Irises;* the Boulle cabinet; Ensor, *Christ's Entry Into Brussels in 1889;* Rembrandt, *Abduction of Europa;* Robert Irwin, *Central Garden.* The Villa in Malibu is closed for renovation and will reopen in 2003 as a center for comparative archaeology and cultures. **Architecture:** Designed by Richard Meier, the museum, which opened in 1997, is a series of pavilions around an outdoor courtyard.

Admission: Free.
Hours: Tuesday and Wednesday, 11 a.m.–7 p.m.; Thursday and Friday, 10 a.m.–9 p.m.; Saturday and Sunday, 10 a.m.–6 p.m. Closed Monday and major holidays.

The Los Angeles County Museum of Art

5905 Wilshire Boulevard, Los Angeles, Calif. 90036
(323) 857-6000
www.lacma.org

2002 EXHIBITIONS

Through January 6
Jasper Johns to Jeff Koons: Four Decades of Art From the Broad Collections

Post–World War II paintings, sculpture and photographs by Richard Artschwager, Roy Lichtenstein, Cy Twombly, Andy Warhol and others. (Travels)

Through January 13
Contemporary Projects 6: Los Carpinteros' Transportable City
A tent installation by the Cuban artists Alexandre Arrechea, Marco Antonio Castillo and Dagoberto Rodríguez.

Through January 20
Luca Giordano
Some 80 works by the Baroque-era painter, including religious compositions, mythological scenes and portraits.

Through April 7
The Kindness of Friends: Notable Gifts of Drawings and Prints, 1920–2001

February 14–July 7
LACMA's Spanish Pietà: A Masterpiece of the 18th Century
A painted and gilded Pietà, dating from around 1725, that is one of the few known sculptures made from glue-soaked, molded linen. The exhibition, which highlights conservation treatment and analysis through X-rays, also features several Baroque textiles and two polychromed sculptures.

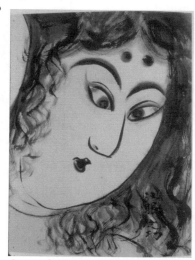

March 10–June 2
Central European Avant-Gardes: Exchange and Transformation, 1910–1930
Approximately 250 works, including paintings, sculpture and works on paper, that demonstrate the international relationships among vanguard intellectual circles. (Travels)

April 4–June 30
Munakata Shikô (1903–1975)

Courtesy of the Los Angeles County Museum of Art.
Munakata Shiko, *Kite Design for Aomori Festival*, 1971.

A retrospective featuring more than 100 works, including prints, calligraphy, paintings and ceramics.

July 14–October 6
Bartolomé Esteban Murillo (1617–1682): Paintings From American Collections
The first exhibition of the Spanish artist's paintings in the Western hemisphere, including portraits, devotional subjects and major commissioned works created for monastic and aristocratic patrons in his native Seville.

July 21–October 6
William Kentridge
A dozen short animated films, the majority of which chronicle the ongoing narrative of two characters struggling with apartheid and its aftermath. Also: about 50 large-scale drawings, many used in the films' creation. (Travels)

September 19–January 5, 2003
Donald Blumberg
Works by the contemporary photographer.

November 10–February 2, 2003
Noh and Kyogen Theater in Japan
Woven silk and gold costumes, wood masks, painted fans and lacquered instruments used in the centuries-old Japanese drama forms.

Continuing
A Century of Fashion, 1900–2000
Costumes from the museum's collection.

PERMANENT COLLECTION

More than 100,000 works from around the world, spanning the history of art from ancient times to the present.

Admission: Adults, $7; students over 18 and seniors, $5; ages 6–18, $1; children 5 and under, free. Free on second Tuesday of every month.
Hours: Monday, Tuesday and Thursday, noon–8 p.m.; Friday, noon–9 p.m.; Saturday and Sunday, 11 a.m.–8 p.m. Closed Wednesday.

The Museum of Contemporary Art (MOCA)

250 South Grand Avenue, Los Angeles, Calif. 90012
(213) 626-6222
www.moca.org

2002 EXHIBITIONS

Through January 6
Matta in America: Paintings and Drawings of the 1940's
Approximately 20 paintings and 15 drawings by the Chilean-born artist Roberto Sebastian Matta, who spent most of his life in Europe.

Through January 6
Aaron Siskind: Expression Through Abstraction
Explores Siskind's photographic contributions to abstraction and its relationship to Abstract Expressionist painting. Examples will be showcased alongside paintings by Franz Kline.

Through March 10
Liz Larner
Survey of the California artist's sculptures and installations over the past 15 years.

February 10–May 5
Tracing the Figure: Drawing by Willem de Kooning
Approximately 60 works on paper from 1940 through 1955 depicting the female form in various states of abstraction.

April 21–July 28
Juan Muñoz
Sculptural and installation work by this Spanish artist.

June 9–September 8
H.C. Westermann
About 120 sculptures and works on paper by this American artist who influenced figurative and Pop Art.

September 15–January 5, 2003
Thomas Struth: A Retrospective
Approximately 80 photographs from the late 1970's to the present by one of the most renowned German artists to emerge in the last 25 years.

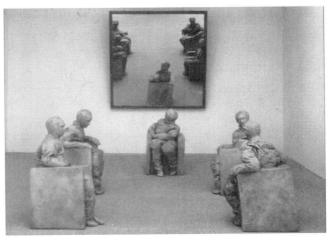

Courtesy of the Museum of Contemporary Art.

Juan Muñoz, *Five Seated Figures*, 1996.

MOCA *at the Geffen Contemporary*

152 North Central Avenue, Los Angeles, Calif. 90013

2002 EXHIBITIONS

Through January 20 (Also at the Pacific Design Center)
What's Shaking: New Architecture in LA
Showcases eight institutional, commercial or public projects
under construction designed by Los Angeles-based and inter-
national architects.

Through January 20
Douglas Gordon
This Scottish artist explores issues of memory and identity
through video, film and photography.

March 10–August 11
Zero to Infinity: Arte Povera, 1962–1972
Survey of this postwar movement, originating in Italy, that
focused on the redefinition of sculpture and the dematerializa-
tion of the art object.

October 6–February 2, 2003
A Minimal Future: Art as Object, 1958–1968
Historical study of the emergence in America and foundations
of "minimal art."

Los Angeles

MOCA at the Pacific Design Center

8687 Melrose Avenue, West Hollywood, Calif. 90069

2002 EXHIBITIONS

January 20–April 21
LA on My Mind: Emerging Artists From MOCA's Permanent Collection
Recent acquisitions, including paintings, sculpture, photography and works on paper.

PERMANENT COLLECTION

Devoted exclusively to art from 1940 to the present, the museum features exhibitions of painting, sculpture, drawings, prints, photographs, installations and environmental work.
Architecture: The museum is located in three art exhibition spaces: MOCA, designed by Arata Isozaki; MOCA at the Geffen Contemporary, designed by Frank Gehry; and MOCA at the Pacific Design Center.

Admission: Adults, $6; seniors and students, $4; children, free. Free on Thursday, 5–8 p.m.
Hours: Tuesday through Sunday, 11 a.m.–5 p.m.; Thursday, until 8 p.m. Closed Monday, New Year's Day, Thanksgiving and Christmas Day.

UCLA Hammer Museum

10899 Wilshire Boulevard, Los Angeles, Calif. 90024
(310) 443-7020; (310) 443-7000 (recording)
www.hammer.ucla.edu

The museum will be closed from February 2002 to early 2003 for an extensive renovation.

2002 EXHIBITIONS

Through January 13
The World From Here: Treasures of the Great Libraries of Los Angeles

Rare books, manuscripts, photographs, prints, drawings and other works of art.

Through January 27
Hammer Project: Katharina Grosse
Abstract paintings by a Berlin-based artist.

Through January 27
Hammer Project: E Chen
Sculptural form by a Taiwan-born artist.

PERMANENT COLLECTION

Founded by Dr. Armand Hammer in 1990, the museum houses The Armand Hammer Collection of Old Master, Impressionist and Post-Impressionist paintings, including works by Rembrandt, Sargent, van Gogh, Monet, Pissarro and Cassatt; works by Daumier and his contemporaries; more than 40,000 works on paper from the Renaissance to the present; outdoor sculpture garden. **Architecture:** Designed by Michael Maltzan.

Admission: Adults, $4.50; seniors, $3; students and age 17 and under, free. Free on Thursday.
Hours: Tuesday through Saturday, 11 a.m.–7 p.m.; Thursday, until 9 p.m.; Sunday, 11 a.m.–5 p.m. Closed Monday, New Year's Day, July 4, Thanksgiving and Christmas Day.

Orange County Museum of Art

Newport Beach

850 San Clemente Drive, Newport Beach, Calif. 92660
(949) 759-1122
www.ocma.net

2002 EXHIBITIONS

Through January 6
F. Scott Hess: The Hours of the Day
A new series of 24 paintings. The metaphorical works explore the emotional subtexts that underlie ordinary interactions.

Newport Beach/Costa Mesa

Through February 3
Enrique Martinez Celaya
Approximately 60 contemporary works, including paintings, drawings, sculpture and photographs. The artist employs tar, wax, resin, fresh flowers, found objects and words in his work.

January 12–March 31
Richard Ross: Gathering Light
Photographs of temples, burial chambers and tourist sites.

February 16–May 19
The Art of Elmer Bischoff
Fifty paintings and 20 works on paper, including early abstract-surrealist efforts, midcareer figurative paintings and nonobjective acrylics from the 1980's. (Travels)

July 6–October 6
Destined for Hollywood: The Art of Dan Sayre Groesbeck
Paintings, drawings, prints and film visualizations by Groesbeck, a self-taught artist who helped 1930's Hollywood moguls envision their movies.

South Coast Plaza

3333 Bristol Street, Costa Mesa, Calif. 92626
(949) 662-3366

2002 EXHIBITIONS

Through January 6
The Artist's Landscape: Photographs by Todd Webb
Images of Georgia O'Keeffe from 1955 to 1981. (Travels)

January 12–March 31
Richard Ross
A series of photographs that show the artist's daughter just before she heads off to high school in the morning.

September 28–December 29
Portraits From the Golden Age of Jazz: Photographs by William P. Gottlieb
Photos from the 1930's and 40's that Gottlieb shot to illustrate his jazz columns in The Washington Post, Down Beat and other publications.

Admission: Newport Beach: Adults, $5; students and seniors, $4; children under 16 and members, free. Free on Tuesday. South Coast Plaza: Free.

Hours: Newport Beach: Tuesday through Sunday, 11 a.m.–5 p.m. Closed Monday. South Coast Plaza: Monday through Friday, 10 a.m.–9 p.m.; Saturday, 10 a.m.–7 p.m.; Sunday, 11 a.m.–6:30 p.m.

Oakland Museum of California

1000 Oak Street, Oakland, Calif. 94607
(888) 625-6873; (510) 238-2200
www.museumca.org

2002 EXHIBITIONS

Through January 20
William Kentridge
Approximately 10 of the South African artist's short animated films, most of which chronicle the struggle of two characters with apartheid and its aftermath. Also, large-scale charcoal drawings used in the making of the films, as well as a selection of related graphic works.

Through May 12
Out of Place: Contemporary Art and the Architectural Uncanny
Works by 12 artists using various media to make familiar interior and exterior spaces appear strange and unsettling.

February 16–May 26
Mies in America
Drawings, scale models, photographs and a series of works by contemporary video artists and photographers inspired by architect Ludwig Mies van der Rohe's use of texture, light, repetition, reflection and movement.

February 16–May 26
Gary Simmons
Drawings and sculptures that deal with black identity and imagery. The art was inspired by American pop culture, ranging from cartoons to architecture.

Oakland

May 26–October 20
Donald Moffett: What Barbara Jordan Wore
Paintings and an audio installation inspired by Jordan, a
congresswoman, lawyer and educator.

June 22–September 22
Andreas Gursky
Large, color, digitally altered photographs.

July 13–October 20
Matta in America: Paintings and Drawings of the 1940's
More than three dozen works by the Chilean-born artist.

October 12–January 17, 2003
Gillian Wearing
Video installations the British artist has created since 1992.

October 12–January 24, 2003
John Currin
Approximately 30 paintings, taken mostly from several series
produced in the past five years.

November 2–January 26, 2003
Arte Latino: Treasures From the Smithsonian American
Museum of Art

PERMANENT COLLECTION

The only museum devoted to the art, history and natural sci-
ences of California. Includes: Gallery of California Art, with
paintings, sculptures, prints, photographs and decorative arts
tracing the development of artistic expression in California;
Cowell Hall of California History, with more than 6,000 arti-
facts illustrating the events and trends that shaped California;
and the Natural Sciences Gallery, a simulated journey through
California's diverse ecosystems. **Architecture:** The 1969
Kevin Roche building is a three-tiered complex of galleries
and gardens.

Admission: Adults, $6; students and seniors, $4; under 6,
free. Free the second Sunday of each month.
Hours: Wednesday through Saturday, 10 a.m.–5 p.m.; Sun-
day, noon–5 p.m.; the first Friday of each month, until 9 p.m.
Closed Monday and Tuesday, New Year's Day, Independence
Day, Thanksgiving and Christmas Day.

The Palm Springs Desert Museum

101 Museum Drive, Palm Springs, Calif. 92262
(760) 325-0189
www.psmuseum.org

2002 EXHIBITIONS

Through January 6
E. Stewart Williams
Photographs and architectural materials relating to projects designed by the Palm Springs architect.

Through February 3
Abstraction at Mid-Century
American 20th-century paintings and works on paper.

Through February 24
Modern Abstractions
Prints and drawings from the museum's collection, including examples from the 1940's through the 70's.

Through February 26
After the Dinosaurs
Robotic animals that move, roar, breathe, blink and provide a glimpse into the world at the dawn of the Age of Mammals.

Through March 3
Stars at Play: Photography by Bill Anderson
Images of Kirk Douglas, Audrey Hepburn, Jane Mansfield, Dinah Shore and other celebrities at Palm Springs.

January 8–March 3
On and Off the Set: Photographs by Sid Avery
Images of movie actors on the set and in their homes.

February 27–May 26
Arte Latino: Treasures From the Smithsonian American Art Museum
More than 65 examples of Colonial, naive, modern and contemporary styles from the past 200 years. (Travels)

March 6–April 7
Artists Council National Juried Exhibition
Some 60 American works in the 33rd annual exhibition.

March 20–September 29
The Namib Desert

Palm Springs/Pasadena

A diorama, photographic murals, cultural artifacts, living reptiles and video programs tell the story of the southwest African desert.

April 10–April 28
Artists Council Members Juried Exhibition
Approximately 60 works, in various media, created by members of the museum's Artists Council.

June 19–September 15
Show Me the Money: The Dollar as Art
Forty works.

Opening in June
Humor as Art
Works from the museum's collection, by Robert Arneson, Roy DeForest, Luis Jimenez, Edward Ruscha, Charles Schultz, William T. Wiley and others.

PERMANENT COLLECTION

Paintings, sculpture, furniture and movie-industry memorabilia from the actor George Montgomery's collection; art and artifacts collected by the actor William Holden; a collection of Western American and American Indian art; about 100 works by 20th-century artists, including Chagall, Modigliani, Giacometti, Ellsworth Kelly, Robert Motherwell and Dale Chihuly.

Admission: Adults, $7.50; seniors, $6.50; students, active military, children ages 6–17, $3.50.
Hours: Tuesday through Saturday, 10 a.m.–5 p.m.; Sunday, noon–5 p.m. Closed Monday and holidays.

Norton Simon Museum

411 West Colorado Boulevard, Pasadena, Calif. 91105
(626) 449-6840
www.nortonsimon.org

2002 EXHIBITIONS
Through February 11
Pop Culture!
Paintings, sculpture and works on paper from the museum's

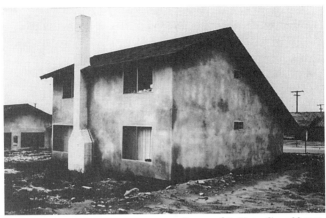

Courtesy of the Norton Simon Museum.

Charles Lewis Baltz, *Tract House #15*, 1971.

collection, by Roy Lichtenstein, Claes Oldenburg, Ed Ruscha,
Wayne Thiebaud, Andy Warhol and other American artists.

Through February 11
Lewis Baltz: Tract House Photographs, 1969-1971
Two dozen black-and-white photographs of a housing
construction site.

Through April 8
Richard Diebenkorn
Fourteen abstract gouaches by the California painter, dating
from 1950, along with several of his oil paintings.

PERMANENT COLLECTION

European art from the Renaissance to the 20th century,
including works by Raphael, Botticelli, Rubens, Rembrandt,
Zurbarán, Watteau, Fragonard and Goya; sculpture from India
and Southeast Asia spanning a period of 2,000 years. Impres-
sionist and Post-Impressionist paintings by Manet, Renoir,
Monet, Degas, van Gogh, Toulouse-Lautrec and Cézanne;
20th-century works by Picasso, Matisse and the German
Expressionists. **Architecture:** 1969 building designed by
Ladd and Kelsey for the Pasadena Art Museum; reorganized in
1974 under Norton Simon's direction; in 1999, gallery space
redesigned by Frank O. Gehry and sculpture garden designed
by Nancy Goslee Power.

Admission: Adults, $6; seniors, $3; students, free.
Hours: Wednesday through Monday, noon–6 p.m.; Friday, until 9 p.m.

Crocker Art Museum

216 O Street, Sacramento, Calif. 95814
(916) 264-5423
www.crockerartmuseum.org

2002 EXHIBITIONS

Through January 6
Compliments of the Season: A Victorian Christmas by Dolph Gotelli
An interior designer and collector adorns the Crocker with holiday ornaments, wreaths, toys and Victoriana.

Through February 17
Quilt National 2001
Quilts by artists from 27 states and 13 foreign countries.

January 26–March 24
Henry Sugimoto: Painting an American Experience
Explores the Japanese-American experience through the work of an artist whose life and art were transformed by his internment during World War II.

March 9–May 12
Time and Transcendence: The Art of Fred Dalkey
Works by a Sacramento artist best known for his self-portraits and figure studies.

April 13–June 23
Ceramic National 2002
Works by 66 ceramic artists, from traditional vessels to abstract sculptures.

June 1–July 22
Primal Visions: Albert Bierstadt "Discovers" America
Paintings, prints and photographs by one of America's preeminent 19th-century artists, from Bierstadt's first trip to the west in 1859 to the "closing of the frontier" in the 1890's. (Travels)

August 10–October 6
The Gilded Age: Treasures From the Smithsonian Museum of American Art
More than 60 works from the 1870's through the 1910's, including ones by Hassam, Ryder, Homer and Sargent.

PERMANENT COLLECTION

Founded in 1885, the Crocker Art Museum was the first public art museum in the West. European Old Master paintings and drawings; 19th- and 20th-century California art; Asian art; ceramics; photography; Victorian decorative arts. **Highlights:** Wayne Thiebaud, *Boston Cremes;* Pieter Bruegel, *Peasant Wedding Dance;* Thomas Hill, *The Great Canyon of the Sierra, Yosemite;* drawings by Dürer, Rembrandt and David.

Admission: Adults, $6; seniors, $4; students, $3; 6 and under, free.
Hours: Tuesday through Sunday, 10 a.m.–5 p.m.; Thursday, until 9 p.m. Closed Monday and major holidays.

Museum of Contemporary Art, San Diego

700 Prospect Street, La Jolla, Calif. 92037
(858) 454-3541
www.mcasandiego.org

2002 EXHIBITIONS

Through January 13
Lateral Thinking: Art of the 1990's
About 40 new paintings, sculptures, photographs, installations and video added to the permanent collection.

Through January 13
Cross-References: Celebrating the Stuart Collection
Selections from the University of California, San Diego's collection of site-specific commissioned works.

Courtesy of the Museum of Contemporary Art, San Diego.
Alexis Smith, *Men Seldom Make Passes at Girls Who Wear Glasses*, 1985.

January 27–May 19
Wolfgang Laib: A Retrospective
Works by the German sculptor, who uses marble and organic
elements such as milk, pollen, rice and beeswax.

June 2–September 8
*Out of the Ordinary: The Architecture and Design of Robert Venturi,
Denise Scott Brown and Associates*
Explores the ideas and influence of the architectural firm that
championed the vernacular and the ordinary.

Downtown San Diego branch

1001 Kettner Boulevard, San Diego, Calif. 92101
(619) 234-1001

2002 EXHIBITIONS

Through January 15
Selections From the Permanent Collection: The 1970's
Works by sculptors and painters, including Donald Judd and
Robert Mangold, and by conceptual artists, including Barry Le
Va and Bruce Nauman.

Through January 15
Alexis Smith and Amy Gerstler: The Sorcerer's Apprentice
Collaborative installation that includes sculpture, collages,
wall texts and dozens of brooms.

January 27–April 21
Indivisible: Stories of American Community
Nearly 200 photographs depicting life in 12 U.S. communities.

April 28–July 14
Adi Nes
Large-scale color works by an Israeli photographer who examines his country's culture.

PERMANENT COLLECTION

More than 3,000 works, including painting, sculpture, works on paper, photography, video and design, created in the latter half of the 20th century.

Admission: La Jolla: Adults and children over 12, $4; students, seniors and military personnel, $2. Downtown branch: Free. Free at both locations on the first Sunday and third Tuesday of each month.

Hours: La Jolla: Daily, 11 a.m.–5 p.m.; Thursday, until 8 p.m. Open until 8 p.m. every day from Memorial Day through Labor Day. Downtown branch: Thursday through Tuesday, 11 a.m.–5 p.m. Closed Wednesday. Both branches closed New Year's Day, Thanksgiving and Christmas Day.

San Diego Museum of Art

1450 El Prado, Balboa Park, San Diego, Calif. 92112
(619) 232-7931
www.sdmart.com

2002 EXHIBITIONS

Through January 13
The Age of Rembrandt: Etchings From Holland's Golden Century
Fifty etchings from the time of Rembrandt, including several by the artist himself.

Through February 3
The Frame in America: 1860–1960
A look at the tools, materials and methods used in gilding and frame manufacture during one of the most prolific and creative periods of American frame design.

San Francisco

February 9–April 7
Master Drawings From the Collection of Alfred Moir
Includes works by Annibale Carracci, Pietro da Cortona, Luca Giordano and Giovanni Battista Tiepolo. (Travels)

June 29–September 15
Idol of the Moderns: Pierre-Auguste Renoir and American Painting
Works by Renoir and American painters such as Cassatt, Hassam and Bellows reflecting the French Impressionist's impact on American art.

PERMANENT COLLECTION

Italian Renaissance and Spanish Baroque art; South Asian paintings; 19th- and 20th-century American paintings and sculptures; works by contemporary California artists. **Architecture:** Opened in 1926, the two-story Spanish colonial building is located in the center of Balboa Park.

Admission: Adults, $8; seniors, college students, ages 18–24 and military personnel, $6; ages 6–17, $3; 5 and under, free. **Hours:** Tuesday through Sunday, 10 a.m.–6 p.m.; Thursday, until 9 p.m. Closed Monday and major holidays.

Asian Art Museum of San Francisco

San Francisco Civic Center, 211 Larkin Street,
 San Francisco, Calif. 94102
(415) 379-8801
www.asianart.org

The museum is closed through fall 2002, when it is scheduled to reopen in an expanded facility at San Francisco's Civic Center.

PERMANENT COLLECTION

Chinese, Korean, Japanese, Indian, Southeast Asian, Himalayan and West Asian art. **Highlights:** The oldest known dated Chinese Buddha; Japanese netsukes; a Shang-

dynasty bronze vessel in the shape of a rhinoceros. **Architecture:** The museum's new home at the Civic Center is designed by Gae Aulenti (Musée d'Orsay).

The Fine Arts Museums of San Francisco

(415) 863-3330
www.thinker.org

California Palace of the Legion of Honor

34th Avenue and Clement Street, Lincoln Park,
 San Francisco, Calif. 94122

2002 EXHIBITIONS

Through January 6
In Focus: Photographically Illustrated Books, 1857–1930, From the Reva and David Logan Collection
Fifteen volumes including works by Ansel Adams, Julia Margaret Cameron, Alvin Langdon Coburn, Peter Henry Emerson, Francis Frith, Eadweard Muybridge, Edward Steichen, Alfred Stieglitz, Doris Ulmann and Clarence White.

Through January 6
Artists' Books in the Modern Era, 1870–2000
More than 175 volumes from the Logan collection, including original prints by Alexander Calder, Marc Chagall, Salvador Dalí, Paul Klee, Henri Matisse and Pablo Picasso, as well as examples of the modern illustrated book by Auguste Rodin, Toulouse-Lautrec and other early practitioners.

January–June
Selected Masterworks: The Marcia and John Friede Collection of New Guinea Art
Approximately 20 works, including a painted skull rack with double faces, a variety of large-scale ceremonial works, a flute

stopper, a carved slit gong and a mortuary mask fashioned from turtle shell, feathers and mother-of-pearl.

January 19–April 14
Richard Diebenkorn: Clubs and Spades
Twenty-five prints and drawings made in 1981 and 1982.

February 2–April 28
Dreaming With Open Eyes: Dada and Surrealist Art From the Israel Museum
Some 200 works from the Vera, Silvia and Arturo Schwarz collection, including sculpture, paintings and photography. Artists include Salvador Dalí, Marcel Duchamp, Max Ernst, Paul Klee, Man Ray, Joan Miró and Francis Picabia.

February 23–May 19
Recent Acquisitions, 1997–2000: Contemporary California Works on Paper

April 27–July 7
Hard Edge: Abstract Prints From Albers to Held
Twenty-five works, by Josef Albers, Al Held, Ellsworth Kelly, Kenneth Noland, Ad Reinhardt, Frank Stella and others.

June 8–August 25
Michiel Sweerts
Forty paintings and 20 engravings by the 17th-century Flemish artist. (Travels)

August 10–November 3
Eternal Egypt: Masterworks of Ancient Art From The British Museum
Pharaohs' personal possessions and statues, as well as jewelry, mirrors, cosmetic containers and other luxury items that were widely produced during their reigns. (Travels)

December 7–February 9, 2003
Casting a Spell: Winslow Homer, Artist and Angler
Watercolors and other paintings.

Continuing
The Triumph of Prudence *and* The Triumph of Fortitude
Tapestries from the 16th-century series *The Triumphs of the Seven Virtues.*

M.H. de Young Memorial Museum

75 Tea Garden Drive, Golden Gate Park, San Francisco, Calif. 94118

PERMANENT COLLECTION

Some 70,000 prints and drawings from the Achenbach Foundation for Graphic Arts; 15th-century Spanish ceiling; Roman, Greek and Assyrian art; paintings by Rembrandt, Rubens, Watteau, de la Tour, Vigée Le Brun, Cézanne, Monet and Picasso; noted collection of Rodin sculpture; American paintings; art from the pre-Columbian Americas, Africa and Oceania; world-renowned collection of textiles.

Admission: Legion of Honor: Adults, $8; seniors, $6; ages 12–17, $5; under 12 and San Francisco students, free. Free on second Wednesday of the month. M.H. de Young: Adults, $7; seniors, $5; ages 12–17, $4; under 12 and San Francisco students, free. Free on first Wednesday of the month.
Hours: Tuesday through Sunday, 9:30 a.m.–5 p.m.; M.H. de Young, until 8:45 p.m. the first Wednesday of the month. Closed Monday.

The San Francisco Museum of Modern Art

151 Third Street, San Francisco, Calif. 94110
(415) 357-4000; (415) 357-4154 (for the deaf)
www.sfmoma.org

2002 EXHIBITIONS

Through January 13
Ansel Adams at 100
More than 100 images by one of San Francisco's favorite sons, who died in 1984. Commemorates the 100th anniversary of the photographer's birth.

Through February 5
SFMOMA Experimental Design Award
Works by the three Bay Area winners of the inaugural award.

San Francisco

Through February 17
Judith Rothschild: An Artist's Search
A retrospective that spans the New York–based painter's five-decade-long career. Included are early Abstract Expressionist pieces, landscapes inspired by the California coast and works created with the relief-painting technique she employed for the last 20 years of her life (1921-1993).

Through June 9
Points of Departure II: Connecting With Contemporary Art
Works from the museum's collection, presented in groups that emphasize particular artistic themes.

Through March 24
Christian Marclay
Several multimedia works, including "Video Quartet," a multiscreen collage of found film footage. The exhibition also includes live musical performances.

February 2–May 19
Eva Hesse: A Retrospective
Drawings, paintings and sculptures the post-Minimalist (1936-1970) created during her 10-year career.

March 1–July 9
Edward Weston: The Last Years in Carmel
California landscape photographs, still-life scenes and portraits of Weston's immediate family.

March 2–May 26
Jack Stauffacher: Selections From the Permanent Collection
Typographic works by the veteran printing-press operator, who uses traditional wood-block letter forms to create semi-abstract graphic compositions.

March 2–May 26
Perfect Acts of Architecture
Works by Peter Eisenman, Rem Koolhaas, Daniel Libeskind, Thom Mayne and Bernard Tschumi.

April 13–July 28
No Ghost, Just a Shell: The Ann Lee Project
A collaborative computer-animation effort.

June 22–September 15
Yes, Yoko Ono
The first American retrospective devoted to the avant-garde artist's 40-year career. The 150 works on view explore her

Courtesy of the San Francisco Museum of Modern Art.
Lewis Carroll, *Xie Kitchin*, ca. 1875.

early conceptual paintings and films as well as her more recent installations and bronze sculptures. (Travels)

July 13–January 5, 2003
Ellsworth Kelly in San Francisco
Bringing together the 22 pieces the museum acquired from Kelly in 1999, including "Cité" (1951) and "Black over Blue" (1963), with other paintings and sculptures from private collections throughout the Bay Area.

August 3–November 5
Lewis Carroll, Photographer
Approximately 80 photos, including portraits of children.

October 11–January 14, 2003
Gerhard Richter: Forty Years of Painting
Some 150 works.

Continuing
Matisse and Beyond: A Century of Modernism
Works from the museum's collection, by Eva Hesse, Frida Kahlo, René Magritte, Piet Mondrian, Robert Rauschenberg, Mark Rothko, Andy Warhol and others.

Continuing
Picturing Modernity: Photographs From the Permanent Collection
Including works by European avant-garde artists of the 1920's and 30's as well as anonymous snapshots, documentary evidence and other images never intended to be art.

PERMANENT COLLECTION

Some 20,000 works of modern and contemporary painting, sculpture, photography, works on paper, architectural drawings and models, design objects and media art forms like video and multimedia installation work.

Admission: Adults, $10; seniors, $7; students, $6; 12 and under, free. Half price on Thursday, 6–9 p.m.; free the first Tuesday of the month.
Hours: Thursday through Tuesday, 11 a.m.–6 p.m. (opens one hour earlier Memorial Day to Labor Day); Thursday, until 9 p.m. Closed Wednesday, New Year's Day, Independence Day, Thanksgiving and Christmas Day.

Yerba Buena Center for the Arts

701 Mission Street, San Francisco, Calif. 94103
(415) 978-2787
www.yerbabuenaarts.org

2002 EXHIBITIONS

Through January 27
Isabella Kirkland
A suite of new paintings based on animal and plant specimens at the California Academy of Sciences. The exhibition also includes holotypes from the academy's archive.

Through January 27
The Metal Party, Bauhaus School (February 9, 1929), 2000
An installation by Josiah McElheny that re-creates a Bauhaus event in which students and faculty came dressed in reflective costumes and danced in a mirrored environment. The installation includes silver bodysuits for audiences and a sound environment created in collaboration with a D.J.

Through January 27
Preserve
A site-specific sculpture by Ellen Gallagher, plus 15 new drawings by her.

February 9–April 21
Building Project
Shannon Kennedy uses a gastroscope, a camera used in medicine to see inside organs, to videotape behind the walls, in the air ducts and in the plumbing of the center's buildings and reveal the chemical traces, water spills, mold and other contaminants that exist hidden in our daily lives.

February 9–April 21
Elder Arts 2002
Three exhibitions that celebrate art created by people older than 65: the 12th annual Art With Elders show, featuring works by nursing-home residents; the Bay Area Elder Artist of the Year exhibition; and an Elder Arts Celebration, with works by local art institutions' alumni, faculty and students.

February 9–April 21
Slowdive: Sculpture and Performance in Real Time
Works by Per Hüttner, Tony Labat, William Rogan and Bruce Tomb, with performances, readings and discussions by Bay Area artists.

May 4–July 14
The Film Art of Isaac Julien
Film and video installations, including a trilogy comprising multiple-screen projections, as well as photographs and prints.

May 4–July 14
Selections From the Cockettes Archives
Posters, photographs, costumes and props from the drag theatrical troupe's history.

May 4–July 14
2000 Dragons
A 500-foot-long scroll painting, hung from the ceiling in a serpentine pattern, by Don Ed Hardyk, a tattoo artist.

Admission: Adults, $6; seniors and students, $3.
Hours: Tuesday through Sunday, 11 a.m.–6 p.m.; Thursday and Friday, until 8 p.m. Closed Monday.

San Jose Museum of Art

110 South Market at San Fernando, San Jose, Calif.
95113
(408) 271-6840; (408) 294-2787 (recording)
www.sjmusart.org

2002 EXHIBITIONS

Through January 20
Catherine Wagner: Cross Sections
Approximately 35 large-scale photographs produced between
1998 and 2001.

Through February 10
Object Lessons: The Paintings of Deborah Oropallo
Contemporary works by the Bay Area painter. (Travels)

Through March 17
First Impressions: The Paulson Press
Examples from the Paulson workshop, which specializes in
intaglio printing. Includes works by Ross Bleckner.

February 8–May 12
The Art of Nathan Oliveira
Contemporary paintings, monoprints, drawings and sculpture
by the Bay Area artist.

March 30–June 23
Toshio Shibata
The Japanese photographer's large-scale black-and-white
images depict American dams and other manmade structures
struggling with natural forces.

June 1–September 22
Hard Candy
Contemporary works in which toys are frightening, animals
are menacing, desserts are weapons and children raise
disturbing issues about power and sexuality.

July 13–November 3
Art/Women/California: Parallels and Intersections
Works produced by women artists working in California
during the last half of the 20th century.

October 15–March 2, 2003
Long Nguyen: Tales of Yellow Skin

Contemporary paintings, prints and sculpture that draw on the American artist's Vietnamese heritage.

November 23–February 16, 2003
Sharon Ellis: A 10-Year Survey
Hallucinatory nature scenes and other paintings by the Los Angeles artist, whose influences include Disney cartoons and computer-generated fractal imagery.

November 23–March 23, 2003
L.A. Post-Cool
Approximately 50 new works from Southern California that are, by design, personally revelatory.

PERMANENT COLLECTION

Twentieth- and 21st-century works, with an emphasis on post-1980 Bay Area artists. Includes works by Milton Avery, Manuel Ocampo, Willem de Kooning, Deborah Oropallo, Bill Viola, Claes Oldenburg and Wayne Thiebaud.

Admission: Free.
Hours: Tuesday through Sunday, 11 a.m.–5 p.m.; Friday, until 10 p.m. Closed Monday, New Year's Day, Thanksgiving and Christmas Day.

The Huntington Library, Art Collections and Botanical Gardens

1151 Oxford Road, San Marino, Calif. 91108
(626) 405-2100
www.huntington.org

2002 EXHIBITIONS

February 3–May 5
Great British Paintings From American Collections
Works by John Constable, Sir Anthony Van Dyck, Thomas Gainsborough, J.M.W. Turner and others.

San Marino

April 9–September 22
William Morris: Creating the Useful and the Beautiful
Stained-glass windows, wallpaper, printed fabrics, carpets, tapestries and books, as well as drawings that illustrate the design processes for the crafts produced by Morris's firm.

Summer
Art Education in America
Artifacts, books and ephemera donated to the Huntington by a Boston educator, Diana Korzenik. The collection, from the colonial period through the early 20th century, includes vintage paint boxes, sketchbooks, crayons, coloring books, stencil kits and drawing manuals for children.

September 15–December 1
George Romney Retrospective
Portraits and other paintings by the 18th-century British artist. (Travels)

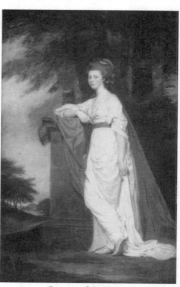

Courtesy of the Huntington Library, Art Collections and Botanical Gardens.
George Romney, *Rose (Gardiner) Milles*, 1780-83.

PERMANENT COLLECTION

In the former private estate of the railroad magnate Henry E. Huntington, world-class collections of rare books, manuscripts and art. **Highlights:** Gainsborough, *The Blue Boy;* a Gutenberg Bible; Chaucer, *Canterbury Tales;* 150 acres of botanical gardens.

Admission: Adults, $10; seniors, $8.50; students, $7; under 12, free. Groups of 10 or more, $7.
Hours: Tuesday through Friday, noon–4:30 p.m.; Saturday and Sunday, 10:30 a.m.–4:30 p.m. Slightly longer hours during the summer.

Santa Barbara Museum of Art

1130 State Street, Santa Barbara, Calif. 93101
(805) 963-4364
www.sbmuseart.org

2002 EXHIBITIONS

Through March 31
Pirkle Jones: 60 Years in Photography
More than 100 works, spanning six decades of the landscape
photographer's career.

March 2-May 26
*Devotion and Desire: Art From India, Tibet and Nepal in the
John and Berthe Ford Collection*
A look at enduring themes in the art of southern Asia.

April 13-June 23
A Passionate Collaboration: Edward Weston and Margrethe Mather
Covering the dozen years of the two photographers'
association, just before and after World War I.

PERMANENT COLLECTION

Art spanning 43 centuries, from Greek and Roman sculpture
to contemporary works. Includes American art; 19th- and
early-20th-century French art; Asian art; classical antiquities;
photography; prints and drawings.

Admission: Adults, $6; seniors, $4; ages 6–17, $3; under 6,
free. Free on Thursday and the first Sunday of every month.
Hours: Tuesday through Saturday, 11 a.m.–5 p.m.; Friday,
until 9 p.m.; Sunday, noon–5 p.m. Closed Monday, New
Year's Day and Christmas Day.

Stanford

Iris & B. Gerald Cantor Center for Visual Arts at Stanford University

Lomita Drive and Museum Way, Stanford, Calif. 94305
(650) 723-4177; (650) 723-1216 (for the deaf)
www.stanford.edu/dept/ccva/

2002 EXHIBITIONS

Through January 6
Liberated Voices: Contemporary Art From South Africa
More than 65 works by 13 ethnically diverse artists.

Through January 27
Paul De Marinis: The Messenger
Explores the forgotten past of the telegraph and the pauses,
noise, ambiguity and misunderstanding of communication.
Paul De Marinis is a professor of art at Stanford University.

Through February 10
Men at Work: Paintings by Kristina Branch
Recent paintings and studies by a Stanford art professor that
focus on people at work.

January 30–April 21
Aerial Muse: The Art of Yvonne Jacquette
A retrospective underscoring the relationship between the
artist's landscape paintings and works on paper.

February 13–May 12
The Southern Metropolis: Pictorial Art in 17th-Century Nanjing
About 25 paintings and woodblock-printed books, including
works by some of the most significant artistic figures of the era
such as Wu Bin, Gong Xian, Wang Kai and Fan Qi.

May 8–August 11
"A Rare and Admirable Collection": Masterworks of Native American Art From the Peabody Essex Museum
About 100 works rarely displayed by the Peabody Museum
and assembled primarily by the East India Marine Society during the early 1800's. (Travels)

May–September
Hannelore Baron: Works From 1969 to 1987
Small-scale sculpture and works on paper using collage.

September 18–December 29
Salviati at Stanford
About 120 Venetian glass vessels from the extensive collection
of 19th-century glassware given to the museum in 1903 by
the celebrated Salviati firm.

PERMANENT COLLECTION

More than 25,000 objects from antiquity to the present,
including American and European drawings, prints, pho-
tographs and paintings and works from Asia, Africa, Oceania
and Native America. **Highlights:** The largest group of Rodin
sculpture outside the Musée Rodin in Paris. **Architecture:**
Renovated historic building with new wing, Rodin Sculpture
Garden and new gardens for contemporary sculpture.

Admission: Free.
Hours: Wednesday through Sunday, 11 a.m.–5 p.m., Thurs-
day, until 8 p.m. Closed Monday and Tuesday.

Denver Art Museum

13th Avenue and Acoma Street, Denver, Colo. 80204
(720) 865-5000 (recording); (720) 865-5003 (for the deaf)
www.denverartmuseum.org

2002 EXHIBITIONS

Through January 20
The Cos Cob Art Colony: Impressionists on the Connecticut Shore
Nearly 60 American paintings from the Cos Cob colony,
including works by Childe Hassam and Theodore Robinson.
Special exhibition ticket required.

Through April 28
*China Meets the American Southwest: Pottery Designs and
Traditions*
Contrasting Native American pieces from the museum's
collection with ancient Chinese examples on loan from the Sze
Hong collection. More than 50 works.

Through June 16
Cultural Coatings: Coats From Different Cultures

Denver

Approximately 20 garments made in Europe, Asia and North America — regional dress to high fashion — from the 18th century to the present.

February 23–May 26
U.S. Design, 1975–2000
Works by architects, including Frank Gehry, Steven Holl, Maya Lin and Robert Venturi.

March 2–May 26
Art and Home: Dutch Interiors in the Age of Rembrandt
A selection of old master paintings and an array of furniture, silver, ceramics and other decorative arts created from 1610 to 1700. Special exhibition ticket required.

June 29–September 29
An American Century of Photography: From Dry-Plate to Digital
More than 240 works from the Hallmark collection. Featured photographers include Ansel Adams, Robert Adams, Harry Callahan, Walker Evans, Alfred Stieglitz and Edward Weston.

Permanent Collection

Founded in 1893, the Denver Art Museum has more than 40,000 works of art, including collections of Asian art; modern and contemporary art; American Indian and New World arts; European and American painting and sculpture; architecture, design and graphics; textile art; art of the American West. **Architecture:** The 28-sided, two-tower building, designed by Gio Ponti of Italy in collaboration with James Sudler Associates of Denver, has seven floors of gallery space and is covered with more than one million gray tiles.

Admission: Adults, $6; seniors and students, $4.50; members and children 12 and under, free; Colorado residents, free on Saturdays.
Hours: Tuesday through Saturday, 10 a.m.–5 p.m.; Wednesday, until 9 p.m.; Sunday, noon–5 p.m. Closed Monday and major holidays.

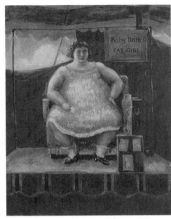

John Steuart Curry, *Baby Ruth*, 1932.

Courtesy of the Wadsworth Atheneum
Museum of Art.

Wadsworth Atheneum Museum of Art

600 Main Street, Hartford, Conn. 06103
(860) 278-2670
www.wadsworthatheneum.org

2002 EXHIBITIONS

Through February 17
Architects of American Fashion: Norman Norell and Pauline Trigère
Garments by two 20th-century fashion designers.

February 2–April 28
UN Studio/MATRIX 146
Amsterdam-based UN Studio blends imagination with computer technology to create "digital architecture" for the 21st century.

February 9–April 21
Sisters Collecting: Selections From the Cone and Adler Collections of the Baltimore Museum of Art
Modernist works from the first half of the 20th century, including paintings and drawings by Matisse, Picasso, Renoir, Bonnard, Kandinsky, Klee, Pollock and van Gogh.

CONNECTICUT

Hartford/New Haven

June 1–August 11
The Stuff of Dreams/Matières des Rêves: Masterworks from the Paris Musée des Arts Décoratifs
One hundred masterpieces of French design — silver, ivory, porcelain, jewelry and furniture — from the Middle Ages to the present day. (Travels)

September 20–December 1
Michiel Sweerts, 1624-1664
Though not as well known today as Johannes Vermeer and Pieter de Hooch, Michiel Sweerts was among the most famous painters working in 17th-century Holland. This is the first exhibition of Sweerts's paintings and prints in nearly 50 years — and the first ever in America. (Travels)

PERMANENT COLLECTION

America's oldest public art museum, founded in 1842, with nearly 50,000 works. Includes a Hudson River School collection; Baroque masterpieces; the Wallace Nutting Collection of Pilgrim-Century Furniture; Meissen and Sèvres porcelain; 19th- and 20th-century American and European art; the Amistad Foundation African-American Collection.

Admission: Adults, $7; students and senior citizens, $5; children 6–17, $3; members and children under 6, free.
Hours: Tuesday through Sunday, 11 a.m.–5 p.m.; first Thursday of each month (except December), until 8 p.m. Closed Monday, New Year's Day, Independence Day, Thanksgiving and Christmas Day.

Yale Center for British Art

1080 Chapel Street, New Haven, Conn. 06520
(203) 432-2800; (203) 432-2850
www.yale.edu/ycba

2002 EXHIBITIONS
January 25–March 17
Painted Ladies: Women at the Court of Charles II, 1660-1685

Portraits of royal family members and King Charles's mistresses, as well as texts written about them.

April 18–June 30
Paula Rego
Large pastel compositions and preparatory drawings by the Portuguese-born British narrative artist.

June 15–September 2
Ron King: Circle Press

September 26–November 30
Late Turner: The Legacy of the Liber Studiorum
A series of works that J.M.W. Turner painted in the last years of his life, based on his Liber Studiorum landscape engravings.

Autumn
The Romantic Watercolor: The Hickman Bacon Collection

PERMANENT COLLECTION

The most comprehensive collection of British art outside the United Kingdom. **Highlights:** The collection of British paintings, drawings, prints, rare books and sculpture given to the University by Paul Mellon (Yale Class of 1929). **Architecture:** The Yale Center for British Art is the final building designed by the American architect Louis I. Kahn (1901–1974). It opened to the public in 1977 and stands across the street from his first major commission, the Yale Art Gallery (1953).

Admission: Free.
Hours: Tuesday through Saturday, 10 a.m.–5 p.m.; Sunday, noon–5 p.m. Closed Monday and major holidays.

Yale University Art Gallery

1111 Chapel Street, New Haven, Conn. 06520
(203) 432-0600
www.yale.edu/artgallery

PERMANENT COLLECTION

Works from Ancient Egyptian dynasties to the present; Asian art, including Japanese screens, ceramics and prints; artifacts

from ancient Dura-Europos; Italian Renaissance art; 19th- and 20th-century European paintings; American art through the 20th century. **Highlights:** Reconstructed Mithraic shrine; van Gogh, *The Night Cafe*; Malevich, *The Knife Grinder*; Smibert, *The Bermuda Group*;

Trumbull, *The Declaration of Independence*; works by Manet and Picasso; contemporary sculpture by Moore, Nevelson and Smith. **Architecture:** Two connecting buildings house the oldest university art museum in the U.S.: 1928 building by Edgerton Swartwout

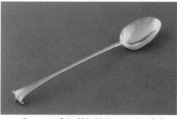

Courtesy of the Yale University Art Gallery.
Myer Myers, *Serving Spoon*, 1760-70.

based on a gothic palace in Viterbo, Italy, and 1953 landmark building by Louis I. Kahn.

Admission: Free.
Hours: Tuesday through Saturday, 10 a.m.–5 p.m.; Sunday, 1–6 p.m. Closed Monday and major holidays.

Delaware Art Museum

2301 Kentmere Parkway, Wilmington, Del. 19806
(302) 571-9590
www.delart.mus.de.us

2002 EXHIBITIONS

Through January 27
Marisol
Twenty-seven works from the 1960's through the 1990's by the renowned Pop artist, including figurative sculpture and tableaux-like assemblages.

February 15–April 28
Impressionism Transformed: The Paintings of Edmund C. Tarbell

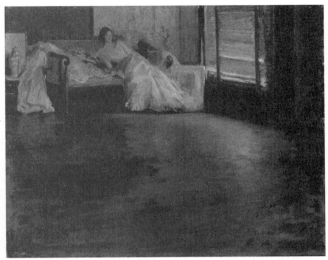

Courtesy of the Delaware Art Museum.

Edmund C. Tarbell, *Across the Room*, ca. 1899.

Fifty works by this American Impressionist, including land-scapes, interiors, riding scenes, still lifes and portraits.

PERMANENT COLLECTION

Pre-Raphaelite art; American illustration; 19th- and 20th-century American art. **Highlights:** John Sloan, *Spring Rain;* Edward Hopper, *Summertime;* Winslow Homer, *Milking Time;* Dante Gabriel Rossetti, *Bella Mano;* Robert Motherwell, *Je t'Aime No. VIII (Mallarmé's Swan: Homage)*.

Admission: Adults, $7; seniors, $5; students, $2.50; 6 and under, free. Free on Saturday, 9 a.m.-noon and Wednesday, 4-9 p.m.

Hours: Tuesday through Saturday, 9 a.m.–4 p.m.; Wednesday, until 9 p.m.; Sunday, 10 a.m.–4 p.m. Closed Monday.

District of Columbia

Corcoran Gallery of Art

500 17th Street NW, Washington, D.C. 20006
(202) 639-1700
www.corcoran.org

2002 EXHIBITIONS

Through January 13
Joseph Goldyne Print Show
Forty prints by the contemporary California artist.

Through February 4
Jim Dine and Roy Lichtenstein: Selected Prints
Approximately 20 works.

Through March 11
Antiquities to Impressionism: The William A. Clark Collection
More than 250 works of European and American art,
including paintings, sculpture, drawings and decorative arts.

January 19–April 8
*Secret Games: Wendy Ewald Collaborative Works With Children,
1969-1999*
Some 200 photographs of and by children.

March 16–June 3
Jasper Johns to Jeff Koons: Masterworks From the Broad Collections
Contemporary works, including pieces by Jasper Johns, Ed
Ruscha, Cy Twombly and Andy Warhol.

April 7–September 30
Jacqueline Kennedy: The White House Years
Selections from the John F. Kennedy Library and Museum.

May 18–July 22
Paris, New York, Hollywood: The Art of Larry Rivers
Paintings, three-dimensional pieces and works on paper
spanning five decades.

August 24–November 28
Goya to Picasso: Spanish Painting, From Romanticism to Impressionism
An overview of 19th-century works made in Spain, from the
Carmen Thyssen-Bornemisza collection.

September 21–January 6, 2003
The Shape of Color: Joan Miró's Painted Sculpture
Twenty polychrome sculptures and 60 related works on paper, as well as photographs and films of the artist at work. The exhibition focuses on the sculpture he produced during the 1960's and 70's.

PERMANENT COLLECTION

A historically varied selection of paintings, sculptures, photographs and drawings, ranging from Barye bronzes to the decorative arts, and European Renaissance to contemporary American paintings.

Admission: Adults, $5; seniors and members' guests, $3; students, $1; families, $8; children under 12 and members, free. Free all day Mondays and Thursdays after 5 p.m.
Hours: Wednesday through Monday, 10 a.m.–5 p.m.; Thursday, until 9 p.m. Closed Tuesday.

Folger Shakespeare Library

201 East Capitol Street SE, Washington, D.C. 20003
(202) 544-4600; (202) 544-7077 (box office and
 recording)
www.folger.edu

2002 EXHIBITIONS

Through January 18
The Reader Revealed
Using manuscripts, books, broadsides and engravings, the exhibition examines how and what people in early modern Europe read, both publicly and privately.

February 4–June 7
Treasures from the Manuscript Collection
Illuminated books; letters and warrants signed by English monarchs; theatrical papers; and many other items relating to Shakespeare and his time.

Washington

June 21–October
A Shared Passion: Henry Clay Folger Jr. and Emily Jordan Folger as Collectors
Books, manuscripts, prints, maps, ephemera, works of art and Shakespearean memorabilia from the couple's collection.

November–March 2003
"Thys Boke Is Myne"
Exploring markings left in books by famous people.

PERMANENT COLLECTION

The Folger is home to the world's largest collection of Shakespeare's printed works, as well as a collection of other rare Renaissance books and manuscripts. It is a major center for scholarly research as well as the literary and performing arts. Some 250 objects pertaining to Shakespeare are on permanent display in the Shakespeare Gallery, a multimedia exhibition.

Admission: Adults: $5; seniors and members' guests, $3; students, $1; children under 12 and members, free; family groups, $8. Free on Monday all day and on Thursday after 5 p.m.
Hours: Monday through Saturday, 10 a.m.–4 p.m. Closed on major federal holidays.

Freer Gallery of Art and Arthur M. Sackler Gallery

Together, the Smithsonian Institution's Freer and Sackler galleries form the national museum of Asian art.

Freer Gallery of Art

Jefferson Drive at 12th Street SW, Washington, D.C. 20560
(202) 357-2700; (202) 357-1729 (for the deaf)
www.si.edu/asia

2002 EXHIBITIONS
Through January 6
Whistler in Venice: The First Set of Etchings

Works James McNeill Whistler made during his first trip to Venice, in 1879.

Through February 3
The Three Friends of Winter: Pine, Bamboo and Plum in Chinese Painting
Examples of the different styles that developed between the 13th and the 18th centuries to depict the three plants.

Through March 10
Storage Jars of Asia
Jars, from diverse cultures, that had a large variety of uses.

Through October 27
The Potter's Brush: The Kenzan Style in Japanese Prints
An attempt to differentiate between the ceramist Ogata Kenzan's works and those by imitators and forgers.

April 14–May 4, 2003
Chinese Buddhist Images: New Perspectives on the Collection
Devotional objects.

Continuing
James McNeill Whistler
Ten oil paintings that demonstrate the evolution of the artist's style between 1860 and 1900.

PERMANENT COLLECTION

Art of China, Japan, Korea, South and Southeast Asia and the Near East, including Chinese paintings, Japanese folding screens, Korean ceramics, Indian and Persian manuscripts, Buddhist sculpture; 19th- and early-20th-century American art, including world's largest group of works by James McNeill Whistler and his Peacock Room.

Admission: Free.
Hours: Daily, 10 a.m.–5:30 p.m.; Thursday, until 8 p.m. from Memorial Day through Labor Day. Closed Christmas Day.

Arthur M. Sackler Gallery

1050 Independence Avenue SW, Washington, D.C. 20560
(202) 357-2700; (202) 357-1729 (for the deaf)
www.si.edu/asia

2002 EXHIBITIONS

Through January 13
Word Play: Installation Art by Xu Bing
Four works, including "A Book From the Sky," which features books, scrolls and posters whose imitation Chinese characters the artist invented to express humankind's communication struggles. Visitors can experiment with calligraphic tools.

Through May 5
Visual Poetry: Paintings and Drawings From Iran and India
Some 30 works from the 16th and 17th centuries, including paintings by Riza Abbasi.

Through July 7
The Cave as Canvas: Hidden Images of Worship Along the Silk Road
Fifteen fifth-century Buddhist mural fragments from a cave in what is now the autonomous region of Xinjiang.

March 17–May 12
Blossoms on the Wind: Master Paintings of 20th-Century Japan
Works, including some never before exhibited in the West, from the Japan Art Institute, which has adapted traditional Japanese methods and themes, including Buddhist iconography and historical subjects, within the context of the century's major international stylistic movements.

June 9–January 5, 2003
Kenro Izu: Sacred Sites Along the Silk Road
More than two dozen large-format photographs of sites in western China, Ladakh and Tibet.

June 23–September 29
The Adventures of Hamza
Approximately 60 16th-century paintings that originally illustrated a narrative story about Hamza, Muhammad's uncle.

November 10–March 9, 2003
Seductive Majesty: Divine Images From South India
Sixty portable bronzes produced between the ninth and 13th centuries. Photo murals of temple bronzes in situ — as well as a single large draped and ornamented figure — re-create the context in which the icons were used.

PERMANENT COLLECTION

Chinese bronzes, jades, paintings and lacquerware; ancient Near Eastern ceramics and metalware; South and Southeast

Asian sculpture; Islamic arts of the book; 19th- and 20th-century Japanese prints and porcelain; Indian, Japanese and Korean paintings; photography.

Admission: Free.
Hours: Daily, 10 a.m.–5:30 p.m.; Thursday, until 8 p.m. from Memorial Day through Labor Day. Closed Christmas Day.

Hillwood Museum and Gardens

4155 Linnean Avenue NW, Washington, D.C. 20008
(202) 686-8500
www.hillwoodmuseum.org

PERMANENT COLLECTION

Estate of the art collector Marjorie Merriweather Post, including the largest collection of imperial Russian art objects outside Russia; chalices and icons; 18th-century French furniture;

Courtesy of the Hillwood Museum and Gardens.
French drawing room, 18th century.

18th- and 19th-century Russian and French decorative and fine art. **Highlights:** Easter eggs by Fabergé; diamond wedding crown of Empress Alexandra; dinner services commissioned by Catherine the Great; Sèvres porcelain.

Admission: Reservations required. $10 refundable reservation deposit. Children under 6 not admitted in mansion, but may visit gardens.

Hours: Tuesday through Saturday, 9 a.m.–5 p.m. Closed Sunday (except certain Sundays in spring and fall), Monday, the month of February, Thanksgiving Day and the day after, Christmas Day, New Year's Day and all federal holidays except Veterans Day.

Hirshhorn Museum and Sculpture Garden

Smithsonian Institution, Independence Avenue at
 Seventh Street SW, Washington, D.C. 20560
(202) 357-3091
www.si.edu/hirshhorn

2002 EXHIBITIONS

Through January 13
Juan Muñoz
First U.S. exhibition surveying the career of the contemporary Spanish sculptor, known for his cast-resin figure ensembles and installations. (Travels)

Through February 18
Directions — Marina Abramovic
Video work of this Belgrade-born, Amsterdam-based performance artist.

February 14–May 12
H.C. Westermann
First posthumous retrospective of the work of this American sculptor, including constructions and assemblages of wood, metal and found objects.

March 21–June 23
Directions — Ernesto Neto
Mixed-media installation by a Brazilian artist.

June 13–September 8
Open City: Street Photographs Since 1950
More than 100 photographs by 19 international artists.

July 18–October 20
Directions — Ron Mueck
Hyperreal figures by an Australian-born, London-based
sculptor.

October 17–January 12, 2003
Zero to Infinity: Arte Povera, 1962–1972
About 140 works by a group of artists who propelled Italy to
the center of the international art scene in the 1960's by fusing
process, materials, concepts and politics. (Travels)

November 7–December 23
Directions — Cecily Brown
Abstract paintings by a British artist.

PERMANENT COLLECTION

The museum, open since 1974, has one of the most compre-
hensive collections of modern sculpture in the United States or
abroad. Other strengths include contemporary art, European
painting since World War II and American painting since the
early 20th century. **Highlights:** Outdoor sculpture garden on
the National Mall includes works by di Suvero, Matisse,
Moore and Rodin. Newly renovated painting galleries (1999)
display works by Bacon, Calder, Hopper, de Kooning, Dubuf-
fet and Giacometti. **Architecture:** Building designed by Gor-
don Bunshaft. Outdoor sculpture plaza, redesigned by the
landscape architect James Urban in 1993, received a Federal
Design Achievement Award in 1995.

Admission: Free.
Hours: Open daily except Christmas Day. Museum: 10 a.m.-
5:30 p.m.; Thursday, until 8 p.m. during summer. Sculpture
Garden: 7:30 a.m.-dusk. Plaza: 7:30 a.m.–5:30 p.m.

Washington

The Kreeger Museum

2401 Foxhall Road NW, Washington, D.C. 20007
(202) 338-3552
www.kreegermuseum.com

PERMANENT COLLECTION

Nineteenth- and 20th-century painting and sculpture, including works by Monet, Renoir, Degas, Picasso, Miró and van Gogh; traditional African and American Indian art. **Architecture:** Former home of the philanthropists Carmen and David Lloyd Kreeger, designed by Philip Johnson.

Admission: Suggested donation, $5. Reservations required.
Hours: Tours of the museum are offered Tuesday through Saturday, at 10:30 a.m. and 1:30 p.m.

Library of Congress

101 Independence Avenue SE, Washington, D.C. 20540
(202) 707-5000; (202) 707-8000 and (202) 707-4604
(recordings); (202) 707-9956 (for the deaf)
www.loc.gov; www.americaslibrary.gov (for children)

2002 EXHIBITIONS

Through May
Margaret Mead: Human Nature and the Power of Culture
Documents and photographs from the library's collection that shed light on Mead's research into environmental influences that affect human behavior.

May 2002–September
Roger L. Stevens
A look at the theater producer's contributions to the performing arts and American cultural history.

PERMANENT COLLECTION

Repository of the nation's books, manuscripts, films, sound recordings, photographs and maps — some 121 million items

Theodore Schwartz,
*Margaret Mead Returns to
Manus*, 1953.

Courtesy of the Library of Congress.

in all. **Architecture:** 1873 Italian Renaissance-style building designed by Smithmeyer and Pelz, opened to the public in 1897, renovated beginning in 1985 and reopened in 1997 on centennial of the building.

Admission: Free.
Hours: Monday through Saturday, 10 a.m.–5:30 p.m. Closed Sunday and federal holidays.

National Building Museum

401 F Street NW, Washington, D.C. 20001
(202) 272-2448
www.nbm.org

2002 EXHIBITIONS

Through January 12
William Price: From Arts and Crafts to Modern Design
Traces the architect's career, from 1883 to 1916, through drawings and paintings, arts and crafts furniture, decorative arts and historic film footage.

Through February 3
Cesar Pelli: Connections
Seven-foot models of skyscrapers, vast models of urban
master plans, drawings and photographs by the American
architect.

Through February 18
A Genius for Place: American Landscapes of the Country Place Era
A look at the country estates fashioned by pioneer landscape
architects in the early 20th century.

Through February
Samuel Mockbee: The Architecture of the Black Warrior River
A selection of works by Mockbee and his firm, Coker.

Through August 11
City Lines: Electric Rail Transit and Urban America
Exploring rail transit's evolution and its prospects.

Continuing
Tools as Art: The Hechinger Collection
A celebration of common tools' dignity and beauty.

PERMANENT COLLECTION

Photographs, drawings and objects celebrating American
achievement in urban planning, construction, engineering and
design. **Architecture:** 1880's Italian Renaissance building by
Montgomery C. Meigs.

Admission: Free.
Hours: Monday through Saturday, 10 a.m.–5 p.m.; Sunday,
noon–5 p.m.

National Gallery of Art and Sculpture Garden

The National Mall, between 3rd and 9th Streets at
 Constitution Avenue NW, Washington, D.C. 20565
(202) 737-4215 (recording); (202) 842-6176 (for the deaf)
www.nga.gov

Courtesy of the National Gallery of Art and Sculpture Garden.
Christo, *Over the River, Project for Arkansas River*, Colorado, 2000.

2002 EXHIBITIONS

Through January 6
Virtue and Beauty: Leonardo's Ginevra deí Benci
Explores female portraiture in Florence from 1440 to 1540,
when the genre was expanded to the merchant class.

Through January 13
Aelbert Cuyp
Paintings and drawings by one of the foremost Dutch painters
and draftsmen of the 17th century.

Through January 21
*Best Impressions: 35 Years of Prints and Sculpture From Gemini
G.E.L.*
Works by artists who have collaborated with Gemini G.E.L.,
one of America's leading printmaking workshops, including
Rauschenberg, Lichtenstein and Johns.

Through January 27
Henry Moore
About 160 bronzes, maquettes, carvings, plasters and works
on paper spanning Moore's entire career in this first major U.S.
retrospective of the artist's work in 20 years.

DISTRICT OF COLUMBIA

Washington

Through April 7
A Century of Drawing
Works by Degas, Rodin, Homer, Picasso, Matisse, Hopper, Pollock, de Kooning and others.

February 3–June 23
Christo and Jeanne-Claude in the Vogel Collection
Studies, drawings and models for projects in which the artists have wrapped and covered natural and constructed forms.

March 3–May 27
The Flowering of Florence: Botanical Art for the Medici, 1550–1750
Explores the links between the arts and natural sciences through the botanical art created in Florence for the Medici.

March 10–June 2
Goya: Images of Women
About 130 paintings, drawings and tapestries depicting women by one of Spain's greatest painters of the late 18th and early 19th centuries.

May 5–July 28
An American Vision: Henry Francis du Pont's Winterthur Museum
About 300 objects from the Winterthur's collection of American furniture, textiles, prints, ceramics, glass, needlework and metalwork made or used between 1640 and 1840.

June 2–September 2
The Unknown Steiglitz
About 100 photographs from the museum's collection of 1,600 images, the largest single collection of Steiglitz's work.

June 30–September 25
Anne Vallayer-Coster: Still-Life Painting in the Age of Marie Antoinette
First retrospective of the work of the 18th-century still-life painter.

October 13–March 2
The Art of Illusion: Five Centuries of Trompe L'Oeil Painting in Europe and America
About 115 paintings exploring the art of trompe l'oeil from its origins in classical antiquity to its influence on 20th-century artists.

PERMANENT COLLECTION

The National Gallery of Art and Sculpture Garden, one of the world's major museums, was created in 1937 with the gift of

Andrew W. Mellon. The gallery's permanent collection of some 100,000 paintings, drawings, prints, photographs, sculpture and decorative arts traces the development of Western art from the Middle Ages to the present. West Building: A comprehensive survey of Italian painting and sculpture, including the only painting by Leonardo da Vinci in the Western Hemisphere, along with Dutch masters and French Impressionists, and surveys of American, British, Flemish, Spanish and 15th- and 16th-century German art. East Building: Major 20th-century artists like Alexander Calder, Henri Matisse, Joan Miró, Pablo Picasso, Jackson Pollock and Mark Rothko. Sculpture Garden: Seventeen major works of post-World War II sculpture by Louise Bourgeois, Mark di Suvero, Roy Lichtenstein, Claes Oldenburg, Coosje van Bruggen, Tony Smith and others. **Architecture:** West Building: Opened in 1941 and designed by John Russell Pope. East Building: Opened in 1978 and designed by I. M. Pei.

Admission: Free.
Hours: Monday through Saturday, 10 a.m.–5 p.m.; Sunday, 11 a.m.–6 p.m. Closed New Year's Day and Christmas Day.

National Museum of African Art

Smithsonian Institution, 950 Independence Avenue SW, Washington, D.C. 20560–0708
(202) 357-4600
www.si.edu/nmafa

2002 Exhibitions

Through February 18
Spectacular Display: The Art of Nkanu Initiation Rituals
Sculpture from the Democratic Republic of the Congo and Angola, including wall panels and masks, that often combine two-dimensional surface decoration with high relief. Also: photographs that depict initiation activities in Washington-area African-American communities.

Through May 5
Making the Grade: African Arts of Initiation

Works from the museum's collection as well as a rare 20th-century drum used in male initiation rites among the Baga peoples of Guinea, on loan from a private collection.

April 14–September 2
Objects as Envoys: Cloth, Imagery and Diplomacy in Madagascar
Textiles used for clothing, burial shrouds and diplomatic gifts, as well as fine-art examples. Articles of clothing dating from the late 19th century to the present. Historical postcards and photographs.

June 9–August 14
A Personal Journey: Central African Art From the Lawrence Gussman Collection
Works from Cameroon, Gabon, Equatorial Guinea, the Republic of Congo, Angola and Gambia, including masks, figures, musical instruments, vessels and weapons.

Opening in November
Playful Performers: The Art of African Children's Masquerades
Masks and handmade toys, as well as photographs and videotaped performances.

Continuing
The Ancient Nubian City of Kerma, 2500–1500 B.C.
Ceramics, jewelry and ivory inlays in animal shapes reveal Kerma's wealth and artistic traditions.

Continuing
The Art of the Personal Object
Chairs, stools, headrests, snuff containers, pipes, cups, a drinking horn, bowls, baskets, combs, a Somali rose water bottle and a Yoruba game board. Most items are from the late 19th century to the early 20th.

Continuing
Images of Power and Identity
Masks and figurative sculpture from sub-Saharan Africa, including two 13th- to 15th-century terra-cotta figures from Mali, a 19th-century Bamum royal figure and a 20th-century palace door carved by the Nigerian artist Olowe of Ise.

PERMANENT COLLECTION

The museum collects and exhibits the visual arts of Africa, from ancient to contemporary. Noteworthy holdings include royal Benin art; utilitarian objects like stools, headrests and other personal and household items; ceramics; and contemporary art.

Admission: Free.
Hours: Daily, 10 a.m.–5:30 p.m.; call about extended summer hours. Closed Christmas Day.

The National Museum of Women in the Arts

1250 New York Avenue NW, Washington, D.C. 20005
(202) 783-5000
www.nmwa.org

2002 EXHIBITIONS

Through January 6
Virgin Territory
Contemporary Brazilian art, including painting, sculpture, installation art, film and new media.

PERMANENT COLLECTION

Founded in 1981 as the only museum dedicated solely to the achievements of women in the visual, performing and literary arts, with some 2,700 works by 800 artists, including Camille Claudel, Georgia O'Keeffe and Elizabeth Catlett. **Highlights:** Elizabeth Louise Vigée-Lebrun, *Portrait of Princess Belozersky*; Frida Kahlo, *Self-Portrait Dedicated to Leon Trotsky*. **Architecture:** 1908 Renaissance Revival building by Waddy Wood originally constructed as a Masonic temple.

Admission: Adults, $5; students with ID and seniors (60 and over), $3; free for members and age 18 and under. Free on first Sunday and Wednesday of each month.
Hours: Monday through Saturday, 10 a.m.–5 p.m.; Sunday, noon–5 p.m. Closed New Year's Day, Thanksgiving and Christmas Day.

Washington

National Portrait Gallery

Smithsonian Institution, Eighth and F Streets NW,
 Washington, D.C. 20560
(202) 357-2700
www.npg.si.edu

Closed for renovations through fall 2004.

PERMANENT COLLECTION

Paintings, sculpture, prints, drawings and photographs of
Americans who contributed to the history and development
of the United States. **Highlights:** Portrait sculptures by
Davidson; Civil War gallery; one of the last photographs of
Lincoln; the Hall of Presidents, including portraits of Wash-
ington and Jefferson by Gilbert Stuart. **Architecture:** 1836
Old Patent Office by Mills, completed in 1867 by Thos.
Ustick Walter.

The Phillips Collection

1600 21st Street NW, Washington, D.C. 20009–1090
(202) 387-2151; (202) 387-2436
www.phillipscollection.org

2002 EXHIBITIONS

Through January 13
Impressionist Still Life
First major exhibition ever devoted to French Impressionist
and Post-Impressionist still life painting, featuring 80 works
from public and private collections. (Travels)

February 16–May 12
*Corot to Picasso: European Masterworks From the Smith College
Museum of Art*
Includes 58 paintings and sculptures from the 19th and early
20th centuries. (Travels)

June 1–August 18
Edward Weston: Photography and Modernism

Courtesy of the Phillips Collection.

Henri Fatin-Latour, *White Cup and Saucer*, 1864.

About 140 of Weston's photographs, from his first experiments with Modernism around 1920 through 1948.

September 21–January 19, 2003
Pierre Bonnard: Early and Late
About 60 works, including paintings, drawings, prints, photographs, decorative arts and sculpture. (Travels)

PERMANENT COLLECTION

Impressionist paintings by van Gogh, Monet, Degas and Cézanne; works by Vuillard, Bonnard, Braque, Picasso, Matisse and Klee; American works by Homer, Eakins, Ryder, O'Keeffe, Marin, Dove, Rothko, Lawrence and Diebenkorn.
Highlights: Renoir, *Luncheon of the Boating Party.*

Admission: Adults, $7.50; seniors and students, $4; 18 and under, free.
Hours: Tuesday through Saturday, 10 a.m.–5 p.m.; Thursday, until 8:30 p.m.; Sunday, noon–7 p.m. Closed Monday and New Year's Day, Independence Day, Thanksgiving and Christmas Day. Sunday summer hours may differ.

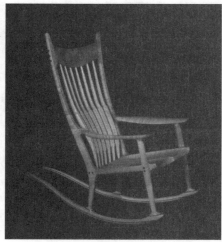

Sam Maloof, *Rocking chair with flat spindles and sculpted arms*, 1999.

Courtesy of the Smithsonian American Art Museum.

Smithsonian American Art Museum

Eighth and G Streets NW, Washington, D.C. 20560–0970
(202) 275-1500; (202) 357-2700
AmericanArt.si.edu

The main building is closed for renovations through late 2004. The Renwick Gallery branch (below) will remain open, and the museum has organized many traveling exhibitions during its hiatus.

PERMANENT COLLECTION

The museum is home to the first federal art collection and the largest collection of American art in the world, with 39,000 objects in all media spanning more than 300 years of the nation's visual heritage. **Architecture:** The museum occupies the historic Old Patent Office Building, dating from 1836 and considered one of the finest Greek Revival structures in the world.

The Renwick Gallery of the Smithsonian American Art Museum

Pennsylvania Avenue at 17th Street NW, Washington,
 D.C. 20560-0510
(202) 357-2531; (202) 357-2700
AmericanArt.si.edu

2002 EXHIBITIONS

Through January 20
The Furniture of Sam Maloof
Sculptural furniture by the designer and craftsman.

March 15–July 21
Wood Turning Since 1930
More than 125 North American works.

June 14–October 14
The Renwick Invitational: Five Discoveries in Craft
Works by Don Fogg, a bladesmith from Jasper, Ala.; James
Koehler, a tapestry weaver from Santa Fe, N.M.; Gyongy Laky,
a basket maker from San Francisco; Kristina Logan, a glass
artist from Portsmouth, N.H.; and Kim Rawdin, a jewelry
maker from Scottsdale, Ariz.

September 13–January 19, 2003
George Catlin and His Indian Gallery
Images of American Indians that Catlin painted during his
travels west of the Mississippi from 1830 to 1836.

PERMANENT COLLECTION

Works in American craft and design in glass, ceramic, metal,
wood and fiber. **Architecture:** 1858 French Second Empire
building by James Renwick. Transferred to the Smithsonian
Institution in 1965 and after renovations reopened as the Ren-
wick Gallery in 1972, it is located across the street from the
White House.

Admission: Free.
Hours: Daily, 10 a.m.–5:30 p.m. Closed Christmas Day.

Florida

Lowe Art Museum

University of Miami, 1301 Stanford Drive, Coral Gables,
 Fla. 33124
(305) 284-3535
www.lowemuseum.org

2002 EXHIBITIONS

Through January 20
Louise Nevelson: Structures Evolving
Sculpture, wall reliefs, collages and prints created between
1945 and 1985. The exhibit examines the wide range of
materials Nevelson employed. (Travels)

Through January 20
*Milton Avery: Paintings From the Collection of the Neuberger
Museum of Art*
More than 25 early paintings and works on paper. (Travels)

Through June
*The Dawn of Empire: The Art of the Late Warring States and
Han Dynasty*
Works from the permanent collection.

February 7–March 31
*El Favor de los Santos: The Retablo Collection of New Mexico State
University*
The exhibit compares retablos — small devotional paintings,
usually on tin, designed to seek the saints' favor — to other
forms of votive art.

March–April 2003
Catalyst: 50 Years of Collecting at the Lowe

April 11–June 2
Andrew Morgan: Paintings of the 90's
Works by the South Florida painter and educator.

June 13–July 28
Soon Come: Contemporary Jamaican Art
Paintings, drawings, ceramics, sculpture, textiles and mixed-
media works explore nationalism and individual identity.

June 13–July 28
The Lithographs of James McNeill Whistler
Works produced during a 20-year period abroad. The
lithograph was the last medium Whistler explored.

August 8–September 8
Florida Visual Arts Fellowships 2000-2001

PERMANENT COLLECTION

Italian Renaissance and Baroque art; Greco-Roman antiqui-
ties; American and European art from the 14th century
through the 21th century; pre-Columbian, African, Asian and
American Indian art.

Admission: Adults, $5; students, $2; adult groups of 10 or
more, $3.
Hours: Tuesday, Wednesday, Friday and Saturday, 10 a.m.–
5 p.m.; Thursday, noon–7 p.m.; Sunday, noon–5 p.m. Closed
Monday.

*Museum of Art,
Fort Lauderdale*

One East Las Olas Boulevard, Fort Lauderdale, Fla. 33301
(954) 525-5500
www.museumofart.org

2002 EXHIBITIONS

Through January 6
Surrounding Interiors: Views Inside the Car
Thirteen artists explore car interiors in a range of media,
including photography, sculpture, video and painting.

Through January 6
Birds in Art
A celebration of birds through 60 sculptures and paintings,
some of them whimsical, others reflecting harsh realities.

Through February 28
Fashion: The Greatest Show on Earth
Drawing on art of the 1960's and 70's, political activism, the-
ater and popular culture, fashion houses have transformed the

Fort Lauderdale

runway show, resulting in a new breed of performance art. This exhibition will examine the importance of this phenomenon through a display of clothing, video, performance and design from leading couturiers and contemporary artists.

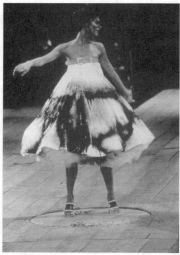

Courtesy of the Museum of Art, Fort Lauderdale. Alexander McQueen, from the spring collection, 1999.

January 20–April 7
From Fauvism to Impressionism: Albert Marquet at the Pompidou
Some 45 paintings and 20 works on paper by Marquet (1875–1947), a French painter and draughtsman who was one of the Fauves who startled the French critics and public at the famous Salon d'Automne in 1905.

March–June
Tracey Emin
The first major U.S. show by this British artist, whose works in multiple media offer intimate confessions.

April 19–July 12
Chester Higgins: Elder Grace
Portraits of African-American elders, accompanied by reflections about the experience of aging.

June–September
Edward Hillel: Beach House
Resulting from a study of Fort Lauderdale's history, personal testimonials and memories are incorporated into a beach house structure built in the museum galleries.

PERMANENT COLLECTION

More than 5,400 works of 20th-century European and American art. **Highlights:** Works by Picasso, Calder, Moore, Dalí and Warhol; the largest collection of CoBrA art (works from Copenhagen, Brussels and Amsterdam after World War II) in

the United States; new wing providing a permanent home for the museum's collection of works by the American Impressionist Williams Glackens.

Admission: Adults, $10; seniors, $8; college students and youths 10–18, $6; children under 10, free.

Hours: Tuesday through Saturday, 10 a.m.–5 p.m.; Sunday, noon–5 p.m. Closed Monday and national holidays.

Miami Art Museum

101 West Flagler Street, Miami, Fla. 33130
(305) 375-3000
www.miamiartmuseum.org

2002 EXHIBITIONS

Through January 13 (Also February 1–April 7, April 26–June 30, November 15–January 19, 2003)
New Work Miami
Yearlong series featuring works by Miami artists.

Through March 3
Vit Acconci: Acts of Architecture
Works that invite visitor participation, in categories that include Architectural Games and Events; Furniture, Devices and Instruments; and Playgrounds, Parks and Gardens. (Travels)

Through July 7
Selections From the Collection

March 22–June 2
Matta in America
Works from 1939 to 1948 examining the Chilean artist Roberto Matta's relationship to Surrealism. (Travels)

June 21–August 25
Ultrabaroque: Aspects of Post–Latin American Art
Explores relationships to the Baroque in a wide range of art by contemporary Latin American artists.

October 25–March 2, 2003
Linking Collection and Community
An overview of the museum's collection five years after its inception.

Miami/Miami Beach

PERMANENT COLLECTION

Paintings, sculpture, installations, works on paper, photographs and mixed-media pieces, including works by Jean Dubuffet, Marcel Duchamp, Adolph Gottlieb, Robert Rauschenberg, Susan Rothenberg and Frank Stella.

Admission: Adults, $5; students and seniors, $2.50; members and children under 12, free. Free on Sunday and free for families on second Saturday of each month.
Hours: Tuesday through Friday, 10 a.m.–5 p.m.; Saturday and Sunday, noon–5 p.m.; third Thursday of each month, until 9 p.m. Closed Monday.

Bass Museum of Art

2121 Park Avenue, Miami Beach, Fla. 33139
(305) 673-7530
www.bassmuseum.org

2002 EXHIBITIONS

Through January 13
Yayoi Kusama
Sculpture, paintings and mixed-media installations from the past two decades, plus several new large works.

Through April 28
The Making of Miami Beach, 1933-1942: The Architecture of Lawrence Murray Dixon
Architectural renderings and vintage sepia-toned photographs from the museum's collection. The exhibition celebrates the restoration of the museum's own limestone building.

Through the Spring
Liza Lou II
A 35-foot trailer, covered inside and out in glittering, multicolored beads, installed outdoors in Collins Park.

February 8–June 9
Joan Miró: Metamorphosis of Form
More than 50 examples of the artist's mature work, including paintings, sculpture, gouaches and tapestries. (Travels)

June 28–September 29
O Fio da Trama: The Thread Unraveled
Approximately 50 contemporary works created by young
Brazilian artists, including photographs, videos, sculpture and
multimedia installations.

July 6–September 29
*The Print in the North: The Age of Albrecht Dürer and Lucas van
Leyden*
More than 80 Renaissance prints from the collection of the
Metropolitan Museum of Art in New York City.

Continuing
Inside and Out: Contemporary Sculpture, Video and Installations

PERMANENT COLLECTION

More than 2,000 works, including European art and decora-
tive arts, as well as American, Asian and contemporary art;
textiles, tapestries, and ecclesiastical vestments and artifacts;
architectural photographs and drawings documenting the his-
tory of Miami Beach. **Architecture:** 1930's Mayan-inspired
building renovated and expanded in 2000 by Arata Isozaki.

Admission: Adults, $6; seniors and students, $4; children
under 6 and members, free.
Hours: Tuesday through Saturday, 10 a.m.–5 p.m.; Wednes-
day, until 9 p.m.; Sunday, 11 a.m.–5 p.m. Closed Monday and
federal holidays.

The Wolfsonian

Florida International University, 1001 Washington
 Avenue, Miami Beach, Fla. 33139
(305) 531-1001
www.wolfsonian.org

2002 EXHIBITIONS

Through April 7
Aluminum by Design
The exhibition explores how aluminum figures in technology,

architecture and design, and how its ready availability has served to promote both consumerism and environmentalism.

Fall

In Pursuit of Pleasure: The Hotel in America, 1875–1945
Renderings and perspective drawings reveal architects' designs. Examples of flatware, furniture, menus and other items.

Continuing

Art and Design in the Modern Age
Approximately 200 selections from the museum's collection, including decorative arts, architectural models, paintings, sculpture, books, posters and postcards.

PERMANENT COLLECTION

Art and design from the period 1885–1945, with more than 70,000 objects, predominantly from North America and Europe.

Admission: Adults, $5; seniors, students and ages 6–12, $3.50; members, children under 6, Florida state university system students, faculty and staff, free. Free on Thursday, 6–9 p.m.

Hours: Monday, Tuesday, Friday and Saturday, 11 a.m.–6 p.m.; Thursday, until 9 p.m.; Sunday, noon–5 p.m. Closed Wednesday.

Flagler Museum

Cocoanut Row and Whitehall Way, Palm Beach, Fla. 33480
(561) 655-2833
www.flagler.org

2002 EXHIBITIONS

January 15–April 14

Henry M. Flagler's Paintings Collection — The Taste of a Gilded Age Collector
Includes Orientalist paintings, Academic style portraits, landscapes and works by Martin Johnson Heade.

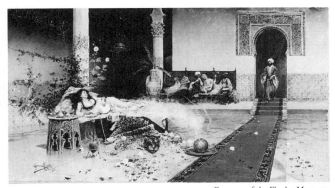

Courtesy of the Flagler Museum.

Juan Gimenez y Martin, *The Sultan's Favorite*.

PERMANENT COLLECTION

Original and period furnishings from the Gilded Age as well as changing exhibitions of period art and history. **Architecture:** Whitehall, 1902 Gilded Age mansion of Henry Morrison Flagler.

Admission: Adults, $8; ages 6–12, $3.

Hours: Tuesday through Saturday, 10 a.m.–5 p.m.; Sunday, noon–5 p.m. Closed Monday, New Year's Day, Thanksgiving and Christmas Day.

The Society of the Four Arts

2 Four Arts Plaza, Palm Beach, Fla. 33480
(561) 655-7227
www.fourarts.org

2002 EXHIBITIONS

Through January 6
63rd Annual National Exhibition of Contemporary American Paintings
Juried show.

January 12–February 12
The Watercolors of Paul Signac

Palm Beach/St. Petersburg

January 16–April 7
The Story of Harness Racing by Currier & Ives

February 16-March 17
The Impressionist Legacy

March 23–April 14
Fashion Photographs of Rene Gruau

PERMANENT COLLECTION

A small collection of paintings and drawings; sculpture garden; a library, a children's library, horticultural gardens, a gallery building with auditorium.

Admission: Suggested donation for galleries: $3. Libraries and gardens, free.
Hours: Monday through Saturday, 10 a.m.–5 p.m.; Sunday, 2–5 p.m. Longer hours during the winter. Closed major holidays and for brief periods between exhibitions.

Museum of Fine Arts

255 Beach Drive N.E., St. Petersburg, Fla. 33701
(727) 896-2667
www.fine-arts.org

2002 EXHIBITIONS

Through January 6
Americanos: Portraits of the Latino Community in the United States
About 120 photographs, by 30 photojournalists, exploring the variety of the American Latino experience.

January 20–April 14
Preserved by Design: Ceramic Art of the American Southwest
More than 100 examples of centuries-old ceramic art and pottery made by indigenous cultures in what is now Arizona, New Mexico, Colorado and Utah.

February 25–May 20
Art of the Goldsmiths: Masterworks From Buccellatti
Jewelry and other works by a contemporary goldsmith, Gianmaria Buccellatti, and three generations of his family.

May 4–June 2
Artistic Discovery: 20th Annual Congressional Art Competition

September 29–January 5, 2003
Red Grooms: The Complete Graphic Works
A selection of 110 wall pieces and 15 pedestal pieces from the
collection of a high school classmate of the artist.

PERMANENT COLLECTION

Eighteenth- and 19th-century European paintings, particu-
larly by the French Impressionists; 19th- to mid-20th-century
American art; photography; contemporary graphic works by
Anuszkiewicz, Close, Dine, Lichtenstein, Mapplethorpe,
Warhol, Rauschenberg and Rosenquist; sculpture; decorative
arts, including Steuben glass; pre-Columbian objects; Asian,
African and American Indian art. **Architecture:** neo-Palladian
design by John Volk & Associates.

Admission: Adults, $6; seniors, $5; students, $2; under 6, free.
Hours: Monday through Saturday, 10 a.m.–5 p.m.; Sunday,
1–5 p.m.; the third Thursday of each month (except during
the summer), until 9 p.m. Closed New Year's Day, Martin
Luther King Day, Thanksgiving and Christmas Day.

The Salvador Dalí Museum

1000 Third Street South, St. Petersburg, Fla. 33701
(727) 823-3767; (800) 442–DALI
www.salvadordalimuseum.org

2002 EXHIBITIONS

Through February 24
In Spite of Everything, Spring: Jacqueline Lamba
Some 25 paintings by the Surrealist (1910-1993), who was the
wife of André Breton, Surrealism's principal theorist.

May 11–September 8
Forms of Cubism: Sculptures and the Avant-Garde, 1909-1918
Works and related drawings by Archipenko, Brancusi, Braque,
Gaudier-Brzeska, Laurens, Lipchitz, Picasso and Zadkine.

November 2–January 19, 2003
Dalí in Focus: Gradiva

PERMANENT COLLECTION

A comprehensive collection of Salvador Dalí's works spanning his four artistic periods from 1914 to 1980 in a variety of media, and changing special exhibits of works by other Surrealist artists or on related themes.

Admission: Adults, $10; seniors, $7; students, $5; under 10, free.
Hours: Monday through Saturday, 9:30 a.m.–5:30 p.m.; Thursday, until 8 p.m.; Sunday, noon–5:30 p.m. Closed Thanksgiving and Christmas Day.

The John and Mable Ringling Museum of Art

5401 Bay Shore Road, Sarasota, Fla. 34243
(941) 359-5700; 941-351-1660 (recording)
www.ringling.org

2002 EXHIBITIONS

Through January 6
One Nation: Patriots and Pirates Portrayed by N.C. Wyeth and James Wyeth
Drawings and paintings by N.C. Wyeth and his grandson chronicling the changing attitude toward "patriotism" from the beginning of the 20th century to the present. (Travels)

Winter 2002
Cà d'Zan
Reopening of the historic home of John and Mable Ringling after a restoration.

February 1–April 14
Images From the World Between: The Circus in 20th-Century American Life
About 90 paintings, sculptures, prints and photographs

depicting the circus, including works by George Bellows, Alexander Calder and Bruce Nauman. (Travels)

June 11–August 14
An American Anthem: 300 Years of Painting From the Butler Institute of Art
Survey of American art from colonial portraiture to 20th-century modernism, including works by Peale, Hopper, Bierstadt, Gottlieb and Warhol. (Travels)

PERMANENT COLLECTION

European Renaissance, Baroque and Rococo art; works by Peter Paul Rubens; antiquities, decorative arts, tapestries, photographs, drawings, prints; modern and contemporary art; circus costumes, wagons and props; circus-related fine art and memorabilia. **Highlights:** Italian Renaissance-style courtyard with full-size sculptural reproductions, including a bronze cast of Michelangelo's *David*. **Architecture:** 1924–26 Venetian Gothic Ringling residence; 1927–29 Renaissance-style villa art museum that was renovated 1989–90.

Admission: Adults, $9; seniors, $8; members and children under 12, free.
Hours: Daily, 10 a.m.–5:30 p.m. Closed New Year's Day, Thanksgiving and Christmas Day.

Norton Museum of Art

1451 South Olive Avenue, West Palm Beach, Fla. 33401
(561) 832-5196
www.norton.org

2002 EXHIBITIONS

Through January 20
American Impressionism: Treasures From the Smithsonian American Art Museum
Works by Mary Cassatt, William Merritt Chase, Childe Hassam, James Whistler and others. (Travels)

St. Petersburg/Sarasota

February 9–April 21
Monks and Merchants: Silk Road Treasures From Northwest China, Gansu and Ningxia
Recently excavated works, many never exhibited outside China, from the fourth century through the seventh. (Travels)

February 16–April 14
Milton Avery: The Late Paintings
Some 50 works by the American artist (1885-1965).

April 25–July 8
A Thousand Hounds
Photographs of people with their dogs spanning more than 150 years, from daguerreotypes to digital prints. Works by Nadar, Eadweard Muybridge, Jacob Riis, Edward Steichen, Thomas Eakins, Alfred Stieglitz, Pablo Picasso, Tina Modotti, Man Ray, Dorothea Lange, William Wegman and others.

Georgia

Georgia Museum of Art

University of Georgia, East Campus, 90 Carlton Street,
 Athens, Ga. 30602–6719
(706) 542-4662; (706) 542-3254
www.uga.edu/gamuseum

2002 EXHIBITIONS

Through February 3
Maps and Arts of Historic Georgia
Decorative arts and historical maps.

January 16–March 17
Muirhead Bone
Works by the Scottish printmaker (1876-1953), who is best
known as an etcher and engraver of architectural subjects.

February 8–March 17
The Arts and Crafts Movement in North Georgia
Exploring the impact of Arts and Crafts on the development
of select educational institutions in the early 20th century.

February 16–April 14
*Landscapes of Retrospection: The Magoon Collection of British
Drawings and Prints, 1739–1854*
Works by John Sell Cotman, William Daniell and others.

April 28–July 8
Fauvism to Impressionism: Albert Marquet From the Pompidou
Oil paintings, watercolors and drawings by the Frenchman
(1875-1947), including portraits, figure studies and
landscapes. (Travels)

May 25–July 21
Lucy May Stanton
Portraits, both miniature and full-scale, by the native Georgian
(1876-1931).

July 20–September 29
*Romantics and Revolutionaries: Regency Portraits From the National
Portrait Gallery, London*
Approximately 50 paintings.

August–September
The Artist Portrayed
Self-portraits and portraits of artists.

Mid-September–December
Earl McCutchen
Innovative glasswork.

October 12–December 8
Sienese Drawings
Works from the late 1400's through the 1700's — some never exhibited before.

October 12–January 5, 2003
Sacred Treasures: Early Italian Paintings From Southern Collections
Tuscan works, from the 13th century through the 16th, that illustrate religious themes.

PERMANENT COLLECTION

Paintings by Childe Hassam, Georgia O'Keeffe, Theodore Robinson, Jacob Lawrence, Marsden Hartley and Robert Henri.

Admission: Donation requested.
Hours: Tuesday through Saturday, 10 a.m.–5 p.m.; Wednesday, until 9 p.m.; Sunday, 1–5 p.m. Closed Monday.

The Michael C. Carlos Museum

Emory University, 571 South Kilgo Street, Atlanta, Ga. 30322
(404) 727-4282
www.carlos.emory.edu

2002 EXHIBITIONS

Through January 6
The Collector's Eye: Masterpieces of Egyptian Art From the Thalassic Collection
More than 175 objects, ranging from 3500 B.C. to the time of Cleopatra, including statues, amulets and jewels.

Through January 28
New Acquisitions of Old Masters: Dürer to Delacroix
Works on paper, from the 16th century to the 19th, including
examples by François Boucher and Giovanni Piranesi.

Through the Fall
The Arts of India and the Himalayas: Recent Acquisitions
An 11th-century high-relief sculpture, a 10th-century bronze
altar, a seated Buddha and other works.

February 23–June 16
Wrapped in Pride: Ghanaian Kente and African-American Identity
Explores the role of Ghanaian kente cloth as an expression of
identity in the United States from the 1950's to the present.

August 10–October 6
*The Tumultuous Fifties: A View From the New York Times Photo
Archive*
Nearly 200 black-and-white photographs focusing on the
1950's, a decade that included McCarthyism, Sputnik, Cold
War politics, bebop and Abstract Expressionism. (Travels)

Opening September 13
The Art of the Ancient Americas
Works from the museum's collection of Mesoamerican, Central
American and Andean art.

October 26–January 19, 2003
Treasures From the Royal Tombs of Ur
More than 200 objects of metal, stone, wood and other prized
materials excavated from the site of Ur, a Sumerian city.

Continuing
Ancient Egypt, Nubia, Near East: The New Galleries
Works from the museum's collection, including coffins,
mummies, canopic urns, amulets and jewelry.

PERMANENT COLLECTION

Some 16,000 objects, including art from Egypt, Greece,
Rome, the Near East, the Americas, Asia, Africa and Oceania;
works on paper from the Middle Ages to the 20th century.
Highlights: Egyptian funerary art, including several coffins
and mummies. **Architecture:** 1916 Beaux-Arts building by
Henry Hornbostel with marble facade and traditional clay tile
roof; major 1993 expansion and all interiors by Michael
Graves.

Admission: Suggested donation: $5.
Hours: Tuesday through Saturday, 10 a.m.–5 p.m.; Thursday, until 9 p.m.; Sunday, noon–5 p.m. Closed Monday and major holidays.

High Museum of Art

1280 Peachtree Street NE, Atlanta, Ga. 30309
(404) 733-4444
www.high.org

2002 EXHIBITIONS

Through February 10
The Color Yellow: Beauford Delaney
Approximately 25 paintings by the African-American artist, who used the color yellow in figurative and abstract art to express angst and comment on prejudice.

Through February 17
How I See Yellow: A Community Outreach Project

February 9–May 5
After "The Scream": The Late Work of Edvard Munch
More than 60 works that Munch painted in Norway during the first decades of the 20th century.

June 8–September 1
American Impressionism: Treasures From the Smithsonian American Art Museum

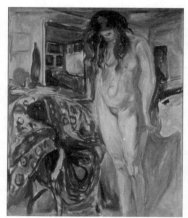
Courtesy of the High Museum of Art.
Edvard Munch, *Model with Wicker Chair*, 1919-21.

June 8–September 1
Light Screens: The Leaded Glass of Frank Lloyd Wright

PERMANENT COLLECTION

Nineteenth and 20th-century American art; decorative arts, including the Virginia Carroll Crawford Collection of Ameri-

can Decorative Arts from 1825 through the early 20th century and the Frances and Emory Cocke Collection of English ceramics; American folk art. **Architecture:** Award-winning design by Richard Meier.

Admission: Adults, $8; students and seniors, $6; children 6–17, $4; members and children under 6, free.
Hours: Tuesday through Saturday, 10 a.m.–5 p.m.; Friday, until 9 p.m.; Sunday, noon–5 p.m. Closed Mondays.

High Museum of Art: Folk Art and Photography Galleries

133 Peachtree Street, (corner of John Wesley Dobbs and
 Peachtree Street at Georgia-Pacific Center,
 downtown), Atlanta, Ga. 30303

2002 EXHIBITIONS

Through January 26
Pictures Tell the Story: Ernest C. Withers
Photographs of the civil rights movement and of celebrities, including Ray Charles, Aretha Franklin, B.B. King, Willie Mays, Elvis Presley, Jackie Robinson and Ike and Tina Turner.

Through April 13
New Treasures, Old Favorites: American Self-Taught Art From the High
Approximately three dozen works.

February 16–April 13
Contemporary Folk Art From the Smithsonian American Art Museum

April 27–August 3
ABCD: A Collection of Art Brut

August 17–December 7
In Response to Place: Photographs From the Nature Conservancy's Last Great Places

Admission: Free.
Hours: Monday through Saturday, 10 a.m.–5 p.m.; first Thursday of every month, until 9 p.m. Closed Sunday.

The Contemporary Museum

2411 Makiki Heights Drive, Honolulu, Hawaii 96822
(808) 526-1322; (808) 526-0232 (recording)
www.tcmhi.org

2002 EXHIBITIONS

January 18–March 17
Selected Works From the Museum's Collection

March 29–June 2
Paintings by Jane Hammond: The John Ashbery Collaboration

June 14–August 18
Tadashi Sato: A Retrospective

August 30–November 3
Big Idea: The Maquettes of Robert Arneson

The Contemporary Museum at First Hawaiian Center

999 Bishop Street, Honolulu, Hawaii 96813

2002 EXHIBITIONS

January 11–April 17
Timothy P. Ohile, Ann Bush and Thomas Woodruff

April 26–September 18
Brian Isobe, Derek Bencomo

PERMANENT COLLECTION

Some 1,200 works since 1940 by Robert Motherwell, Andy Warhol, Josef Albers, Louise Nevelson, Jim Dine, Jasper Johns, William Wegman and others. **Highlights:** David Hockney's walk-in environment inspired by Ravel's opera *L'Enfant et les Sortilèges.* **Architecture:** Former home of Alice Coke Spalding, built in the 1920's and most recently renovated in 1988.

Admission: Makiki Galleries, adults, $5; students and seniors, $3; 12 and under, free. First Hawaiian Center, free.
Hours: Makiki Galleries: Tuesday through Saturday, 10 a.m.–4 p.m.; Sunday, noon–4 p.m. Closed Monday and major holi-

days. First Hawaiian Center: Monday through Thursday, 8:30 a.m.–4 p.m.; Friday, until 6 p.m. Closed weekends and holidays.

The Honolulu Academy of Arts

900 South Beretania Street, Honolulu, Hawaii 96814
(808) 532-8700; (808) 532-8701 (recording)
www.honoluluacademy.org

2002 EXHIBITIONS

January 17–March 17
American Watercolors and Drawings From the Academy's Collection

January 31–March 31
Taisho Chic: Japanese Romanticism and Art Deco (1900–1950)
Paintings, textiles and decorative arts from the Taisho period, which featured the blending of old images with new ones.

March 21–May 19
Snowden Hodges: The Labors of Hercules
Oversize figure drawings, augmented by theatrical light effects, that are based on statues of Hercules by the Italian Renaissance sculptor Vicenzo de Rossi.

April 25–June 16
Hawaii Calls: Island Art in Private Hands
A wide range of works tracing Hawaii's history, from images of the monarchy and examples of its material culture to modernist decorative arts. Includes drawings and quilts as well as promotional materials, kitsch and objects associated with the state's status as a vacation paradise.

July 18–August 25
Artists of Hawaii 2002
The 52nd annual statewide multimedia exhibition.

July 18–August 25
Ansel Adams in Hawaii
Images that reflect the landscapes and spirit of Hawaii in the middle of the 20th century.

HAWAII

Honolulu

August
Showcase 2002
New works by local contemporary artists. The art sale benefits children's programming at the academy.

August 1–September 15
Treasures of the Shingon Sect
Objects from the Mount Koya Shingon Buddhist complex.

September 5–October 27
Gaugin's Zombie: An Installation by Debra Drexler
Seven large-scale paintings and a wood carving, plus fictional writing, that explore the historic relationships between male artists and female models, as well as other themes.

December 5–February 16, 2003
From Monet to van Gogh: Impressionist and Post-Impressionist Masterpieces From Japan

PERMANENT COLLECTION

Asian art; American paintings and decorative arts from the Colonial period to the present; works from Africa, Oceania, the Americas; contemporary graphic arts; Hawaiian art. **Highlights:** The James A. Michener collection of 5,400 Japanese Ukiyo-E prints, with the largest single grouping of prints in the world by Utagawa Hiroshige; the Samuel H. Kress Foundation collection of Italian Renaissance paintings; Hawaiian Collection, chronicling the history of art in Hawaii. **Architecture:** 1927 building by Bertram Goodhue; Luce Pavilion Complex added in 2001.

Branch: The Academy Art Center, 1111 Victoria Street (across the street from the academy), with free exhibitions by local contemporary artists.

Admission: Adults, $7; students, seniors and military, $4; children under 13, free. Free on first Wednesday of the month. **Hours:** Tuesday through Saturday, 10 a.m.–4:30 p.m.; Sunday, 1–5 p.m. Closed Monday, New Year's Day, Independence Day, Thanksgiving and Christmas Day.

Boise Art Museum

670 South Julia Davis Drive, Boise, Idaho 83702
(208) 345-8330
www.boiseartmuseum.org

2002 EXHIBITIONS

Through February 16
Beauty in All Things: Imperial and Folk Treasures of China and Japan
Nearly 100 works that explore rituals and lifestyles.

Through May 5
Larger Than Life: Ceramic Figures by Viola Frey
An installation featuring five large-scale ceramic sculptures.

June 1–August 4
Hung Liu
Large-scale photo-derived paintings that explore human rights issues during China's Cultural Revolution.

Late July–October 13
Pop Art
Works by Jim Dine, Robert Indiana, Ed Kienholz, Roy Lichtenstein, James Rosenquist, Andy Warhol and others.

December 15–March 1, 2003
Gary Hill
A series of new video installations that focus on language and visual perceptions.

PERMANENT COLLECTION

Some 2,000 works focusing on 20th-century American art, especially artists of the Pacific Northwest, American Realism and ceramics. **Architecture:** Expansion in 1997 added 13,500 square feet, including a 2,800-square-foot interior sculpture court and 16 new galleries.

Admission: Adults, $4; college students and seniors, $2; grades K through 12, $1; children under 6 and members, free.
Hours: Tuesday through Friday, 10 a.m.–5 p.m.; Saturday and Sunday, noon–5 p.m. Closed Monday, except June through August.

Illinois

The Art Institute of Chicago

111 South Michigan Avenue, Chicago, Ill. 60603
(312) 443-3600
www.artic.edu

2002 EXHIBITIONS

Through January 13
Van Gogh and Gauguin: The Studio of the South
More than 100 paintings, as well as drawings, sculptures
and ceramic pieces. The exhibition examines the personal
and professional relationship of Vincent van Gogh (1853-
90) and Paul Gauguin (1848-1903). Separate admission
charge.

Through April 21
Sight-Set-Sequence
Approximately 50 photographs from the museum's collection,
including works by Bernd and Hilla Becher, August Sander,
Alfred Stieglitz and Minor White.

Through April 28
The Sidewalk Never Ends: Street Photography Since the 1970's
Images by New Yorkers, including Melanie Einzig, Jeff
Mermelstein and Tom Roma.

Through July 28
*Modern Trains and Splendid Stations: Architecture and Design for
the 21st Century*
Drawings, computer renderings, models and photographs of
new railway stations from around the world, plus an
installation by David Childs, who helped design the new Penn
Station planned for New York City.

February 13–May 27
The Nitty-Gritty of Weave Structure, Part I
Plain-weave examples from the institute's collection, exhibited
so visitors can see the fronts and backs. Also included is an
overview of the most frequently used weaves, in anticipation of
additional exhibitions in the series.

February 16–June 1
Animals, Mortals and Immortals in Indian Paintings
Paintings of animals which, in Indian art, have long been associated with the rulers of the heavens and the earth.

February 23–June 2
Ansel Adams at 100
More than 110 photographs, drawn largely from the first part of the artist's career, including "Monolith, the Face of Half Dome" (1927), "Moonrise, Hernandez, New Mexico" (1941) and lesser-known images. (Travels)

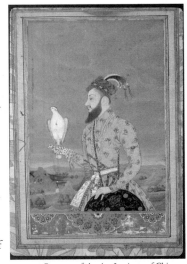

Courtesy of the Art Institute of Chicago. India, Himachal Pradesh, Kangra, *Ganesh with Women Attendants*, ca. 1800.

March 2–May 12
Taken by Design: Photographs From the Institute of Design, 1937–1971
More than 200 images by faculty and students, including Harry Callahan, László Moholy-Nagy, Art Sinsabaugh and Aaron Siskind.

June 15–September 22
German Art and Its Revival
Prints, drawings and other works by Georg Baselitz, Anselm Kiefer, Max Klinger, Käthe Kollwitz, Ludwig Meidner, Sigmar Polke, Philip Otto Runge and others.

June 22–September 15
Gerhard Richter: Forty Years of Painting
Nearly 200 of the German artist's paintings, prints, drawings and photographs, from the 1960's to the present. (Travels)

July 3–November 3
Fukusa and Furoshiki: A Gift of Splendid Japanese Gift Covers
Japanese textiles, especially gift covers (*fukusa*) and wrapping covers (*furoshiki*) made since 1750.

Chicago

September 14–December 8
Juan Muñoz
Approximately 60 works created by the Spanish sculptor since the mid-1980's. (Travels)

November 9–February 2, 2003
The Medici, Michelangelo and the Art of Late Renaissance Florence
Some 180 works, including paintings, sculpture, graphics, porcelain, tapestries and costumes, made between 1537 and 1631. Featured are Michelangelo sculptures, Pontormo paintings and items never before exhibited outside of Florence.

October 4–February 15, 2003
African Artistry: Gifts From the Richard and Barbara Faletti Family Collection
Including a terra-cotta commemorative head from the court of Benin, in present-day Nigeria; an Asante linguist staff covered in gold leaf, from Ghana; and an abstract, geometrically patterned Bwa mask, from Burkina Faso.

November 23–April 20, 2003
David Adler: The American Country House
Plans and drawings by the American architect (1882-1949), plus images newly realized by the Chicago architectural photography firm of Hedrich-Blessing.

December 4–April 6, 2003
Renaissance Velvets and Silks
Vestments, altar frontals and smaller textiles that would have been fashioned into expensive garments, featuring patterns and designs familiar through Renaissance paintings.

PERMANENT COLLECTION

A collection spanning 50 centuries includes everything from ancient Chinese bronzes to African wood carvings, textiles and photographs. Noteworthy are an acclaimed collection of Impressionist and Post-Impressionist paintings, an extensive collection of 20th-century European and American art and the Thorne Miniature Rooms. **Highlights:** Georges Seurat, *Sunday on La Grande Jatte;* Edward Hopper, *Nighthawks*; Grant Wood, *American Gothic.*

Admission: Suggested donation: adults, $10; children, students and seniors, $6. Free on Tuesday, except for certain special exhibitions.

Hours: Monday through Friday, 10:30 a.m.–4:30 p.m.; Tuesday, until 8 p.m.; Saturday and Sunday, 10 a.m.–5 p.m. Closed Thanksgiving and Christmas Day.

Museum of Contemporary Art

220 East Chicago Avenue, Chicago, Ill. 60611
(312) 280-2660
www.mcachicago.org

2002 EXHIBITIONS

Through January 20
William Kentridge
A dozen short animated films, the majority of which chronicle the ongoing narrative of two characters struggling with apartheid and its aftermath. Also: about 50 large-scale drawings, many used in the films' creation. (Travels)

Through May 12
Out of Place: Contemporary Art and the Architectural Uncanny
Works by 12 artists using various media to make familiar interior and exterior spaces appear strange and unsettling.

February 16–May 26
Mies in America
Drawings, scale models, photographs and a series of works by contemporary video artists and photographers inspired by the architect Ludwig Mies van der Rohe's use of texture, light, repetition, reflection and movement.

February 16–May 26
Gary Simmons
Drawings and sculptures that deal with black identity and imagery. The art was inspired by American pop culture, ranging from cartoons to architecture.

May 26–October 20
Donald Moffett: What Barbara Jordan Wore
Paintings and an audio installation inspired by Jordan, a congresswoman, lawyer and educator.

June 22–September 22
Andreas Gursky
Large, color, digitally altered photographs.

July 13–October 20
Matta in America: Paintings and Drawings of the 1940's
More than three dozen works by the Chilean-born artist.

October 12–January 17, 2003
Gillian Wearing
Video installations the British artist has created since 1992.

October 12–January 24, 2003
John Currin
Approximately 30 paintings, taken mostly from several series
produced in the past five years.

PERMANENT COLLECTION

Painting, sculpture, photography, video, film and performance
art created since 1945, including Minimalism, post-Minimal-
ism, Conceptualism and Surrealism as well as works by
Chicago-based artists.

Admission: Adults, $10; students and seniors, $6.50; mem-
bers and children 12 and under, free. Free on Tuesday.
Hours: Tuesday, 10 a.m.–8 p.m.; Wednesday through Sunday,
10 a.m.–5 p.m. Closed Monday, New Year's Day, Thanksgiv-
ing and Christmas Day.

Terra Museum of American Art

664 North Michigan Avenue, Chicago, Ill. 60611
(312) 664-3939
www.terramuseum.org

2002 EXHIBITIONS

Through February 3
Frederick Carl Frieseke: The Evolution of an American Impressionist

About 70 works, including oils, watercolors and sketches, representing all three periods of the artist's career.

May 11–July 20
Impressionism Transformed: The Paintings of Edmund C. Tarbell
Paintings by this turn-of-the-century artist working in Boston who figured prominently in American Impressionism. (Travels)

August 10–October 20
Young America: Treasures From the Smithsonian American Art Museum
Works from the 1770's to the 1860's, including portraits by John Singleton Copley, landscapes by Thomas Cole and sculptures by Hiram Power. (Travels)

PERMANENT COLLECTION

Founded by Daniel J. Terra in 1980, the museum offers works by Mary Cassatt, Winslow Homer, Maurice Brazil Prendergast, John Singer Sargent, James A. McNeill Whistler and others.

Admission: Adults, $7; seniors, $3.50; educators, students with ID, veterans and children, free. Free on Tuesday and first Sunday of every month.
Hours: Tuesday through Saturday, 10 a.m.–6 p.m.; Tuesday, until 8 p.m.; Sunday, noon–5 p.m. Closed Monday.

Indianapolis Museum of Art

1200 West 38th Street, Indianapolis, Ind. 46208
(317) 923-1331; (317) 920-2660 (recording)
www.ima-art.org

2002 EXHIBITIONS

Through January 13
Gifts to the Tsars, 1500-1700: Treasures From the Kremlin
Gold, silver and silver-gilt objects; jewels; precious textiles; parade arms and armor; and ceremonial horse trappings. Includes items never before exhibited outside of Russia.

Indianapolis

March 24–August 18
The Fabric of Moroccan Life
More than 150 embroideries, hangings and rugs, featuring bright colors and geometric and floral designs.

October 13–January 19, 2003
Making Madonnas: Giovanni Bellini and the Art of Devotion
Twenty works featuring "Madonna and Child." The exhibition examines the production of replicas in Renaissance workshops and investigates new evidence about art — invisible to the naked eye — revealed in diagnostic images.

Courtesy of the Indianapolis Museum of Art.
Ait Ouaouzguite, *saddle rug*, early 20th century.

PERMANENT COLLECTION

American, African, Asian, European, contemporary and decorative art. **Highlights:** J.M.W. Turner Collection of watercolors and drawings; Gauguin and the School of Pont-Aven; neo-Impressionists; Japanese Edo period paintings; Clowes Collection of Old Master works.

Admission: Free; suggested donation for special exhibitions.
Hours: Tuesday through Saturday, 10 a.m.–5 p.m.; Thursday, until 8:30 p.m.; Sunday, noon–5 p.m. Closed Monday and major holidays.

Davenport Museum of Art

1737 West 12th Street, Davenport, Iowa 52804
(563) 326-7804
www.art-dma.org

2002 EXHIBITIONS

Through January 27
The Photography of Alfred Stieglitz: Georgia O'Keeffe's Enduring Gift
Photographs that O'Keeffe donated to the George Eastman
House, exhibited for the first time beyond its walls.

February 16–March 31
Devotion and the Sacred
Works from the museum's collection, including illuminated
manuscript pages from the 15th century and religious
paintings and prints from the 16th, 17th and 18th centuries,
made in Europe and colonial Mexico.

April 20–June 30
Old West, New West
Works by Frederick Remington and contemporaries are
contrasted with works by contemporary artists.

August 10–November 3
Defining Craft
More than 150 examples by artists whose work with glass,
clay, metal, fiber and wood has helped shape the history of
craft during the past 50 years.

November 23–January 4, 2003
Migration of the Spirit
Four installations, consisting of paintings and sculpture, by a
Haitian-born artist, Edouard Duval-Carrié. Includes *Endless
Flight*, a new work.

PERMANENT COLLECTION

Regional, national and international art from the 15th century
to the present. Works by Grant Wood; one of the largest col-
lections of Mexican Colonial art and Haitian art.

Admission: Free.
Hours: Tuesday through Saturday, 10 a.m.–4:30 p.m.; Thurs-
day, until 8 p.m.; Sunday, 1–4:30 p.m.

Des Moines Art Center

4700 Grand Avenue, Des Moines, Iowa 50312
(515) 277-4405
www.desmoinesartcenter.org

2002 EXHIBITIONS

Through January 13
Apocalypse: Visions and Prophecies of the End of Time
Prints by Albrecht Dürer, Hans Holbein, Odilon Redon and
others, spanning five centuries.

Through February
Anna Gaskell
New large-scale color photographs and a video installation by
the Des Moines native.

February 9–April 21
Andy Goldsworthy: Three Cairns
Photographs and ephemeral and permanent sculptures made
with stone and other natural materials.

March–May
Lee Mingwei
An interactive project by the Taiwanese artist.

May 4–June 30
*Modernism and Abstraction: Treasures From the Smithsonian
American Art Museum*

July–October
Iowa Artists 2002

Opening in November
Magic Markers: Contemporary Constructed Objects
Works by Robert Gober, David Hammons, Robert
Rauschenberg, Richard Tuttle and others, including Indian,
Asian, African and aboriginal artists.

PERMANENT COLLECTION

Paintings and sculptures by Bacon, Brancusi, Cassatt, Dubuf-
fet, Johns, Koons, Moore, Rodin, Oldenburg, Serra and Stella.
Architecture: Three interconnected buildings designed by
Eliel Saarinen, I. M. Pei and Richard Meier.

Admission: Free.

Hours: Tuesday through Saturday, 11 a.m.–4 p.m.; Thursday, until 9 p.m.; first Friday of each month, until 9 p.m.; Sunday, noon–4 p.m. Closed Monday.

The Spencer Museum of Art

University of Kansas, 1301 Mississippi Street, Lawrence, Kan. 66045
(785) 864-4710
www.ukans.edu/~sma

2002 EXHIBITIONS

Through February 24
Shinoda Toko and Kwang Jean Park
Contemporary works by the two women.

January 19–March 10
Shouts From the Wall
Posters and black-and-white photographs brought home by American volunteers who fought on the Republican side of the Spanish Civil War.

February 2–10
Tim Rollins/KOS and Lawrence Celebrates Langston Hughes
Rollins collaborates with middle-school students to produce a work based on Hughes' writings. Part of the community-wide celebration of the 100th anniversary of Hughes's birth. The resulting art remains on display through May.

March 9–May 19
Contemporary Ceramics
Asian, European and American examples.

March 30–May 19
Goltzius and the Third Dimension
The exhibition of 33 prints and four bronze statuettes explores the relationship between the sculpture of Willem Danielsz van Tetrode (ca.1525–1580) and the engravings and woodcuts of Hendrick Goltzius (1558–1617).

Mid-April–June
Amish Quilts, 1800 to 1940

Nearly three dozen quilts from the collection of Faith and Stephen Brown, including examples made in Pennsylvania, Indiana, Ohio and Kansas.

September 21–November 17
Milk and Eggs: The American Revival of Tempera Painting, 1930–1950
Works by Thomas Hart Benton, John Steuart Curry, Andrew Wyeth and others.

December 17–March 15, 2003
Innovation/Imagination: Fifty Years of Polaroid Photography
Works by Ansel Adams, David Hockney, Helmut Newton, Minor White, Joel-Peter Witkin and others.

PERMANENT COLLECTION

American and European painting and sculpture; Edo period (1615–1868) Japanese paintings; Korean ceramics; Japanese prints; contemporary Chinese painting. **Highlights:** Homer, *Cloud Shadows*; Kandinsky, *Kleine Welten VI*; Rossetti, *La Pia de'Tolommei;* Fragonard, *Portrait of a Young Boy*; Benton, *The Ballad of the Jealous Lover of Lone Green Valley.*

Admission: Free; $3 donation suggested.
Hours: Tuesday through Saturday, 10 a.m.–5 p.m.; Thursday, until 9 p.m.; Sunday, noon–5 p.m. Closed Monday, New Year's Day, Independence Day, Thanksgiving and Christmas Day.

The Wichita Art Museum

619 Stackman Drive, Wichita, Kan. 67203
(316) 268-4921
www.wichitaartmuseum.org

The museum is closed for a major expansion project, expected to be completed by early 2003.

PERMANENT COLLECTION

American art from Colonial times to the present. *An American Homecoming,* an exhibition from the collection, presents 130 works in nine thematic sections, including pieces by Copley, Eakins, Remington, O'Keeffe and Nevelson. **Highlights:**

Edward Hopper, *Sunlight on Brownstones;* Mary Cassatt, *Mother and Child;* Winslow Homer, *In the Mowing*; Arthur Dove, *Noon;* the John W. and Mildred L. Graves Collection of American Impressionism; the M. C. Naftzger Collection of works by Charles M. Russell. **Architecture:** Designed by Edward Larrabee Barnes in 1977.

Admission: Free.
Hours: Tuesday through Saturday, 10 a.m.–5 p.m.; Sunday, noon–5 p.m. Closed Monday.

The University of Kentucky Art Museum

Rose Street and Euclid Avenue, Lexington, Ky. 40506
(859) 257-5716
www.uky.edu/ArtMuseum

2002 EXHIBITIONS

Through January 27
Springfed Pond: A Friendship With Five Kentucky Writers
Photographs by James Baker Hall, Kentucky's Poet Laureate, chronicling his friendships with Kentucky authors and poets.

January 20–March 10
American Impressionism, 1885–1945
Oil, watercolor and pastel works by John Joseph Enneking, Adele Williams, Louis Kronberg and others, including landscapes, portraits and still lives. (Travels)

February 17–May 5
Ann Stewart Anderson: Mythic Women
The Kentucky artist celebrates women.

March 31–June 23
Robert James Foose
A retrospective of the University of Kentucky art professor's 40-year career, featuring watercolors and oils.

May 26–August 18
Cole Carothers
Works by the Kentucky-born painter.

145

PERMANENT COLLECTION

Nineteenth- and 20th-century European and American painting and sculpture; Old Master paintings and prints, particularly Italian Baroque works; photography; prints from the 1980's; decorative arts; W.P.A./F.A.P. paintings and works on paper; regional art; and art of Asia, Africa and the Americas. **Highlights:** American Impressionist and Pont-Aven school painters; Proskauer bequest art glass.

Admission: Free.
Hours: Tuesday through Sunday, noon–5 p.m.; Friday, until 8 p.m. Closed Monday and university holidays.

The Speed Art Museum

2035 South Third Street, Louisville, Ky. 40208
(502) 634-2700
www.speedmuseum.org

2002 EXHIBITIONS

Through January 27
A Brush with History: Paintings From the Collection of the National Portrait Gallery
Portraits of American statesmen, artists, inventors, writers, educators and scientists, from the 18th century to the present. (Travels)

February 9–April 14
A Bountiful Plenty From the Shelburne Museum: Folk Art Traditions in America
Trade signs, cigar-store figures, carousel animals, weather vanes, ships' carvings, scrimshaw, decoys, quilts, furniture, and primitive paintings from the 18th and 19th centuries. The exhibition explores folk art's role in modern American art's development. (Travels)

March 16–May 12
Masterworks From the Albertina
Drawings and prints from the Albertina in Vienna, Austria, including works from the High Renaissance through Rococo periods. (Travels)

Courtesy of the Speed Art Museum.

Paul Cézanne, *Two Apples on a Table*, 1895-1900.

November 5–February 2, 2003
Millet to Matisse: 19th- and 20th-Century French Painting From the Kelvingrove Art Gallery, Glasgow, Scotland
Works from the Impressionist, Post-Impressionist and Modern periods by Monet, Renoir, van Gogh, Picasso and others.

PERMANENT COLLECTION

More than 8,000 pieces spanning 6,000 years, ranging from ancient Egyptian to contemporary art. Includes 17th-century Dutch and Flemish painting; 18th-century French art; Renaissance and Baroque tapestries; African and Native American works.

Admission: Free.
Hours: Tuesday through Friday, 10:30 a.m.–4 p.m.; Thursday, until 8 p.m.; Saturday, 10:30 a.m.–5 p.m.; Sunday, noon–5 p.m. Closed Monday.

New Orleans Museum of Art

City Park, 1 Collins Diboll Circle, New Orleans, La.
 70179
(504) 488-2631
www.noma.org

2002 EXHIBITIONS

Through January 13
Magnificent, Marvelous Martelé: American Art Nouveau Silver
More than 300 works from the collection of Louisianians
Robert and Jolie Shelton. (Travels)

Through April 14
Matsmura Goshun and His Followers

January 19–March 31
Soldiers' Snapshots: Personal Perspectives on Vietnam

February 16–April 28
The Sport of Life and Death: The Mesoamerican Ballgame
More than 150 objects, most never before exhibited in the
United States, showcasing what is said to be the world's first
team sport, played with a rubber ball in elaborate masonry
courts by the Aztecs and earlier civilizations. (Travels)

April 6–June 23
Southern Graphics Council Printmakers Emeritus, 1978–2002
Sixty prints.

May 6–August 20
Seasonal Celebrations and Observances in Japanese Painting
Paintings from the museum's collection, depicting cherry
blossoms in spring, maple leaves in autumn, New Year's
festivities and other seasonal celebrations observed in Edo-
period Japan (1615–1868).

June 1–August 11
*A Brush with History: Paintings From the National Portrait
Gallery*
Portraits by Edgar Degas, Thomas Eakins and others,
featuring Benjamin Franklin and other historical figures.

July 6–September 29
From Another Dimension: Works on Paper by Sculptors
Sixty works, by Louise Bourgeois, Alberto Giacometti, Marino
Marini, Henry Moore, Claes Oldenburg, David Smith and

other 20th-century American and European sculptors, including drawings, watercolors and prints.

August 31–October 26
An Enduring Vision: Japanese Painting From the Manyo'an Collection
More than 140 works, including calligraphy, from the 17th century to the 20th.

August 31–October 26
Highlights From the Japanese Painting Collection

November 10–January 12, 2003
Working on a Building: New Orleans Building Arts Through the Generations
An interactive exhibition exploring the idea of the city as an art object and investigating historic preservation projects in non-affluent neighborhoods.

Courtesy of the New Orleans Museum of Art.
Nakahara Nantembo, *Half-Body Daruma*, 1917.

PERMANENT COLLECTION

European painting and sculpture from 16th century to present; American painting and sculpture from 18th century to present; European and American decorative arts, including the nation's sixth-largest collection of glass; Asian art, particularly Japanese painting from the Edo period (1615–1868); ethnographic art, including African, Oceanic, pre-Columbian and Native American photography. **Highlights:** Degas, *Portrait of Estelle Muson Degas*; works by other Impressionists, including Monet, Renoir and Cassatt; Fabergé Imperial Easter eggs and the bejeweled Imperial Lilies of the Valley Basket; Vigée-Lebrun, *Marie Antoinette, Queen of France*. **Architecture:** 1911 Beaux-Arts structure by Samuel Marx in a 1,500-acre city park.

Admission: Adults, $6; seniors, $5; ages 3–17, $3.
Hours: Tuesday through Sunday, 10 a.m.–5 p.m. Closed Monday and legal holidays.

Bowdoin College Museum of Art

9400 College Station, Brunswick, Me. 04011
(207) 725-3275
www.academic.bowdoin.edu/artmuseum

2002 EXHIBITIONS

Through January 13
Modernism and the Nude
Explores the role of the female nude in the development of
Modernism between 1860 and the 1920's.

Through January 20
In Extremis: Four Centuries of Violence and Death
Representations of violence and death in painting, sculpture
and works on paper from the permanent collection.

January 22–April 7
*Images for the Afterlife: Olmec, West Mexican and Mayan
Sculpture*
Ceramic funerary figures from ancient Mexican cultures,
including the shaman, warrior and ritual dancer.

Continuing
Asian Art From the Permanent Collection
Includes decorative arts spanning many centuries and cultures.

Continuing
Portraits From the Permanent Collection
American portraiture from the 18th to early 20th century,
including works by Stuart, Sargent and Eakins.

Continuing
European Art From the Permanent Collection
Includes Italian Renaissance works, as well as decorative arts
and small sculptures.

Continuing
*Art and Life in the Ancient Mediterranean From the Permanent
Collection*
Works from the 4th millennium B.C. to the 4th century
A.D., including Assyrian, Egyptian, Cypriot, Greek and
Roman objects in marble, terra cotta, bronze, stone, ivory and
glass.

PERMANENT COLLECTION

Portraits by Gilbert Stuart, Robert Feke and others; American landscape paintings; antiquities from the Mediterranean; European paintings; works on paper. **Architecture:** 1894 building by McKim, Mead and White.

Admission: Free.
Hours: Tuesday through Saturday, 10 a.m.–5 p.m.; Sunday, 2–5 p.m. Closed Monday and national holidays. The museum building will be closing in the summer of 2002 for renovations, but selected programs will continue.

Portland Museum of Art

7 Congress Square, Portland, Me. 04101
(207) 775-6148; (207) 773–ARTS (recording); (800) 639-4067
www.portlandmuseum.org

2002 EXHIBITIONS

Through January 6
Harmonies and Contrasts: The Art of Marguerite and William Zorach
Paintings and sculpture, including the couple's early experiments and later works. The exhibition spotlights their exchange of ideas and the vision they shared of art expressing the beauty they found in nature and in family life.

Through January 27
Dahlov Ipcar
A retrospective of the artist's work, spanning the 1930's to the present, including oils, watercolors, illustrations, prints and soft sculptures. Ipcar is the daughter of the artists Marguerite and William Zorach.

January 5–February 24
Open House: Tanja Alexia Hollander
New photographs that give visitors a sense of the museum's behind-the-scenes restoration process.

January 24–March 24
Robert Doisneau's Paris

Courtesy of the Portland Museum of Art.

Dahlov Ipcar, *Blue Savanna*, 1978.

More than 100 photographs taken in and around Paris by Doisneau (1912–1944).

April 11–June 9
Bernard Langlais
More than 60 sculptures by the Maine artist, charting his development from the late 1950's to his death in 1977.

June 27–October 20
Neo-Impressionism: Artists on the Edge
Works by Henri-Edmond Cross, Georges Seurat, Paul Signac and others.

PERMANENT COLLECTION

Decorative and fine arts from the 18th century to the present. Includes the Joan Whitney Payson Collection, with works by Degas, Monet, Picasso, Renoir and others, and the American Galleries, with works by Hartley, Homer and Wyeth. **Architecture:** Built in 1983 and designed by Henry N. Cobb of I. M. Pei & Partners.

Admission: Adults, $6; seniors and students, $5; children 6–12, $1; children under 6, free. Free on Friday, 5–9 p.m.
Hours: Tuesday through Sunday, 10 a.m.–5 p.m.; Thursday and Friday, until 9 p.m.; Monday from Memorial Day through Columbus Day, 10 a.m.–5 p.m.

Farnsworth Art Museum

16 Museum Street, Rockland, Me. 04843
(207) 596-6457
www.farnsworthmuseum.org

2002 EXHIBITIONS

Through February 24
Characters in Hand: Puppets by Maine Puppeteers
Whimsical and traditional examples by Ashley Bryan, Nancy
Nye, Frances Silenzi and others.

Through February 24
Samuel Gelber: The Seasons Suite
A series of large-scale paintings that portray the landscape
surrounding the artist's Maine farmhouse.

Through May 19
Andrew Wyeth Selections
Tempera paintings, watercolors and drawings.

March 3–June 2
Recent Work by Celeste Roberge, Alison Hildreth and John von Bergen
Sculpture and mixed-media paintings that draw upon nature
for inspiration.

Continuing
Maine in America
Selections from the museum's collection.

Continuing
Louise Nevelson
Works from the museum's collection, including rarely seen
early paintings, drawings and sculpture as well as examples of
her more familiar mature style.

Continuing
N.C. Wyeth in Maine
Landscapes and seascapes the painter created during his 25
summers in the Pine Tree State.

PERMANENT COLLECTION

Works by Stuart, Sully, Eakins, Lane, Eastman Johnson;
American Impressionists, including Benson, Hassam, Pren-
dergast and Twachtman; works by N. C., Andrew and Jamie
Wyeth in the Wyeth Center; a large collection of works by

Louise Nevelson on view in the Nevelson-Berliawsky Gallery.
Architecture: The museum complex includes the adjacent
Farnsworth family homestead, a preserved 19th-century Vic-
torian residence, and the historic Olson House in nearby
Cushing.

Admission: Adults, $9; seniors, $8; students, $5; children
under 17 and Rockland residents, free. There is a $1 discount
for all during the winter. There is an additional charge for the
Olson House.
Hours: Museum and Wyeth Center, daily, 9 a.m.–5 p.m.
Homestead, daily, 10 a.m.–noon and 1–4 p.m. Olson House,
daily, 11 a.m.–4 p.m. During the winter, the museum and
Wyeth Center have shortened hours and the homestead and
Olson House are closed.

American Visionary Art Museum

800 Key Highway, Baltimore, Md. 21230
(410) 244-1900
www.avam.org

2002 Exhibitions
Through September
The Art of War & Peace
Multicultural exhibition featuring clothing, shrines and illus-
trated diaries created by soldiers and civilians.

Permanent Collection

Giant Whirligig, a large outdoor sculpture at the Central Plaza
by Vollis Simpson, a 76-year-old mechanic, farmer and vision-
ary artist.

Admission: Adults, $6; seniors and students, $4; children
under 4, free.
Hours: Tuesday through Sunday, 10 a.m.–6 p.m. Closed
Monday, Thanksgiving and Christmas Day.

The Baltimore Museum of Art

10 Art Museum Drive, Baltimore, Md. 21218
(410) 396-7100
www.artbma.org

2002 EXHIBITIONS

Through February 3
Picasso: Classicism
Rarely seen drawings from a period when Picasso was inspired
by classical subjects.

February 6–May 5
Looking Forward/Looking Black
Explores the changing depictions of African-Americans in
20th-century art through photographs, paintings and collages.

February 17–May 26
*Reflections of Sea and Light: Paintings and Watercolors by J.M.W.
Turner*
More than 100 watercolors, paintings and prints from the Tate
Museum in London.

October 2–January 5, 2003
Northern Renaissance Painted Prints
First extensive exhibition of hand-colored prints from the
Renaissance and Baroque periods. (Travels)

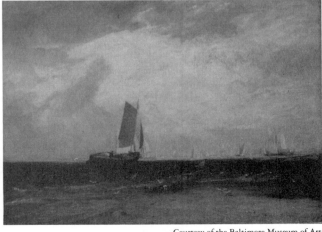

Courtesy of the Baltimore Museum of Art.
J.M.W. Turner, *Fishing Upon the Blythe Sound, Tide Setting In.*

PERMANENT COLLECTION

More than 85,000 objects, ranging from ancient mosaics to contemporary art. The Cone Collection of Modern Art features 500 works by Matisse and major examples by Picasso, Cézanne, van Gogh, Renoir and others; West Wing for Contemporary Art; American and European decorative arts; pre-Columbian, American Indian, African and Asian art; textiles; prints, drawings and photographs; American and European painting and sculpture. **Architecture:** 1929 building and 1937 addition by John Russell Pope; two outdoor sculpture gardens; 1994 West Wing by Bower Lewis Thrower.

Admission: Adults, $7; seniors and students, $5; members and ages 18 and under, free. First Thursday of each month, free. **Hours:** Wednesday through Friday, 11 a.m.–5 p.m.; Saturday and Sunday, 11 a.m.–6 p.m.; first Thursday of every month, until 9 p.m. Closed Monday and Tuesday, New Year's Day, Independence Day, Thanksgiving and Christmas Day.

The Walters Art Museum

600 North Charles Street, Baltimore, Md. 21201
(410) 547-9000
www.thewalters.org

2002 EXHIBITIONS

Continuing
Wondrous Journeys: The Walters Collection From Egyptian Tombs to Medieval Castles
Works reflecting the customs, beliefs and daily lives of ancient and medieval civilizations.

Through January 13
Desire and Devotion: Art From India, Nepal and Tibet in the John and Berthe Ford Collection
About 150 works from one of the most important holdings of Indian and Himalayan art in the world.

Through January 20
Expanding World Views: A Millennium of Maps
Selection of rare and seldom-seen maps.

Through June
Facing Museums
In collaboration with the Contemporary Museum, installations on the outer wall of the Walters by Dennis Adams and Isaac Julien.

February 17–May 26
The Age of Impressionism: European Masterpieces From Ordrupgaard, Copenhagen
Nearly 70 paintings by Corot, Cézanne, Degas, Delacroix, Gauguin, Manet, Monet, Pisarro, Renoir, Rousseau and others.

Opening in April
Reopening of the 19th-Century Galleries
After years of traveling, the Walters's 19th-century art collection returns to newly renovated galleries.

October 13–January 5, 2003
Sacred Images, Holy Wars: The Bible of Saint Louis of France
Focuses on the Crusader Bible of the 13th century, which is unbound and can be viewed in its entirety.

Continuing
Japanese Print Exhibitions
Rotating exhibitions of Japanese prints from the museum's collections, many of them inspired by Kabuki plays.

PERMANENT COLLECTION

Collection spanning 55 centuries, from ancient Egyptian art through 19th-century European art. Ancient and medieval art, manuscripts and rare books, decorative objects, Asian art, Old Master and 19th-century paintings.

Admission: Adults, $8; senior citizens, $6; ages 18–25, $5; ages 17 and under, free.
Hours: Tuesday through Sunday, 10 a.m.–5 p.m. Closed Monday.

Massachusetts

Addison Gallery of American Art

Phillips Academy, Andover, Mass. 01810
(978) 749-4015
www.addisongallery.org

2002 Exhibitions

Through January 7
Do It
Works created by students and community members, following artists' instructions.

January–March
Anna Gaskell: Artist in Residence Project
A photographic installation featuring surrealistic images of female students in a high school biology laboratory.

January 20–April 1
Eye of the World: Miniature and Microcosm in the Art of the Self-Taught
Contemporary works by artists who explore alternate worlds.

January 20–March 14
Maurice Prendergast: Learning to Look
Sixty works by the American Post-Impressionist (1848-1924).

Opening in Spring
SiteLines
A series of temporary outdoor sculpture projects created by artists working with local high school students.

May 4–July 31
Louis Faurer Retrospective
Fashion images and street photography.

Permanent Collection

More than 12,000 works, including pieces by Stuart, Copley, Eakins, Homer, Whistler, Sargent, Twatchman, O'Keeffe and Stella, as well as extensive photographic holdings.

Admission: Free.
Hours: Tuesday through Saturday, 10 a.m.–5 p.m.; Sunday, 1–5 p.m. Closed Monday, federal holidays and the month of August.

The Institute of Contemporary Art

955 Boylston Street, Boston, Mass. 02115
(617) 266-5152
www.icaboston.org

2002 EXHIBITIONS

January 23–April 7
Chic Clicks: Creativity and Commerce in Contemporary Fashion Photography
Explores the creative and commercial aspects of fashion photography through the works of nearly 30 photographers from the United States and Europe. (Travels)

April 24–June 30
Building, Artists Address Architecture
Works by contemporary artists whose work blurs the boundaries between sculpture and architectural models.

October 16–January 5, 2003
Art and Healing: Ritual and Transformation
Works exploring the role of ritual, narrative, metaphor and movement to promote healing.

PERMANENT COLLECTION

None. For more than 65 years the ICA has presented exhibitions by national and international contemporary artists.

Admission: Adults, $6; seniors and students, $4; children under 12, free. Free on Thursday after 5 p.m.
Hours: Wednesday and Friday, noon–5 p.m.; Thursday, noon–9 p.m.; Saturday and Sunday, 11 a.m.–5 p.m. Closed Monday, Tuesday and all major holidays.

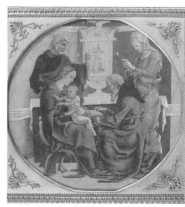

Cosmè Tura,
The Circumcision, ca. 1470.

Courtesy of the Isabella Stewart Gardner Museum.

Isabella Stewart Gardner Museum

280 The Fenway, Boston, Mass. 02115
(617) 566-1401
www.gardnermuseum.org

2002 EXHIBITIONS

January 30–May 12
Cosmè Tura and Ferrara: A Forgotten Renaissance
Paintings, tapestries, drawings, manuscript illuminations and
medals by Tura, a Renaissance artist at the court of Ferrara.

May
Community Creations
Annual exhibition by students and teachers from six Boston-
area programs.

May–September
Manfred Bischoff
Miniature sculptures by the jewelry artist, who works with
gold, silver and coral and occasionally jade and diamonds.

September–January 2003
Contemporary Exhibition

PERMANENT COLLECTION

Three thousand objects spanning 30 centuries and representing
many cultures. Works by Titian, Botticelli, Raphael, Rem-

brandt, Degas, Matisse, Sargent and Whistler. **Highlights:**
Titian, *Europa*; Botticelli, *Madonna and Child of the Eucharist*
and *Tragedy of Lucretia*; Giotto, *Presentation of the Child Jesus at
the Temple*; Raphael, *Pietà*; a 1629 Rembrandt self-portrait.
Architecture: Built from 1899 to 1902 in the style of a 15th-
century Venetian palace, the museum centers on an interior
courtyard filled with sculpture and flowering plants and trees.

Admission: Adults, $10 ($11 on weekends); seniors, $7;
college students, $5; members and children under 18, free.
Hours: Tuesday through Sunday, 11 a.m.–5 p.m. Closed
Monday, Thanksgiving Day and Christmas Day.

 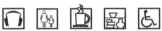

Museum of Fine Arts, Boston

Avenue of the Arts, 465 Huntington Avenue, Boston,
 Mass. 02115
(617) 267-9300
www.mfa.org

2002 EXHIBITIONS

Through January 6
The Look: Photographs by Horst and Hoyningen-Huene
Celebrity portraits and other works by the fashion photographer
Horst P. Horst and his mentor, George Hoyningen-Huene.

Through January 21
Sophie Ristelhueber: Details of the World
Focusing on the artist's
attention to landscape as a
manifestation of memory,
with images of areas reeling
from recent conflict, including
wars in Beirut and Kuwait.

Through March 10
*Netsuke: Fantasy and Reality in
Japanese Miniature Sculpture*
Approximately 350
intricately carved netsuke,
which were used during the

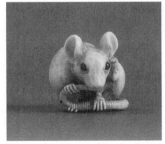

Courtesy of the Museum of Fine Arts Boston.
Masanao of Kyoto, *Rat Licking His
Tail*, ca. 1781.

Edo period (1615–1868) as toggles that helped secure purses suspended from kimonos.

Through January 21
Poetry of the Loom: Persian Textiles in the MFA
Some 40 Persian textiles, from the sixth century to the 20th, including silks, velvets, embroideries, painted cottons, woven rugs and costumes.

January 23–April 28
From Paris to Provincetown: Blanche Lazzell and the Color Woodcut
More than 130 prints.

February 17–June 9
Impressionist Still Life
Works by Basil, Caillebotte, Cassatt, Cézanne, Courbet, Degas, Fantin-Latour, Gauguin, van Gogh, Manet, Monet, Morisot, Pissarro, Renoir and Sisley. (Travels)

June 12–September 22
The Poetry of Everyday Life: Dutch Paintings in Boston Collections
Landscapes, cityscapes, seascapes, church interiors, portraits and animal paintings by 17th-century Dutch artists.

July 21–October 20
Jasper Johns to Jeff Koons: Four Decades of Art From the Broad Collections
Works by Andy Warhol, Jasper Johns, Cy Twombly, Ed Ruscha, Roy Lichtenstein and others. (Travels)

October 23–January 2, 2003
Charles Sheeler: Objective Before the Rest
Works by the photographer (1883–1965), including a short film he made with Paul Strand. (Travels)

PERMANENT COLLECTION

Some 350,000 items, including Egyptian and Classical works; Asian and Islamic art, including Chinese export porcelain; Peruvian and Coptic tiles; French and Flemish tapestries; European and American paintings and decorative arts; English and French silver; costumes; prints and drawings; ancient musical instruments; photographs. **Highlights:** *Bust of Prince Ankh-haf; Minoan Snake Goddess; Greek Head of Aphrodite;* Cassatt, *Five o'Clock Tea;* Monet, *Haystack* series; O'Keeffe, *White Rose With Larkspur No. 2*; Picasso, *Rape of the Sabine Women;* Renoir, *Le Bal à Bougival;* Sargent, *The Daughters of Edward D. Boit;* Turner, *The Slave Ship;* Warhol, *Red Disaster*. **Architec-**

ture: 1909 building by Guy Lowell; 1915 Evans Wing; 1928 White Wing by Stubbins; 1981 West Wing by I. M. Pei. The museum has a branch in Nagoya, Japan.

Admission: Adults, $12; seniors and college students, $10; 17 and under, free (except during school hours, when admission is $5 until 3 p.m.); members, free; Thursday and Friday after 5 p.m., $2 discount; Wednesday after 4 p.m., admission by voluntary contribution. Additional fees for some shows.
Hours: Monday through Friday, 10 a.m.–4:45 p.m. (Thursday and Friday after 5 p.m., only the West Wing is open); Saturday and Sunday, 10 a.m.–5:45 p.m. Closed Thanksgiving and Christmas Day.

Harvard University Art Museums

(617) 495-9400
www.artmuseums.harvard.edu

Fogg Art Museum
Busch-Reisinger Museum

32 Quincy Street, Cambridge, Mass. 02138

Arthur M. Sackler Museum

485 Broadway, Cambridge, Mass. 02138

2002 EXHIBITIONS

Through January 27 (Sackler)
Richard Neutra's Windshield House
Drawings, renderings, photographs and a model of the only signficant house Neutra built on the East Coast. (Travels)

Through April 7 (Sert Gallery, Carpenter Center, Fogg)
Extreme Connoisseurship
Works by Bruce Nauman, Bridget Riley, David Hammons, Gabriel Orozco, Donald Judd and others.

Through March 17 (Fogg)
Calming the Tempest With Peter Paul Rubens
Explores an oil sketch in the Fogg's collection by the Baroque master.

May 18–September 1 (Fogg)
Treasures From the Royal Tombs of Ur
Jewelry, accessories, tools, vessels and statues from the Sumerian city of Ur excavated in the 1930's.

PERMANENT COLLECTION

The approximately 150,000 objects in the art museums' collections range from antiquity to the present and come from Europe, North America, North Africa, the Middle East, India, Southeast Asia and East Asia. **Highlights:** Early Italian Renaissance paintings, 19th-century French paintings and drawings, Ben Shahn photography at the Fogg; Indian sculpture, ancient Chinese jades and bronzes, Korean ceramics, Greek and Roman coins, Greek vases at the Sackler; and Joseph Beuys and Walter Gropius archives, German Expressionist paintings, drawings and medieval sculpture at the Busch-Reisinger.

Admission: Adults, $5; seniors, $4; students, $3; children under 18, free. Free Saturday morning and all day Wednesday. Admission includes all three museums. Admission to Sert Gallery (in Carpenter Center, adjacent to museums) is free. **Hours:** Monday through Saturday, 10 a.m.–5 p.m.; Sunday, 1–5 p.m. Closed national holidays.

Massachusetts Museum of Contemporary Art (Mass MOCA)

1040 Mass MOCA Way, North Adams, Mass. 01247
(413) 662-2111
www.massmoca.org

2002 EXHIBITIONS

January 26–May 29
Choose Your Own Exhibition

Using a computer database of images and video projections, visitors can create their own exhibition.

May 26–March 31, 2003
Viennese Seen
Some 50 works by a group of provocative Viennese artists, including conceptual works and parodies.

PERMANENT COLLECTION

Several long-term installations. **Highlights:** Sound art by Bruce Odland and Sam Auinger, Walter Fähndrich and Christina Kubisch; Ron Kuivila, *Visitations*; Natalie Jeremijenko, *Tree Logic.* **Architecture:** Restored 13-acre, 19th-century factory campus.

Admission: Adults, $8; children, $3; members and children under 6, free; slightly lower prices during the winter.
Hours: June through October, daily, 10 a.m.–6 p.m.; November through May, daily except Tuesday, 11 a.m.–5 p.m.

The Springfield Museum of Fine Arts and the George Walter Vincent Smith Art Museum

The Quadrangle, 220 State Street, Springfield, Mass. 01103
(413) 263-6800
www.quadrangle.org

2002 EXHIBITIONS

February 17–April 14 (Museum of Fine Arts)
American Impressionism: Treasures From the Smithsonian American Art Museum
Landscapes, domestic scenes and figure compositions, including works by Childe Hassam, John Twachtman, William Merritt Chase, Theodore Robinson, Mary Cassatt, Robert Reid and Maurice Prendergast. (Travels)

Courtesy of the Springfield Museum of Fine Arts.
Abbott H. Thayer, *Cornish Headlands*, 1898.

March 2–June 9 (Smith Art Museum)
From Mickey to the Grinch: Art of Animated Film
Animation cels, model sheets, animation drawings and con-
cept drawings from the early days of full animation in the
1930's to the revival of animated films in the 1970's.

October 5–December 1 (Museum of Fine Arts)
Out of Time: 20th-Century Design
A Smithsonian Institution exhibition of watercolors, oil paint-
ings, pen-and-ink drawings and other renderings of futuristic
visions of architecture, transportation, urban communities,
space exploration and robotics. (Travels)

PERMANENT COLLECTION

American art from the 18th through 20th centuries. Works
by Degas, Pissarro, Gauguin, Monet and Gericault. The
George Walter Vincent Smith Art Museum includes Japanese
arms and armor, screens, lacquers and ceramics; Middle East-
ern rugs and decorative arts; Chinese cloisonné; a Shinto
wheel shrine and American paintings. **Highlights:** Erastus
Salisbury Field, *Historical Monument of the American Republic.*
Architecture: Opened in 1896; built in the style of an Ital-
ian palazzo.

Admission: Adults, $6; seniors and college students, $3; ages
6–18, $1; children under 6, free. Includes entry into all four
Quadrangle museums.

Hours: Wednesday through Sunday, noon–5 p.m.; Saturday and Sunday, 11 a.m.–4 p.m. Closed Monday and Tuesday (open Tuesday in July and August), New Year's Day, Independence Day, Thanksgiving, Christmas Day.

Davis Museum and Cultural Center

Wellesley College, 106 Central Street, Wellesley, Mass. 02140
(781) 283-2034
www.wellesley.edu/DavisMuseum/davismenu.html

2002 EXHIBITIONS

February 21–June 9
Surrounding Interiors: Views Inside the Car
Fifteen contemporary artists explore car interiors through photography, video, sculpture, painting and multimedia.

September 17–December 8
Women Who Ruled: Queens, Goddesses, Amazons, 1500–1650
Explores the visual representation of powerful women in the 16th and early 17th century in Europe, a period when many states and kingdoms were led by women.

PERMANENT COLLECTION

More than 7,000 works covering the history of visual arts, with emphasis on African art, European and American art of the 20th century, medieval, ancient and pre-Columbian art and works by women. Included are works by Monet, Cézanne, de Kooning, Calder and Krasner. **Architecture:** 1993 design by Rafael Moneo.

Admission: Free.
Hours: Tuesday through Saturday, 11 a.m.–5 p.m.; Wednesday and Thursday from February through May and from September through December, until 8 p.m.; Sunday, 1–5 p.m. Closed Monday and major holidays.

Williamstown

Sterling and Francine Clark Art Institute

225 South Street, Williamstown, Mass. 01267
(413) 458-9545; (413) 458-2303 (recording)
www.clarkart.edu

2002 EXHIBITIONS

February 17–May 5
Arctic Diary: Paintings and Photographs by William Bradford
Some forty photographs from Bradford's album *The Arctic Regions Illustrated With Photographs Taken on an Art Expedition to Greenland* (London, 1873), acquired by the museum in 1999.

June 30–September 3
Gustav Klimt Landscapes
Created from the 1890's until the artist's death in 1918, colorful landscape paintings representing a relatively little-known aspect of the work of the Viennese Symbolist Gustav Klimt.

June 30–September 3
Vienna in the 19th Century

June 30–September 3
Bellotto: Vienna in the Age of Mozart

November–December
Edouard Baldus and the Photography of Leisure
Examines the phenomenon of photographing leisure in the French countryside through a series by the pioneering French photographer Edouard Baldus. (Travels)

PERMANENT COLLECTION

French Impressionist paintings by Renoir, Monet and Degas; American works by Homer, Sargent, Remington and Cassatt; Old Master paintings; English and American silver, porcelain, furniture, sculpture, prints, drawings and photographs. **Highlights:** Renoir, *At the Concert*; Sargent, *Fumé d'Ambergris*; Homer, *Undertow*; Fragonard, *The Warrior;* Piero della Francesca, *Virgin and Child Enthroned With Four Angels.*

Admission: November through June, free. July through October, adults, $5; students and children 18 and under, free. Free on Tuesday.

MASSACHUSETTS
Williamstown

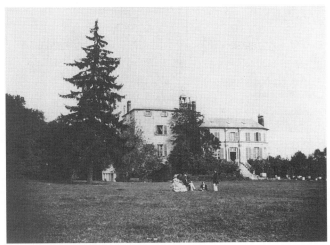

Courtesy of the Sterling and Francine Clark Art Institute.
Édouard Baldus, *Château de la Faloise*, 1857.

Hours: Tuesday through Sunday, 10 a.m.–5 p.m. (also Monday, July through August and President's Day, Memorial Day, Labor Day and Columbus Day). Closed New Year's Day, Thanksgiving and Christmas Day.

Williams College Museum of Art

15 Lawrence Hall, Main Street, Williamstown, Mass.
01267
(413) 597-2429
www.williams.edu/WCMA

2002 EXHIBITIONS

Through January 6
Pulling Prints: Modern and Contemporary Works From the Collection
Works by Francisco Goya, Alberto Giacometti, Judy Pfaff, Roger Brown and others, including traditional lithography and etching as well as serigraph, monoprint, silkscreen, inkjet and photogravure techniques.

MASSACHUSETTS
Williamstown

Through February 17
Art of India
Indian and Islamic painting, sculpture and textiles from the museum's collection.

Through March 31
Idol: A New Work by Michael Oatman
A massive sculpture accompanied by chalkboard walls, displays of teaching tools and an audio track of one-minute lectures by Williams professors. The installation was created in honor of the museum's 75th anniversary.

July
American Art Before 1950
More than 50 works from the museum's collection — paintings, drawings, prints, photographs, sculpture and decorative arts — by unfamiliar as well as famous artists.

Continuing
Ancient Spirits from the Palace of Ashurnasirpal II
Two Assyrian reliefs, along with computer-animated renderings of the reliefs as they existed in their original ninth century B.C. context in what is now Iraq.

Continuing
Masterpieces, Ancient to Modern
Paintings, sculpture and works on paper.

Continuing
A Wall Drawing by Sol LeWitt
The 33-foot-high painting is titled *Uneven Bands From the Upper Right Corner.*

PERMANENT COLLECTION

Includes some 12,000 works spanning the history of art. Contemporary and modern art; American art from the late 18th century to the present; art of world cultures. **Architecture:** The neo-Classical rotunda of the original structure was designed by Thomas S. Tefft in 1846; extensive additions in 1983 and 1986 by Charles Moore.

Admission: Free.
Hours: Tuesday through Saturday, 10 a.m.–5 p.m.; Sunday, 1–5 p.m. Closed Monday.

Worcester Art Museum

55 Salisbury Street, Worcester, Mass. 01609
(508) 799-4406
www.worcesterart.org

2002 EXHIBITIONS

Through January 6
Modernism & Abstraction: Treasures From the Smithsonian American Art Museum
Seldom lent works by 20th-century artists including Max Weber, Georgia O'Keeffe, Robert Motherwell, Franz Kline, Willem de Kooning, Hans Hoffman, Robert Rauschenberg and David Hockney.

Through January 20
Dressing Up: Images of Style and Fashion
Explores changing styles over the years through photographs from the museum's collection, including images by Gosta Peterson, Richard Avedon, Man Ray and Cindy Sherman.

Through March 24
Staged! Contemporary Photography by Gregory Crewdson, Rosemary Laing and Sharon Lockhart
Works by a new generation of photographers who use scrupulously detailed staging, giving the images a cinematic quality.

February 23-May 5
Collective Images: The Sketchbooks of John Steuart Curry
Selections from the 98 sketchbooks that the artist's widow, Kathleen Gould Curry, donated to the museum in 1999.

April 7-June 2
Weegee's World: Life, Death and the Human Drama

Some 100 works by Arthur Fellig, nicknamed Weegee, a photographer for the New York dailies who from 1936 to 1945 captured crime and accident scenes, entertainers, kids at play and the joys and sorrows of everyday life.

April 27-August 11
Tony Feher
This American artist melds humble, "forgettable" materials — bottle caps, empty bottles, clothesline, plastic milk crates, marbles and coins — into sculptures.

Worcester

PERMANENT COLLECTION

Fifty centuries of art. **Highlights:** Egyptian artifacts, Roman mosaics and works by Judith Leyster and Claude Monet.

Admission: Adults, $8; seniors and students, $6; members and children under 17, free. Free on Saturday, 10 a.m.–noon. **Hours:** Sunday and Wednesday through Friday, 11 a.m.–5 p.m.; Saturday, 10 a.m.–5 p.m. Closed Monday and Tuesday, Easter, Independence Day, Thanksgiving, Christmas Day and New Year's Day.

Michigan

The University of Michigan Museum of Art

525 South State Street, Ann Arbor, Mich. 48109
(734) 763–UMMA; (734) 764-0395
www.umich.edu/~umma

2002 EXHIBITIONS

Through January 5
Pattern and Purpose: Japanese Fishermen's Coats of Awaji Island
Examines the embroidered coats' history and aesthetics.

February 17–May 5
Women Who Ruled: Queens, Goddesses, Amazons, 1500–1650
Renaissance and Baroque paintings, sculpture, prints and drawings. (Travels)

February 21–May 5
Cavafy's World: Hidden Things
A suite of etchings executed in 1966 by David Hockney accompanies Constantine P. Cavafy poems.

Courtesy of the University of Michigan Museum of Art.
Agnolo Bronzino, *Eleonora of Toledo and Her Son*, ca. 1545-1550.

March 9–May 26
An Installation by Kara Walker
A panoramic frieze in the artist's signature medium: black-paper cutouts on a life-size scale.

PERMANENT COLLECTION

Nearly 14,000 works of art from around the world, including European paintings from the 14th to 19th centuries; Chinese and Japanese paintings and ceramics; the Curtis Gallery of African and African-American Art; an authentic Japanese tea-

house; Old Master prints and drawings; contemporary paintings, sculpture and works on paper.

Admission: Suggested donation: $5.
Hours: Tuesday through Saturday, 10 a.m.–5 p.m.; Thursday, until 9 p.m.; Sunday, noon–5 p.m. Closed Monday and most major holidays.

Detroit Institute of Arts

5200 Woodward Avenue, Detroit, Mich. 48202
(313) 833-7900; (313) 833-2323 (tickets)
www.dia.org

2002 EXHIBITIONS

Through March
Some Fluxus From the Gilbert and Lila Silverman Fluxus Collection Foundation
Avant-garde works.

Through May
Dance of the Forest Spirits: A Set of Native American Masks
Ceremonial masks from the Pacific Northwest.

February 24–May 19
Over the Line: The Art and Life of Jacob Lawrence
A retrospective that includes an examination of Lawrence's creative process and a broad overview of his work.

October 20–January 12, 2003
Edgar Degas: The Painter of Dancers
Paintings, drawings, graphics and sculpture.

PERMANENT COLLECTION

More than 65,000 works from ancient to modern times, including collections of German Expressionist and French Impressionist paintings, Italian Renaissance art and 20th-century art. **Highlights:** Diego Rivera's *Detroit Industry* occupies four walls of the museum's central court. **Architecture:** The central 1927 building, in Italian Renaissance style, was enlarged in 1966 and 1971.

Admission: Suggested donation: adults, $4; children and members, free.

Hours: Wednesday and Thursday, 11 a.m.–4 p.m.; Friday, 10 a.m.–9 p.m.; Saturday and Sunday, 10 a.m.–5 p.m. Closed Monday, Tuesday and some holidays.

Grand Rapids Art Museum

155 Division North, Grand Rapids, Mich. 49503
(616) 831-1000; (616) 831-1001
www.gramonline.org

2002 EXHIBITIONS

Through January 6
Light Screens: The Leaded Glass of Frank Lloyd Wright
More than 50 original windows, many from private collections and never before seen by the public. (Travels)

Through August 31
A Children's Garden: Friedrich Froebel's Creative Learning Methods
A look at how kindergarten, invented by Froebel, inspired Frank Lloyd Wright and Bauhaus artists.

February 15–June 9
Landmarks of Modernism: 20th-Century Painting From the Detroit Institute of Arts
Thirty works.

June 7–June 23
Festival 2002
Annual juried exhibition of regional artists, featuring several hundred pieces of art.

June 28–August 25
Kilim: Weaving Past and Present, New Work by Dell Michel
Weaving-related art by Michel, a retiring art professor at Hope College in Holland, Mich., and an overview of traditional weaving.

Opening in October
Eye of the Beholder: The Photography of Ellsworth Kelly

Seventy works, including some maquettes. The exhibition explores how Kelly was inspired by nature and influenced by the artists Jean Arp, Constantin Brancusi and Alexander Calder.

PERMANENT COLLECTION

European and American painting, sculpture and works on paper from Renaissance to contemporary art, with additional collections in 20th-century design and decorative arts. **Highlights:** Richard Diebenkorn, *Ingleside.* **Architecture:** 1895 Beaux-Arts building listed in the National Register.

Admission: Adults, $5; students and seniors, $2; children 6–17, $1; children under 5, free. Prices may vary for ticketed shows.
Hours: Tuesday through Sunday, 11 a.m.–6 p.m.; Friday, until 9 p.m. Closed Monday.

Minnesota

The Minneapolis Institute of Arts

2400 Third Avenue South, Minneapolis, Minn. 55404
(612) 870-3131; (888) MIA-ARTS
www.artsMIA.org

2002 EXHIBITIONS

Through April 7
The Photographs of Danny Lyon

February 3–April 14
A Japanese Legacy: Four Generations of Yoshida Family Artists
Oil paintings, watercolors and woodblock prints by nine
artists from a single Japanese family, from the late 1800's to
the present.

May–September
Live on Stage: Photographs of Toby Old
Satirical images.

May 12–August 4
Jim Dine Prints, 1985–2000
Approximately 100 works, including lithographs, intaglios,
woodcuts and book illustrations.

June 16–November 10
Appreciating China: Gifts From Ruth and Bruce Dayton
Some 300 Chinese and Tibetan works purchased for the
museum by the Daytons during the last 10 years.

September 22–November 17
The American Sublime
Approximately 80 canvasses by American landscape painters
of the mid-19th century, including Albert Bierstadt, Frederick
Church and Thomas Cole.

December 22–March 16, 2003
*Eternal Egypt: Masterworks of Ancient Art From the British
Museum*
More than 125 objects, from about 3100 B.C. to the fourth
century A.D. (Travels)

Minneapolis

PERMANENT COLLECTION

The newly expanded museum houses nearly 100,000 objects spanning 5,000 years. **Highlights:** Lorrain, *Pastoral Landscape;* a Plains Indian tepee; terra-cotta shrine head from Nigeria; Ch'ing Dynasty Jade Mounain; Chinese period rooms; Rembrandt's *Lucretia.*

Admission: Free; fees for special exhibitions.
Hours: Tuesday through Saturday, 10 a.m.–5 p.m.; Thursday and Friday, 10 a.m.–9 p.m.; Sunday, noon–5 p.m. Closed Monday, Thanksgiving, Christmas Day and Independence Day.

Walker Art Center

Vineland Place, Minneapolis, Minn. 55403
(612) 375-7622
www.walkerart.org

2002 EXHIBITIONS

Through January 13
Zero to Infinity: Arte Povera, 1962–1972
Early works by Italian Minimalists who employed sand, wood, stone and other readily available materials. (Travels)

Through March 31
The Essential Donald Judd
The newly restored *Untitled* (1971), rarely exhibited due to its size, plus a portfolio of 30 woodblock prints and other works.

February 17–May 12
Vital Forms: American Art in the Atomic Age, 1940–1960
From the Studebaker and the Slinky to paintings by Willem de Kooning and Mark Rothko, an exhibition of some 200 objects that explores the use of organic forms. (Travels)

October 13–January 5, 2003
Ultra Baroque: Aspects of Post–Latin American Art
Contemporary works by 16 Baroque-influenced artists.

Meyer Vaisman, *Untitled Turkey I*, 1992.

Courtesy of the Walker Art Center.

PERMANENT COLLECTION

Primarily 20th-century art of all major movements. The Minneapolis Sculpture Garden has more than 40 sculptures on 11 acres. At its center is the playful fountain sculpture *Spoonbridge and Cherry* by Claes Oldenburg and Coosje van Bruggen. **Highlights:** Matthew Barney, *Cremaster 4*; Lucio Fontana, *Concetto Spaziale* (Spatial Concept); Jasper Johns, *Flashlight*; Ellsworth Kelly, *Red, Yellow, Blue III*; Louise Nevelson, *Dawn Tree*; Charles Ray, *Unpainted Sculpture*; Kazuo Shiraga, *Untitled*; Kara Walker, *Do You Like Creme in Your Coffee and Chocolate in Your Milk?*

Admission: Adults, $6; children 12–18, students and seniors, $4; members and children under 12, free. Free on Thursday and the first Saturday of each month.

Hours: Tuesday through Saturday, 10 a.m.–5 p.m.; Thursday, until 9 p.m.; Sunday, 11 a.m.–5 p.m. Closed Monday.

Minnesota Museum of American Art

Landmark Center, 75 West Fifth Street, Second Floor, St.
Paul, Minn. 55102
(651) 292-4380; (651) 292-4355 (recording)
www.mmaa.org

2002 EXHIBITIONS

Through February 10
Small Bronzes by Harriet Whitney Frishmuth
Three dozen sculptures created between 1910 and 1939.

May 11–August 11
Minnesota Biennial: 3D 2002
Contemporary three-dimensional works by Minnesota artists.

August 31–October 6
In Response to Place: Photographs from the Nature Conservancy's Last Great Places
Works by William Christenberry, Lee Friedlander, Annie
Leibovitz, Sally Mann, Richard Misrach, William Wegman
and others. (Travels)

October 27–December 29
Robert Henri and His Influence
Works by Henri and artists he influenced, including Arthur
Bowen Davies, Maurice Prendergast, John Sloan and the other
members of The Eight, as well as George Bellows, William
Merritt Chase and Walt Kuhn.

PERMANENT COLLECTION

Nineteenth and 20th-century American paintings, prints and
sculpture, including works by the Minnesotan Evelyn Ray-
mond and the St. Paul native Paul Manship. **Highlights:**
Paintings by Thomas Hart Benton, Robert Henri and Jacob
Lawrence, as well as the Minnesotans Doug Argue, George
Morrison, Elsa Jemne and Cameron Booth. **Architecture:**
1902 Landmark Center, originally a federal courthouse and
post office.

Admission: Free.

Hours: Tuesday through Saturday, 11 a.m.–4 p.m.; Thursday, until 7:30 p.m.; Sunday, 1–5 p.m. Closed Monday and major holidays.

Mississippi Museum of Art

201 East Pascagoula Street, Jackson, Miss. 39201
(601) 960-1515
www.msmuseumart.org

2002 EXHIBITIONS

Through January 6
Mississippi Watercolor Society Grand National Watercolor Exhibition
Works in various water-based media.

Through February 17
Gods and Monsters: Pre-Columbian Art
Objects, ranging from sacred to whimsical, from the museum's collection.

March 2–June 30
Georgia O'Keeffe and the Landscape Tradition
Paintings and works on paper by O'Keeffe. (Travels)

July 13–October 6
Passages: Photography in Africa by Carol Beckwith and Angela Fisher
Photographs, plus a selection of objects, that mark rites of passage in Africans' lives.

October 19–December 1
Looking Through the Glass: Rediscovered American Works on Paper, 1862–1922
More than 75 works, tracing the evolution of American art.

PERMANENT COLLECTION

More than 3,600 works, many by and relating to Mississippians and their culturally diverse heritage. The collection is strong in 19th- and 20th-century American and European art, Japanese prints, photographs by Southerners and about the South, folk art and pre-Columbian and Oceanic artifacts.

Admission: Fees vary; call for information.
Hours: Monday through Saturday, 10 a.m.–5 p.m.; Tuesday, until 8 p.m.; Sunday, noon–5 p.m. Closed major holidays.

The Nelson-Atkins Museum of Art

4525 Oak Street, Kansas City, Mo. 64111-1873
(816) 561-4000; (816) 751-1ART (recording)
www.nelson-atkins.org

2002 EXHIBITIONS

Through January 6
Mirror With a Memory: The American Daguerreotype
Nearly 100 works by unknown photographers made between 1840 and 1860 using the first successful photographic process.

Through January 6
Carrie Mae Weems: The Hampton Project
Images of the Hampton Normal and Agricultural Institute, a school for the education of African and Native Americans, taken in 1899 and transformed by Weems. (Travels)

April 12–July 7
Eternal Egypt: Masterworks of Ancient Art From the British Museum
More than 140 objects created as gifts to the gods or objects to accompany the dead and reflecting the lives and beliefs of the people of ancient Egypt. (Travels)

October 6–May 4, 2003
Art of the Lega
African art.

PERMANENT COLLECTION

More than 28,000 works, including 5,000 objects of Asian art; European paintings; modern sculpture. **Highlights:** Kansas City Sculpture Park, featuring monumental bronzes by Henry

Courtesy of the Nelson-Atkins Museum of Art.
The Kansas City Sculpture Garden at the Nelson-Atkins Museum of Art.

Moore; the largest public collection of works by Thomas Hart
Benton; Caravaggio, *St. John the Baptist*; Monet, *Boulevard des
Capucines*; de Kooning, *Woman IV.* **Architecture:** 1933 build-
ing by Wight & Wight.

Admission: Free through mid-2002 during parking garage
construction project.
Hours: Tuesday through Thursday, 10 a.m.–4 p.m.; Friday,
until 9 p.m.; Saturday, until 5 p.m.; Sunday, noon–5 p.m.
Closed Monday, Independence Day, Thanksgiving, Christmas
Eve, Christmas Day and New Year's Day.

Saint Louis Art Museum

Forest Park, 1 Fine Arts Drive, St. Louis, Mo. 63110
(314) 721-0072; (314) 721-4807 (for the deaf)
www.slam.org

2002 EXHIBITIONS

Through January 20
Oriental Carpets From the Collection: Tribal, Cottage, Village
A sleeping carpet, medallion carpets, prayer rugs and other
examples from the 19th century.

Through February 24
Currents 86: Jorge Pardo
Contemporary works by the Los Angeles artist and designer.

February 9–May 12
John Singer Sargent: Beyond the Portrait Studio
Sketches, drawings and watercolors from the collection of the
Metropolitan Museum of Art in New York City. Included are
sketchbooks from Sargent's youth, works that detail his travels
and watercolors of World War I scenes. Admission charge.

June 15–September 15
The Gentileschi: Father and Daughter
Some 70 works by the 17th-century Italian painter Orazio
Gentileschi and his daughter Artemisia. Admission charge.

PERMANENT COLLECTION

Ancient to contemporary art. Includes pre-Columbian,
Renaissance, Impressionist and German Expressionist works;
American, European and Asian art; period rooms. **Architecture:** A historic landmark designed by Cass Gilbert as the
only permanent structure for the 1904 World's Fair.

Admission: Free; fee for special exhibitions, except on Tuesday.
Hours: Tuesday, 1:30–8:30 p.m.; Wednesday through Sunday,
10 a.m.–5 p.m. Closed Monday (except Memorial Day and
Labor Day), New Year's Day, Thanksgiving and Christmas Day.

Yellowstone Art Museum

401 North 27th Street, Billings, Mont. 59101
(406) 256-6804
www.yellowstone.artmuseum.org

2002 EXHIBITIONS

March 23–June 30
The Romance Paintings: Lanny Frances Devuono
Landscape paintings by an artist living in the Northwest.

March 23–June 30
*American Anthem, 1719–1989: Master Paintings From the Butler
Institute of American Art*
Includes works by Rembrandt Peale, Winslow Homer and
Andy Warhol.

March 23–June 30
The Most Difficult Journey: The Poindexter Collections of Abstract Expressionist Art

April 13–June 14
Crow Country and Other Documents: Ken Blackbird

October 9–May 5, 2003
Lone Cowboy: Paintings and Drawings by Will James

PERMANENT COLLECTION

Contemporary Western art, including sculpture by Deborah Butterfield, paintings by Theodore Waddell and the Virginia Snook collection by Will James.

Admission: Adults, $5; students and seniors, $3; children, $2.
Hours: Tuesday through Saturday, 10 a.m.–5 p.m.; Thursday, until 8 p.m.; Sunday, noon–5 p.m.

Sheldon Memorial Art Gallery and Sculpture Garden

University of Nebraska, 12th and R Streets, Lincoln, Neb. 68588–0300
(402) 472-2461
sheldon.unl.edu

2002 EXHIBITIONS

Through January 27
The Prints of Enrique Chagoya
Works by this Mexican-born artist who uses imagery from indigenous Central American cultures, Catholicism, Spanish colonialism and American pop culture.

Through February 24
Cartoons, Heroes and American Visual Culture
Explores the history and role of American cartoons, from Krazy Kat and Dick Tracy to the superheroes Spiderman, Batman and Superman.

Lincoln

Through February 24
Sheldon Statewide: The Stieglitz Circle
Works in various media by American avant-garde artists who were connected with the photographer Alfred Stieglitz and his 291 gallery in New York, including Alfred Maurer, Arthur B. Carles, Charles Sheeler and Gaston Lachaise.

Through March 3
African-American Photography From the Permanent Collection
Includes works by William Christenberry, Roy de Carava, James Van Der Zee and Carrie Mae Weems.

Through March
A Survey History of Ceramics From the Permanent Collection
Works reflecting the diversity of contemporary ceramic art.

March–May
Anne Truitt: Recent Sculpture
Works by this artist known for the minimalist sculpture she has exhibited since the 1960's.

April 1–June
Losing Our Instructions: An Aesthetic Intervention by Tim Van Laar and Barbara Kendrick
Explores the artist's relationship with museum collections and other artists.

October 10–November 25
The Visual Culture of Prairie Schooner: 1927–2001
Explores how visual imagery interacted with the poetry, short fiction and essays in the literary magazine Prairie Schooner.

PERMANENT COLLECTION

American art from the 18th century to the present, with an emphasis on the 20th century, including works by Albert Bierstadt, Robert Henri, Edward Hopper, Georgia O'Keeffe, Mark Rothko, Frank Stella, Joseph Stella, Clyfford Still, John Twachtman and Andy Warhol. Sculpture garden with *Torn Notebook,* by Claes Oldenburg and Coosje van Bruggen, and works by Gaston Lachaise, Jacques Lipchitz, David Smith and Richard Serra.

Admission: Free.

Hours: Tuesday through Saturday, 10 a.m.–5 p.m.; also 7–9 p.m. Thursday through Saturday; Sunday, 2–9 p.m. Closed Monday and major holidays.

Joslyn Art Museum

2200 Dodge Street, Omaha, Neb. 68102
(402) 342-3300
www.joslyn.org

2002 EXHIBITIONS

Through January 20
Painters and the American West: The Anschutz Collection
Nearly 150 works, by George Caleb Bingham, George Catlin, Seth Eastman, Georgia O'Keeffe and others.

February 2–March 24
Tracey Moffatt
Images by the Australian photographer of aboriginal descent, addressing race, identity, gender and sexuality.

February 16–May 12
Tools as Art: The Hechinger Collection
Celebrates the variety of 20th-century art that represents or incorporates tools and hardware. Artists include Arman, Jim Dine, Richard Estes and Jean Tinguely.

June 8–September 1
The Sport of Life and Death: The Mesoamerican Ballgame
More than 150 objects, most never before exhibited in the United States, showcasing what is said to be be the world's first team sport, played with a rubber ball in elaborate masonry courts by the Aztecs and earlier civilizations. (Travels)

July 6–September 1
Max and Gaby's Alphabet
Color etchings by a printmaker, Tony Fitzpatrick, that spell out the alphabet in images suggested by his two young children.

August 10–September 29
Exotica: Plant Portraits From Around the World

Botanical prints, created before the advent of the camera, by
John J. Audubon, Pierre Joseph Redouté, Johann Michael
Seligmann, Dr. Robert John Thornton and others.

September 28–December 29
A Faithful and Vivid Picture: Karl Bodmer's North American Prints
Approximately 100 works, including original watercolors and
drawings the artist made in the 1830's. The exhibition traces
the watercolors' evolution from field sketches to book
illustrations, and it includes a selection of steel and copper
plates from which the images were pulled.

October 26–January 5, 2003
Midlands Invitational 2002
The fifth annual exhibition honoring artists in Colorado, Iowa,
Kansas, Missouri, Nebraska, South Dakota and Wyoming.

PERMANENT COLLECTION

Works from antiquity to the present. **Highlights:** The
museum is noted for art of the American West and the Swiss
artist Karl Bodmer's watercolors and prints documenting his
1832-34 journey to the Missouri River frontier. **Architecture:**
1931 Art Deco building by John and Alan McDonald; 1994
addition by Sir Norman Foster and Partners.

Admission: Adults, $6; students and seniors, $4; ages 5–17,
$3.50. Free on Saturday, 10 a.m.–noon.
Hours: Tuesday through Saturday, 10 a.m.–4 p.m.; Sunday,
noon–4 p.m. Closed Monday and major holidays.

The Currier Gallery of Art

201 Myrtle Way, Manchester, N.H. 03104
(603) 669-6144
www.currier.org

2002 EXHIBITIONS

Through January 6
Impressionism Transformed: The Paintings of Edmund C. Tarbell
A retrospective of work by the American artist, including
little-known early paintings, the plein-air scenes with which

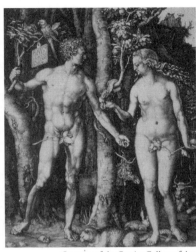

Albrecht Dürer,
Adam and Eve, 1504.

Courtesy of the Currier Gallery of Art.

he established his reputation in the 1890s and the domestic interiors for which he is best known today. (Travels)

March 22–June 16
The Print in the North: The Age of Albrecht Dürer and Lucas Van Leyden
More than 80 works — including religious subjects, portraits, landscapes and architectural and mythological scenes, made in Northern Europe between 1440 and 1550 — from the Metropolitan Museum of Art collection.

July 13–September 1
Contemporary Work by Emerging Northern New England Artists: The Gloria Wilcher Memorial Exhibition
The eighth biennial exhibition, focusing on early and mid-career artists from Maine, New Hampshire and Vermont.

September 27–January 5, 2003
New York, New Work
Recent paintings, sculpture and new media works by artists active in the New York City gallery and studio art scene.

PERMANENT COLLECTION

European and American paintings and sculpture from the 14th century to the present. **Highlights:** The Zimmerman House, designed in 1950 by Frank Lloyd Wright; early Amer-

ican furniture; decorative arts; works by Picasso, Monet, Sargent, Homer, Wyeth, Rothko and O'Keeffe; sculpture by Matisse, Remington and Saint-Gaudens.

Admission: Adults, $5; students and seniors, $4; children under 18, free. Free on Saturday, 10 a.m.–1 p.m.
Hours: Monday, Wednesday, Thursday and Sunday, 11 a.m.–5 p.m.; Friday, until 8 p.m.; Saturday 10 a.m.–5 p.m. Closed Tuesday.

Hood Museum of Art

Dartmouth College, Hanover, N.H. 03755
(603) 646-2808
www.dartmouth.edu/~hood/Menu.html

2002 EXHIBITIONS

January 12–March 10
Mel Kendrick: Core Samples
Wood sculptures that reflect the textures and growth patterns of the trees from which they originate. (Travels)

January 12–March 10
Reflections in Black: Smithsonian African-American Photography, Art and Activism
Examining the role of African-American photographers in motivating cultural change during the beginnings of the civil-rights and black-power movements.

March 26–June 16
José Clemente Orozco in the United States, 1927–1934
Easel paintings, prints, drawings and mural studies for frescoes. (Travels)

June 29–September 1
Ambassadors of Progress: American Women Photographers in Paris, 1900–1901
Works by 29 women, including Gertrude Käsebier, Amelia van Buren and Zaida Ben-Yusef. A partial reconstruction of an exhibition held in Paris at the turn of the last century.

September 14–December 1
Carrie Mae Weems: The Hampton Project

An installation by the contemporary photographer and a selection of photographs from Frances Benjamin Johnson's "Hampton Album" of 1900. The women, distanced by time and race, both focused on what is now Hampton University.

September 28–December 15
The Renaissance Revival in Late 19th-Century French Sculpture

Continuing
Survival/Art/History: American Indian Collections from the Hood Museum of Art

PERMANENT COLLECTION

African, Oceanic and native North American art; early American silver; 19th- and 20th-century American painting, European prints and contemporary art. **Highlights:** Six limestone reliefs from the palace of the Assyrian King Ashurnasirpal II (883–859 B.C.); José Clemente Orozco, *The Epic of American Civilization*. **Architecture:** 1985 building by Charles Moore and Chad Floyd.

Admission: Free.
Hours: Tuesday through Saturday, 10 a.m.–5 p.m.; Wednesday, until 9 p.m.; Sunday, noon–5 p.m. Closed Monday, New Year's Day, Independence Day, Labor Day, Thanksgiving, Christmas Eve and Christmas Day.

The Montclair Art Museum

3 South Mountain Avenue, Montclair, N.J. 07042
(973) 746-5555; (973) 783-8716 (for the deaf)
www.montclair-art.org

2002 EXHIBITIONS

Through February 3
Primal Visions: Albert Bierstadt
Fifty works by Bierstadt and his contemporaries, examining European explorers' impressions of the New World. (Travels)

February–May
Art in Two Worlds: The Native American Fine Art Invitational, 1983–1997

Paintings, drawings and sculptures.

May–August
The New Jersey Crafts Annual
Works by artisans and visual artists.

May–August
Strokes of Genius II
A miniature golf course designed by New Jersey artists.

September–January 2003
On the Edge of Your Seat: Popular Theater and Film in Early-20th-Century American Art
Works by Charles Demuth, John Sloan, Edward Hopper, Robert Henri and other American modernists. Featuring posters, playbills, song sheets, postcards and vintage lighting and motion picture equipment.

Permanent Collection

About 15,000 objects, focusing on American and American Indian art and artifacts, mid-18th century to the present, including paintings, works on paper, sculptures and costumes. **Architecture:** Neo-Classical building in an arboretum setting.

Admission: Adults, $5; seniors and students, $4; members and children under 12, free. Free on Saturday, 11 a.m.– 2 p.m. **Hours:** Tuesday through Sunday, 11 a.m.–5 p.m.; Thursday, until 9 p.m. Closed Monday and major holidays.

The Newark Museum

49 Washington Street, Newark, N.J. 07101–0540
(973) 596-6550; (973) 596-6355 (for the deaf);
 (800) 7MUSEUM
www.newarkmuseum.org

2002 Exhibitions

Through February 24
Faces of Worship: A Yoruba God in Two Worlds
Features a shrine to Shango, the thunder god of the Yoruba people of southwestern Nigeria, and altars for the same deity from Brazil, Trinidad and New Jersey.

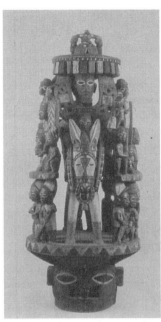

BamgBoye of Odo-Owa, Nigeria,
Yoruba people, *Epa Mask*, 1920.

Courtesy of the Newark Museum of Art.

Through May
Poetry, Proclamation and Propaganda: Chinese Calligraphy From The Newark Museum Collection
Explores the use of calligraphy in poetry, memorial tributes, imperial edicts and government propaganda.

Through May
In a Gentleman's Study: Korean Calligraphy and Scholarly Pursuits
An exhibition designed to suggest a gentleman's study in 19th-century Korea, featuring screens painted with Confucian quotations, a zither and a scholar's horsehair hats and silk robes.

April 18–September 8
Shaped With a Passion: The Carl A. Weyerhaeuser Collection of Japanese Ceramics From the 1970's
Folk art and tea ceremony ceramics by major Japanese potters. (Travels)

May–July
Tutankhamun's Wardrobe
Replicas of garments found in King Tutankhamun's tomb, which are too fragile to leave the Cairo Museum. (Travels)

NEW JERSEY

Newark

May 4–August
Homer's Odyssey

August–October
Sign at the Crossroads

Opening in Fall
Dynamic Earth: Revealing Nature's Secrets
Innovative ongoing science exhibit showcasing the museum's natural history collection.

October 18–December 29
Life, Death and Sport: The Mesoamerican Ballgame
Explores the historical and religious aspects of the ancient Mesoamerican ballgame, traced back to the Olmec civilization in Mexico in 1500 B.C. (Travels)

November–January 2003
Three Views

November 27–January 2003
Christmas in the Ballantine House: Feasting With Family and Friends
A traditional Victorian holiday is recreated in this 1885 house, a restored National Historic Landmark.

Continuing
Picturing America
More than 300 works by American artists over 250 years from the permanent collection.

PERMANENT COLLECTION

American painting and sculpture from the 18th, 19th and 20th centuries; decorative arts collection; the arts of Africa, the Americas and the Pacific; Asian art collection; Egyptian, Greek, Etruscan and Roman antiquities; ancient glass collection; numismatic collection. **Highlights:** American works on permanent display include paintings by Bearden, Cassatt, O'Keeffe, Sargent and Stella; Hiram Powers, *Greek Slave* (1847); contemporary outdoor sculptures in the Alice Ransom Dreyfuss Memorial Garden; Tibetan Buddhist altar consecrated by the Dalai Lama; 1885 Ballantine House, a restored national historic landmark. **Architecture:** Renovation and expansions designed by Michael Graves and completed in 1989.

Admission: Free; tour groups pay $5 per person (reservations required).

Hours: Wednesday through Sunday, noon–5 p.m.; Thursday, until 8:30 p.m. Closed Monday and Tuesday, New Year's Day, Independence Day, Thanksgiving and Christmas Day.

Museum of New Mexico

www.museumofnewmexico.org
(505) 827-6463

Museum of Fine Arts

107 West Palace Avenue on the Plaza, Santa Fe, N.M.
 87501
(505) 476-5072

2002 Exhibitions

Through January 7
Carr, O'Keeffe, Kahlo: Places of Their Own
Compares the art, achievements and lives of Emily Carr, Georgia O'Keeffe and Frida Kahlo.

Through February 15
Eliseo Rodriguez: El Sexto Pintor
A retrospective spanning seven decades of work by the 20th-century New Mexico artist, who revived the ancient art of straw appliqué.

Through May 20
The Avant-Garde Photography of Alexander Macijauskas
Black-and-white photographs that were shot in the former Soviet Union, documenting everyday existence.

February 1–May 12
Meredith Monk

June 28–September 22
Arte Latino: Treasures From the Smithsonian American Museum of Art

July 19–December 1
Southwesternist Illusions: Charles Lummis and the Invention of Tourism in New Mexico

Santa Fe

October 11–February 1, 2003
Moholy-Nagy

October 14–February 15, 2003
Taller de Grafía Popular

PERMANENT COLLECTION

More than 20,000 works of historical and contemporary fine art of the Southwest, including painting, photography and sculpture. **Architecture:** 1917 building patterned after mission churches.

Museum of International Folk Art

Camino Lejo, off Old Santa Fe Trail, Santa Fe, N.M.
 87501
(505) 476-1200
www.moifa.org

2002 EXHIBITIONS

Through February 17
Cyber Arte
Works by Elena Baca, Marion Martinez, Alma Lopez and other contemporary Hispanas/Chicanas/Latinas who incorporate computer technology in their folk art.

Through March 17
Collections Seldom Seen
Textiles and objects from Latin America, North America, Europe, Asia and Africa, including lanterns, jewelry, beaded aprons and fishing decoys.

Through June 16
Curiouser and Curiouser: A Walk Through the Looking Glass
Organized around Lewis Carroll's "Alice in Wonderland," the exhibition explores ideas of visual perception and illusion.

June 16–September 7, 2003
Majolica

October 5–July 6, 2003
Neutrogena III

November 15–September 15, 2003
Bad Girls

Works by Goldie Garcia, Marie Romero Cash and other female artists, depicting the "other" women of the Bible, those not usually represented in art because of their controversial nature.

Continuing
Children's Dress
A textile exhibition.

PERMANENT COLLECTION

Traditional art from more than 100 countries, with toys, textiles, household goods and religious art.

Museum of Indian Arts and Culture/Laboratory of Anthropology

Camino Lejo, off Old Santa Fe Trail, Santa Fe, N.M. 87501
(505) 476-1250
www.miaclab.org

2002 EXHIBITIONS

Through February 3
Tourist Icons: Native American Kitsch, Camp and Fine Art Along Route 66
Items from souvenir shops and tourist stops.

Through April 15
The Keystone of the Arch: The Stewart Collection
Native textiles, silver, belts, bridles and other works.

March 1–January 2, 2003
Tewa Thematic Exhibit

May 1–October 15
Jewels of the Southwest

PERMANENT COLLECTION

More than 70,000 items of Southwest Native American culture from ancestral to contemporary times.

Santa Fe

The Palace of Governors

105 West Palace Avenue, on the Plaza, Santa Fe, N.M. 87501
(505) 476-5100
www.palaceofthegovernors.org

2002 EXHIBITIONS

Continuing
Jewish Pioneers of New Mexico
Photographs, artifacts and diaries that mark the history of Jewish settlers in the state, through World War I.

PERMANENT COLLECTION

New Mexico's state history museum, located in the oldest continuously occupied public housing building in the United States.

ALL FOUR MUSEUMS:

Admission: $10 four-day, four-museum pass; $5 one-day, one-museum pass; under 17, free. Free on Friday, 5–8 p.m. New Mexico residents, $1 on Sunday; New Mexico seniors, free on Wednesday.
Hours: Tuesday through Sunday, 10 a.m.–5 p.m. Closed Monday and major holidays.

Georgia O'Keeffe Museum

217 Johnson Street, Santa Fe, N.M. 87501
(505) 995-0785
www.okeeffemuseum.org

2002 EXHIBITIONS

Through January 13
O'Keeffe's O'Keeffes: The Artist's Collection
More than 70 of the 1,000-plus O'Keeffe works that the artist herself owned at the time of her death in 1984. (Travels)

January 24–May 12
Edward Weston: Photography and Modernism
Approximately 85 photographs that Weston shot between
1920 and 1948, including portraits and landscapes. (Travels)

May 24–September 21
*The Artist's Landscape:
Photographs by Todd Webb*
Nearly 40 images of
Georgia O'Keeffe's life in
New Mexico.

**October 1–January 14,
2003**
*The Calla Lily in American
Art, 1860–1940*
Some 50 works, by Charles
Demuth, Marsden Hartley,
Georgia O'Keeffe and 22
others. (Travels)

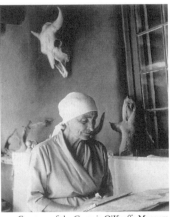

Courtesy of the Georgia O'Keeffe Museum.
Todd Webb, *O'Keeffe on the Portal, Ghost
Ranch*, 1964.

**PERMANENT
COLLECTION**

Approximately 140 works by Georgia O'Keeffe that provide
an overview of her work from 1904 to 1970. **Highlights:**
Black Lines, 1916; *From the Plains*, 1919; *Petunia, No. 2*, 1924;
Abstraction, White Rose II, 1927; *Black Hollyhock, Blue Lark-
spur*, 1929; *Jimson Weed*, 1932; *Belladonna-Hana*, 1939; *Pelvis
Series Red and Yellow*, 1945; *My Last Door*, 1954. **Architec-
ture:** The building was originally a Baptist church in the
1950's. In 1997, an addition was built in the Santa Fe vernac-
ular style.

Admission: Adults, $5; under 16, free. Free on Friday, 5–8
p.m.; Sunday, $4 for New Mexico residents; Thursday, $4 for
senior citizens.
Hours: Tuesday, Thursday through Sunday and holidays, 10
a.m.–5 p.m.; Friday, until 8 p.m. Closed Monday and
Wednesday (open Wednesday July through October), New
Year's Day, Easter Sunday, Thanksgiving and Christmas Day.

New York

Brooklyn Museum of Art

200 Eastern Parkway, Brooklyn, N.Y. 11238
(718) 638-5000
www.brooklynart.org

2002 EXHIBITIONS

Through February 24
Eternal Egypt: Masterworks of Ancient Art From The British Museum
More than 140 works, many of which have never before
traveled to the United States, spanning 3,500 years of
Egyptian history through the Roman conquest. Highlights
include a 5,000-pound lion statue and part of a temple
column with a monumental carving of a goddess.

April 5–July 7
"Star Wars": The Magic of Myth
Artwork, props and costumes used to create the original "Star
Wars" movie trilogy and its prequel. Included are more than
30 mannequins and 35 models, as well as a 26-minute
documentary film on the making of the four movies.

September 2–January 5, 2003
Exposed: The Victorian Nude
Paintings, drawings, sculpture, illustrations, caricatures and
advertising items demonstrating the prevalence of the nude in
Victorian culture.

Continuing
Identities: A Reinterpretation of American Art
Approximately 350 works from the museum's collection,
forming a thematic survey of American paintings, sculpture
and decorative art from the early 18th century to the present.

PERMANENT COLLECTION

More than 1.5 million works of art. **Highlights:** Egyptian col-
lection; American paintings and sculpture. **Architecture:**
560,000-square-foot Beaux-Arts structure by McKim, Mead
and White built in 1897.

Admission: Adults, $6; students and seniors, $3; members
and children under 12, free.

Hours: Wednesday through Friday, 10 a.m.–5 p.m.; Saturday and Sunday, 11 a.m.–6 p.m.; first Saturday of each month, 11 a.m.–11 p.m. Closed Monday and Tuesday, New Year's Day, Thanksgiving and Christmas Day.

Albright-Knox Art Gallery

1285 Elmwood Avenue, Buffalo, N.Y. 14222
(716) 882-8700
www.albrightknox.org

2002 EXHIBITIONS

Through January 6
The Triumph of French Painting
Nineteenth and early–20th-century works by Ingres, Corot, Manet, Monet, Renoir, Cézanne, van Gogh, Picasso, Matisse and others.

Through March 10
Following a Line: Part II
Seldom-seen drawings and mixed media on paper from 1940 to 2001, including works by Milton Avery, Joseph Cornell, Jim Dine and Sylvia Plimack Mangold.

January 26–April 7
The Tumultuous Fifties: A View From the New York Times Photo Archive
Nearly 200 black-and-white photographs focusing on the 1950's, a decade that included McCarthyism, Sputnik, Cold War politics, bebop and Abstract Expressionism. (Travels)

April 27–July 14
Edwin Dickinson
Retrospective featuring paintings and works on paper by this American artist, including landscapes, self-portraits, nudes, still lifes and large-scale compositions.

Opening May 11
New Room of Contemporary Art: Janet Cardiff
Using headphones, an artist walk through the gallery by this Canadian artist.

Edwin Dickinson,
An Anniversary, 1921.

Courtesy of the Albright-Knox Art Gallery.

May 11–July 28
Romare Bearden: Upstate New York Collectons
Works by this African-American artist, including lesser-known early works in watercolor and oil.

August 3–September 29
In WNY 2002
Works by artists of western New York.

October 19–January 12, 2003
Modigliani and the Artists of Montparnasse
The first major Modigliani (1884–1920) exhibition in the United States in 40 years, featuring approximately 45 paintings plus works by his contemporaries.

PERMANENT COLLECTION

Art through the centuries, starting from 3000 B.C. It is rich in 20th-century American and European works.

Admission: Adults, $5; seniors and students (13–18), $4; children 12 and under, free. Free on Saturday, 11 a.m.–1 p.m.
Hours: Tuesday through Saturday, 11 a.m.–5 p.m.; Sunday, noon–5 p.m. Closed Monday, Thanksgiving, Christmas Day and New Year's Day.

Herbert F. Johnson Museum of Art

Cornell University, Ithaca, N.Y. 14853
(607) 255-6464
www.museum.cornell.edu

2002 EXHIBITIONS

Through January 13
No Ordinary Land: Encounters in a Changing Environment
Photographs by Anne McPhee and Virginia Beahan that
capture nature's beauty and our impact on the environment.

Through January 13
Carlos Ulloa: Sculpture
Surreal collages by the contemporary Latino artist.

Through March 17
Red Grooms: Bus
A work characteristic of the artist: A New York City bus roars
into the museum, filled with eccentric passengers.

January 27–March 24
*Shaped With a Passion: The Carl A. Weyerhaeuser Collection of
Japanese Ceramics From the 1970's*
More than 100 works.

March 30–August 11
Photography Since 1950
A survey of major trends and ideas.

April 6–July 14
Oh Mona!
A look at the enduring fascination with one of Western art's
most famous paintings — Leonardo da Vinci's *La Gioconda,*
the *Mona Lisa* — and its subject's role as a popular icon.
Includes works by contemporary artists.

April 13–June 16
Redouté
Prints and watercolors from a private collection.

PERMANENT COLLECTION

Asian, American and European art; large collection of prints, drawings and photographs. **Architecture:** 1973 building by I.M. Pei, overlooking Lake Cayuga and the Cornell campus.

Admission: Free.
Hours: Tuesday through Sunday, 10 a.m.–5 p.m. Closed Monday, New Year's Day, Independence Day and Thanksgiving.

Isamu Noguchi Garden Museum

32–37 Vernon Boulevard (at 33rd Road), Long Island
 City (Queens), N.Y. 11106
(718) 721-1932
www.noguchi.org

The museum building will be closed through the spring of 2003 for a major renovation. The museum has relocated to a temporary space at 36-01 43rd Avenue, Long Island City, where changing exhibitions of works from the permanent collection will be shown.

PERMANENT COLLECTION

Works by Noguchi (1904–1988) in 13 galleries and a sculpture garden. More than 250 stone, wood and clay pieces, as well as his Akari light sculptures, dance sets and documentation of his gardens and playgrounds.

Admission: Adults, $4; students and seniors, $2.
Hours: Wednesday through Friday, 10 a.m.–5 p.m.; Saturday and Sunday, 11 a.m.–6 p.m.

P.S. 1 Contemporary Art Center

22–25 Jackson Avenue, at 46th Avenue, Long Island
 City (Queens), N.Y. 11101
(718) 784-2084
www.ps1.org

2002 EXHIBITIONS

Through January 2
Animations
Explores how visual artists are using animation today.

Through January 31
Janet Cardiff
Survey of the career of this Canadian artist known for her
audio and audio-video works.

Through January 31
Richard Deacon
Large outdoor works by this British sculptor designed
specifically for P.S. 1.

Opening Winter 2002
Loop
Explores the concept of the loop in contemporary projection
work and installations.

PERMANENT COLLECTION

P.S. 1, an affiliate of the Museum of Modern Art, is a noncol-
lecting institution that maintains long-term, site-specific
installations throughout its 125,000 square feet of gallery
space by artists including James Turrell, Pipilotti Rist,
Richard Serra, Lucio Pozzi, Julian Schnabel and Richard
Artschwager. A branch, the Clocktower Gallery at 108
Leonard Street in the TriBeCa section of Manhattan, is open
for special shows and events. **Architecture:** Romanesque
Revival school building, built from 1893 to 1906 and reno-
vated by Frederick Fisher with the addition of a courtyard and
a two-story project space.

Admission: Suggested donation: Adults, $5; students and
seniors, $2; members, free.

Hours: Wednesday through Sunday, noon–6 p.m. Closed
Monday, Tuesday and major holidays.

Storm King Art Center

Old Pleasant Hill Road, Mountainville, N.Y. 10953
(845) 534-3115
www.stormking.org

2002 EXHIBITIONS

Through November 2004
Grand Intuitions: Calder Monumental Sculpture
Largest exhibition ever of the artist's monumental sculptures.

PERMANENT COLLECTION

A 500-acre outdoor sculpture park and museum featuring
post-1945 works, many on a monumental scale. **Highlights:**
Isamu Noguchi, *Momo Taro*; Alexander Calder, *The Arch*; Mark
di Suvero, *Pyramidian*; Richard Serra, *Schunnemunk Fork*; Louise
Nevelson, *City on the High Mountain*; Andy Goldsworthy, *Storm
King Wall*; Kenneth Snelson, *Free Ride Home*; Magadalena
Abakanowicz, *Sarcophagi in Glass Houses*; 13 sculptures by
David Smith. **Architecture:** 1935 Normandy-style building
by Maxwell Kimball.

Admission: Adults, $9; seniors, $7; students, $5; members
and children under 5, free.
Hours: April 1–October 27, daily, 11 a.m.–5:30 p.m.;
October 28– November 15, 11 a.m.–5 p.m. Closed Novem-
ber 16–March 31.

American Craft Museum

40 West 53rd Street, New York, N.Y. 10019
(212) 956-3535
www.americancraftmuseum.org

2002 EXHIBITIONS

Through January 6
Mikromegas
Stickpins created by 220 artists from around the world.

Through January 6
Objects for Use: Handmade by Design
More than 400 works by 200 artists.

January 18–April 28
Wall Works: Glass
Works by 35 renowned glass artists from around the world.

January 18–April 28
The Lipton Collection of Wood
More than 50 pieces, including vessels and sculptures.

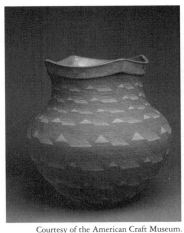

May 9–September 8
Changing Hands: Native American Arts Today
Contemporary works by 40 artists from the Southwest.

May 9–September 8
Zero Karats: Jewelry From the Donna Schneier Collection
Non-precious jewelry.

Courtesy of the American Craft Museum.
Richard Zane Smith, vase, 2001.

Works feature rubber, vinyl, tin, wood, glass and other mundane materials.

September 20–January 5, 2003
Body and Soul: Fiber Art Now
Contemporary works by artists from around the globe.

September 20–January 5, 2003
Elegant Fantasy: The Jewelry of Arline Fisch
A retrospective of the designer's four-decade career.

PERMANENT COLLECTION

Hand-crafted 20th-century works in the fields of art, design, architecture and fashion.

Admission: Adults, $7.50; students and seniors, $4.50; members and children under 12, free. Pay what you wish, Thursday, 6–8 p.m.
Hours: Tuesday through Sunday, 10 a.m.–6 p.m.; Thursday, until 8 p.m. Closed Monday and major holidays.

American Folk Art Museum

45 West 53rd Street, New York, N.Y. 10019
212-977-7170
www.folkartmuseum.org

Formerly known as the Museum of American Folk Art, the museum reopened in a new location in December 2001 while keeping its former space.

2002 EXHIBITIONS

Through April
American Anthem Part I: American Radiance
Selections from the Ralph Esmerian Collection, a gift to the museum of more than 400 works, including paintings, sculpture, pottery, needlework, fraktur, scrimshaw and furniture from the 18th and 19th centuries.

Through April
Darger: The Henry Darger Collection at the American Folk Art Museum
Double-sided paintings, manuscripts and books by this self-taught artist.

May–September
Masterworks From the Permanent Collection
New acquisitions of traditional and contemporary folk art.

PERMANENT COLLECTION

More than 4,000 works from the 18th, 19th and 20th centuries. Traditional folk paintings; sculpture, including weather

vanes, carousel animals and shop figures; painted and embell-
ished furniture; pottery; decorative objects; and works by con-
temporary and self-taught artists. **Highlights:** *Girl in Red
With Cat and Dog* by the 19th-century folk painter Ammi
Phillips; *Bird of Paradise,* c. 1860 quilt; *St. Tammany*, a nine-
foot-high molded copper weather vane; *Episode 3 Place Not
Mentioned/Battle Scene and Approaching Storm,* a double-sided
painting by the 20th-century self-taught artist Henry Darger.
Architecture: The museum's new home is a 30,000-square-
foot building by Tod Williams, Billie Tsien and Associates.

Admission: Adults, $9; students and seniors, $5; members
and children under 12, free.
Hours: Tuesday through Sunday, 10 a.m.–6 p.m., Friday,
until 8 p.m. Closed Monday.

Gallery at Lincoln Square

2 Lincoln Square, Columbus Avenue at 66th Street, New
York, N.Y. 10023
(212) 595-9533
www.folkartmuseum.org

2002 EXHIBITIONS

January 21–May
Studies and Sketches: Henry Darger
More than 75 drawings and studies revealing the artist's work-
ing methods.

Admission: Suggested donation, $3.
Hours: Daily, 11:30 a.m.–7:30 p.m.

Cooper-Hewitt, National Design Museum

Smithsonian Institution, 2 East 91st Street, New York, N.Y. 10128

(212) 849-8400

www.si.edu/ndm

2002 EXHIBITIONS

Through February 24

Glass of the Avant-Garde: From Secession to Bauhaus

The Torsten Bröhan collection, featuring 200 examples of early 20th-century glass from Austria, Bohemia and Germany. Includes Witwe Lötz art glass as well as vases, goblets and other objects by Josef Hoffmann, Koloman Moser and others.

Through March 10

Russel Wright: Creating American Lifestyle

A retrospective of the products and ideas developed and marketed by the industrial designer, whose mass-produced dinnerware, appliances, textiles and furniture helped make modern design accessible to the middle class.

April 22–September 8

Skin: Surface and Substance in Contemporary Design

An international mix of products, fashion, architecture and digital media, exploring the role of simulated skin.

Courtesy of the Cooper Hewitt National Design Museum.
Computer rendering of the proposed Oswango Delta Spa in Botswana, Africa, designed by Lindy Roy, 1998.

October 15–February 23, 2003
New Hotels for Global Nomads
Custom installations, models, drawings and photographs, as
well as furnishings, toiletries, souvenirs and other products.

PERMANENT COLLECTION

The only American museum devoted exclusively to design,
with more than 250,000 items, including drawings, prints,
textiles, furniture, metalwork, ceramics, glass, wallcoverings
and woodwork spanning 3,000 years and cultures from around
the world; a 50,000-volume library includes 5,000 rare books.
Architecture: 1902 Andrew Carnegie mansion by Babb,
Cook & Willard; a $20 million renovation completed in 1998.

Admission: Adults, $8; students and seniors, $5; children
under 12, free. Free on Tuesday, 5–9 p.m.
Hours: Wednesday through Saturday, 10 a.m.–5 p.m.; Tues-
day, until 9 p.m.; Sunday, noon to 5 p.m. Closed Monday and
federal holidays.

The Dahesh Museum of Art

601 Fifth Avenue, New York, N.Y. 10017
(212) 759-0606
www.daheshmuseum.org

2002 EXHIBITIONS

Through January 5
Telling Tales II: Religious Images in 19th-Century Academic Art
Works featuring biblical themes.

February 19–May 18
French Master Drawings From the Collection of Muriel Butkin
Sixty examples, most from the 18th and 19th centuries,
including works by François Boucher, Edgar Degas, Théodore
Géricault and Jean-François Millet.

June 4–August 24
*Fire and Ice: Treasures From the Photographic Collection of Frederic
Church at Olana*

Never-before-exhibited images that the landscape painter acquired to document his travels throughout the world.

September 10–December 7
Against the Modern: Jean Dagnan-Bouveret and the Transformation of the Academic Tradition
A retrospective of the Gérôme student's paintings, including early academic studies, naturalistic genre scenes, photo realism, portraits and religious compositions.

PERMANENT COLLECTION

European academic art from the 19th and early 20th centuries. **Highlights:** Works by William Adolphe Bouguereau, Lord Leighton and Alexandre Cabanel. **Architecture:** 1911 commercial building.

Admission: Free.
Hours: Tuesday through Saturday, 11 a.m.–6 p.m. Closed Sunday, Monday, New Year's Day, Independence Day, Thanksgiving and Christmas Day.

Dia Center for the Arts

548 West 22nd Street, New York, N.Y. 10001
(212) 989-5566
www.diacenter.org

2002 EXHIBITIONS

Through January
Diana Thater: Knots + Surfaces
Large-scale, multiprojection video installation by a Los Angeles–based artist.

Through June
Alfred Jensen
Works by Jensen (1903–1981) drawing on science and the Mayan and ancient Chinese calendrical systems.

Through June
Rani Horn

Courtesy of the Dia Center for the Arts.

Alfred Jensen, *Remote Sensing, Per I and II*, 1979.

New photograph-based works and a glass sculpture by a New York City-based artist.

Through June
Jorge Pardo: Project
New installation on the ground floor of the center.

PERMANENT COLLECTION

The collection features works by artists who came to maturity in the 1960's and 1970's, including Joseph Beuys, John Chamberlain, Walter De Maria, Dan Flavin, Donald Judd, Imi Knoebel, Blinky Palermo, Fred Sandback, Cy Twombly, Andy Warhol and Robert Whitman. **Architecture:** Two industrial spaces renovated by Richard Gluckman Architects: a four-story warehouse at 548 West 22nd Street and a one-story former garage at 545 West 22nd Street.

Admission: Adults, $6; students and seniors, $3; members and children under 10, free.
Hours: Wednesday through Sunday, noon–6 p.m. Closed Monday and Tuesday.

The Frick Collection

1 East 70th Street, New York, N.Y. 10021
(212) 288-0700
www.frick.org

2002 EXHIBITIONS

Through February 17
The Art of the Timekeeper: Masterpieces From the Winthrop Edey Bequest
Thirteen clocks and eight watches, from about 1500 to 1830.

May 14–August 4
Greuze the Draftsman
Approximately 60 drawings by the 18th-century French artist Jean-Baptiste Greuze. (Travels)

PERMANENT COLLECTION

The holdings of a private collector. Works by Bellini, El Greco, Rembrandt, Titian, Turner, Vermeer and Whistler. **Highlights:** Bellini, *St. Francis in Ecstasy*; della Francesca, *St. John the Evangelist*; van Eyck, *Virgin With Child, With Saints and Donor*; Vermeer, *Officer and Laughing Girl*; Holbein, *Sir Thomas More and Thomas Cromwell*; Rembrandt, *Self-Portrait*; Stuart, *George Washington*. **Architecture:** 1913–1914 Gilded Age mansion by Thomas Hastings; 1931–1935 addition by John Russell Pope; 1977 garden by Russell Page.

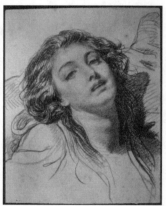

Courtesy of the Frick Collection.
Jean-Baptiste Greuze, *Head of a Woman*, 1765.

Admission: Adults, $10; students and seniors, $5; children under 10 are not admitted, and those under 16 must be accompanied by an adult.
Hours: Tuesday through Saturday, 10 a.m.–6 p.m.; Sunday, 1–6 p.m.; Lincoln's Birthday, Election Day and Veterans Day, 1–6 p.m. Closed Monday, New Year's Day, Independence Day, Thanksgiving, Christmas Eve and Christmas Day.

Solomon R. Guggenheim Museum

1071 Fifth Avenue, New York, N.Y. 10128
(212) 423-3500
www.guggenheim.org

2002 EXHIBITIONS

Through January 20
Brazil: Body and Soul
Works reflecting the cultural diversity and the integration of
physical and spiritual experience in Brazilian art.

Through March 3
Norman Rockwell: Pictures for the American People
Comprehensive exhibition spanning more than 60 years of the
artist's career, including 70 oil paintings and all 322 of the
covers he created for The Saturday Evening Post.

February 15–May 5
*Matthew Barney:
The CREMASTER Cycle*
A five-part film project
accompanied by related
sculptures, photographs
and drawings.

May 30–September 4
*Kazimir Malevich: Suprema-
tism*
About 120 paintings,
drawings and objects by
Malevich, who between
1915 and 1932 developed a
system of abstract painting
meant to be comprehensi-
ble to all cultures.

Courtesy of the Solomon R. Guggenheim Museum.
Matthew Barney, production still from
CREMASTER 5, 1997.

May 30–September 4
*Art and the Holy Image: The Rise of Russian Icon Painting, 14th
Through 16th Century*
More than 100 icons exploring the aesthetics and ideology of
sacred images between the 14th and 16th centuries.

September 27–January 19, 2003
James Rosenquist: A Retrospective
First comprehensive survey since 1972 of this leading Pop
artist's work, which uses images from advertising.

PERMANENT COLLECTION

Significant holdings of Kandinsky, Picasso, Brancusi and Cha-
gall, as well as major works by Arp, Beuys, Bourgeois,
Cézanne, Flavin, Mapplethorpe, Pollock, Rothko, Rauschen-
berg, Serra, van Gogh and Warhol. **Architecture:** Landmark
1959 building by Frank Lloyd Wright; 1992 wing by Gwath-
mey Siegel & Associates.

Admission: Adults, $12; students and seniors, $8; children
under 12, free. Pay what you wish, Friday, 6–8 p.m.
Hours: Sunday through Wednesday, 9 a.m.–6 p.m.; Friday and
Saturday, until 8 p.m. Closed Thursday and Christmas Day.

Guggenheim Museum SoHo

575 Broadway (at Prince Street), New York, N.Y. 10012
(212) 423-3500
www.guggenheim.org

Architecture: A loft building designed in 1993 by Arata
Isozaki.

Admission: Free
Hours: Thursday through Monday, 11 a.m.–6 p.m. Closed
Tuesday and Wednesday.

International Center of Photography

1133 Avenue of the Americas, New York, N.Y. 10036
(212) 860-1778
www.icp.org

2002 EXHIBITIONS

January 11–March 17
Hidden Truths: Bloody Sunday 1972
Images of the shooting of Irish civil rights activists by British
soldiers in Derry, Ireland.

January 11–March 17
New Histories of Photography 3: The First Snapshots
Amateur photographs taken after the first handheld Kodak
cameras went on sale in 1888.

January 11–March 17
*Imaging the Future 2: Foreign Body — Photography and the Pre-
lude to Genetic Modification*
Depictions of physical anomalies in medical and scientific
photographs and popular imagery over the years.

March 29–June 16
Dream Street: Photographs by W. Eugene Smith
Photographs of Pittsburgh in 1955 when it was at its peak as
America's industrial center.

March 29–June 16
*Rise of the Picture Press: Photographic Reportage and the Illustrated
Press, 1918–1939*
Explores the growth of large-format illustrated magazines
around the world, such as Life in the United States and the
Berliner Illustrirte Zeitung in Germany.

March 29–June 16
*New Histories of Photography 4: Photography and the Book —
Selections From the Richard and Ronay Menschel Library*
Explores how the photograph gradually became assimilated
with the printed page between 1839 and 1900.

June 28–September 1
*A Portrait in Time: New Jersey Urban Landscapes — Photographs
by George Tice*

New York

Images of the diners, shops, housing developments, movie theaters and gas stations of urban and suburban New Jersey.

June 28–September 1
Manual: From Analog to Digital
Retrospective of the collaborative electronic works of Suzanne Bloom and Ed Hill.

Uptown branch

1130 Fifth Avenue, New York, N.Y., 10128
(212) 860-1777

PERMANENT COLLECTION

More than 55,000 prints, including works by Berenice Abbott, Cornell and Robert Capa, Alfred Eisenstadt and Weegee, as well as contemporary prints. **Architecture:** Midtown location: designed by Gwathmey Siegel. Uptown location: 1915 neo-Georgian building by Delano and Aldrich.

Admission: Adults, $8; students and seniors, $6; children under 12 and members, free.
Hours: Tuesday through Thursday, 10 a.m.–5 p.m.; Friday, until 8 p.m.; Saturday and Sunday, 10 a.m.–6 p.m. Closed Monday.

The Jewish Museum

1109 Fifth Avenue, New York, N.Y. 10128
(212) 423-3200
www.thejewishmuseum.org

2002 EXHIBITIONS

Through February 10
Arnold Dreyblatt: Recollection Mechanism
A multimedia exhibition with projected and recited text.

Through February 10
Ben Katchor
Illustrations, graphic novels, set design and drawings.

Courtesy of the Jewish Museum.

Ben Katchor, production still from *Julius Knipl, Real Estate Photographer: Stories*, 1996.

Through February 10
Doug and Mike Starn: Rampart's Café
The twin brothers' multimedia installation invites visitors to pull up a chair at a Jerusalem cafe.

Through March 17
The Emergence of Jewish Artists in 19th-Century Europe
Works by Jozef Israëls, Max Liebermann, Camille Pissarro, Simeon Solomon and others.

April 28–September 29
New York: Capital of Photography
Nearly 100 photographs chronicling the changing face of New York City during the 20th century, including works by Diane Arbus, Henri Cartier-Bresson, Walker Evans, Helen Levitt, Ben Shahn, Alfred Stieglitz and Weegee.

Continuing
Camels and Caravans: Daily Life in Ancient Israel
Re-creating a home and a marketplace setting, the exhibition includes antiquities from the museum's collection, as well as hands-on activities for children and adults.

PERMANENT COLLECTION

More than 28,000 objects that span 4,000 years, from ancient artifacts to contemporary art. **Includes** Israeli archaeological artifacts; textiles; ceremonial objects; paintings, drawings and prints by Marc Chagall, David Bomberg, Max Weber and Deborah Kass. **Highlights:** George Segal's sculpture *The Holocaust*. **Architecture:** 1908 Warburg mansion by Gilbert; 1959 sculpture court; 1963 List Building; 1993 renovation and expansion by Roche, Dinkeloo and Associates.

Admission: Adults, $8; students and seniors, $5.50; children under 12, free. Pay what you wish, Tuesday, 5–8 p.m.
Hours: Sunday through Thursday, 11 a.m.–5:45 p.m.; Tuesday, until 8 p.m. Closed Friday, Saturday and major legal and Jewish holidays.

The Metropolitan Museum of Art

Fifth Avenue at 82nd Street, New York, N.Y. 10028
(212) 879-5500; (212) 535-7710 (recording)
www.metmuseum.org

2002 EXHIBITIONS

Through March 3
Extreme Beauty: The Body Transformed
The extreme strategies practiced on different parts of the body — from foot binding to neck elongation — in the quest for beauty throughout history and across cultures.

Through August 4
Splendid Isolation: Art of Easter Island
Explores the artistic heritage of this remote Pacific island, featuring rarely seen works in wood, stone and other media.

January 15–April 21
Earthly Bodies: Irving Penn's Nudes, 1949–1950
Approximately 80 intimate, noncommercial works from the collection of one of the world's great photographers.

January 23–April 21
Benjamin Breckness Turner: Rural England Through a Victorian Lens
Some 40 rare and richly toned prints created in the early 1850's by this photographer of English country scenes.

February 1–May 5
Surrealism: Desire Unbound
Explores Surrealism's preoccupation with desire through sculpture, drawings, prints, photographs, films, poetry and texts by Dalí, Duchamp, Ernst, Magritte, Picasso, Man Ray and other pioneering 20th-century artists.

February 14–May 12
Orazio and Artemisia Gentileschi: Father and Daughter Painters in Baroque Italy
The first full-scale exhibition devoted to a follower of Caravaggio, Orazio Gentileschi (ca. 1562–ca. 1647), and to Orazio's daughter, Artemisia (1593–ca. 1651).

Courtesy of the Metropolitan Museum of Art.
Artemisia Gentileschi, *Judith Slaying Holofernes*, ca. 1611-13.

March 6–June 16
Treasures from a Lost Civilization: Ancient Chinese Art From Sichuan
More than 120 monumental bronze images of deities, lively human figures, bronze vessels, jades and ceramic sculptures from the 13th century B.C. to the 3rd century A.D.

March 14–June 16
Tapestry in the Renaissance: Art and Magnificence
The first major survey of tapestry production between 1460 and 1560, along with preparatory drawings.

May–Late Fall
The Iris and B. Gerald Cantor Roof Garden
Modern sculpture with a panoramic view of the Manhattan skyline.

May–August
Head to Toe
Hats, combs, gloves, bags, belts and shoes from the Costume

Institute tracing the evolution of accessories from the 1700's to the present.

June–Early September
Summer Selections: American Drawings and Watercolors in the Metropolitan
Sampling of drawings, watercolors and pastels by 18th- and 19th-century American artists.

June 18–September 15
Thomas Eakins
The first comprehensive survey of the artist (1844-1916) in 30 years, featuring some 200 oil paintings, watercolors, drawings, photographs and sculptures.

June 18–October 20
Gauguin in New York Collections
Paintings, drawings, sculpture and prints by Paul Gauguin from the museum's collection and other New York public and private collections.

June 18–September 8
Impressionist and Post-Impressionist Paintings from the Ordrupgaard Collection

September–December
Ancient Ornaments from the Eastern Eurasian Steppes: The Eugene Thaw Collection
Some 200 bronze and gold ornaments, mostly dating from the sixth century B.C. to the second century A.D.

September–November
Epigrams: Describing Style
Juxtaposes literary descriptions of dress with actual garments from the vast holdings of the Costume Institute.

September 10–March 2, 2003
Chi Wara Headdresses From Mali
Some 50 examples of Bamana headdresses, whose linear compositions and elegant abstractions have made them among the most widely known and appreciated of African art forms.

September 26–January 5, 2003
Avedon's Portraits
About 100 photographic portraits from Avedon's entire career, including his earliest photographs of Sicilian street children in the late 1940's and his portraits of key artistic,

intellectual and political figures from the late 1950's through the early 1970's.

October 22–January 5
Theodore Chasseriau

October 28–February 16, 2003
The Legacy of Genghis Khan: Courtly Art and Culture in Western Asia, 1256–1353
Illustrated books, works in the decorative arts and architectural decoration from the period of Ilkhanid rule in the Iranian region.

November 25–May 25, 2003
Italian Manuscripts

December–April 2003
The Windsor Moment: 1935–1940

PERMANENT COLLECTION

One of the world's largest and most comprehensive museums. **Highlights:** New Greek Galleries; New Cypriot Galleries; Mary and Michael Jaharis Galleries for Byzantine Art; Temple of Dendur; Chinese Astor Court; American Wing; European Paintings; the Cloisters, in Fort Tryon Park, Manhattan, devoted to medieval art. **Architecture:** Vaux and Mould (1880); Richard Morris Hunt and son (1902); McKim, Mead and White (1911, 1913); Kevin Roche John Dinkeloo and Associates (recent wings).

Admission: Suggested donation: Adults, $10; seniors and students, $5; children under 12 with an adult, free.
Hours: Sunday, Tuesday through Thursday, 9:30 a.m.–5:30 p.m.; Friday and Saturday, until 9 p.m. Closed Monday, New Year's Day, Thanksgiving and Christmas Day. The Cloisters: Tuesday through Sunday, November through February, 9:30 a.m.–4:45 p.m.; March through October, until 5:15 p.m.

The Morgan Library

29 East 36th Street, New York, N.Y. 10016
(212) 685-0610
www.morganlibrary.org

2002 EXHIBITIONS

Through January 13
Cottontails and Corgis: The Children's Books of Beatrix Potter and Tasha Tudor

Through January 13
Oscar Wilde: A Life in Six Acts
Manuscripts and other printed works, as well as drawings, photographs, theater programs, ephemera, juvenilia and personal possessions.

Through January 20
Views of Yellowstone: William Henry Jackson Photographs From the Gilder Lehrman Collection
Approximately 50 albumen prints produced in 1871, along with a group of stereoscopic cards. Historical documents help explain the photographs' role in the creation of the first national park, one year later.

February 14–May 19
Pierre Matisse and His Artists
Archival records from the New York City gallery run by Matisse, an art dealer and son of the artist Henri Matisse. The exhibition includes some tribal art.

Continuing
Collecting for the Centuries
Manuscripts, books, bindings and drawings.

PERMANENT COLLECTION

Rare books, manuscripts and drawings that focus mainly on the history, art and literature of Western civilization from the Middle Ages to the 20th century. **Highlights:** The ninth-century Lindau Gospels; three copies of the Gutenberg Bible; the Hours of Catherine of Cleves; Dürer's *Adam and Eve*; drawings by da Vinci, Rubens and Degas; the autographed manuscript of Mozart's "Haffner" Symphony; original manuscripts by

Charlotte Brontë and John Steinbeck; several hundred letters from George Washington and Thomas Jefferson; the Carter Burden Collection of American Literature and the Pierre Matisse Gallery Archives.

Admission: Suggested donation: Adults, $8; students and seniors, $6; children 12 and under accompanied by an adult, free.
Hours: Tuesday through Thursday, 10:30 a.m.–5 p.m.; Friday, until 8 p.m.; Saturday, until 6 p.m.; Sunday, noon–6 p.m. Closed Monday and major holidays.

El Museo del Barrio

1230 Fifth Avenue, New York, N.Y. 10029
(212) 831-7272
www.elmuseo.org

PERMANENT COLLECTION

Some 8,000 objects of Caribbean and Latin American art, including 20th-century prints, drawings, paintings, sculptures, installations, photography, film and videos, as well as pre-Columbian Taino artifacts.

Admission: Adults, $4; students and seniors, $2; members and children under 12 accompanied by adult, free.
Hours: Wednesday through Sunday, 11 a.m.–5 p.m.; Thursday during the summer, until 8 p.m. Closed Monday, Tuesday, New Year's Day, Thanksgiving and Christmas Day.

Museum for African Art

593 Broadway, New York, N.Y. 10012
(212) 966-1313
www.africanart.org

2002 EXHIBITIONS

February 15–August 15
Material Differences in African Art
About 100 works focusing on materials used in African art
and their symbolic meaning.

PERMANENT COLLECTION

Permanent collection under development. **Architecture:**
1860's building; interior redesigned by Maya Lin.

Admission: Adults, $5; seniors, students and children, $2.50.
Free on Sunday and from 5:30–8:30 p.m. the third Thursday
of each month.
Hours: Tuesday through Friday, 10:30 a.m.–5:30 p.m.; third
Thursday of each month, until 8:30 p.m.; Saturday and Sun-
day, noon–6 p.m. Closed Monday and major holidays.

Museum of Modern Art

11 West 53rd Street, New York, N.Y. 10019
(212) 708-9400; (212) 247-1230 (for the deaf)
www.moma.org

The museum will move temporarily to Queens in mid-2002
because of a building project. It is expected to reopen in late
2004 or early 2005.

2002 EXHIBITIONS

Through January 8
Alberto Giacometti
Some 90 sculptures, 40 paintings and 60 drawings, including
examples from each of the Swiss artist's major periods.

Through February 19
Collection Highlights

Familiar icons of early modern art, including van Gogh's *The Starry Night* and Picasso's *Les Demoiselles d'Avignon*, as well as examples of the museum's more recent holdings.

February 21–May 21
Gerhard Richter: Forty Years of Painting
A retrospective that includes subtly modulated photo-based works, monochrome abstractions and heavily painted, highly colored canvases.

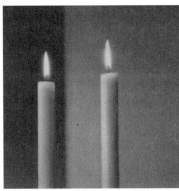

March 21–June 11
The Russian Avant-Garde Book, 1910–1934
More than 300 illustrated books and graphic designs by Kasimir Malevich, El

Courtesy of the Museum of Modern Art.
Gerhard Richter, *Two Candles*, 1982.

Lissitzky, Olga Rozanova, Natalia Goncharova and others. The exhibition explores a variety of genres, including children's literature, Judaica, periodicals, exhibition catalogs and sheet music.

PERMANENT COLLECTION

More than 100,000 paintings, sculptures, drawings, prints, photographs, architectural models and drawings and design objects as well as some 14,000 films and four million film stills. **Highlights:** Cézanne, *The Bather*; Chagall, *I and the Village*; van Gogh, *Portrait of Joseph Roulin* and *The Starry Night*; Hopper, *House by the Railroad*; Matisse, *The Blue Window*; Mondrian, *Broadway Boogie-Woogie*; Monet, *Waterlilies*; Picasso, *Les Demoiselles d'Avignon* and *Three Musicians*; Rauschenberg, *Bed*; Rousseau, *The Sleeping Gypsy*; sculpture garden. **Architecture:** 1939 building by Goodwin and Stone. New expansion project designed by Yashio Taniguchi.

Admission: Adults, $10; students and seniors, $6.50; children under 16 accompanied by an adult, free. Pay what you wish, Friday, 4:30–8:15 p.m.
Hours: Saturday through Tuesday, 10:30 a.m.–5:45 p.m.; Friday, until 8:15 p.m. Closed Wednesday.

MoMA QNS

45-20 33rd Street, at Queens Boulevard, Long Island
City, N.Y. 11101
(212) 708-9400; (212) 247-1230 (for the deaf)

2002 EXHIBITIONS

Opening in June
Collection Highlights

October 17–January 7, 2003
Contemporary Drawings: Eight Propositions
Works by more than three dozen artists.

National Museum of the American Indian

George Gustav Heye Center, Smithsonian Institution,
One Bowling Green, New York, N.Y. 10004
(212) 668-6624
www.si.edu/nmai

2002 EXHIBITIONS

Through April 28
All Roads Are Good: Native Voices on Life and Culture
More than 300 objects from the museum's collection.

Through May 19
Across Borders: Beadwork in Iroquois Life
More than 300 items, including clothing, picture frames and
souvenir pincushions, made since the mid-19th century.

Through June
The New Old World
Approximately 70 photographs that reflect the cultural
continuance of the indigenous peoples from the Greater
Antilles (including areas in Puerto Rico and the Dominican
Republic) and the Lesser Antilles (where Carib communities
are found in Dominica and Trinidad).

Through July 21
Spirit Capture: Native Americans and the Photographic Image
Images of and by Native Americans. The exhibition explores
the photographers' motives and their subjects' thoughts.

June 16–March 15, 2003
Great Masters of Mexican Folk Art
More than 800 works by 183 artists. Materials include clay, wood, straw, leather, silk, cotton, metal and stone. (Travels)

PERMANENT COLLECTION

The Heye center is named for the collector who amassed more than one million Indian artifacts in his travels through the Americas. Wood, horn and stone carvings from the Northwest Coast of North America; Navajo weaving and blankets; archaeological objects from the Caribbean; textiles from Peru and Mexico; basketry from the Southwest; gold works from Colombia, Mexico and Peru; Aztec mosaics; painted hides and garments from the North American Plains Indians. **Architecture:** Landmark 1907 Beaux-Arts building by Cass Gilbert, originally the Alexander Hamilton United States Custom House.

Admission: Free.
Hours: Daily, 10 a.m.–5 p.m.; Thursday, until 8 p.m. Closed Christmas Day.

New Museum of Contemporary Art

583 Broadway, New York, N.Y. 10012
(212) 219-1222
www.newmuseum.org

2002 EXHIBITIONS

Through January 13
Jacqueline Fraser: Portrait of the Lost Boys
Walk-through installation of sumptuous fabric and wire figures on the theme of the high incidence of teenage suicide in boys.

Through January 13
A Work in Progress: Selections From the New Museum Collection
Conceptual art, performance, photography, painting, political art, new media and installation art are represented.

Through February 3
Jason Middlebrook, Dig

New York

Site-specific project around the perimeter ledge mimicking an excavation site.

Through February 3
Tom Friedman
Sculpture, works on paper and photographs by an artist who uses everyday materials such as sugar cubes, gum and aspirin.

Through February 3
Open Source Lounge
Profiles local and international Web-based projects whose source codes are publicly available, allowing viewers to distribute and adapt the work.

Through December 30
Cin-o-Matic: Memory and Cinematic Perception
Explores the impact of new media on the moving image.

January 25–April 14
Wim Delvoye, Cloaca
Installation built of laboratory glassware, electric pumps, computer monitors and plastic tubing, intended to duplicate the human digestive system.

February 14–April 21
The Films of Francesco Vezzoli
Brief films in which private fantasies are played out by figures from the film and fashion world.

February 22–June 2
Marlene Dumas, Name No Names
Works on paper inspired by imagery from films stars such as Brigitte Bardot and art icons such as Manet's Olympia.

May 2–July 14
Leah Gilliam: Agenda for a Landscape
Interactive exhibition about the 1997 Mars Pathfinder mission.

May 17–August 11
José Antonio Hernández-Diez
Sculpture and multimedia installations by a Venezuelan artist.

Admission: Adults, $6; artists, students and seniors, $3; children under 19, free. Thursday, 6–8 p.m., free.
Hours: Tuesday through Saturday, noon–6 p.m.; until 8 p.m., Thursday. Closed Monday.

Studio Museum in Harlem

144 West 125th Street, New York, N.Y. 10027
(212) 864-4500
www.studiomuseuminharlem.org

2002 EXHIBITIONS

January 30–March 30
Yinka Shinobare
Works by an artist who grew up in the UK and Nigeria and
whose sculptures, installations and photographs explore the
black British experience and the African diaspora.

January 30–March 30
Jacob Lawrence

April 23–June 24
Black Romantic
Paintings, drawings and sculptures based on figurative
imagery.

July 10–September 22
The Color Yellow: Beauford Delaney
More than 30 paintings focusing on the artist's use of yellow
in both figurative and abstract works. (Travels)

July 10–September 22
*Artists-in-Residence 2001–2002: Kira Lynn Harris, Adia Millet
and Kehinde Wiley*
Works by the three artists.

October 9–January 3, 2003
Gary Simmons
Works by a contemporary artist addressing identity.

PERMANENT COLLECTION

Traditional and contemporary African art and artifacts, 19th-
and 20th-century African-American art and 20th-century
Caribbean art. **Highlights:** Works by Romare Bearden, Eliza-
beth Catlett, Jacob Lawrence and Norman Lewis; the James
Van Der Zee photographic archives. **Architecture:** 19th-
century building renovated by Max Bond in 1982; extensive
renovations 1998–99.

Admission: Adults, $5; seniors and students, $3; children under 12, $1; members, free. Free on first Saturday of each month.
Hours: Wednesday through Friday, 10 a.m.–5 p.m.; Saturday and Sunday, 1–6 p.m. Closed Monday, Tuesday and major holidays.

Whitney Museum of American Art

945 Madison Avenue, New York, N.Y. 10021
(212) 570-3676; (877) WHITNEY
www.whitney.org

2002 EXHIBITIONS

Through January 7
First Exposure: Sharon Harper's Photographs From the Floating World
Black-and-white images of rural landscapes taken from a high-speed train, plus an installation of cloud photographs toned with metallic colors.

Through January 27
Into the Light: The Projected Image in American Art, 1964-1977
Film, video and slide-installation works by Vito Acconci, Dan Graham, Robert Morris, Bruce Nauman, Yoko Ono, Andy Warhol and others.

Courtesy of the Whitney Museum of American Art. Mary Lucier, Polaroid Image Series: *Shigeko*, ca. 1970.

Through February 3
Over the Line: The Art and Life of Jacob Lawrence
A retrospective of the modernist painter's work.

Through February 24
Paul Pfeiffer
A new video installation by the Whitney artist-in-residence.

January 12–May 12
Dancer: 1999 Nudes by Irving Penn
Series of nudes that the photographer shot when he was 82
years old. (Travels)

March 7–May
2002 Biennial

PERMANENT COLLECTION

Some 12,000 works of art representing more than 1,900
artists, especially 20th-century and contemporary American
art. **Highlights:** The artistic estate of Edward Hopper; signifi-
cant works by Marsh, Calder, Gorky, Hartley, O'Keeffe,
Rauschenberg, Johns and others. **Architecture:** 1966 build-
ing by Marcel Breuer.

Admission: Adults, $10; seniors and students, $8; members and
children under 12, free. Pay what you wish, Friday, 6–9 p.m.
Hours: Tuesday through Thursday and Saturday-Sunday, 11
a.m.–6 p.m.; Friday, 1–9 p.m. Closed Monday.

Whitney Museum of American Art at Philip Morris

120 Park Avenue at 42nd Street, New York, N.Y. 10017
(917) 663-2453

2002 EXHIBITIONS

Through January 4
Alex Katz: Small Paintings
Approximately 75 works, from the mid-1950's to the present.

Admission: Free.
Hours: Gallery: Monday through Friday, 11 a.m.–6 p.m.;
Thursday, until 7:30 p.m. Sculpture court: Monday through Sat-
urday, 7:30 a.m.–9:30 p.m.; Sunday and holidays, 11 a.m.–7 p.m.

Purchase

Neuberger Museum of Art

Purchase College, State University of New York, 735
 Anderson Hill Road, Purchase, N.Y. 10577
(914) 251-6100
www.neuberger.org

2002 EXHIBITIONS

Through January 6
Howard Ben Tré
Thirty cast glass sculptures, 11 works on paper and four public art projects created by the internationally recognized glass artist between 1984 and 1999.

Through January 6
Grace Hartigan
Fifteen large-scale major works from 1950 to the present reflecting themes drawn from popular culture, the urban landscape, classical mythology, fantasy and autobiography.

Courtesy of the Neuberger Museum of Art.
Grace Hartigan, *Society Wedding*, 1988.

Through January 13
The Lawrence Gussman Collection of Central African Art
Seventy-five pieces of African art from a gift to the Neuberger and other art museums. (Travels)

February 3–May 5
Beyond the Pale
Works by 14 artists who have pushed painting and sculpture beyond traditional categories of figuration and abstraction.

February 3–May 19
Renewing Tradition: The Revitalization of Bogolan in Mali and Abroad
Explores the responses of the Malian textile tradition called bogolan (known as "mudcloth" in the United States) to modern-day influences.

May 19–September 8
Nature Takes a Turn
Juried exhibition of works of utilitarian woodturning.

June 16–September 8
The Art of Nathan Oliveira
Paintings, monotypes, drawings, watercolors and sculpture by
this 20th-century American artist.

June 17–September 2
Marisol
Selections from the sculptor's work since the 1950's.

September 9–January 13, 2002
Central African Art From the Lawrence Gussman Collection
Among the 75 works in this exhibition are several reliquary
guardian figures from Gabon and a rare harp used in religious
rituals. (Travels)

Continuing
Selections From the Roy R. Neuberger Collection
More than 60 pieces of American art, including works by
Avery, Diebenkorn, Frankenthaler, Hartigan, Hopper,
Noguchi and Pollock.

Continuing
African Art From the Permanent Collection
Works from the last two centuries that reflect African tradi-
tions, rites and religious beliefs.

Continuing
Ancient Civilizations: The Roy R. Neuberger Collection
Art from Greek, Roman, Mesopotamian and Egyptian civi-
lizations.

PERMANENT COLLECTION

More than 6,000 paintings, sculpture, prints, photographs and
works on paper, including works by Avery, Bearden, de Koon-
ing, Frankenthaler, Graves, Hopper, Lawrence, O'Keeffe, Pol-
lock and Rothko. **Highlights:** The Roy R. Neuberger Collec-
tion of American Art and ancient artifacts; the Aimee W.
Hirshberg Collection of African Art; the Lawrence Gussman
Collection of African Art; the George and Edith Rickey Col-
lection of Constructivist Art; the Hans Richter Bequest of
Dada and Surrealist Objects. **Architecture:** 1974 building by
Philip Johnson and John Burgee.

Admission: Adults, $4; seniors and students, $2; children
under 13, free.

Purchase/Rochesteer

Hours: Tuesday through Friday, 10 a.m.–4 p.m.; Saturday and Sunday, 11 a.m.–5 p.m. Closed Monday and major holidays.

Memorial Art Gallery of the University of Rochester

500 University Avenue, Rochester, N.Y. 14607
(716) 473-7720
mag.rochester.edu

2002 EXHIBITIONS

Through January 13
American Spectrum: Painting and Sculpture From the Smith College Museum of Art
More than 60 paintings and 14 sculptures, including works by Alexander Calder, John Singleton Copley, Winslow Homer, Edward Hopper and Georgia O'Keeffe. (Travels)

February 17–April 21
Ken Aptekar: Eye Contact
Paintings inspired by those in museum collections, with text superimposed — in a variety of voices — to help viewers make their own connections.

February 17–April 21
Sandy Skoglund: Breathing Glass
Mosaic-encrusted mannequins floating upside down, with a backdrop featuring thousands of handmade glass dragonflies.

June 16–September 15
Circa 1900: From the Genteel Tradition to the Jazz Age
Paintings, sculpture, photographs and decorative arts by Paul Cézanne, Winslow Homer, Frederick MacMonnies and others.

October 13–January 5, 2003
Degas in Bronze
Little Dancer and 73 other sculptures, plus selected paintings and works on paper.

Continuing
New Acquisitions for a New Millennium

Two dozen works, including a Walter Goodman painting, a Dale Chihuly glass sculpture and the coffin of an Egyptian nobleman from the fourth century B.C.

Continuing
About Face: Copley's Portrait of a Colonial Silversmith
An interactive installation that explores the lives and times of the artists John Singleton Copley and Nathaniel Hurd.

PERMANENT COLLECTION

Some 10,000 works spanning 50 centuries, including works by Monet, Cézanne, Matisse, Homer, Cassatt, Wendell Castle, Albert Paley and Helen Frankenthaler. **Architecture:** 1913 neo-Renaissance building by Foster, Gade and Gram; 1927 addition by McKim, Mead and White; 1987 sculpture pavilion by Handler, Grosso.

Admission: Adults, $7; students and senior citizens, $5; children 6–18, $3; members and children 5 and under, free. Tuesday, 5–9 p.m., $2.

Hours: Tuesday, noon–9 p.m.; Wednesday through Friday, 10 a.m.–4 p.m.; Saturday, 10 a.m.–5 p.m.; Sunday, noon–5 p.m. Closed Monday, Independence Day, Christmas Day and New Year's Day.

Munson-Williams-Proctor Institute

310 Genesee Street, Utica, N.Y. 13502
(315) 797-0000
www.mwpi.edu

2002 EXHIBITIONS

Through January 12
Al Wardle: Master Silversmith
Hand-wrought sterling silver hollowware, including chalices, teapots, bowls, pitchers and wall reliefs.

Through January 27
The 59th Exhibition of Central New York Artists
A juried show featuring a variety of media.

March 9–April 28
Winslow Homer and His Contemporaries: American Prints From the Metropolitan Museum of Art
Homer apprenticed with a printmaker and refined his skills recording the Civil War for Harper's Weekly.

June 1–August 25
Substance, Not Shadow: Daguerrotypes From the George Eastman House Collection
Includes portraits, street scenes, landscapes and interior views dating from the 1840's and 1850's.

Permanent Collection

More than 25,000 works, mainly American and European paintings and sculptures from the 18th, 19th and 20th centuries; decorative arts; Western and Asian graphic arts; Asian and pre-Columbian antiquities. **Highlights:** Proctor watch, thimble, manuscript and rare book collections; Thomas Cole, *The Voyage of Life*. **Architecture:** 1960 gallery building by Philip Johnson with connecting wing to Fountain Elms, a restored 1850 Italianate mansion.

Admission: Free.
Hours: Tuesday through Saturday, 10 a.m.–5 p.m.; Sunday, 1–5 p.m. Closed Monday, New Year's Day, Thanksgiving and Christmas Day.

Mint Museum of Art

2730 Randolph Road, Charlotte, N.C. 28207
(704) 337-2000
www.mintmuseum.org

2002 Exhibitions

Through May 31
Art Glass From the McDorman Collection
About 30 examples of American and European art glass dating from 1875 to 1920.

January 26–April 14
The Gilded Age: Treasures From the Smithsonian's American Art Museum
Works by American artists in the three decades before World War I, reflecting a new sophistication and elegance.

March 2–July 28
Pierre Joseph Redouté: A Man Passionate About Flowers
Twenty-four 19th-century botanical hand-colored engravings.

May 18–July 14
The Allure of East Asia
Furniture, ceramics, ivory carvings, folding screens and textiles from East Asia, particularly China and Japan.

July 27–October 21
Charlotte's Romare Bearden
Works, primarily collages, by this Charlotte-born artist.

August 23–October 25
Narratives of African-American Art and Identity: The David C. Driskell Collection
More than 100 paintings by leading African-American artists of the 19th and 20th centuries.

November 22–January 26, 2003
Furniture of the American South, 1680–1830: The Colonial Williamsburg Collection
Fifty-two examples from the nation's largest collection of Southern furniture.

PERMANENT COLLECTION

American and European paintings, furniture and decorative arts; African, pre-Columbian and Spanish Colonial art; porcelain and pottery; regional crafts; historic costumes. **Architecture:** The 1836 building was originally the first branch of the United States Mint.

Admission: Adults, $6; students and seniors, $5; children 6–11, $2.50; members and 5 and under, free. Group rates are available.
Hours: Tuesday, 10 a.m.–10 p.m.; Wednesday through Saturday, 10 a.m.–5 p.m.; Sunday, noon–5 p.m. Closed Monday, Thanksgiving Day, Christmas Eve, Christmas Day and New Year's Day.

Charlotte

Mint Museum of Craft and Design

220 North Tryon Street, Charlotte, N.C. 28202
(704) 337-2000
www.mintmuseum.org

2002 EXHIBITIONS

Through March 31
William Morris: Myth, Object and the Animal
Glassware in symbolic forms. Includes several large-scale
installations as well as 20 individual pieces. (Travels)

January 19–March 31
Findings: The Jewelry of Ramona Solberg
About 75 pieces from the 1950's to the present, including
necklaces using found and ethnic objects.

May 4–July 28
American Modernism, 1925–1940: Design for a New Age
Works by some 50 designers, including furniture, glass,
ceramics, metalwork, textiles, posters and product renderings.

PERMANENT COLLECTION

Traces the development of craft from utilitarian objects of
America's 19th-century rural economy to the contemporary art
of today's studio craft. Includes objects made of ceramics, fiber,
glass, metal and wood.

Admission: Adults, $6; students and seniors, $5; children
6–11, $2.50; members and children 5 and under, free.
Hours: Tuesday through Saturday, 10 a.m.–5 p.m.; Sunday,
noon–5 p.m. Closed Monday, Thanksgiving, Christmas Eve,
Christmas Day and New Year's Day.

The Weatherspoon Art Gallery

University of North Carolina at Greensboro, Spring
 Garden and Tate Streets, Greensboro, N.C. 27402
(336) 334-5770
www.uncg.edu/wag

2002 EXHIBITIONS

Through February 3
Still Lives From the Permanent Collection

Through February 3
Henri Matisse: Prints and Bronzes From the Cone Collection
Six early bronze sculptures, plus etchings and lithographs primarily from the 1920's.

January 13–March 31
Lab Results: Three Artists' Residencies in the Sciences
Exhibition featuring three visiting visual artists whose work is rooted in the sciences.

Courtesy of the Weatherspoon Art Gallery.
Tom Knechtel, *Under the Elephant*, 1995.

April 21–July 14
On Wanting to Grow Horns: The Little Theatre of Tom Knechtel

August 18–October 20
Inside the Floating World: Japanese Prints From the Lenoir C. Wright Collection
Prints from the museum's permanent collection of more than 700 works from the 17th to 20th centuries.

November 10–January 19, 2003
Art on Paper 2002
Works by emerging and established artists from throughout the United States and a juried selection of North Carolina artists.

PERMANENT COLLECTION

More than 5,000 works, primarily contemporary American
art. Includes works by Willem de Kooning, Robert Rauschen-
berg, Eva Hesse, Sol LeWitt, Robert Colescott, Mel Chin,
Alex Katz and Alison Saar. **Highlights:** Dillard Collection of
Art on Paper; the Cone Collection of prints and bronzes by
Henri Matisse; Japanese woodblock prints; a sculpture court-
yard; a site-specific sculptural frieze by Tom Otterness. **Archi-
tecture:** 1989 building by Ronaldo Giurgola.

Admission: Free.
Hours: Tuesday through Friday, 10 a.m.–5 p.m.; Wednesday,
until 8 p.m.; Saturday and Sunday, 1–5 p.m. Closed Monday.

The North Carolina Museum of Art

2110 Blue Ridge Road, Raleigh, N.C. 27607
(919) 839-6262
www.ncartmuseum.org

2002 EXHIBITIONS

Through January 6
Indivisible: Stories of American Community
Images by 12 photographers who recently explored grass-roots
democracy at sites across the United States.

Through March 12
Speed of Light: Video Now
Works by some of the leading names in video art, spanning a
wide range of techniques and thematic approaches.

April 1–August 25
Rev. McKendree Long: Picture Painter of the Apocalypse
A retrospective featuring portraits, paintings of Biblical scenes
and illustrations of the Book of Revelation.

May 18–July 28
Empire of the Sultans: Ottoman Art From the Khalili Collection
More than 200 objects, including illuminated manuscripts,
ceramics, rugs and armor. (Travels)

242

October 13–January 5, 2003
Jan Miense Molenaer: Painter of the Dutch Golden Age
Approximately 50 works, painted from 1628 to the 1660's, including interiors, group portraits and allegorical images.

PERMANENT COLLECTION

Spanning more than 5,000 years, from ancient Egypt to the present. Egyptian, Classical, European, American, African, Ancient American, Oceanic and Jewish ceremonial art. **Highlights:** European paintings and sculpture from the Renaissance through Impressionism. **Architecture:** 1983 building by Edward Durell Stone and Associates, New York, and Holloway-Reeves, Raleigh.

Admission: Free; fees for some exhibitions.
Hours: Tuesday through Saturday, 9 a.m.–5 p.m.; Friday, until 9 p.m.; Sunday, 11 a.m.–6 p.m. Closed Monday, New Year's Day, Martin Luther King Day, Memorial Day, Independence Day, Labor Day, Thanksgiving and Christmas Day.

Reynolda House, Museum of American Art

2250 Reynolda Road, Winston-Salem, N.C. 27106
(336) 725-5325; (888) 663-1149
www.reynoldahouse.org

2002 EXHIBITIONS

February 28-June 2
Passions-Politics-Prohibition: Benton's Bootleggers
New interpretation of Thomas Hart Benton's 1937 painting using political cartoons and caricatures of the period.

PERMANENT COLLECTION

American art from 1755 to the present, including painting, sculpture, paper, photography and decorative arts. **Architecture:** 1917 country estate of R.J. Reynolds, founder of Reynolds Tobacco Company, designed by Charles Barton Keen.

Admission: Adults, $6; seniors, $5; children 5–18, $3; students and children under 5, free.

Hours: Tuesday through Saturday, 9:30 a.m.–4:30 p.m.; Sunday, 1:30–4:30 p.m. Closed Monday, New Year's Day, Thanksgiving and Christmas Day.

Southeastern Center for Contemporary Art

750 Marguerite Drive, Winston-Salem, N.C. 27106
(336) 725-1904
www.secca.org

2002 Exhibitions

Through January 13
Half Past Autumn: The Art of Gordon Parks
A retrospective featuring photographs, portraits, books, music, film and poetry, including images from each of Parks's major photography series from 1940 through 1997.

January 26–April 14
Adventures in Science: Bonk Business Inc.
Fabricated archival photographs, year-end reports, commercial advertising and other items describing the fictitious 150-year history of Bonk, dreamed up by a Finnish art collective.

April 27–June 30
Free Basin by Simparch
The undulating wooden form in the center's main gallery, designed by the New Mexico art/architecture team Simparch, is both a sculpture and a functioning skateboard bowl. Visitors are invited to use the facility while the museum is open.

April 27–June 30
Gregory Barsamian: Wake-up Call
Spinning steel sculpture.

July 13–September 27
James Harold Jennings
A retrospective of the North Carolina outsider artist's painted wooden structures and sculptures.

Courtesy of the Southeastern Center for Contemporary Art.
Gregory Barsamian, *The Scream.*

July 13–September 27
Delicate Avalanche
Works by three sculptors, Jyung Mee Park, Lisa Hoke and
Kristin Casey, incorporating light, paper, plastic and fabric.

Admission: Adults, $3; students and seniors, $2; members
and children under 12, free.
Hours: Tuesday through Saturday, 10 a.m.–5 p.m.; Sunday,
2–5 p.m. Closed Monday and national holidays.

Cincinnati Art Museum

953 Eden Park Drive, Cincinnati, Ohio 45202
(513) 639-2995
www.cincinnatiartmuseum.org

2002 EXHIBITIONS

Through January 6
Posters of the Belle Époque: Toulouse-Lautrec to Mucha
Lithographs from the museum's collection by Pierre Bonnard,
Jules Chéret, Alphonse Mucha and Henri de Toulouse-Lautrec.

Through January 6
*The Photographic Impulse: Selections From the Joseph and Elaine
Monsen Collection*

245

Courtesy of the Cincinnati Art Museum.

Winslow Homer, *Hauling in Anchor (Key West)*, 1903-04

Some 200 photographs, spanning the history of the medium, including works by Édouard-Denis Baldus, Julia Margaret Cameron, Adam Fuss, Cindy Sherman, Alfred Stieglitz, Thomas Struth and Edward Weston.

February 3–April 28
American Watercolors: Whistler to Wyeth
More than 20 works from the museum's collection, by Winslow Homer, John Marin, John Singer Sargent, James Abbott McNeill Whistler and Andrew Wyeth.

February 3–April 28
Positively Alive: The Photographs of Maureen France
A retrospective spanning the Cincinnati documentary photographer's 20-year career.

March 17–June 9
Egypt in the Age of Pyramids
Sculpture, furniture, jewelry, pottery and relief carvings in stone from the Egyptian Old Kingdom (2765–2130 B.C.), along with an ancillary exhibition featuring the excavated finds of L.D. Covington, a Cincinnati archaeologist.

May 18–August 18
New Acquisitions From the Prints and Drawings Collections
Some 20 works, by Henry Moore and others.

July 14–September 15
Weegee's World: Life, Death and the Human Drama

More than 200 images by the photojournalist (1899–1968), including early works that portray life in New York City, later Hollywood works and abstract manipulated photographs.

PERMANENT COLLECTION

Ancient art of Egypt, Greece and Rome; Near and Far Eastern art; furniture, glass and silver; paintings by Titian, Hals, Rubens, Gainsborough and other European Old Masters; 19th-century works by Cézanne, van Gogh, Cassatt and Monet; 20th-century works by Picasso, Modigliani, Miró and Chagall; American works by Cole, Wyeth, Wood, Hopper and Rothko. **Highlights:** The Herbert Greer Rench collection of Old Master prints; European and American portrait miniatures. **Architecture:** 1886 Romanesque building by James MacLaughlin; early 1890's Greek Revival addition by Daniel Burnham; 1930 Beaux-Arts wings by Garber and Woodward; 1937 addition by Rendings, Panzer and Martin; 1965 International Style addition by Potter, Tyler, Martin and Roth; 1993 renovation by Glaser and Associates.

Admission: Adults, $5; seniors and students, $4; children under 18, free; Saturday, donation suggested. Additional fees for some exhibitions.
Hours: Tuesday, Thursday and Friday, 11 a.m.–5 p.m.; Wednesday, 11 a.m.–9 p.m.; Saturday, 10 a.m.–5 p.m.; Sunday, noon–6 p.m. Closed Monday, Thanksgiving and Christmas Day.

The Contemporary Arts Center

115 East Fifth Street, Cincinnati, Ohio 45202
(513) 345-8400
www.spiral.org

2002 EXHIBITIONS

Through January 13
Iran do Espirito Santo
New sculptures and murals by this Brazilian artist.

OHIO

Cincinnati

Through January 13
En Cada Barrio Revolucion
Contemporary art by Cuban artists.

Through April 7
Screen Room: An Interactive Colored Light Environment
An interactive installation by Paul Tzanetopoulos that allows
visitors to manipulate colors and lights in a room.

January 26–March 24
My Reality: The Culture of Anime
Explores the impact of the Japanese animation form on today's
art and culture.

January 26–March 24
Liam Gillick
First U.S. solo exhibition of works by a British artist whose
sculptural works use elements of corporate design.

April 13–June 9
Sprawl
Works by international artists who create deliberately chaotic
environments from fine art and found materials.

June 22–August 18
Ecovention
Explores art that has an impact on the environment, such as
transforming polluted waterways and brownfields.

June 22–August 25
Evocations: Sharon Ellis, 1991–2001
Twenty-three paintings by a Los Angeles artist.

Continuing
Toward a New CAC: The Architecture of Zaha Hadid
Drawings and models of the architect's design for a new
museum.

Admission: Adults, $3.50; students and seniors, $2; mem-
bers, free.
Hours: Monday through Saturday, 10 a.m.–6 p.m.; Sunday,
noon–5 p.m.

248

Taft Museum of Art

316 Pike Street, Cincinnati, Ohio 45202
(513) 241-0343
www.taftmuseum.org

The museum is closed for a renovation and expansion project and is scheduled to reopen in the spring of 2003.

PERMANENT COLLECTION

Old Master paintings; Chinese ceramics from the Qing dynasty; French Renaissance Limoges enamels; antique watches. **Highlights:** Gothic ivory virgin and child from the Abbey Church of St. Denis; Turner, *Europa and the Bull;* Whistler, *At the Piano;* Rembrandt, *Man Rising From His Chair.* **Architecture:** Former Baum-Taft House, circa 1820, a National Historic Landmark house.

The Cleveland Museum of Art

11150 East Boulevard, Cleveland, Ohio 44106
(216) 421-7350; (888) 262-0033
www.clevelandart.org

2002 EXHIBITIONS

Through January 6
Picasso: The Artist's Studio
More than 35 paintings and nine drawings that demonstrate the variety of ways that Pablo Picasso employed the artist's studio theme.

Through January 27
The Stamp of Impulse: Abstract Expressionist Prints
One hundred prints made from 1942 to 1975, ranging from small drypoints to mural-size lithographs, including works by Richard Diebenkorn, Adolph Gottlieb, Willem de Kooning, Nathan Oliveira and Jackson Pollock. (Travels)

Through February 27
Artists Photographing Artists
Works by photographers made during the past 145 years.

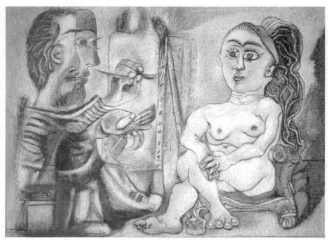

Courtesy of the Cleveland Museum of Art.

Pablo Picasso, *Painter and His Model*, 1963.

Subjects include artists at work, at play and in formal portraits. The exhibition also includes a group of self-portraits.

Through February 27
Gordon Parks: Photojournalism
Seventeen vintage black-and-white prints in three series: Harlem life in the late 1940's; the Black Muslim and civil rights movements of the 60's; and portraits of Malcolm X and Muhammad Ali.

February 17–April 28
Photographs From the Metropolitan Bank & Trust Collection
Some 70 contemporary images, including large-scale works.

February 24–May 19
Treasury of the World: Jeweled Arts of India in the Age of the Mughals
Approximately 325 works, including a 249-carat ruby inscribed with the names of five emperors. (Travels)

May 19–July 28
From Paris to Provincetown: Blanche Lazzell and the Color Woodcut
Works of decorative, geometric Cubism featuring views of Provincetown, Mass., flowers and abstract designs.

June 23–September 1
Into the Light: The Projected Image in American Art, 1964–1977
Projected-media works, including holography, slides and film

installations, by Vito Acconci, Dan Graham, Robert Morris, Bruce Nauman, Yoko Ono, Andy Warhol and others. (Travels)

August 25–October 27
Raphael and His Age: Drawings From Lille
Forty Renaissance drawings, half by Raphael, on loan from the Palais des Beaux-Arts de Lille.

August 25–October 27
A Print in Focus: Antonio Pollaiuolo's Battle of the Nudes
The museum's first-state impression of Pollaiuolo's 15th-century engraving.

September 15–January 5, 2003
Elizabeth Catlett: Works on Paper, 1944–1996
Fifty prints, plus several sculptures.

PERMANENT COLLECTION

Spanning five millennia, collection includes Asian art, with some 4,800 pieces; medieval European art; pre-Columbian art; paintings by Caravaggio, Poussin, Turner, Church, Monet and Picasso. Recent acquisitions include Salvador Dalí's *The Dream*, a large Tang dynasty tomb guardian pair, a Greek bronze statuette of an athlete, Frans Hals's portrait of Tieleman Roosterman, and Andy Warhol's *Marilyn x 100*. **Architecture:** 1916 Beaux-Arts building by Hubbell and Benes; additions by Hays & Ruth (1958), Marcel Breuer (1970) and Peter van Dijk (1984).

Admission: Free; fees for some exhibitions and programs.
Hours: Tuesday through Sunday, 10 a.m.–5 p.m.; Wednesday and Friday, until 9 p.m. Closed Monday, New Year's Day, Independence Day, Thanksgiving and Christmas Day.

Columbus Museum of Art

480 East Broad Street, Columbus, Ohio 43215
(614) 221-6801; (614) 221-4848 (recording)
www.columbusart.mus.oh.us

2002 EXHIBITIONS
January 12–March 20
An American in Europe

OHIO

Columbus

Some 100 photographs by Europeans and Americans working in Europe from the collection of Baroness Jeane Von Oppenheim, an American who married a German banker.

February 7–April 28
Edward Middleton Manigault: A Willful Modernist
Works by this Canadian-born artist (1887–1922) whose brief career was marked by intense experimentation.

February 7–April 28
Primal Visions: Albert Bierstadt "Discovers" America, 1859–1893
More than 50 paintings, prints and photographs by Bierstadt and his contemporaries (including Thomas and Edward Moran, Frederic E. Church and Eadweard Muybridge) from Bierstadt's first trip west in 1859 to the "closing of the frontier" in the 1890's. (Travels)

February 16–April
Gilda Edwards Memorial Exhibition
Paintings, sculptures, drawings, prints and installations by this Ohio African-American artist.

March 23–June
Short Distances, Definite Places: The Photographs and Notebooks of William Gedney
Photographs and notebooks of William Gedney from the 1960's, when Gedney lived with coal miners in Eastern Kentucky and hippies in San Francisco.

April–August
Ohio Art League
Works from the league's annual juried exhibition.

May 10–July 28
Grandma Moses in the 21st Century
Eighty paintings by Anna Mary Robertson Moses, known as "Grandma" Moses, one of the most popular artists in the United States during the 1940's and 1950's.

August 30–November 24
Museums for a New Millennium
An overview of the most important art museums designed or built during the last decade.

September 2002–January 2003
Georgia O'Keeffe
Traces the development of the artist's work.

December 13–April 2003
Aminah Robinson
Retrospective of the work of this Ohio African-American artist and book illustrator.

Permanent Collection

Impressionist, German Expressionist, Cubist and American Modernist art, including works by Degas, Monet, Matisse, Picasso, Bellows, Demuth, Hopper, Marin and O'Keeffe; contemporary art, including a recent commission by Alison Saar and works by Dale Chihuly, Mark Tasey and Mel Chin; Ross Photography Center; Russell Page Sculpture Garden. **Architecture:** 1931 Italian Renaissance revival building; 1974 new wing; 1979 sculpture garden.

Admission: Adults, $6; students, seniors and age 6 and older, $4; members and children under 6, free. Free on Thursday, 5:30–8:30 p.m.
Hours: Tuesday through Sunday, 10 a.m.–5:30 p.m.; Thursday, until 8:30 p.m. Closed Monday.

The Wexner Center for the Arts

Ohio State University
1871 North High Street, Columbus, Ohio 43210
(614) 292-3535
www.wexarts.org

2002 Exhibitions

Through Spring
Franz West: 2Topia
New chairs and tables in the center's cafe designed by the Austrian artist, plus an adjacent area with Internet access.

February 3–Spring
Mood River
Thousands of objects from everyday life — including toothbrushes, shoes, electronic gadgets and recent works of art — distributed throughout the center's galleries to generate feelings of bliss, ecstasy, rage and trauma.

PERMANENT COLLECTION

None. Contemporary arts center and laboratory for the arts, with exhibitions in 12,000 square feet of gallery space, films year-round, performing arts in a variety of venues and educational programs. **Architecture:** 1989 postmodern building by Peter Eisenman and Richard Trott.

Courtesy of the Wexner Center for the Arts.
Issey Miyake, *Colombe dress*, 1990.

Admission: Adults, $3; students and seniors, $2; children under 12, Ohio State students, faculty and staff, free. Free on Thursday, 5–9 p.m.

Hours: Tuesday through Saturday, 10 a.m.–6 p.m.; Thursday, until 9 p.m.; Sunday, noon–6 p.m. Closed Monday.

The Dayton Art Institute

456 Belmonte Park North, Dayton, Ohio 45405–4700
(937) 223-5277; (937) 223-0800 (recording)
www.daytonartinstitute.org

2002 EXHIBITIONS

January 12–March 24
Scenes From American Life: Treasures From the Smithsonian American Art Museum
Paintings, from the Roaring Twenties through the postwar period, by Thomas Hart Benton, William Glackens, Edward Hopper, Jacob Lawrence, John Sloan and others. (Travels)

January 12–June 23
The Shaw Collection: Pre-Columbian Treasures
More than 100 objects — ranging from delicate gold creations by ancient Panamanians to powerful carvings and ceramics by

the Aztecs — from the late Howard Shaw's collection, which is being shown to the public for the first time.

April 20–June 23
Linda McCartney's Sixties: Portrait of an Era
Photographs of the Beatles, Ray Charles, Aretha Franklin, Jimi Hendrix, Janis Joplin, B.B. King, Otis Redding, the Rolling Stones, the Grateful Dead and others.

July 9–September 8
Looking Forward, Looking Black
A selection of 20th-century paintings, drawings and photographs by African-Americans.

PERMANENT COLLECTION

More than 12,000 objects covering 5,000 years of art history. Includes an Asian collection; 17th-century Baroque paintings; 18th- and 19th-century American art; contemporary works. **Architecture:** 1930 Italian Renaissance-style building; $17 million renovation and expansion in 1997; Eilleen Dicke Gallery of Glass in 1999.

Admission: Free; fees for some exhibitions.
Hours: Daily, 10 a.m.–5 p.m.; Thursday, until 9 p.m.

Allen Memorial Art Museum

Oberlin College, 87 North Main Street, Oberlin, Ohio
 44074
(440) 775-8665
www.oberlin.edu/allenart

2002 EXHIBITIONS

Through June
A Matter of Taste: The African Collection at the Allen
Works from the mid-15th to the mid-20th century, representing traditional art in West and Central Africa, particularly sculpture.

Through June
Art of the 20th Century: Selections From the Permanent Collection

Oberlin

Modern western art, including works by Modigliani, Picasso, Mondrian, Klee, Matisse and Kirchner.

Through June
Modern and Contemporary Sculpture
Sculpture by American artists, including Eva Hess, Donald Judd, Jackie Windsor, Leonard Drew, Willie Cole and others.

January–December
Selections From the Asian Collection
Chinese and Japanese paintings and decorative arts, Japanese prints and Islamic rugs.

January–December
Highlights of 14th to 19th-Century Painting and Sculpture
Medieval, Renaissance, Baroque and neo-Classical paintings and sculptures by European and American artists, including Peter Paul Rubens, Hendrick ter Brugghen, Herri met de Bles and Edmonia Lewis.

March 5–May
Woven Treasures: Tribal Textiles From Central Asia
Traditional textile arts of the nomadic and semi-nomadic peoples who inhabit the steppes, mountains and deserts of central Asia, including rugs, bags and animal trappings.

PERMANENT COLLECTION

More than 11,000 objects, including 17th-century Dutch and Flemish paintings; European paintings of the late 19th and early 20th centuries; Old Master and Japanese Ukiyo-E prints; contemporary American works. **Highlights:** Monet, *Garden of the Princess;* Rubens, *The Finding of Erichthonius*; Gorgy, *The Plough and the Song*; Modigliani, *Nude With Coral Necklace*.
Architecture: Landmark 1917 building by Cass Gilbert; 1976 addition by Venturi, Rauch and Associates.

Admission: Suggested donation: $3.
Hours: Tuesday through Saturday, 10 a.m.–5 p.m.; Sunday, 1–5 p.m. Closed Monday and major holidays.

Toledo Museum of Art

2445 Monroe Street, Toledo, Ohio 43620
(419) 255-8000; (800) 644-6862
www.toledomuseum.org

2002 EXHIBITIONS

Through January 5
"Star Wars": The Magic of Myth (see Brooklyn Museum of Art)

March 24–June 16
The Alliance of Art and Industry: Toledo Designs for a Modern America
Explores the role that Toledo's industry played in the development of modern industrial design.

PERMANENT COLLECTION

Objects from ancient Egypt, Greece and Rome, and from Africa and Asia; European and American art; glass and decorative arts. Work by Rubens, El Greco, Rembrandt and Monet.
Architecture: 1912 neo-Classical marble building by Edward Green; 1992 arts school addition by Frank O. Gehry.

Admission: Free; fees for some exhibitions.
Hours: Tuesday through Saturday, 10 a.m.–4 p.m.; Friday, until 10 p.m.; Sunday 11 a.m.–5 p.m. Closed Monday, New Year's Day, Independence Day, Thanksgiving and Christmas Day.

The Butler Institute of American Art

524 Wick Avenue, Youngstown, Ohio 44502
(330) 743-1711
www.butlerart.com

2002 EXHIBITIONS

January–February
More Than One: Prints and Portfolios From the Center Street Studio, Boston

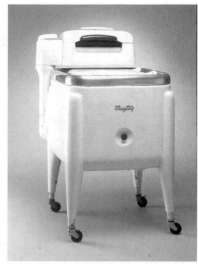

Harold Van Doren and Associates, with Thomas P. Smith, *Maytag Washer Model E,* 1939.

Courtesy of the Butler Institute of American Art.

Some 150 images by 20 artists, including landscapes, still lifes and whimsical subjects.

February–April
Don Gummer: Sculpture
Thirty-year survey of work by this American sculptor, including indoor and outdoor sculptures, maquettes and drawings.

PERMANENT COLLECTION

Three centuries of American art, from the Colonial period to the present. **Highlights:** 19th-century works by Homer, Eakins and Harnett; Marine Collection, featuring Lane, Waugh and Bricher; American Western Collection, including works by Burbank, Sharp and Higgins; American Impressionist works by Cassatt, Vonnoh and Chase; 20th-century works by Motherwell, Nevelson, Frankenthaler, Close and Rauschenberg. **Architecture:** Designed by McKim, Mead and White; additions in 1931, 1968, 1987 and 1999. Sculpture terrace, Beecher high-tech wing.

Admission: Free.
Hours: Tuesday through Saturday, 11 a.m. to 4 p.m.; Wednesday, until 8 p.m.; Sunday, noon–4 p.m. Closed Monday and major holidays.

Trumbull County Branch

9350 East Market Street, Howland, Ohio
(330) 609-9900
Hours: Wednesday through Sunday, 11 a.m.–4 p.m.

Salem Branch

343 East State Street, Salem, Ohio
(330) 332-8213
Hours: Thursday through Sunday, 11 a.m.–4 p.m.

Gilcrease Museum

1400 Gilcrease Museum Road, Tulsa, Okla. 74127
(918) 596-2700; (888) 655-2278
www.gilcrease.org

2002 EXHIBITIONS

Through February 11
The Poetry of Place: Works on Paper by Thomas Moran
More than 80 watercolors, drawings and prints from the
museum's collection.

February 27–April 14
Grandma Moses in the 21st Century
Major retrospective of the work of Anna Mary Robertson
Moses, known as Grandma Moses. (Travels)

February 11–April 14
The Hewitt Collection of African American Art
Paintings, drawings and works on paper, many portraying his-
torical, political and social events.

PERMANENT COLLECTION

Largest collection of fine art, artifacts and archives about the
American West. Paintings, drawings, prints and sculpture by
more than 400 artists, including Frederic Remington, Charles
Russell and Thomas Moran; American Indian art and artifacts

as well as historical manuscripts, documents and maps. **Architecture:** Original structure was built in 1949 in the style of an American Indian longhouse; expansion and renovation in 1987.

Admission: Free.

Hours: Tuesday through Saturday, 9 a.m.–5 p.m.; Sunday and federal holidays, 11 a.m.–5 p.m. Open Monday from Memorial Day to Labor Day, 9 a.m.–5 p.m. Closed Christmas Day.

Philbrook Museum of Art

2727 South Rockford Road, Tulsa, Okla. 74114
(918) 749-7941; (800) 324-7941
www.philbrook.org

2002 EXHIBITIONS

Through January 6
American Watercolors and Drawings From the Permanent Collection

February 10–April 7
The Lawrence Gussman Collection of African Art
More than 70 pieces of African art, including sculptures believed to hold power over sickness and health, good and evil, fertility and death. (Travels)

April 28–June 16
Women Who Paint the West: Paintings by Alyce Frank and Barbara Zaring
Landscapes of the American West.

August 23–November 17
American Modern, 1925–1940: Design for a New Age
Exploring design movements from Art Deco to streamlining, the exhibition features such influential designers as Norman Bel Geddes, Donald Deskey, Raymond Loewy, Eliel Saarinen and Frank Lloyd Wright.

PERMANENT COLLECTION

More than 8,500 works from around the world, including Italian paintings and sculpture; 19th-century French paintings and sculpture; 18th- and 19th-century decorative arts; Ameri-

can art, especially 19th-century landscape paintings and 20th-century works; African, Asian and American Indian art and artifacts. **Architecture:** 1928 Italianate villa by Edward Buehler Delk; 1990 wing by Urban Design Group in association with Michael Lustig.

Admission: Adults, $5.40; seniors, students and groups, $3.25; members and children under 13, free.

Hours: Tuesday through Saturday, 10 a.m.–5 p.m.; Thursday, until 8 p.m.; Sunday, 11 a.m.–5 p.m. Closed Monday and major holidays.

Portland Art Museum

1219 Southwest Park Avenue, Portland, Ore. 97205
(503) 226-2811
www.portlandartmuseum.org

2002 EXHIBITIONS

Through January 6
En Suite: Contemporary Prints From the Collections of Jordan D. Schnitzer and the Jordan & Mina Schnitzer Foundation
Fifty-five prints, including works by Jasper Johns, Roy Lichtenstein and Andy Warhol.

Through January 6
European Masterpieces: Six Centuries of Paintings From the National Gallery of Victoria, Australia
Includes works by Tintoretto, Van Dyck, Rembrandt, Gainsborough, Constable, Turner, Monet and Picasso. (Travels)

January 12–March 24
Equivalents: Faces of the Oregon Art Scene
Larger-than-life drawings by George Johanson, a Portland artist, of 80 Oregon artists. (Travels)

February 2–April 28
Matières de Rêves: Stuff of Dreams
From the Musée des Art Décoratifs, about 100 objects of French design, from the Middle Ages to the present, including furniture, jewelry, sculpture, ceramics and glass. (Travels)

OREGON

Portland

June 1–September 22
Splendors of Imperial Japan: Art of the Meiji Period From the Khalili Collection
Works in metal, lacquer, ceramic, enamel and porcelain from the Meiji Era (1868–1912).

August 27–December 1
Grandma Moses in the 21st Century
Reexamines Grandma Moses' paintings from a contemporary viewpoint and charts the evolution of her style. (Travels)

August 17–December 1
Beyond Beads and Feathers: Recent Work by Six Contemporary Native American Artists
Recent works by six Native American artists

October 12–January 5, 2003
Contemporary Art From the UBS PaineWebber Collection
First public exhibition of this collection of contemporary art, which includes works by de Kooning, Freud, Lichtenstein, Salle, Schnabel, Twombly and Warhol.

PERMANENT COLLECTION

Works spanning 35 centuries of Asian, European, American and contemporary art. **Highlights:** The new Centers for Northwest Art and Native American Art; newly acquired de Troy, Giordano and the Clement Greenberg Collection of Modern and Contemporary Art; Brancusi, *Muse*; Monet, *Waterlilies*; Renoir, *Two Girls Reading*; Tlingit, *Wolf Hat*.
Architecture: 1932 Petro Belluchi building, which has been newly renovated.

Admission: Adults, $7.50; seniors and students, $6; children 5–18, $4; members, free.
Hours: Tuesday through Saturday, 10 a.m.–5 p.m.; Sunday, noon–5 p.m.; every Wednesday and the first Thursday of every month, until 9 p.m. Closed Monday.

Pennsylvania

Brandywine River Museum

Brandywine Conservancy, Route 1, Chadds Ford, Pa. 19317
(610) 388-2700
www.brandywinemuseum.org

2002 EXHIBITIONS

Through March 3
Highlights From the Collection
Selections from the museum's extensive collection of works by
three generations of the Wyeth family, as well as American
illustration, still life and landscape painting.

March 9–May 19
*Milk and Eggs: The American Revival of Tempera Painting,
1930–1950*
Works in tempera by Andrew Wyeth, Thomas Hart Benton,
Paul Cadmus, George Tooker and others.

September 13–November 24
N.C. Wyeth Arrives in Wilmington
Examines the state of illustration at the end of the 19th century,
featuring works by popular illustrators of the period.

September 14–November 24
Battle of the Brandywine
Paintings, drawings and prints depicting this Revolutionary
War battle to mark its 225th anniversary.

November 29–January 12, 2003
A Brandywine Christmas
Holiday displays, including antique dolls, a model railroad, an
elaborate Victorian dollhouse and whimsical ornaments.

November 29–January 12, 2003
Palmer Cox's Brownies From the Collection
Works by this late-19th-century children's book writer and
illustrator known for his brownie characters.

PERMANENT COLLECTION

American art with an emphasis on the Brandywine region.
Landscapes by Cropsey, Doughty, Moran and Richards;

trompe l'oeil works by Cope, Harnett and Peto; illustrations
by Darley, Pyle, Parrish, Gibson and Dunn. **Highlights:**
Paintings by three generations of Wyeths; Andrew Wyeth
Gallery; Brandywine Heritage Galleries. **Architecture:**
1864 grist mill renovated in 1971 by James Grieves; 1984
addition by Grieves features glass-walled lobbies with views
of countryside.

Admission: Adults, $6; seniors, students, children 6–12, $3;
members, free.

Hours: Daily, 9:30 a.m.–4:30 p.m. Closed Christmas Day.

James A. Michener Art Museum

138 South Pine Street, Doylestown, Pa. 18901
(215) 340-9800
www.michenerartmuseum.org

2002 EXHIBITIONS

Through January 6
*Artists of the Commonwealth: Realism in Pennsylvania Painting,
1950–2000*
Works by 25 Realist artists who were born in or lived in Penn-
sylvania, including Keith Haring, Alice Neel, Andy Warhol
and Andrew Wyeth.

Through January 27
Taking Liberties: Photographs by David Graham
Images of America's heartland, including suburban backyards,
campgrounds, pet cemeteries and other American icons.

January 19–April 14
Stylish Hats: 200 Years of Sartorial Sculpture
A look at the changing fashion of designer hats over the last
two centuries, including an 18th-century silk and taffeta
calash, Edwardian hats and the cloche of the 1920's.

February 9–May 5
Roy C. Nuse: Figures and Farms

Landscapes of Bucks County and figurative works by Nuse (1885–1975), an influential Pennsylvania artist who taught at the Pennsylvania Academy of Fine Arts.

April 27–July 7
Bucks County Invitational V
Works by Vincent Ceglia (painter), Karl Karhumaa (sculptor), Lisa Manheim (painter), and Claus Mroczynski (photographer).

May 25–September 8
A Woman's Place

June 29–November 3
Michael S. Smith, Photographs

July 20–October 13
Walker Evans
Photographs from *Let Us Now Praise Famous Men* (written by James Agee) portraying an Alabama sharecropper family and reflecting both the beauty and desperation of their lives.

PERMANENT COLLECTION

Pennsylvania Impressionist paintings; 19th- and 20th-century American paintings; regional contemporary and figurative art; Patricia D. Pfundt Sculpture Garden; featuring American sculpture; exhibition on the author James A. Michener; multimedia interactive exhibition, "Creative Bucks County: A Celebration of Art and Artists." **Highlights:** Daniel Garber's mural *A Wooded Watershed.* **Architecture:** Renovated 1884 Bucks County Prison.

Admission: Adults, $6; seniors, $5.50; students, $2.50; members and children under 12, free.
Hours: Tuesday through Friday, 10 a.m.–4:30 p.m.; Wednesday, until 9 p.m.; Saturday and Sunday, 10 a.m.–5 p.m. Closed Monday.

The Barnes Foundation

300 North Latch's Lane, Merion, Pa. 19066
(610) 667-0290
www.barnesfoundation.org

PERMANENT COLLECTION

Extensive collection of early French Modern and Post-Impressionist paintings. Works by Picasso, Renoir, Cézanne, Monet and Degas. Museum established by Dr. Albert C. Barnes in 1922 to "promote the advancement of education and the appreciation of the fine arts." The collection spans 3,000 years and is one of the first purposely multicultural collections in the nation, featuring African sculpture, American Indian art, Chinese painting, Egyptian, Greek and Roman antiquities and 18th- and 19th-century decorative arts. Arboretum noted for its diversity of species and rare specimens. **Architecture:** 1925 French limestone structures; 1994 renovations.

Admission: $5. Reservation required.

Hours: Friday through Sunday, 9:30 a.m.-5 p.m. Open Wednesday and Thursday in July and August.

Institute of Contemporary Art

University of Pennsylvania, 118 South 36th Street,
 Philadelphia, Pa. 19104
(215) 898-7108
www.icaphila.org

2002 EXHIBITIONS

Through February 10
Painting Against the Grid/Surface/Frame
Works by New York City and Philadelphia artists who employ deconstruction strategies, murals and virtual and three-dimensional methods.

Through February 10
Asymptote and Karim Rashid

A collaboration between Rashid, an industrial designer, and his brother's architecture firm.

Through February 10
Richard Tuttle
An installation featuring 13 bodies of work, dating from late 1977, that explore the "spaces in between."

March 2–April 28
Ellen Gallagher
About 25 paintings and a selection of drawings.

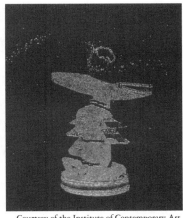

March 2–April 28
The Photogenic
Works by a half-dozen contemporary artists that are informed in unexpected ways by photography.

March 2–April 28
Jill Bonovitz
Porcelain bowls and delicate wire baskets.

Courtesy of the Institute of Contemporary Art.
Ellen Gallagher, *Untitled*, 2000

May 11–July 14
Charles LeDray
Miniature works, mainly since 1989, that address gender identification, adolescent trauma and sexuality.

May 11–July 14
Space 1026
A spontaneous collaborative installation by artists from the experimental studio Space 1026.

Admission: Adults, $3; students, artists and seniors, $2; children under 12, free. Free on Sunday, 11 a.m.–1 p.m.
Hours: Wednesday through Friday, noon–8 p.m.; Saturday and Sunday, 11 a.m.–5 p.m. Closed Monday and Tuesday.

Philadelphia

Pennsylvania Academy of the Fine Arts

118 North Broad Street, Philadelphia, Pa. 19102
(215) 972-7600
www.pafa.org

School Gallery

1301 Cherry Street, Philadelphia, Pa. 19107

2002 EXHIBITIONS

Through January 13
Process on Paper: Eakins Drawings From the Bregler Collection
More than 30 works reflecting the importance of drawing in
Thomas Eakins's artistic and teaching career.

Through February 3
BASEKAMP
An installation of plastic casts by BaseKamp, a collaborative
artist team of Academy graduates.

January 12–April 7
American Modern, 1925–1940: Design for a New Age
More than 125 objects, such as furniture, glass, ceramics and
metalworks, by some 50 design pioneers, including Norman
Bel Geddes, Isamu Noguchi and Russel Wright. (Travels)

February 2–April 14
Francis Criss, American Modernist: Paintings From the 1930's
Cityscapes and portraits by an Academy graduate.

May–June
Annual Student Exhibition and Graduate Thesis Exhibition
The country's oldest and largest student show.

June 17–August 25
American Sublime
More than 60 large-scale works by Hudson River School
painters, including Cole, Durand, Heade and Bierstadt.

PERMANENT COLLECTION

America's first art museum and school of fine arts. The
museum covers more than two centuries of American art,

including works by Benjamin West, Charles Willson Peale and Cecilia Beaux. **Architecture:** 1876 Gothic Victorian building by Frank Furness and George Hewitt.

Admission: Adults, $5; seniors and students, $4; ages 5–18, $3. Free on Sunday, 3–5 p.m., except for special exhibitions. School Gallery, free.

Hours: Tuesday through Saturday, 10 a.m.–5 p.m.; Sunday, 11 a.m.–5 p.m. Closed Monday. School Gallery: Daily, 9 a.m.–7 p.m., or by appointment.

The Philadelphia Museum of Art

26th Street and Benjamin Franklin Parkway,
 Philadelphia, Pa. 19101
(215) 763-8100; (215) 684-7500 (recording)
www.philamuseum.org

2002 EXHIBITIONS

Through January 6
Thomas Eakins
Some 60 major oil paintings, along with photography, water-colors, drawings and sculpture produced by Eakins (1844–1916), who was based in Philadelphia. (Travels)

Through February 24
Dox Thrash: An African Master Printmaker Rediscovered
Some 60 prints and 30 drawings and watercolors by this artist who rose to prominence in the 1930's. (Travels)

Through April
Italian Renaissance Ceramics, 1500–1600: The Howard I. and Janet H. Stein Collection
Exhibition celebrating a gift to the museum of 70 pieces of Italian Renaissance Maiolica (tin-glazed earthenware).

March 24–July 7
Barnett Newman
More than 100 works by this prominent New York artist

(1905–1970), including his Surrealist-inspired drawings and trademark vertical stripe paintings. (Travels)

August 10–October 6
Indivisible: Stories of American Community
Explores challenges faced by communities in cities nationwide through photographs and oral history. (Travels)

September 21–December
Gifts That Transform
Newly acquired works, including Italian miniature paintings, a Japanese scroll and visionary American folk art.

November 3–January 5, 2003
Giorgio de Chirico and the Myth of Ariadne
First exhibition bringing together the Italian artist's haunting series of Ariadne paintings, depicting a reclining statue of the princess of Greek mythology in an empty piazza. (Travels)

PERMANENT COLLECTION

Architectural installations and period rooms, including a 12th-century French Romanesque facade, a 16th-century carved granite Hindu temple hall and a Japanese tea house, temple and garden; Robert Adams's drawing room from Lansdowne House; modern sculpture; German folk art; Kretzschmar von Kienbusch collection of arms and armor. **Highlights:** Cézanne, *Large Bathers*; Duchamp, *Nude Descending a Staircase*; Picasso, *The Three Musicians*; van Gogh, *Sunflowers*; Rubens, *Prometheus Bound*. **Architecture:** 1928 neo-Classical building by Horace Trumbauer and Zantzinger, Borie, and Medary, housing more than 200 galleries across an expanse of 600,000 square feet.

Admission: Adults, $10; students, ages 13–18 and seniors, $7; 12 and under, free. Pay what you wish, Sunday.
Hours: Tuesday through Sunday, 10 a.m.–5 p.m.; Wednesday, until 8:45 p.m. Closed Monday and major holidays.

University of Pennsylvania Museum of Archaeology and Anthropology

33rd and Spruce Streets, Philadelphia, Pa. 19104
(215) 898-4000
www.upenn.edu/museum

2002 EXHIBITIONS

Through March 24
Six Highlight Objects From "Treasures of the Royal Tomb of Ur"
Features the Ram-in-the-Thicket, Lady Puabi's lapis lazuli and carnelian jewelry, Lady Puabi's headdress, an electrum drinking tumbler, a gold ostrich egg and a silver bull's head.

Through July
Modern Mongolia:
Reclaiming Genghis Khan
Looks at Mongolian life in the past century and challenges the image of Genghis Khan as a fierce 13th-century marauder.

PERMANENT COLLECTION

Materials from ancient Egypt, Asia, Africa, Polynesia, the Americas and the ancient Greco-Roman world. **Highlights:** A 12-ton sphinx and architectural remnants from the

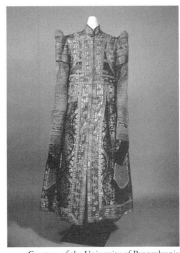

Courtesy of the University of Pennsylvania Museum of Archaeology and Anthropology. A married halh woman's summer deel and long vest, early 20th century.

palace of Merenptah, circa 1200 B.C.; samples of the world's oldest written language; Chinese sculpture; ancient Mayan stelae; Nigerian Benin bronzes. **Architecture:** 1899 American Arts and Crafts building by Wilson Eyre, Cope and Stewardson and Frank Miles Day and Brother; 1915 rotunda addition; 1926 Coxe Memorial Wing by Charles G. Klauder; Sharpe Wing completed in 1929.

Admission: Suggested donation: Adults, $5; seniors and students, $2.50; members, children under 6 and PENNcard holders, free.

Hours: Tuesday through Saturday, 10 a.m.–4:30 p.m.; Sunday, 1–5 p.m. Closed Sunday from Memorial Day through Labor Day; closed Monday and holidays.

Carnegie Museum of Art

4400 Forbes Avenue, Pittsburgh, Pa, 15213
(412) 622-3131; (412) 622-3172
www.cmoa.org

2002 Exhibitions

Through January 6
Neapolitan Presepio
A depiction of 18th-century village life, handmade by Neapolitan artisans between 1700 and 1830. The 250-square-foot work includes more than 100 human and angelic figures, along with animals, architectural elements and accessories.

Through January 6
Perfect Acts of Architecture
More than 140 drawings and collages on the meditations of the architects Peter Eisenman, Rem Koolhaas, Daniel Libeskind, Thom Mayne and Bernard Tschumi.

Through February 10
Dream Street: W. Eugene Smith's Pittsburgh Photographs
Two hundred images Smith captured during 1955.

Through February 24
Diane Samuels
An installation featuring handmade objects and video and sound recordings.

May 4–August 4
Selections From the William and Maxine Block Collection of Contemporary Glass
Seventy works by more than 50 artists from North America, Europe and Australia.

November 9–January 12, 2003
*Out of the Ordinary: The Architecture and Design of Robert Venturi,
Denise Scott Brown and Associates*
Approximately 250 works.

PERMANENT COLLECTION

Nineteenth-century American, French Impressionist and
Post-Impressionist, modern and contemporary collections,
including film and video, European and American decorative
arts, and architectural drawings and models. Rotating exhi-
bitions. Home of the Carnegie International. **Highlights:**
Monet's *Waterlilies*; the Chariot of Aurora from the ocean
liner Normandie; de Kooning's *Woman VI*; one of the world's
three architectural cast courts. **Architecture:** 1907 building
by Alden and Harlow; 1974 wing by Edward Larrabee
Barnes.

Admission: Adults, $6; seniors, $5; children and students,
$4; members, free.
Hours: Monday through Saturday, 10 a.m.–5 p.m.; Sunday,
1–5 p.m. Closed Monday from Labor Day through June, and
major holidays.

The Frick Art and Historical Center

7227 Reynolds Street, Pittsburgh, Pa. 15208
(412) 371-0600
www.frickart.org

2002 EXHIBITIONS

Through March 3
Masterworks of the Albertina
More than 100 works on paper from Vienna's Albertina, by
Dürer, Michelangelo, Rembrandt, Rubens, Titian and others.

June 28–September 22
Artist-in-Residence: Christian Milovanoff

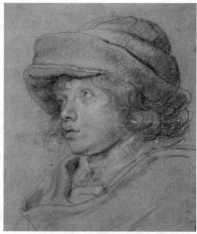

Peter Paul Rubens, *Rubens's Son Nicholas With a Cap*, 1626-27.

Courtesy of the Frick Art and Historical Center.

October 19–January 2, 2003
19th- and 20th-Century French Drawings From the Danish National Gallery
More than 100 drawings by Ingres, Millet, Rousseau, Rodin, Toulouse-Lautrec, Manet, Degas, Pissarro, Gauguin, Picasso and others. (Travels)

PERMANENT COLLECTION

Italian Renaissance and French 18th-century works acquired by Henry Clay Frick's daughter, Helen Clay Frick. **Highlights:** Art collection in Clayton, the restored Gilded Age residence of Henry Clay Frick; collection of pre-1940 vehicles in the Car and Carriage Museum. **Architecture:** 1969 building by Pratt, Schafer and Slowik.

Admission: Frick Art Museum and Car and Carriage Museum, free. Clayton: Adults; $8; seniors, $7; students, $6; reservations required.
Hours: Tuesday through Saturday, 10 a.m.–5 p.m.; Sunday, noon–6 p.m. Closed Monday and major holidays.

The Andy Warhol Museum

117 Sandusky Street, Pittsburgh, Pa. 15212
(412) 237-8300
www.warhol.org

2002 EXHIBITIONS

March 2–May 19
Possession Obsession: Objects From Andy Warhol's Personal Collection
About 300 objects from Warhol's collection, reunited after
being sold at a 1988 Sotheby's auction.

PERMANENT COLLECTION

Andy Warhol drawings, prints, paintings, sculpture, film,
audio and videotapes, with archives that range from ephemera
to records, source material for works of art and other docu-
ments from the artist's life. **Architecture:** Industrial ware-
house built in 1911; renovated by Richard Gluckman.

Admission: Adults, $8; seniors, $7; students and age 4 and
older, $4; members and 3 and under, free.
Hours: Tuesday through Sunday, 10 a.m.–5 p.m.; Friday,
until 10 p.m. Closed Monday.

Museum of Art, Rhode Island School of Design

224 Benefit Street, Providence, R.I. 02903
(401) 454-6500
www.risd.edu/museum.cfm

2002 EXHIBITIONS

Through January 20
Ann Hamilton: malediction (1991) and other works
A large-scale sensory installation, videos and photographic
works by this MacArthur Fellowship recipient.

Through January 27
Jonathan Bonner: Front Pockets

RHODE ISLAND

Providence

Eleven pairs of objects designed to fit into trouser pockets by a Rhode Island–based sculptor.

Through January 27
William Congdon: "My Life Has Been a Painting"
First U.S. retrospective since his death in 1998 of this Rhode Island–born painter whose work reflects his frequent travels between Italy and New York.

Through February
In the High Himalayas: Textiles From the Kingdom of Bhutan
Traditional handwoven textiles of silk, cotton or wool with intricate patterns.

February–April
Art ConText: Edgar Heap of Birds
Marker drawings, prints, paintings and textual messages by the artist done in collaboration with representatives of the Narragansett Tribe.

February 15–April 14
Windshield: Richard Neutra's House
Explores the design, construction process and role of the client in the creation of Neutra's first house on the East Coast, on Fishers Island. (Travels)

March 8–June 2
Meiji- and Taisho-Period Prints

March–June
Sitings 2002
Works by RISD students.

March–December
A Tribute to Miss Lucy: Textiles From the Permanent Collection I, II, III
Textiles given to the museum by Lucy Truman Aldrich, including Japanese No theater robes, Buddhist priest robes and Chinese, Ottoman, Mughal and Persian court costume.

September 20–November 17
Print, Power and Persuasion: Graphic Design in Germany, 1890–1945
Posters, books, journals, drawings, prints, menus, brochures and other printed materials tracing the emergence of modern commercialized communications in Germany.

PERMANENT COLLECTION

More than 80,000 works of art from antiquity to the present, including Greek and Roman sculpture, Chinese stone and terra cotta sculpture, French Impressionist paintings and contemporary art in various media. **Highlights:** 12th-century sculpture from the Third Abbey Church of Cluny, France; coffin and mummy of the Egyptian priest Nesmin; 9-foot Buddha Dainichi Nyorai from a medieval temple near Kyoto; masterpieces of European and American painting. **Architecture:** 1897 original building; 1906 Colonial Revival addition by Stone, Carpenter and Wilson, called Pendleton House; 1926 Radeke Building by William T. Aldrich; 1933 Contemporary Daphne Farago Wing by Tony Atkin and Associates.

Admission: Adults, $5; seniors, $4; students, $2; children 5–18, $1.

Hours: Tuesday through Sunday, 10 a.m.–5 p.m.; third Thursday of each month, until 9 p.m. Closed Monday, New Year's Day, Easter Sunday, Independence Day, Thanksgiving and Christmas Day.

Gibbes Museum of Art

135 Meeting Street, Charleston, S.C. 29401
(843) 722–2706
www.gibbes.com

2002 EXHIBITIONS

Through February 17
Twentieth Century in Review
A survey of the art movements of the last hundred years in America, from Impressionism to Modernism, regionalism and post-Modernism. Works by Birge Harrison, Robert Henri, Childe Hassam, Jacob Lawrence, Jasper Johns, Robert Rauschenburg and others.

Through April 14
Walter O. Evans Collection of African–American Art
A survey of art by African Americans from the last 150 years, including sculpture, painting, drawing and prints by Romare

SOUTH CAROLINA

Charleston

Bearden, Jacob Lawrence, Robert Scott Duncanson, Marcy Edmonia Lewis and Charles White.

January 2–March 31
Sight Once Seen — Daguerreotyping Fremont's Last Expedition Through the Rockies
Works by Solomon Nunez Carvalho, a daguerreotyping photographer from Charleston who traveled with John Charles Fremont on his last expedition from Missouri to California in 1853 in search of a route for a transcontinental railroad.

February 1–October 20
African-American Images in Charleston
Works of African-American subjects from the Lowcountry.

April 12–August 4
Thomas Moran Prints of the American West — The Rick Throckmorton Collection

May 11–August 4
Ansel Adams, a Legacy: Masterworks From the Friends of Photography Collection
Some 115 photographs, surveying the wide-ranging career of one of the medium's most influential practitioners, including his well-known vistas such as *Monolith, The Face of Half Dome* and *Moonrise, Hernandez, New Mexico* as well as portraits, closeups and architectural views.

May 17–December 31
Ballard Print Collection
A display of European prints, including works by Piranesi, Carracci and Dürer.

June 28–September 29
Charleston in My Time: The Paintings of West Fraser
Approximately 24 canvases by one of the country's foremost plein air painters.

September 15–November 17
A Portion of the People
Paintings, miniatures, photographs and cultural objects trace 300 years of Jewish heritage. (Travels)

December 13–February 2, 2003
Edward Middleton Manigault (1887–1922): A Willful Modernist
The first major retrospective of the artist's works since his death, including paintings, etchings, ceramics, carved wood construction and furniture and interior designs.

PERMANENT COLLECTION

Portraits of notable South Carolinians; views of Charleston and landscapes; photography; miniature portraits; Japanese wood-block prints. **Architecture:** Beaux-Arts building, built as a memorial to James Shoolbred Gibbes and designed by Frank P. Milburn.

Admission: Adults, $7; seniors, students and members of the military, $6; ages 6–18, $4; under 6 and members, free.
Hours: Tuesday through Saturday, 10 a.m.–5 p.m.; Sunday, 1–5 p.m; until 9 p.m., second Tuesday of the month. Closed Monday and holidays.

The Greenville County Museum of Art

420 College Street, Greenville, S.C. 29601
(864) 271-7570
www.greenvillemuseum.org

2002 EXHIBITIONS

Through January 6
Father and Son: Jerry and Brian Pinkney
Works by the children's book illustrators.

Through January 6
Mary Cassatt: Color Prints From the Collection of St. John's Museum of Art
Thirteen etchings.

Through January 6
Jack Leigh: The Land I'm Bound To
More than 50 photographs of the South Carolina Lowcountry.

Through June
American Impressionism With a Southern Accent
Paintings by Alfred Hutty, Gari Melchers, Helen Turner, Catherine Wiley and others.

January 23–March 24
Upstate Artists Invitational: See How We Are

Greenville

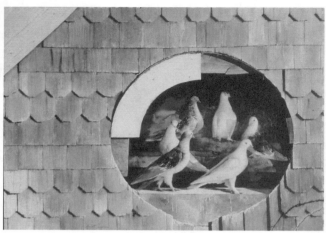

Courtesy of the Greenville County Museum of Art.
Herbert Shuptrine, *Pigeon Family*, 1992.

Monotypes by 25 artists — sculptors, painters, potters and printmakers — who are collaborating with a local studio to explore a medium in which many of them have never worked before. Also featuring works in each artist's practiced medium.

April 17–June 9
Charleston in My Time: The Paintings of West Fraser
Realist paintings of Charleston, S.C., made during the past two decades.

July–September
An American Palette: Works From the Collection of John and Delores Beck
Works, from the mid-19th century through the mid-20th, by Thomas Hart Benton, Albert Bierstadt, Charles Burchfield, Stuart Davis, Robert Henri, George Inness, Charles Sheeler, Max Weber and others.

October 2–January 5, 2003
Ezra Jack Keats
Collages and other works by the children's book illustrator.

Continuing
Andrew Wyeth: The Greenville Collection
More than 25 paintings, including a collection of watercolors.

Continuing
Stephen Scott Young: A Portrait of Greenville
More than 40 watercolors, tempera works and drawings.

PERMANENT COLLECTION

American art from the colonial period to the present, focusing on artists and art related to the South. **Highlights:** Twentieth-century works by Georgia O'Keeffe, Hans Hofmann, Josef Albers and Andy Warhol; 26 paintings by Andrew Wyeth. **Architecture:** 1974 building by Craig, Gaulden & Davis.

Admission: Free.
Hours: Tuesday through Saturday, 10 a.m.–5 p.m.; Sunday, 1–5 p.m. Closed Monday and major holidays.

Knoxville Museum of Art

1050 World's Fair Park Drive, Knoxville, Tenn. 37916
(423) 525-6101
www.knoxart.org

2002 EXHIBITIONS

Through January 6
Worlds of Transformation: Tibetan Art of Wisdom and Compassion
Fifty examples of Tibetan shrine painting created during the last six centuries. The majority of the works are on fabric and depict Buddhist ideas about the human soul.

January 11–April 7
A Painting for Over the Sofa: That's Not Really a Painting

February 1–May 19
Craft on the Edge: Selections From the Arrowmont Collection
Exhibition of approximately 50 objects examining the ways artists are blurring the lines between craft and art.

June 14–September 8
Lure of the West: Treasures From the Smithsonian's Museum of American Art
Paintings and sculpture by artists who traveled west in the decades following the Lewis and Clark expedition, including Albert Bierstadt, George Catlin and Emanuel Leutze. (Travels)

August 16–November 17
Innovation/Imagination: Fifty Years of Polaroid Photography, 1947–1997

More than 100 works, by Ansel Adams, Robert Mapplethorpe, Andy Warhol, William Wegman and others. (Travels)

PERMANENT COLLECTION

American painting, sculpture, photography and works on paper during and after the 1960's. **Architecture:** 1990 Edward Larrabee Barnes steel-and-concrete building, faced in Tennessee pink marble.

Admission: Adults, $4; seniors and children, $2.
Hours: Tuesday through Saturday, 10 a.m.–5 p.m.; Friday, until 9 p.m.; Sunday, noon–5 p.m. Closed Monday, New Year's Day, Thanksgiving and Christmas Day.

The Dixon Gallery and Gardens

4339 Park Avenue, Memphis, Tenn. 38117
(901) 761-5250
www.dixon.org

PERMANENT COLLECTION

French and American Impressionists; Post-Impressionists and related schools; the Montgomery H. W. Ritchie Collection, which includes French and American art from the 19th and early 20th centuries; the Stout Collection of 18th-century German porcelain; the Adler Pewter Collection; the Dixon gardens. Works by Monet, Renoir, Degas, Braque, Cassatt, Cézanne, Chagall, Daumier, Gauguin, Matisse and Rodin. **Architecture:** Georgian-style residence and gallery complex surrounded by 17 acres of gardens and woodlands.

Admission: Adults, $5; seniors, $4; students, $3; children under 12, $1; groups of 20 or more, $4; members, free.
Hours: Tuesday through Saturday, 10 a.m.–5 p.m.; Sunday, 1–5 p.m.; Monday, gardens only, for half-price admission, 10 a.m.–5 p.m.

Memphis Brooks Museum of Art

1934 Poplar Avenue, Memphis, Tenn. 38104
(901) 544-6200
www.brooksmuseum.org

2002 EXHIBITIONS

Through January 13
The Art of Warner Bros. Cartoons
More than 160 drawings, paintings, cels and related artworks used in making Warner's classic cartoons from the 1930's through 1960, including works by Chuck Jones, Tex Avery, Friz Freleng and Bob Clampett.

Through January 20
English and American Silver: The Enlightened Years
Traces the development of English and American silver from 1700 until 1910, including innovations associated with Tiffany and Gorham.

February 23–May 19
Presidential Portraits From the National Portrait Gallery
Includes portraits of George and Martha Washington by Rembrandt Peale, John Quincy Adams by George Caleb Birmingham and Richard Nixon by Norman Rockwell.

May 12–July 21
Myth, Memory and Imagination
Painting, photography, sculpture and folk art reflecting the essence of Southern life.

June 2–July 28
Almost Warm and Fuzzy
An exhibition aimed at young people, featuring works such as Sandy Skoglund's *Shimmering Madness*, a dreamlike environment of thousands of jellybeans.

August 18–October 13
Arts of the South Seas
About 110 exotic artifacts from the South Seas collections of the Barbier-Mueller Museum in Geneva, Switzerland, including wooden and stone statues, masks, shields, jewelry in gold, ivory and mother of pearl, textiles, drums and sculptures.

PERMANENT COLLECTION

Italian Renaissance and Baroque paintings; decorative arts, including period furniture and textiles; African art; works by Carroll Cloar, a regionalist artist. **Architecture:** 1916 Beaux-Arts building by James Gamble Rogers; 1973 and 1990 expansions and renovations.

Admission: Adults, $5; seniors, $4; students, $2. Free on Wednesday.
Hours: Tuesday through Friday, 10 a.m.–4 p.m.; Saturday, until 5 p.m.; Sunday, 11:30 a.m.–5 p.m. Closed Monday, New Year's Day, Independence Day, Thanksgiving and Christmas Day.

Cheekwood — Tennessee Botanical Garden and Museum of Art

1200 Forrest Park Drive, Nashville, Tenn. 37205
(615) 356-8000
www.cheekwood.org

2002 EXHIBITIONS

February 1–March 31
Recent Sculptures by Terry Glispin
New works by the Nashville artist and educator.

February 1–April 28
Photography's Multiple Roles: Art, Document, Market, Science
More than 150 works, by Ansel Adams, Diane Arbus, Louise Dahl-Wolfe, Walker Evans, Robert Frank, Nan Goldin, George Hurrell, Dorothea Lange, Annie Leibovitz, Sally Mann, Irving Penn, William Wegman and others. (Travels)

July 13–October 13
A Century of Progress: Twentieth-Century Painting in Tennessee
Seventy canvases, including works by Robert Ryman. (Travels)

November 1–December 31
The Sight of Music
Works on paper by 68 artists, including Thomas Hart Benton,

John Cage, Chuck Close, Jasper Johns, Roy Lichtenstein and Andy Warhol. (Travels)

PERMANENT COLLECTION

Nineteenth- and 20th-century American art; sculpture by William Edmondson; Woodland Sculpture Trail featuring works by James Turrell, Sophie Ryder, Ian Hamilton Finlay and Jenny Holtzer; decorative arts collection, showcasing more than 200 pieces of Worcester porcelain and 650 works in silver.

Admission: Adults, $10; seniors and college students, $8; youth/college students, $5; children under 6 and members, free. After 3 p.m., half-price.
Hours: Tuesday through Saturday, 9:30 a.m.–4:30 p.m.; Sunday, 11 a.m.–4:30 p.m. Closed Monday except federal holidays, New Year's Day, Thanksgiving, Christmas Day and the second Saturday in June.

Texas

Austin Museum of Art

Downtown

823 Congress Avenue, Austin, Tex. 78701
(512) 495-9224
www.amoa.org

Interim space until the opening of the museum's new building, scheduled for 2004.

2002 EXHIBITIONS

January 19–March 24
Visualizing the Blues: Images of the American South, 1862–1999
More than 100 photographs, from the 19th century to the present, chronicling enduring elements of Southern culture.

April 6–May 26
Twenty Under Forty: Austin Area Art Update
Paintings, sculpture, photography and other works produced since 2000 by local artists born after 1962.

June 8–August 18
Images From the World Between: The Circus in 20th-Century American Art
Paintings, sculpture, prints, photographs and video works by 20th-century American artists, including George Bellows, Alexander Calder, Charles Demuth, Diane Arbus, Lisette Model and Bruce Nauman.

September 6–November 10
Common Objects/Extended Meanings: Sometimes a Cigar Is Not Just a Cigar
Exploring a recent trend in sculpture: assigning deep meaning to everyday objects.

PERMANENT COLLECTION

Small collection of post–World War II paintings, sculpture, photographs, prints and drawings from the United States,

Mexico and Caribbean. **Architecture:** 1916 Mediterranean-style villa.

Admission: Adults, $3; seniors and students, $2; members and children under 12; free; Thursday, $1.
Hours: Tuesday through Saturday, 10 a.m.–6 p.m.; Thursday, until 8 p.m.; Sunday, noon–5 p.m. Closed Monday, New Year's Day and Christmas Day.

Austin Museum of Art — Laguna Gloria

3809 West 35th Street, Austin, Tex. 78703
(512) 458-8191

Temporarily closed for restoration. Sculpture garden remains open.

Admission: Adults, $2; seniors and students, $1; members and children under 12, free.
Hours: Tuesday through Saturday, 10 a.m.–5 p.m.; Thursday, until 8 p.m.; Sunday, noon–5 p.m. Closed Monday.

Jack S. Blanton Museum of Art

The University of Texas at Austin
23nd and San Jacinto Streets, Austin, Tex. 78712
(512) 471-7324
www.blantonmuseum.org

2002 EXHIBITIONS

January 25–July 14
time/frame
Explores temporality in 20th-century art through works from the museum's American and Latin American collections.

PERMANENT COLLECTION

More than 16,000 works of art, from antiquity to the present. Suida-Manning Collection of Renaissance and Baroque art; Michener Collection of 20th-century American art; contemporary Latin American art.

Admission: Free.
Hours: Monday through Friday, 9 a.m.–5 p.m.; Thursday, until 9 p.m.; Saturday and Sunday, 1–5 p.m.

Dallas Museum of Art

St. Paul Street at Woodall Rodgers Freeway, Dallas, Tex. 75201
(214) 922-1200
www.dm-art.org.

2002 EXHIBITIONS

Through January 6
Great Masters of Mexican Folk Art
More than 1,000 objects, including guitars, capes and blankets, created from natural materials and decorated with indigenous designs. (Travels)

May 12–August 18
Thomas Struth
Portraits, black-and-white photographs of cities and color photos of Asian mountains and forests. (Travels)

October 13–January 5, 2003
Anne Vallayer-Coster: Still-Life Painting in the Age of Marie Antoinette
Some 60 paintings by Vallayer-Coster (1744–1818), as well as works by several of her contemporaries. (Travels)

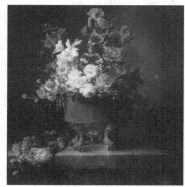

Courtesy of the Dallas Museum of Art.
Anne Vallayer-Coster, *Bouquet of Flowers in a Blue Porcelain Vase*, 1776.

November 2–January 12, 2003
The Gilded Age: Treasures From the Smithsonian Museum of American Art
More than 60 works from the 1870's through the 1910's, including ones by Hassam, Ryder, Homer and Sargent. (Travels)

PERMANENT COLLECTION

Western art from classical to contemporary times. African art and art of the Americas. **Architecture:** Minimalist buildings by Edward Larrabee Barnes, 1983 and 1993.

Admission: Adults, $6; seniors and students 12 and over, $4; children under 12, free.
Hours: Tuesday through Sunday, 11 a.m.–5 p.m.; Thursday, until 9 p.m. Closed Monday, New Year's Day, Thanksgiving and Christmas Day.

Amon Carter Museum

3501 Camp Bowie Boulevard, Fort Worth, Tex. 76107
(817) 738-1933
www.cartermuseum.org

2002 EXHIBITIONS

Through January 27
Robert Adams: True West
Fifty prints by this influential landscape photographer surveying his 30-year career.

Through February 10
Revealed Treasures: Drawings From the Permanent Collection
Watercolors and drawings from 1791 to 1965, including works by Homer, Moran, Dove, O'Keeffe, Demuth and Marin.

Through March 3
Masterworks of American Photography
Selections from the permanent collection, which has a particular focus on depictions of the American West, soft-focus pictorialism and modernism.

Fort Worth

Through March 31
Laura Gilpin and Eliot Porter in New Mexico
Images by two New Mexico photographers who were contemporaries, Gilpin (1891–1979) and Porter (1901–1990)

Through March 31
Avedon's American West
Images of working people in the American West by the well-known fashion and celebrity photographer Richard Avedon.

Through March 31
Common Ground: Settling Colorado
Nineteen images reflecting Colorado's explosive growth in the aftermath of the 1858 Pike's Peak gold rush.

Through May 26
The Artist and the American West: A Century of Western Art
Ninety paintings, sculptures, watercolors, drawings, photographs and rare books by 52 artists who depicted the frontier.

March 2–May 12
Stamp of Impulse: Abstract Expressionist Prints
Some 100 prints from the 1940's to the 1960's reflecting the impact of Abstract Expressionism on the graphic arts.

May 25–August 25
Eye Contact: Modern American Portrait Drawings From the National Portrait Gallery
Nearly 50 works on paper exploring a century of portraiture, including self-portraits by Mary Cassatt and Joseph Stella.

September 14–November 17
Celebrating America: Masterworks From Texas Collections
Paintings, sculptures, watercolors and photographs from public and private collections in Texas.

December 7–March 23, 2003
Eliot Porter: The Color of Wildness
About 165 prints exploring the legacy of Eliot Porter (1901– 1990), who helped forge an acceptance of color photography.

PERMANENT COLLECTION

Paintings, sculpture, photographs and works on paper. Art of the American West, including works by Remington and Russell; 19th- and 20th-century painting, sculpture and graphic art by Cole, Davis, Demuth, Harnett, Homer, Marin, Nadel-

man and O'Keeffe. Extensive photography collection. **Highlights:** Grant Wood, *Parson Weems' Fable*; Eakins, *Swimming*; Remington, *The Fall of the Cowboy*; O'Keeffe, *Dark Mesa and Pink Sky*. **Architecture:** Original 1961 building and 2001 expansion by Philip Johnson.

Admission: Free.
Hours: Tuesday and Wednesday, 11 a.m.–5 p.m.; Thursday, 11 a.m.–9 p.m.; Friday and Saturday, 11 a.m.–8 p.m.; Sunday, noon–5 p.m. Closed Monday and major holidays.

Kimbell Art Museum

3333 Camp Bowie Boulevard, Fort Worth, Tex. 76107
(817) 332-8451
www.kimbellart.org

2002 EXHIBITIONS

Through January 13
Treasures From a Lost Civilization: Ancient Chinese Art From Sichuan
About 128 bronze, jade and clay works recently excavated in Sichuan Province, from the 13th century B.C. to 2nd century A.D. (Travels)

March 10–June 2
Bartolomé Esteban Murillo (1617–1682): Paintings From American Collections
First major U.S. retrospective of the Spanish artist, featuring 35 paintings. (Travels)

PERMANENT COLLECTION

Works from antiquity to the present, including masterpieces from Fra Angelico and Caravaggio

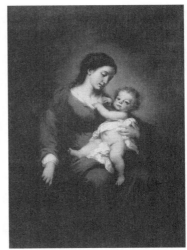

Courtesy of the Kimbell Art Museum.
Bartolomé Esteban Murillo, *Virgin and Child*, 1670.

to Cézanne and Matisse; Asian art; Mesoamerican and African art; Mediterranean antiquities. **Architecture:** Classic modern building by Louis I. Kahn.

Admission: Free. Special exhibitions: $6–$10; discounts for children, seniors and students; members, free.

Hours: Tuesday through Thursday and Saturday, 10 a.m.–5 p.m.; Friday, noon–8 p.m.; Sunday, noon–5 p.m. Closed Monday, New Year's Day, Independence Day, Thanksgiving and Christmas Day.

Modern Art Museum of Fort Worth

1309 Montgomery Street, Fort Worth, Tex. 76107
(817) 738-9215
www.the modern.org

The Montgomery Street location will close on May 1, 2002, for the museum's relocation to a new building on Darnell Street, scheduled to open in November 2002.

The Modern at Sundance Square

410 Houston Street, Fort Worth, Tex. 76102
(817) 335-9215

2002 EXHIBITIONS

Through January 20
Trenton Hancock: The Life and Death of #1
Mixed-media works exploring this Texas artist's alter ego.

February 10–April 14
Museums for a New Millennium: Concepts, Projects, Buildings
Explores several major international museums constructed at the end of the 20th century.

November 10–mid-January 2003
110 Years: The Permanent Collection of the Modern Art Museum of Fort Worth
Inaugural exhibition in the museum's new building featuring painting, sculpture, photography and works on paper.

Permanent Collection

Some 3,000 paintings, sculptures, photographs, drawings and prints, focusing on American and European art after 1945; works by Diebenkorn, Guston, Baselitz, Kiefer, Sherman and Gilbert & George; contemporary sculpture on museum grounds. **Highlights:** Large Robert Motherwell collection, including *Spanish Picture With Window;* Jackson Pollock, *Masqued Image;* Andy Warhol, *Twenty-Five Colored Marilyns.* **Architecture:** Montgomery Street: 1954 building by Herbert Bayer; 1974 addition with courtyard and solarium by O'Neil Ford & Associates. New building: designed by Tadao Ando. Annex in Sanger Building: listed on the National Register of Historic Places.

Admission: Free.
Hours: Tuesday through Friday, 10 a.m.–5 p.m.; Saturday, 11 a.m.–5 p.m.; Sunday, noon–5 p.m. Closed Monday and major holidays. The Modern at Sundance Square: Monday through Thursday, 11 a.m.–6 p.m.; Friday and Saturday, until 10 p.m.; Sunday, 1–5 p.m. New Darnell Street location: Tuesday–Saturday, 10 a.m.–8 p.m.; Sunday, 11 a.m.–5 p.m. Closed Monday and major holidays.

Contemporary Arts Museum

5216 Montrose Boulevard, Houston, Tex. 77006
(713) 284-8250
www.camh.org

2002 Exhibitions

Through February 17
The Inward Eye: Transcendence in Contemporary Art
Thirty diverse works created between 1970 and 2000, including perceptual, tactile and metaphorical art.

January 11–March 3
William Lundberg
Film installation works that haven't been displayed in roughly 25 years, plus a new one by Lundberg, who recently began exhibiting again after a residency at ArtPace in San Antonio.

Courtesy of the Contemporary Art Museum.
William Kentridge, production still from *Felix in Exile*, 1994.

March 1–May 5
William Kentridge
Short animated films and drawings by the South African.

May 3–June 23
Christine Borland
New works by the Glasgow-based artist that explore the role of plants in the development of medicines. (Travels)

June 28–August
Sanford Biggers: Nkisi
A new installation in which the artist investigates the ambiguous territory between the sacred and mundane.

August 17–October 13
Roxy Paine
A look at the relationship between the Brooklyn, N.Y., artist's machines and his horticultural sculptures and installations.

October 4–December 1
The Complete Graphic Works of H.C. Westermann
Lithographs, linoleum cuts and woodblock prints as well as linoleum and wood blocks made by Westermann (1922–1981). Coincides with a retrospective of his painting and sculpture on display at The Menil Collection in Houston.

October 26–January 5, 2003
Splat Boom Pow!: The Influence of Cartoons, 1970–2000

More than 70 objects by at least 30 artists, showing the absorption of pop culture in the contemporary art landscape.

Architecture: 1972 stainless-steel parallelogram designed by Gunner Birkerts and Assocates of Michigan; 1997 renovation by William F. Stern & Associates.

Admission: Free.

Hours: Tuesday through Saturday, 10 a.m.–5 p.m.; Thursday, until 9 p.m.; Sunday, noon–5 p.m. Closed Monday, New Year's Day, Thanksgiving and Christmas Day.

The Menil Collection

1515 Sul Ross, Houston, Tex. 77006
(713) 525-9400
www.menil.org

2002 EXHIBITIONS

Through January 6
Victor Brauner: Surrealist Eccentric
More than 55 paintings, sculptures and works on paper.

Through February 3
Mineko Grimmer
A new installation featuring water and music.

February 1–May 26
Agnes Martin
Some 30 paintings by the minimalist.

Courtesy of the Menil Collection.
Victor Brauner, *Lá-Bas (Over There)*, 1949.

October 4–January 5, 2003
H.C. Westermann
The first posthumous retrospective of the American artist's work, including *Death Ships*, figurative sculptures, box works and drawings.

PERMANENT COLLECTION

Opened in 1987 to preserve and exhibit the collection of Dominique and John de Menil. More than 15,000 paintings,

sculptures, prints, drawings, photographs and rare books, from
antiquity, the Byzantine and medieval worlds, the tribal cul-
tures of Africa, Oceania and the Pacific Northwest and the
20th century. **Highlights:** The Cy Twombly Gallery, devoted
to paintings, sculpture and works on paper by the American
artist; Richmond Hall, home of a fluorescent light environ-
ment by Dan Flavin. **Architecture:** Building and Twombly
Gallery designed by Renzo Piano.

Admission: Free.
Hours: Wednesday through Sunday, 11 a.m.–7 p.m. Closed
Monday, Tuesday and major holidays.

The Museum of Fine Arts

Caroline Wiess Law Building: 1001 Bissonnet
Audrey Jones Beck Building: 5601 Main Street
Glassell School of Art: 5101 Montrose Street
Houston, Tex. 77265
(713) 639-7300; (713) 639-7379 (Spanish); (713) 639-
 7390 (for the deaf)
www.mfah.org

2002 Exhibitions

Through January 21
Space: Sculptors' Drawings and Drawing About Sculpture
Drawings by Eva Hesse, Aristide Maillol, David Smith
and other 20th-century sculptors, plus two large drawings
by Robert Moskowitz that relate to a bronze in the collection.

Through February 3
*Earth and Fire: Italian Terra Cotta Sculpture, From Donatello
to Canova*
Works in clay by Verrocchio, Bernini and other sculptors, as
well as works on paper and canvas. Explores the evolution of
concepts, from drawings to clay models to the finished marble.

Through February 17
American Traditions: Quilts and Coverlets, 1760–1900
Twenty-five examples.

Through February 24
Color, Myth and Music: Stanton Macdonald-Wright and Synchromism
The first retrospective devoted to Macdonald-Wright
(1890–1973), a painter who challenged the limits of Cubism,
broke new ground in color theory and delved into mysticism.

Through February 24
Eye on Third Ward: Yates Magnet School Photography

Through February 24
Japanese Prints by Goyo

January 13–April 28
Texas Flags, 1836-1945
Dozens of historic flags.

January 17–March 10
Peter Sarkisian: Hover
A mixed-media video-projection installation.

January 20–March 31
Richard Pousette-Dart: Timeless Perspective
Works on paper spanning the career of the Abstract
Expressionist, from the 1930's through his death in 1992.

January 20–April 14
Louis Faurer Retrospective
Photographs of cities, primarily New York.

February 2–April 28
Postwar Italian Photography

March 17–June 16
Dancer: Photographs by Irving Penn
Three series of nudes, shot in one session with one model, that
Penn made when he was 82 years old. (Travels)

March 22–April 21
2002 Core Exhibition
The 20th annual exhibition of works by the core artists in
residence at the museum's Glassell School of Art.

March 31–August 4
*Splendors of Vice Regal Mexico: Three Centuries of Treasures From
the Museo Franz Mayer*
Works created from 1521 to 1821. (Travels)

April 28–August 4
Spotlight on the Collection: Color Field

Houston

May 12–August 4
Americanos: Latino Life in the United States
More than 100 contemporary works by 32 Latino
photojournalists, who recently sought to document the
diversity and energy of Latin-American communities. (Travels)

June 30–September 22
*Mughal Painting From the Arthur M.
Sackler Gallery and the Art and
History Trust*

June 30–October 27
*Treasury of the World: The Jeweled
Arts in the Age of the Mughals*
More than 200 objects, including
royal and princely personal
adornment items, jade pieces and
jeweled weapons. (Travels)

September 8–November 17
The Quilts of Gees Bend
One hundred 20th-century quilts
made by African-American women
in Gees Bend, Alabama.

October 6–January 5, 2003
*Over the Line: The Art and Life of
Jacob Lawrence*
Paintings of historical and
contemporary subjects. (Travels)

Courtesy of the Museum of Fine Arts.
Mughal, *dagger with hilt made of
three large-faceted emeralds*,
17th century.

December 8–February 17, 2003
Leonardo da Vinci and the Splendor of Poland
Da Vinci's *Portrait of the Lady with the Ermine*, Rembrandt's
Portrait of Martin Soolmans, views of Warsaw by Bernardo
Bellotto and other works.

December 15–March 9, 2003
*The Impressionists and Their Masters: Three Centuries of French
Painting From the State Pushkin Museum of Fine Arts, Moscow*
The first such exhibition in America drawn exclusively
from the Pushkin, including works never before exhibited
outside Russia. Masterpieces from the 17th century through
the 19th.

PERMANENT COLLECTION

More than 40,000 works from six continents, spanning 5,000 years of art history. Includes Impressionist and Post-Impressionist art; Renaissance and Baroque works; African gold; the Cullen Sculpture Garden; American and European decorative arts. **Architecture:** Original 1924 Beaux-Arts museum building designed by William Ward Watkin; glass-walled International Style addition by Mies van der Rohe; new Beck Building, opened in 2000, by Rafael Moneo.

Admission: Adults, $5; students, seniors and children 6–18, $2.50; children 5 and under, free. Free on Thursday.
Hours: Tuesday through Saturday, 10 a.m.–7 p.m.; Thursday and Friday, until 9 p.m.; Sunday, 12:15–7 p.m. Closed Monday, except holidays.

Marion Koogler McNay Art Museum

6000 North New Braunfels Avenue, San Antonio, Tex.
 78209
(210) 824-5368
www.mcnayart.org

2002 EXHIBITIONS

Through January 20
Corot to Picasso: European Masterworks From the Smith College Museum of Art
Some 58 paintings and sculptures of the 19th and 20th centuries, including works by Corot, Ingres, Delacroix, Courbet, Manet, Monet, Degas, Renoir, Cézanne, Gauguin and Picasso.

January 8–February 24
Bill Viola: The Greeting
Video installation inspired by the painting *Visitation* by the Italian Mannerist Jacopo Pontormo.

February 5–April 7
Texas Modern: The Prints of Bill Reily

TEXAS

San Antonio

Works by a San Antonio painter and printmaker whose most important works were produced from the 1940's to 1960's.

March 11–May 19
Theater of Drawing: Early Artworks of Robert Wilson
Drawings, notebook pages and sculptures by the avant-garde theater and opera director.

April 9–May 6
Rodchenko: Modern Photography, Photomontage and Film
Works from 1923 to 1947 by Aleksandr Rodchenko, a Russian artist who was a major figure in Constructivism.

May 4–July 7
The Essential Image: Minimalist Works on Paper
Includes works by artists, such as Donald Judd and Agnest Martin, who took the concepts of Modernism to an extreme.

June 11–September 15
Hans Hoffmann, Paintings From the 1960's: The Berkeley Art Museum Collection
Some 30 late works from the 47 paintings the artist (1880–1966) gave to the university.

July 2–September 1
Ray Smith: ARTMATTERS II
Figurative and fantastical paintings by the Texas-born artist who splits his time between New York City and Mexico.

July 21–September 15
Drawing in San Antonio: Contemporary Area Artists
Recent drawings by San Antonio artists.

October 8–January 5, 2003
From Fauvism to Impressionism: Albert Marquet at the Pompidou
Some 40 paintings and 15 drawings spanning the artist's career, from his bold experiments in Fauvism to his Impressionist work.

October 8–January 5, 2003
A View From the Top: Henri Rivière and the Eiffel Tower
Celebrates the museum's acquisition of the artist's album of color woodblock prints, *Thirty-Six Views of the Eiffel Tower.*

October 18–November 24
Collectors Gallery XXXV
Exhibition of works for sale by dealers.

November 5–January 12, 2003
Mostly British: Scene and Costume Design of the 20th Century
Theatrical designs influenced by the teachings of Edward Gordon Craig, who promoted visual simplicity.

PERMANENT COLLECTION

Nineteenth- and 20th-century art, including French Post-Impressionist paintings and pre-World War II American paintings; medieval and Renaissance European sculpture and painting; 19th- and 20th-century prints, drawings and theater arts. **Architecture:** 1926–28 Spanish-Mediterranean-style residence by Atlee B. and Robert M. Ayres.

Admission: Free; fees for special exhibitions.
Hours: Tuesday through Saturday, 10 a.m.–5 p.m.; Sunday, noon–5 p.m. Closed Monday, New Year's Day, Independence Day, Thanksgiving and Christmas Day.

San Antonio Museum of Art

200 West Jones Avenue, San Antonio, Tex. 78215
(210) 978-8100
www.sa-museum.org

2002 EXHIBITIONS

Through April 7
Chicano Visions: American Painters on the Verge
More than 80 works on paper, ranging from 1969 to 2001, mainly from the actor Cheech Marin's collection.

February 2–April 28
Weaving China's Past: The Amy S. Clague Collection of Chinese Textiles
More than 30 examples, dating from the 10th century to the 20th, including clothing and Buddhist ritual items.

September 28–January 5, 2003
Maestros de Plata: William Spratling and Mexico's Silver Renaissance
Works by Spratling and other Mexican silver designers.

Permanent Collection

Greek, Roman and Egyptian antiquities; American and European paintings; Asian art; modern art. **Highlights:** The Nelson A. Rockefeller Center for Latin American Art. **Architecture:** A historic brewery building along the banks of the San Antonio River.

Admission: Adults, $5; students and seniors, $4; children 4–11, $1.75. Free on Tuesday, 3–9 p.m.

Hours: Wednesday through Saturday, 10 a.m.–5 p.m.; Tuesday, until 9 p.m.; Sunday, noon–5 p.m. Closed Monday, Easter, Battle of Flowers Parade Day, Thanksgiving and Christmas Day.

Chrysler Museum of Art

245 West Olney Road, Norfolk, Va. 23510
(757) 664-6200
www.chrysler.org

2002 Exhibitions

Through January 13
Pop Impressions Europe/USA
Nearly 100 American and European prints and multiples from the collection of the Museum of Modern Art in New York.

Through March 17
Survey From the Photography Collection

March 1–May 19
An American Century of Photography: From Dry Plate to Digital
Selections from the Hallmark Photographic Collection, including works by Sally Mann, Jacob Riis, Edward Steichen, Afred Stieglitz and Edward Weston. (Travels)

June 21–July 31
Works on Paper
Drawings and prints from the museum's collection, ranging from the 15th century to the 19th, including works by Albrecht Dürer and Jean-François Millet.

August–fall
The Virginian-Pilot Newspaper: One Hundred Years of Great Photography

October 4–January 5, 2003
American Impressionism: Treasures From the Smithsonian American Art Museum
Works by John White Alexander, Mary Cassatt, Childe Hassam, Maurice Brazil Prendergast and others. (Travels)

December–March 2003
The Southern Civil Rights Movement by Danny Lyon

PERMANENT COLLECTION

More than 30,000 objects spanning 5,000 years, including European and American painting and sculpture; glass; decorative arts; photography; pre-Columbian, African and Asian art. The museum administers two historic houses in Norfolk: the Moses Myers House, 331 Bank Street, and the Willoughby-Baylor House, 601 East Freemason Street.

Admission: Adults, $7; students, seniors and military, $5; children 12 and under, free. Free on Wednesday.
Hours: Wednesday, 10 a.m.–9 p.m.; Thursday through Saturday, 10 a.m.–5 p.m.; Sunday, 1–5 p.m. Closed Monday, Tuesday and major holidays.

Virginia Museum of Fine Arts

2800 Grove Avenue, Richmond, Va. 23221
(804) 340-1400; (804) 340-1401 (for the deaf)
www.vmfa.state.va.us

2002 EXHIBITIONS

Through January 6
Print Matters: New Works and Modern Treasures
Recent acquisitions by artists such as Richard Serra, Chuck Close, Alison Saar and William Kentridge as well as works

Courtesy of the Virginia Museum of Fine Arts.
Pipilotti Rist, production still from *Sip My Ocean*, 1996.

from the permanent collection, including Robert Indiana's famous *Love* image.

Through February 24
Works of Wonder and Desire: Indian Paintings From the Virginia Museum of Fine Arts
First comprehensive exhibition from the museum's extensive South Asian collection, featuring Indian paintings from the 12th to the early 20th centuries.

January 19–March 17
Pipilotti Rist: Sip My Ocean

April 6–June 2
Shirin Neshat: Rapture

June 22–August 18
Jane and Louise Wilson: Stasi City
Three-part exhibition featuring large-scale video installations by international video artists who have emerged in the past decade: Rist of Switzerland, Neshat of Iran and the Wilsons of England.

PERMANENT COLLECTION

French Impressionist and Post-Impressionist art; Art Nouveau and Art Deco decorative arts; American and European art since World War II; Russian Easter eggs by Peter Carl Fabergé; African art; pre-Columbian art; Byzantine and

Medieval art; ancient Egyptian, Greek and Roman art; British sporting art; art from India, Nepal and Tibet; European art from the Renaissance to the 20th century. **Architecture:** 1936 Georgian building.

Admission: Suggested donation, $5; fees for some exhibitions. **Hours:** Tuesday through Sunday, 11 a.m.–5 p.m.; Thursday, until 8 p.m. Closed Monday, New Year's Day, Independence Day, Thanksgiving and Christmas Day.

Washington

Frye Art Museum

704 Terry Avenue, Seattle, Wash. 98104
(206) 622-9250
www.fryeart.org

2002 EXHIBITIONS

Through January 6
Fechin/Bongart
Paintings by two Russian-American artists, Nicolai Fechin
and Sergei Bongart.

Through January 13
Witness and Legacy
The legacy of the Holocaust
as seen by 22 contemporary
American artists.

January 11–March 10
Fredrick Brosen

February 8–March 24
*Selections From the Permanent
Collection*

March 15–May 5
Mark Spencer: Paintings

April 6–June 16
An American in Europe

May 10–July 7
William Beckman

Courtesy of the Frye Art Museum.
Arnold Tractman, *Peace in Our Time*,
1991-92.

June 29–September 22
The Perception of Appearance: A Decade of American Drawing

July 12–September 8
Jim Phalen

September 13–November 10
Teng Chiu

October 5–January 19, 2003
Fairfield Porter: A Life in Art, 1907–1975

November 15–January 5, 2003
Avard Fairbanks

PERMANENT COLLECTION

More than 1,200 paintings by 19th- and 20th-century American and European Representational artists. Extensive collections of late-19th-century German art from the Munich School Secession; the American artists Copley, Sargent, Hassam and Whistler; and Alaskan art. **Architecture:** 1952 International Modernist building by Paul Thiry; 1997 renovation by Olson Sundberg Architects, Seattle.

Admission: Free.
Hours: Tuesday through Saturday, 10 a.m.–5 p.m.; Thursday, until 9 p.m.; Sunday, noon–5 p.m. Closed Monday, New Year's Day, Independence Day, Thanksgiving and Christmas Day.

Henry Art Gallery

15th Avenue Northeast and Northeast 41st Street,
 Seattle, Wash. 98195
(206) 543-2280
www.henryart.org

2002 EXHIBITIONS

Through January 6
Jeffry Mitchell: Hanabuki
Contemporary sculpture by the Seattle artist.

Through March 3
Superflat
Contemporary mixed-media works by Japanese artists.

April 4–July 28
Gene(sis): Contemporary Art Explores Human Genomics
New works. (Travels)

Admission: Adults, $6; seniors, $4.50; students, members and children under 14, free. Pay what you wish, Thursday 5–8 p.m.

Seattle

Hours: Tuesday through Sunday, 11 a.m.–5 p.m.; Thursday, until 8 p.m. Closed Monday, New Year's Day, Independence Day, Thanksgiving and Christmas Day.

Seattle Art Museum

100 University Street, Seattle, Wash. 98101
(206) 654-3100
www.seattleartmuseum.org

2002 Exhibitions

Through January 2
First Person Singular
An installation composed of portraits, featuring paintings, sculpture and photographs.

Through January 6
Annie Leibovitz: "Women"
Portraits from the
photographer's 1999 book.

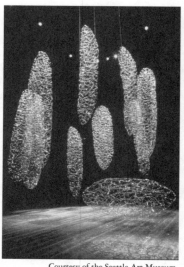

Through February 17
Anna Skibska: Vertical
An installation featuring
glass stretched into
spidery lines. Part of the
Poncho series.

February 7–May 19
Long Steps Never Broke a Back: Art From Africa in America
Selections from the
museum's African
collection interspersed
with contemporary
installations incorporating
sound, music and performance dynamics.

Courtesy of the Seattle Art Museum.
Anna Skibska, *One*, 2000

June 20–September 15
Corot to Picasso: European Masterworks From the Smith College Museum of Art

Paintings and sculpture from the 19th and early 20th
centuries, including works by Paul Cézanne, Edgar Degas,
Vassily Kandinsky and Claude Monet.

October 17–January 5, 2003
*Frida Kahlo, Diego Rivera and 20th-Century Mexican Art: The
Jacques and Natasha Gelman Collection*
Including paintings by José Clemente Orozco, David Alfaro
Siqueiros and Rufino Tamayo.

Continuing
A Maasai Community Adorns a Bride
A costume featuring 20 layers of beadwork.

Continuing
West African Wax Print Cloths
More than 50 examples of cotton fabric printed in dazzling
colors and used for both traditional and Western clothing.

Continuing
Is Egyptian Art African?
Visitors are invited to compare ancient Egyptian deities to
sub-Saharan masqueraders and to view examples of personal
adornment, posture and divine kingship that are shared on
different parts of the continent.

Continuing
*Kiln Art for Palaces, Priests and the Proletariat: Korean Ceramics of
the Koryo and Choson Periods*
Works from the museum's collection, plus 19th-century ink
paintings by three Korean artists.

Continuing
The Return of Ancient American Artworks
Objects ranging from 500 to 3,000 years old.

Seattle Asian Art Museum

Volunteer Park, 1400 East Prospect, Seattle, Wash. 98102
(206) 654-3100
www.seattleartmuseum.org

2002 EXHIBITIONS

Continuing
Wonders of Clay and Fire: Chinese Ceramics Through the Ages

Continuing
Tangible Grace: Chinese Furniture
Examples from the museum's collection.

Continuing
Signs of Fortune, Symbols of Immortality
Japanese paintings, screens, hanging scrolls and folk textiles.

Continuing
Explore Korea: A Visit to Grandfather's House
Visitors can enter the rooms of a traditional Korean home,
including a kitchen and men's and women's quarters. The
exhibition includes hands-on activities.

Permanent Collection

Some 23,000 objects, primarily Asian, African, Northwest
Coast Native American, modern art and European painting
and decorative arts. The Volunteer Park building houses the
majority of the Asian art collection. **Architecture:** 1991
building by Robert Venturi. Asian Art Museum: 1933 art
moderne structure in Volunteer Park, designed by the Seattle
architect Carl Gould.

Admission: Suggested donation: Adults, $7; seniors and students, $5. Suggested donation at the Asian Art Museum: $3.
Hours: Tuesday through Sunday, 10 a.m.–5 p.m.; Thursday,
until 9 p.m. Closed Monday, Thanksgiving, Christmas Day
and New Year's Day.

Milwaukee Art Museum

700 North Art Museum Drive, Milwaukee, Wis. 53202
(414) 224-3200; (414) 224-3220 (recording)
www.mam.org

2002 Exhibitions

Through January 13
Elizabeth Catlett: Works on Paper, 1944–1992

Through January 20
If These Pots Could Talk: Collecting 2,000 Years of British Pottery

Works created from the time of the ancient Gauls to the early 20th century, with an emphasis on 16th-century ceramics.

Through January 27
Milton Avery: The Late Paintings
More than 50 oil paintings created between the late 1940's and the early 60's.

Through February 24
Currents 29: Rodney Graham

Through April 28
Empire of the Sultans: Ottoman Art From the Khalili Collection
More than 200 objects, including arms, armor, scientific instruments, textiles and manuscripts. (Travels)

February 8–April 28
Romanticism to Impressionism: 19th-Century German Prints and Drawings From the René von Schleinitz Memorial Fund

February 15–June 9
The Truth Lies Within: Furniture Fakes From the Chipstone Collection

March 22–May 19
Vito Acconci: Acts of Architecture
Approximately 25 sculptures patterned after architecture and furniture forms, made since 1980. The interactive exhibition also examines Acconci's public works, both built and unbuilt, represented in drawings, photographs and models. (Travels)

May 3–August 25
Geometry/Form/Photography

May 4–August 4
From Generation to Generation: Milton Rogovin Photographs

May 24–August 4
Art Museums at the Turn of the Millennium: Concepts, Projects, Buildings
Sketches, drawings and models of structures that have been, in most cases, completed within the last decade. Included in the exhibition are Frank Gehry's Guggenheim Museum in Bilbao, Spain, Mario Botta's San Francisco Museum of Modern Art and the Milwaukee Art Museum's own expansion.

May 24–August 11
New Prints From Landfall Press

June 14–September 1
On Nature: Five Wisconsin Artists

September 12–November 24
Leonardo da Vinci and the Splendor of Poland
Examines the evolution of Poland's artistic institutions since the 15th century.

PERMANENT COLLECTION

Nearly 20,000 works spanning antiquity to the present. 19th- and 20th-century American and European art, contemporary art, American decorative arts, Old Master works, and American and European folk art. **Architecture:** Built in 1957 by Eero Saarinen; 1975 addition by David Kahler; 2001 expansion by Santiago Calatrava.

Admission: Adults, $6; students and seniors, $4; children under 12 and members, free.
Hours: Tuesday, Wednesday and Saturday, 10 a.m.–5 p.m.; Thursday, noon–9 p.m.; Friday, 10 a.m.-9 p.m.; Sunday, noon–5 p.m. Closed Monday, New Year's Day, Thanksgiving and Christmas Day.

Buffalo Bill Historical Center

720 Sheridan Avenue, Cody, Wyo. 82414
(307) 587-4771
www.bbhc.org

PERMANENT COLLECTION

Western heritage center composed of the Buffalo Bill Museum, the Whitney Gallery of Western Art, the Plains Indian Museum, the Cody Firearms Museum, the Draper Museum of Natural History (opening in 2002) and the McCracken Research Library.

Admission: Adults, $10 (two consecutive days to all four museums); students, $6; children over 5, $4.

Hours: June through September 19, 7 a.m.–8 p.m.; call for seasonal hours.

National Museum of Wildlife Art

2820 Rungius Road, Jackson, Wyo. 83002
(307) 733-5328
www.wildlifeart.org

2002 EXHIBITIONS

January–May
The Strenuous Life: Cowboy Paintings From the Gilcrease Museum

February–April
Jackson Collects
Works by local artists.

February–April
Under Antarctic Ice: Photographs by Norbert Wu
Photographs by a National Geographic photographer.

March–August
Bob Kuhn Retrospective
Works by this highly regarded contemporary wildlife artist.

September–November
The Poetry of Place: Works on Paper by Thomas Moran From the Gilcrease Museum

September–November
A Carnival of Animals: Beasts, Birds and Bugs in Original Illustrations From Children's Books

PERMANENT COLLECTION

More than 2,300 works of art from 2000 B.C. to the present, focusing primarily on European and American painting and sculpture. Works by Delacroix, Dürer, Peale, Catlin, Bierstadt and Audubon. **Highlights**: Carl Rungius Collection, featuring works by the American Impressionist who painted wildlife; John Clymer Collection; American Bison Collection.

Admission: Adults, $6; students and seniors, $5; family rate, $14.
Hours: Daily, 8 a.m.–5 p.m. in summer, 9 a.m.–5 p.m. in winter. Closed Thanksgiving Day and Christmas Day.

Museo de Arte de Ponce

2325 Avenida de las Americas, Ponce, P.R. 00717
(787) 848-0505; (787) 641-3129
www.museoarteponce.org

PERMANENT COLLECTION

More than 2,500 works, including paintings and sculptures by Rubens, Velazquez, Murillo, Strozzi, Delacroix and Bougereau; 18th-century paintings from Peru and South America as well as 18th- and 19th-century works by Puerto Rico's José Campeche and Francisco Oller. Contemporary artists include Fernando Botero, Claudio Bravo, Myrna Baez, Jesús Rafael Soto and Antonio Martorell. **Highlights:** Collection of Pre-Raphaelites and Leighton's *Flaming June.* **Architecture:** 1965 building by Edward Durrell Stone.

Admission: Adults, $4; seniors and children under 12, $2; students, $1; members, free.
Hours: Daily, 10 a.m.–5 p.m. Closed Christmas Day, New Year's Day, January 6 and Good Friday.

Museo de Arte de Puerto Rico

Former Municipal Hospital, 299 De Diego Avenue,
 Santurce, San Juan, P.R. 00940–2001
(787) 977-6277
www.mapr.org

PERMANENT COLLECTION

Puerto Rican art from the 17th century to the present. Modern works include paintings by Olga Albizu and Rafael Tufino, portraits by José Campeche and murals and still lifes

by Francisco Oller y Cestero. **Architecture:** West wing: Neo-classical structure from the 1920's designed by William H. Shimmelphening. East wing: modern structure designed by Otto Reyes and Luis Gutierrez.

Admission: Adults, $5; children, students and seniors, $3. **Hours:** Tuesday through Saturday, 10 a.m.–5 p.m.; Wednesday, until 8 p.m.; Sunday, 11 a.m.–6 p.m. Closed Monday, New Year's Day, January 6, Good Friday, Thanksgiving and Christmas Day.

Finding the Avant-Garde In Europe

By Alan Riding

European museums may be competing ever more heatedly to attract crowds, but they rarely hold up contemporary art as an enticement. Publicize a show of Rembrandt, Velázquez or Vermeer, of Van Gogh, Cézanne or Monet, and the public comes running. Offer a show of installation or video art, with not a painting, drawing or bronze sculpture in sight, and attendance figures are far lower.

True, a score of older living painters — England's Lucian Freud, Spain's Antoní Tapies and Germany's Gerhard Richter, to name just three — have found a place in European museums, but in reality their work is rooted in earlier times. With true avant-garde art, museums are more hesitant. They worry about investing in a passing fad that will not bear the test of time. They even fear being mocked if they display it.

Yet every major art movement in history — even those reassuring Impressionists — began by raising eyebrows. So it is safe to presume that some of today's cutting-edge art will become tomorrow's establishment art. For the moment, little of it can be found in the great museums of Western Europe, but off the beaten track, notably in London, Paris, Berlin and Amsterdam, artists and galleries are busily testing the future. Here is how to find them.

LONDON

London is currently the European capital of contemporary art thanks to the creative talent and marketing skills of a brash group known as the Y.B.A.'s, or young British artists. They reached a larger public when their work entered the venerable Royal Academy of Arts in 1997 in an eye-opening exhibition called "Sensation." They occasionally show at the Serpentine Gallery and the Whitechapel Gallery, both government-owned spaces. A handful of them now also have works in the perma-

nent collection of Tate Britain. But the real action, so to speak, is to be found elsewhere.

Y.B.A.'s like Rachel Whiteread, Damien Hirst and Douglas Gordon made their names through a handful of private galleries. First among these was the **Saatchi Gallery** (98a Boundary Road, Tel. 020-7624-8299), although its millionaire owner, Charles Saatchi, is more collector than dealer. More crucial to the commercial success of Y.B.A.'s have been **White Cube** (44 Duke Street, Tel. 020-7930-5373) and the **Lisson Gallery** (67 Lisson Street, Tel. 020-7724-2739), which also organize public shows of artists they represent. The Anthony d'Offay Gallery, another West End trend-setter, has just closed its doors.

The new fame of the Y.B.A.'s has encouraged legions of still younger artists. To make room for them, the focus of London's art boom has shifted from high-rent Mayfair to the run-down East End. It is there, in areas around Old Street and Bethnal Green, that artists have found ample and cheap studio space. It is also there that scores of new galleries have sprung up. One West End gallery, **White Cube2** (48 Hoxton Square, Tel. 020-7930-5373), has also expanded eastwards, while **Flowers East** (199-205 Richmond Road, Tel. 020-8985-3333), one of the first East End galleries, has now also opened in Mayfair at **Flowers Central** (21 Cork Street, Tel. 020-7439-7766).

The East End galleries are scattered over a two-square-mile area, with Hoxton Square something of a crossroads. Along with White Cube2, the square includes the **Lux Gallery** (2-4 Hoxton Square, Tel. 020-7684-2785), **Dominic Bering** (1 Hoxton Square, Tel. 020-7739-4222) and the **Art Attack Project** (9 Hoxton Square, Tel. 020-7729-9907). And in nearby streets, smaller galleries are multiplying. A few hundred yards away, an old warehouse has become the splendid new quarters of the **Victoria Miro Gallery** (16 Wharf Road, Tel. 020-7336-8109).

To the east, there is another cluster of galleries in Bethnal Green. Of these, the best known is **Maureen Paley/Interim Art** (21 Herald Street, Tel. 020-7729-4112), but several others are fast gaining recognition, among them **The Approach** (47 Approach Road, Tel. 020-8983-3878), **Anthony Wilkinson Gallery** (242 Cambridge Heath Road, Tel. 020-8980-2662), **Nylon** (10 Vyner Street, Tel. 020-8983-5333) and **The Showroom** (44 Bonner Road, Tel. 020-8983-4115).

The exhibitions in these galleries change frequently, with information on current shows to be found in weekly magazines like Time Out as well as on a web site (www.newexhibitions.com). For those reluctant to explore the East End with map in hand, the Contemporary Art Society (www.contempart.org.uk) organizes a five-hour "mystery" bus tour of new spaces, open studios and interesting exhibitions in galleries across London. Tickets costing 18 pounds ($25) can be pre-booked (020-7831-7311) or bought on the same day. The bus leaves 17 Bloomsbury Square at 11 a.m. on the last Saturday of the month from September through June.

PARIS

During the first half of the 20th century, as Post-Impressionism and Fauvism gave way to Cubism and Surrealism, Paris was the cradle of modern art. Today, the 20th-century flag is kept flying by the Musée National d'Art Moderne at the Georges Pompidou Center and the Musée d'Art Moderne de la Ville de Paris (as well as by temporary shows at the Jeu de Paume and the Fondation Cartier pour l'Art Contemporain). The Mayfair of Paris, with galleries displaying art of all ages, is centered around the Avenue Matignon off the Champs-Elyseés, but anything truly contemporary is to be found further east.

The Pompidou Center, which opened in 1979, gentrified the Marais neighborhood and spawned dozens of new galleries. Several have found space in the fine private mansions that pepper the area, among them the **Galerie Marian Goodman**, a branch of the same gallery in New York (79 rue du Temple, Tel. 01-4804-7052), and the **Galerie Romain Larivière** (79 rue du Temple, Tel. 01-4272-8077), which stand opposite each other in an inner courtyard of the 17th-century Hôtel de Montmor, one block from the new Museum of Jewish History.

Other galleries have chosen the nearby rue Vieille du Temple, with a cluster occupying a mansion at No. 108: **Galerie Yvon Lambert** (Tel. 01-4271-0933), **Galerie Cent8** (Tel. 01-4274-5357), Galerie Xippas (Tel. 01-4027-0555) and **Galerie Sabine Puget** (Tel. 01-4271-0420). Rather than focusing exclusively on French art, these galleries tend to show international contemporary art, as do others on the same street like the **Galerie Vieille du Temple** at No. 23 (Tel. 01-4029-9752), the **Galerie le Troisième Oeil** at No. 98 (Tel. 01-4804-3025) and the **Galerie Robert Y. Carrat** at No. 127 (Tel. 01-4276-0386). The **Mexican Cultural Center** at No.

199 presents interesting shows (Tel. 01-4461-8444). And nearby, the **Galerie Thaddeus Ropac** is also prestigious (7 rue Debelleyme, Tel. 01-4272-9900).

While the Marais is made for flâneurs, however, an entirely new art scene has recently opened up in a far less picturesque quarter on the Left Bank behind the new François Mitterrand National Library. Eager to improve a neighborhood of public housing and government offices, the local mayor arranged for street-level spaces of a modern ministerial building on the rue Louise Weiss to be rented by art galleries. And, in just a few years, this street, with a spillover onto the adjacent rue Duchefdelaville, has become the city's avant-garde art head-quarters. To add to the buzz, the galleries often coordinate their openings, with the rue Louise Weiss closed to traffic to encourage art lovers to explore.

Three galleries have even opened two spaces each: the **Galerie Emmanuel Perrotin** (5-7 and 30 rue Louise Weiss, Tel. 01-4216-7979), **Galerie Almine Rech** (11 and 24 rue Louise Weiss, Tel. 01-4583-7190) and the **Galerie Kreo** (9 rue Louise Weiss and 22 rue Delachefdelaville, Tel. 01-5360-1842). Also on rue Louise Weiss are **Entreprise Jousse** at No. 34, which focuses on contemporary design (Tel. 01-5382-1360), **Galerie Praz-Delavallarde** at No. 28 (Tel. 01-4586-2000) and **Air de Paris** at No. 32 (Tel. 01-4423-0277). Most of these galleries are open only in the afternoon and all are closed in August. Information about shows and openings at these galleries can be obtained by calling the Association Louise Weiss at 01-4584-8529.

BERLIN

With the unification of Germany in 1990, Berlin found itself with no fewer than 170 museums sprawled across what was long a divided city. Even with such a heritage, however, the city still did not boast a wealth of 20th-century art. Since then, however, two new museums built around private collections have made amends. Heinz Berggruen's fine collection of works by Picasso, Klee and other modern masters is housed in the Berggruen Museum near the Charlottenberg Palace. And thanks to the generosity of Erich Marx, Berlin now has a Museum of Contemporary Art at the Hamburger Bahnhof, a former railroad station.

The real novelty of the past decade, though, has been the explosive growth of new art. When the city was still divided,

West Berlin was popular among young artists who could find cheap space in the depressed neighborhood of Kreuzberg near the old Berlin Wall. But the more established galleries handling contemporary art were — and still are — concentrated in the prosperous Charlottenburg district. Today, work by recognized German and other European artists can be found at the **Galerie Thomas Shulte** (Mommsenstrasse 56, Tel. 030-3240-0440), **Fine Art Rafael Vorstell** (Knesebeckstrasse 30, Tel. 030-885-2280) and **Galerie Springer & Winkler** (Fasanenstrasse 13, Tel. 030-315-7220).

After unification, many artists went east and new galleries followed. The Mitte district, once downtown East Berlin, is rapidly becoming the cultural center of a united Berlin, with Museums Island at its heart. A stone's throw away, the **Kunsthaus Tacheles** (Oranienburger Strasse 54, Tel. 030-282-6185) stands as a symbol of artistic freedom. First occupied by squatters, the large dilapidated building was then used as a free exhibition space by aspiring artists. Now, having resisted government efforts to raze it, Tacheles has earned a sentimental place in Berlin's new art scene.

In surrounding streets, a score of new commercial galleries have also opened up to cater to both German artists and the many Eastern European and other foreign artists who have flocked to Berlin in recent years. Their fare is predictably varied, but much of it is decidedly avant-garde. Galleries worth visiting include **Galerie 96 im Kunsthof** (Oranienburger Strasse 27, Tel. 030-2809-8160), **Eigen und Art** (Auguststrasse 26, Tel. 030-280-6605), **Galerie Weisser Elefant** (Auguststrasse 21, Tel. 030-2888-4454), **Die Neue Aktiongalerie** (Auguststrasse 20, Tel. 030-2859-9650), **Kunste-Werke Berlin** (Auguststrasse 69, Tel. 030-243-4590) and **Galerie Wohnmaschine** (Tucholskystrasse 35, Tel. 030-3087-2015). Also making its mark is **Galerie Barbara Thumm** (Dirckenstrasse 41, Tel. 030-2839-0347), near the Hackescher Market.

The other district now bursting with artistic energy is Prenzlauer Berg, about two miles northwest of Museums Island. In prewar times, this was a lively workers' neighborhood, with its trademark apartment blocs hiding several inner courtyards, but it was badly neglected under Communism. Today, artists are breathing life back into it, not only by painting exotic murals, but also by spawning a host of small new galleries, some showing cutting-edge art, others displaying

crafts. A few galleries have gained a reputation, among them
KulturBrauerei (Knaackstrasse 97, Tel. 030-441-9269),
Galerie & Kunstgiesserei Flieri (Schliemannstrasse 30, Tel.
030-445-5181) and **Anton Gallery** (Pappelallee 10, Tel. 030-
4465-3006). But, as always, the best way of finding the unex-
pected is to wander, not to search.

AMSTERDAM

What Amsterdam lacks in size, it makes up for in daring.
But it is only outsiders who are surprised by its social experi-
ments and laid-back lifestyle. For locals, the unconventional is
taken for granted. Here contemporary art need not seek refuge
in some down-at-heel district; it is scattered around the city.
Indeed, as part of a policy of encouraging artists, the city gov-
ernment often offers them modest subsidies as well as inexpen-
sive studio and living spaces. For example, accommodation for
artists is now available in a sprawling former city hospital and
in abandoned warehouses behind the Central Station. Several
neighborhoods also have art libraries, known as S.B.K., which
both lend and sell paintings, prints or sculptures from their
collections.

Amsterdam's modern art museum, properly known as the
Stedelijk Museum, remains the place of prestige, with tempo-
rary shows of contemporary art adding life to its permanent
collection. But, as in other cities, while pricey commercial gal-
leries are located at fashionable addresses, in this case along the
Spiegelstraat and Spiegelgracht, it is in narrow back streets and
beside smaller canals that less established work is found.

One of the most enterprising places is the officially spon-
sored Flemish Cultural Centre, called **de Brakke Grond**, near
the Dam square, which often has group shows of intriguing
young Flemish and Dutch artists in its large spaces and theater
(Nes 45, Tel. 020-622-9014). Another gallery within walking
distance of the Dam, in the Jordaan, the former Jewish quarter,
is **Galerie Binnen** (Keizersgracht 82, Tel. 020-625-9603).
Also worth visiting there are **Galerie de Expeditie**
(Leliegracht 47, Tel. 020-620-4758), **Galerie TE** (Linden-
gracht 300, Tel. 020-638-7854) and **Galerie Torch** (Laurier-
gracht 94, Tel. 020-626-0284). **Galerie Jos Art** (KNSM Laan
291, Tel 020-418-7003) is a little farther afield, a short ferry
ride to an island behind the Central Station.

In the south of the city, reachable by tramlines 1 and 6, is a converted hospital, the Wilhelmina Gasthuis. Here more than 100 artists live and work in a large, century-old compound. Among them are weavers, painters and printers who work in wood, metal or pottery. Their common exposition space is run as a collective and is known as **WG-Kunst** (Marius van Bouwdijk Bastiaansestraat 28, Tel 020-616-1515). Through WG-Kunst, it is usually possible to visit one or several private studios on the premises. On occasional "open days," the entire compound can be visited.

Galleries are often closed Mondays and Tuesdays. The best guide to cultural events, including gallery shows and open days for artists' studios, is the monthly Day by Day, published by V.V.V., the Amsterdam Tourist Board, available for the equivalent of around $1 at hotels and newsstands.

Alan Riding is the European cultural correspondent of The New York Times.

Exhibition Schedules for Museums Outside the United States

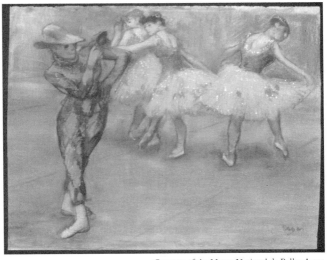

Courtesy of the Museo Nacional de Bellas Artes.

Edgar Degas, *Arlequin Dancing.*

Argentina

Centro Cultural Recoleta

1930 Junin, Buenos Aires 1113, Argentina
(54-114) 803-1041; (54-114) 803-1040
www.centroculturalrecoleta.org

PERMANENT COLLECTION

None. **Architecture:** Built in the 17th century by the Jesuit
architects Juan Kraus and Juan Wolf and the Italian Andrés
Blanqui as a convent for Franciscan friars; 1870 renovations by
Testa, Bedel and Benedit; mid-20th-century facade by
Buschiazzo; neo-Gothic chapel.

Admission: Free.
Hours: Tuesday through Friday, 2–9 p.m.; Saturday, Sunday
and holidays, 10 a.m.–9 p.m. Closed Monday, New Year's Day,
May 1 and Christmas Day.

Fundación Proa

1929 Avenida Pedro de Mendoza, Buenos Aires 1169,
 Argentina
(54-114) 303-0909
www.proa.org

Architecture: A converted residence in a historic immigrant
neighborhood; renovated in 1996 by the Italian architectural
group Caruso-Torricella.

Admission: Adults, $3; students, $2; seniors, $1.
Hours: Tuesday through Sunday, 11 a.m.–7 p.m. Closed
Monday, New Year's Day and Christmas Day.

Museo de Arte Hispanoamericano Isaac Fernández Blanco

1422 Suipacha, Buenos Aires 1011, Argentina
(54-114) 327-0272; (54-114) 327-0228
www.buenosaires.gov.ar/cultura/museos/html

PERMANENT COLLECTION

South American colonial silver, as well as paintings from the schools of Lima, Cuzco and Upper Peru and furniture and decorative arts from the 18th and 19th centuries. **Highlights:** Alto Peruvian tabernacle with engraved flora and fauna; Baroque votive lamp in repoussé and chiseled cast silver.

Admission: $1. Thursday, free.
Hours: Tuesday through Sunday, 2–7 p.m. Closed Monday, the month of January, May 1 and Christmas Day.

Museo de Arte Moderno

350 Avenue San Juan, Buenos Aires, Argentina
(54-114) 361-1121
www.buenosaires.gov.ar/cultura/museos/html

PERMANENT COLLECTION

Contemporary Argentine art by Ernest Deira, Alberto Greco, Kenneth Kemble, Gyula Kosice, Tomás Maldonado, Jorge de la Vega and others; works by Matisse, Miró, Picabia and Picasso. **Architecture:** Renovated 19th-century cigarette factory in the historic San Telmo neighborhood.

Admission: $1.
Hours: Tuesday through Friday, 10 a.m.–8 p.m.; Saturday and Sunday, 11 a.m.–8 p.m. Closed Monday, New Year's Day, May 1 and Christmas Day. Renovations are under way, and some wings are closed to the public.

Museo Nacional de Arte Decorativo

1902 Avenue del Libertador, Buenos Aires 1425,
Argentina
(54-114) 801-8248; (54-114) 802-6606
www.mnad.org

PERMANENT COLLECTION

European paintings, sculpture, furniture, tapestries and glass
ranging from the 16th century to the 20th. **Architecture:**
French neo-Classical style building by René Sergent built
between 1911 and 1917.

Admission: $1. Tuesday, free.
Hours: Tuesday through Sunday, 2–7 p.m. Closed Monday,
Good Thursday, May 1, Christmas Day and New Year's Day.

Museo Nacional de Bellas Artes

1473 Avenue del Libertador, Buenos Aires 1425,
Argentina
(54-114) 803-0802; (54-114) 803-8814

PERMANENT COLLECTION

Works from the medieval period to the present; 20th-century
Latin American art; 19th-century French art, including works
by Corot, Courbet, Degas, Manet, Millet and Toulouse-Lautrec.

Admission: Free.
Hours: Tuesday through Friday, 12:30–7:30 p.m.; Saturday,
Sunday and holidays, 9:30 a.m.–7:30 p.m. Closed Monday,
New Year's Day and Christmas Day.

Australia

National Gallery of Australia

Parkes Place, Canberra ACT 2601, Australia
(61-26) 240-6502
www.nga.gov.au

2002 EXHIBITIONS

Through February 10
Rodin: A Magnificent Obsession
More than 70 bronzes from the Iris and B. Gerald Cantor
Foundation's collection.

Through February 24
William Robinson: A Retrospective
Works by an Australian contemporary landscape artist.

Through March 10
National Sculpture Prize and Exhibition
Works by finalists in the competition.

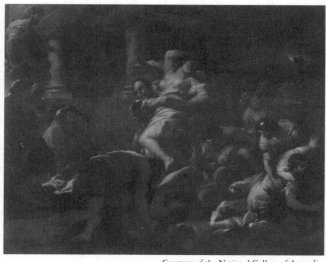

Courtesy of the National Gallery of Australia.
Luca Giordano, *The Rape of Sabines*, ca. 1672-74.

Through April 1
Seeing Red: The Art and Science of Infrared Analysis
Explores the use of infrared light to look through the layers of
a painting and gather information about the artist's materials
and techniques.

PERMANENT COLLECTION

Spans 5,000 years of international art and more than 30,000
years of indigenous Australian culture. Major holdings include
works by Monet, Pollock and Rubens. New acquisitions include
Lucian Freud's *After Cézanne* and Luca Giordano's *The Rape of
Sabines.* **Architecture:** Building designed by Colin Madigan;
sculpture garden by Harry Howard and Associates.

Admission: Free. Fees for special exhibitions.
Hours: Daily, 10 a.m.–5 p.m. Closed Christmas Day.

Queensland Art Gallery

Queensland Cultural Center, Melbourne Street, South
 Brisbane, Queensland 4101, Australia
(61-73) 840-7303
www.qag.qld.gov.au

2002 EXHIBITIONS

Through February 3
Dragon or Rainbow Serpent: A Myth Glorified or Feared
Nine large drawings by Cai Guo Qiang, made using spent
gunpowder, on scrolls that recall Chinese calligraphic forms.

PERMANENT COLLECTION

Established in 1895, the gallery features Australian, Asian-
Pacific and international art, including painting, sculpture,
decorative arts, prints, photographs, installations and videos.
Among the Australian and indigenous artists represented are
Rupert Bunny, Russell Drysdale, Ian Fairweather, Emily Kame
Kngwarreye and Arthur Streeton. **Architecture:** Designed by
Robin Gibson and Partners and opened in its present premises

in the Queensland Cultural Center in 1982. A special feature is the Water Mall, with its natural light and rippling sound.

Admission: Free. Fees for special exhibitions.
Hours: Daily, 10 a.m.–5 p.m. Closed Good Friday and Christmas Day.

Museum of Contemporary Art

Circular Quay West, Sydney 1223, Australia
(61-29) 241-5876; (61-29) 241-5892 (recording)
www.mca.com.au

2002 EXHIBITIONS
Through February 10
Neo-Tokyo: Japanese Art Now
Sculpture, paintings, installations, moving images and digital works that explore the legacy of Pop and the impact of city life and subcultures on contemporary art.

PERMANENT COLLECTION

More than 8,000 works, including approximately 1,000 drawings and paintings by the museum's founding benefactor, John Power; contemporary Australian and international art, including indigenous art from Arnhem Land; works by Australian and international artists.

Admission: Free. Fees for some exhibitions.
Hours: Daily, 10 a.m.–5 p.m. Closed Christmas Day.

Austria

Kunsthistorisches Museum

Maria-Theresien-Platz, Vienna 1010, Austria
(43) 152-5240
www.khm.at

2002 EXHIBITIONS

Through January 13
The Discovery of the World, The World of Discoveries
Some 800 items that offer insight into Austrian explorations,
covering the period from the Enlightenment to the end of the
Austro-Hungarian Empire in 1918. Includes a model of the
frigate Novara, the first ship to sail around the globe under an
Austrian flag.

Through March 17
Gold of the Pharaohs
Ancient Egyptian jewelry, including hair bands, pectorals,
bracelets and items adorned with semiprecious stones.

May 23–September 15
Christian Frescoes From Nubia

PERMANENT COLLECTION

Paintings by the Flemish, Dutch, German, Italian, Spanish and
French schools, including works by Dürer, Rubens, Rembrandt
and Titian; Bruegel collection; antiquities. **Architecture:**
Neo-Renaissance building by Gottfried Semper and Karl
Hasenauer, 1871–91. Together with its companions across the
square, the Natural History Museum and the Hofburg, the
museum was planned as part of the Imperial Forum on the
Ringstrasse, which was never completed.

Admission: 70–100 schillings.
Hours: Tuesday through Sunday, 10 a.m.–6 p.m.; Thursday,
until 9 p.m. Closed Monday.

Palais Harrach

Freyung 3, Vienna 1010, Austria
(43-1) 533-7811
www.khm.at

2002 EXHIBITIONS

January 15–February 28
Alfred Hrdlicka

March 18–July 21
Seventeenth-Century Flemish Still Lifes

Architecture: Baroque palace restored in the 1990's.

Admission: 70–100 schillings.
Hours: Daily, 10 a.m.–6 p.m.

KunstHausWien

13 Untere Weissgerberstrasse, Vienna A-1030, Austria
(43-1) 712-0495; (43-1) 712-0496
www.kunsthauswien.com

2002 EXHIBITIONS

Through February 3
Naive Art: In Quest of Lost Paradise
Some 200 works from the Charlotte Zander Museum in
Stuttgart, the world's largest collection of naïve art and art
brut.

February 14–May 26
Pierre & Gilles: Douce Violence
Naive works by the contemporary French team, one a
photographer and the other a painter.

PERMANENT COLLECTION

Paintings, graphics, drawings and tapestries examining the
philosophy, ecology and architecture of the Austrian artist
Friedensreich Hundertwasser. **Architecture:** 1892 factory
building redesigned by Hundertwasser between 1989 and
1991 in his distinctive playful and ecological style, including
trees growing out of walls and undulating floors.

Max Raffler, *Portrait of Gisela Pfeiffer*, 1971.

Courtesy of the KunstHausWien.

Admission: 95 schillings; seniors and students, 70 schillings; under 10, free.

Hours: Daily, 10 a.m.–7 p.m.

Belgium

Royal Museum of Fine Arts

Leopold De Wawlplaats, Antwerp 2000, Belgium
(32-3) 238-7809
www.dma.be/cultuur/kmska/

2002 EXHIBITIONS

April 6–June 23
Jane Graverol and Rachel Baes: Two Belgian Surrealists
Fifty works, executed between 1940 and 1975, plus letters, photographs and personal documents that help explain the artists' lives.

September 15–December 8
Hans Vredeman de Vries
Some 140 works, including paintings, drawings, prints, books
and applied art.

Continuing
Hans Memlinc's Christ With Singing and Music-Making Angels
Restored
Visitors can witness the 15th-century painting's restoration at
close range.

Continuing
Jan van Eyck's Madonna at the Fountain *Restored*

PERMANENT COLLECTION

Art produced in the region since the 14th century, including
works by Van Dyck, Meunier and Titian. **Highlights:** Van
Eyck, *Saint Barbara;* Rubens, *Adoration of the Magi.*

Admission: Adults, 150 francs; seniors, students and groups,
120 francs; children, free. Free on Friday. Fees for special
exhibitions.
Hours: Tuesday through Sunday, 10 a.m.–5 p.m. Closed
Monday, New Year's Day, January 2, May 1, Ascension Day
and Christmas Day.

Royal Museums of Fine Arts of Belgium

3 Rue de la Régence, Brussels 1000, Belgium
(32-2) 508-3211
www.fine-arts-museum.be

PERMANENT COLLECTION

Belgium's largest art complex encompasses the Museum of
Ancient Art (paintings and sculpture from the 15th century
to the 18th), the Museum of Modern Art (from early 19th
century to Conceptual art) and museums dedicated to
Constantin Meunier and Antoine-Joseph Wiertz. Primitive
Flemish art; works by Bruegel the Elder, Rubens, van Dyck,

Courtesy of the Royal Museums of Fine Arts of Belgium.
The Museum of Ancient Art.

Cranach, Tiepolo and Rembrandt; Delvaux and Magritte rooms.

Admission: Adults, 150 francs; seniors and students, 100 francs; children, 50 francs.
Hours: Tuesday through Sunday, 10 a.m.–5 p.m. Closed Monday, New Year's Day, May 1, November 11 and Christmas Day.

 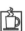

Brazil

Eva Klabin Rapaport Foundation

2480 Avenida Epitácio Pessoa, Lagoa, Rio de Janeiro
22471, Brazil
(55-21) 523-3471

PERMANENT COLLECTION

An eclectic collection assembled by Rapaport (1903–91). Antiquities, including Greek and Chinese examples; paintings

by Gainsborough, Laurencin, Pissarro, Tintoretto and others. Works of art are kept as they were arranged by the founder in the house where she lived from 1960 until her death.

Admission: 10 reals. Reservations required.
Hours: Monday through Friday, 1–6 p.m. Closed Saturday and Sunday.

International Museum of Naïve Art From Brazil

561 Cosme Velho Street, Rio de Janeiro 22241-090, Brazil (55-21) 205-8612

2002 EXHIBITIONS

Continuing
Brasil, Brasileiro
Works by Brazilian painters, including a giant canvas by Lia Mittarakis that portrays Rio de Janeiro.

Continuing
Brazil, Five Centuries
Aparecida Azedo's work, on what is considered to be the world's largest naïve canvas, tells the history of Brazil in 19 scenes, from its discovery until the 1960's.

Continuing
International Paintings
More than 100 works from five continents.

PERMANENT COLLECTION

More than 8,000 paintings by artists from Brazil and 30 other countries, providing a historical record of naïve art from the 14th century to the present.

Admission: Adults, 5 reals; seniors, students and children, 2.50 reals.
Hours: Tuesday through Friday, 10 a.m.–6 p.m.; Saturday and Sunday, noon–6 p.m. Closed Monday, New Year's Day and Christmas Day.

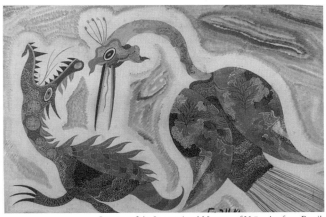

Courtesy of the International Museum of Naïve Art from Brazil.
Chico da Silva, *The Fight*, 1967.

National Museum of Fine Arts

199 Avenida Rio Branco, Rio de Janeiro, 20040-008,
 Brazil
(55-21) 240-0068

2002 EXHIBITIONS

February 2–April 4
Taizi Harada
Paintings by the Japanese contemporary naïve artist.

March–April
Caravaggio
Paintings.

March 5–April 14
Bruno Giorgi
Contemporary Brazilian sculpture.

May 16–June 6
Abelardo Zaluar
Works by the Brazilian abstract painter.

PERMANENT COLLECTION

More than 15,000 paintings, sculptures, prints and drawings
from Brazil and other countries. African and indigenous art;

Italian Baroque paintings from the 16th century through the 18th; 19th- and 20th-century art. **Highlights:** a large collection of Eugène Boudin paintings.

Admission: 5 reals. Free on Sunday.
Hours: Tuesday through Friday, 10 a.m.–6 p.m.; Saturday and Sunday, 2–6 p.m. Closed Monday.

Museum of Contemporary Art of the University of São Paulo

160 Rua da Reitoria, Cidade Universitária 05508, São
 Paulo, Brazil
(55-11) 3818-3027
www.mac.usp.br

2002 EXHIBITIONS

January–August
Di Cavalcanti: 435 Works on Paper

August–December
XX Century: The '50s and Beyond

PERMANENT COLLECTION

Some 8,000 items from 1906 to the present. Significant works by Brazilian and international modern artists, including Tarsila do Amaral, Chirico, Boccioni, Picasso, Calder, DiCavalcanti, Anita Malfatti. **Highlights:** Paper's Cabinet, an exhibition space with vertical hanging storage for 400 works on paper.

Admission: Free.
Hours: Tuesday through Friday, 10 a.m.–7 p.m.; Thursday, 11 a.m.–8 p.m.; Saturday and Sunday, 10 a.m.–4 p.m. Closed Monday.

MAC/*Centro Cultural FIESP*

Galeria de Arte do SESI
1313 Avenida Paulista
(55-11) 284-3639

2002 EXHIBITIONS

March–July
Italian Modern Art From the MAC's Collection
Some 130 works, including paintings, drawings, engravings
and sculptures.

August–October
Geraldo de Barros
Works by a leading Brazilian modernist artist.

Admission: Free.
Hours: Tuesday through Saturday, 10 a.m.–8 p.m.; Sunday, 10
a.m.–7 p.m. Closed Monday.

São Paulo Museum of Modern Art

3 Parque do Ibirapuera Gate, São Paulo 04094, Brazil
(55-115) 549-9688
www.mam.org.br

2002 EXHIBITIONS

January 31–March 10
Beyond Preconceptions: The Sixties Experiment
Works from Europe, Japan and the Americas.

March 21–June 16
Patricia Phelps de Cisneros Collection
Latin American works, including examples of Venezuelan
kinetic and neo-concrete abstraction, Argentine and
Uruguayan abstraction and Brazilian concrete and neo-concrete
abstraction.

PERMANENT COLLECTION

More than 2,800 paintings, sculptures, objects, installations,
drawings and engravings by Brazilian artists.

Admission: Adults, 5 reals; students, 2.50 reals; seniors and under 12, free. Free on Tuesday and on Thursday after 5 p.m.
Hours: Tuesday through Friday, noon–6 p.m.; Thursday, until 10 p.m.; Saturday and Sunday, 10 a.m.–6 p.m. Closed Monday.

Canada

Glenbow Museum

130 Ninth Avenue S.E., Calgary, Alberta T2G 0P3, Canada
(403) 268-4100; (403) 777-5506 (recording)
www.glenbow.org

2002 EXHIBITIONS

Through February 3
Unexpected: Treasures From the Vault
Works from the museum's rarely seen collections.

Through February 18
Celebrating Virtue: Prestige Costume and Fabrics of Late Imperial China
Garments and textiles reflecting the opulence and pageantry of China's last imperial age.

February 23–May 26
Pop Impressions Europe/USA: Prints and Multiples From the Museum of Modern Art
Works by Andy Warhol and other Pop artists.

June 15–October 14
The Group of Seven in the West
Works made in the Canadian west by members of the Toronto-based Group of Seven.

PERMANENT COLLECTION

Glenbow, built in 1976, specializes in documenting the history of the settlement of western Canada. Native North American

collections, particularly of the Plains natives; Canadian paintings, prints, drawings and illustrations; military history.

Admission: $10 (Canadian dollars); seniors, $7.50; students, $6; ages 5–17, $6; under 6, free; family (two adults and up to four children), $30.
Hours: Daily, 9 a.m.–5 p.m.; Thursday and Friday, until 9 p.m. Closed New Year's Day, Christmas Day.

Edmonton Art Gallery

2 Sir Winston Churchill Square, Edmonton, Alberta T5J
 2C1, Canada
(780) 422-6223
www.eag.org

2002 EXHIBITIONS

Through January 14
Marc Chagall: Worlds of Fable and Fantasy
More than 50 works on paper, including etchings produced for Jean de la Fontaine's *Fables* (1952) and a series of lithographs published under the title *Circus* (1967).

Through February 2
Group of Seven

Through February 2
Stand by Your Man: My Life With Tom Thomson
A fictional narrative of Thomson's life, featuring artifacts and works by the artist and his contemporaries.

Admission: $4 (Canadian dollars); seniors and students, $2; ages 6–12, $1; members and under 6, free.
Hours: Monday through Friday, 10:30 a.m.–5 p.m.; Thursday, until 8 p.m.; Saturday and Sunday, 11 a.m.–5 p.m.

Canadian Museum of Civilization

(Musée Canadien des Civilisations)

100 Laurier Street, Hull, Quebec J8X 4H2 Canada
(800) 555-5621; (819) 776-7000
www.civilization.ca

2002 EXHIBITIONS

May 6–October 14
Vikings: The North Atlantic Saga
Artifacts from various regions the Vikings visited during their westward expansion, including silver, jewelry, grave finds, church carvings and manuscripts.

Opening December 6
The Mysterious Bog People
Artifacts that were sacrificed during mysterious rituals by early peoples of northwestern Europe, including a canoe dating from 8,500 B.C.

Continuing
The Lands Within Me: Expressions by Canadian Artists of Arab Origin
Visual arts and performance arts.

PERMANENT COLLECTION

More than five million artifacts, including ethnological and historical pieces, folk art and fine art; the Grand Hall, devoted to Pacific Native peoples, with a large collection of totem poles; the Canada Hall, a series of walk-through settings illustrating 1,000 years of Canadian history; Canadian Children's Museum; Canadian Postal Museum; an Imax/Omnimax theater.

Admission: $8 (Canadian dollars); seniors, $7; students, $6; ages 2–12, $4; families (up to five people), $20. Half-price on Sunday. Free on Thursday, 4–9 p.m.
Hours: Tuesday through Sunday, 9 a.m.–5 p.m.; Thursday, until 9 p.m. Closed Monday and Christmas Day. May 1 through October 8: daily, 9 a.m.–6 p.m.; Thursday, until 9 p.m. (also Friday until 9 p.m. July 1–September 3).

Canadian Center for Architecture

(Centre Canadien d'Architecture)

1920 Baile Street, Montreal, Quebec H3H 2S6, Canada
(514) 939-7026
www.cca.qc.ca

2002 EXHIBITIONS

Through January 20
Architecture Remembered: Souvenir Buildings From the CCA Collection

Through January 20
Mies in America
Explores Mies van der Rohe's encounter with American technology between 1938 and 1969. Traces the architect's life through his avid reading, his art collecting and the collages, drawings and models he made. (Travels)

Through March 3
Floor Play: An Installation by Medium
A multilevel exhibition.

PERMANENT COLLECTION

Works of art and documentation of architecture, urban planning and landscape design from around the world.

Admission: $6 (Canadian dollars); seniors, $4; students, $3; under 12, free.
Hours: Wednesday through Sunday, 11 a.m.–5 p.m.; Wednesday and Friday until 6 p.m.; Thursday until 8 p.m. Closed Monday and Tuesday. June through September: Tuesday through Sunday, 11 a.m.–6 p.m.; Thursday until 9 p.m. Closed Monday.

The Montreal Museum of Fine Art

(Musée des beaux-arts de Montréal)

1379–1380 Sherbrooke Street West, Montreal, Quebec
 H3G 2T9, Canada
(514) 285-1600; (514) 285-2000 (recording)
www.mmfa.qc.ca

2002 EXHIBITIONS

Through January 27
Piranesi-Goya
Some 300 prints by two major printmakers of the 18th and
early 19th century reflecting disillusionment with the
Enlightenment in Europe.

Through January 27
Francisco Goya and Jake and Dinos Chapman: Disasters of War
Prints from Goya's series and its contemporary counterpart by
two British artists.

Through February 3
Callot: The Large Miseries of War
Eighteen large-format prints by Jacques Callot on the violence
of the Thirty Years' War, published in Paris in 1633.

January 24–April 14
Herbert List
Approximately 170 prints
by the German
photographer
(1903–1975). (Travels)

April 25–August 4
*Raphael to Tiepolo: Master
Italian Paintings From the
Budapest Museum of Fine
Arts*
Forty-three works from
the major Italian schools
of the 15th to 18th
centuries.

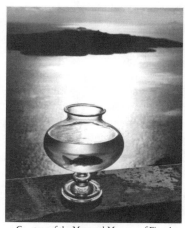

Courtesy of the Montreal Museum of Fine Art.
Herbert List, *Goldfish Bowl*, 1938.

346

September 19–January 5, 2003
Richelieu's Century
Some 240 works exploring the patronage of Cardinal
Richelieu and his use of the visual arts to advance his vision
for France.

PERMANENT COLLECTION

More than 30,000 objects, from antiquity to the present.
Decorative arts; Canadian arts; prints and drawings; Old
Master paintings; modern and contemporary art; African,
Oceanian, Asian, Islamic and pre-Columbian art; textiles;
Japanese incense boxes. **Architecture:** 1912 building by
Edward and William S. Maxwell; 1976 pavilion by Fred
Lebensold; 1991 pavilion by Moshe Safdie.

Admission: Free; fees for special exhibitions.
Hours: Tuesday through Sunday, 11 a.m.–6 p.m. Longer hours
for some exhibitions. Closed Monday (except holidays), New
Year's Day and Christmas Day.

Canadian Museum of Contemporary Photography

1 Rideau Canal, Ottawa, Ontario, K1N 9N6, Canada
(613) 990-8257
cmcp.gallery.ca

2002 EXHIBITIONS

January–March
Bringing to Order: Formalism and Canadian Photographic Practice
Works from the museum's collection. A look at modernist
photography and its emphasis on form.

January–March
Displacement and Encounter: Arni Haraldsson and Manuel Piña
Haraldsson, a Canadian, and Piña, a Cuban, examine city life.

January–March
Peter Pitseolak, Inuit Photographer
Images of Inuit life during the 1940's.

Spring
Malak Karsh

Spring
Image and Memory: Mariana Yampolsky

PERMANENT COLLECTION

More than 158,000 images by Canadian photographers.
Architecture: Constructed in 1992 in an abandoned railway tunnel in downtown Ottawa.

Admission: Suggested donation.
Hours: Wednesday through Sunday, 10 a.m.–5 p.m.; Thursday, until 8 p.m. Closed Monday and Tuesday. May through September: daily, 10 a.m.–6 p.m.; Thursday until 8.

National Gallery of Canada

380 Sussex Drive, Ottawa, Ontario, K1N 9N4, Canada
(800) 319-2787; (613) 990-1985
national.gallery.ca

2002 EXHIBITIONS

Through January 6
Louis-Philippe Hébert
Some 150 works, illustrating the wide range of themes and materials the Montreal sculptor has used in his career, including wood, bronze, marble, plaster, terra cotta and stone.

Through January 13
Sixteenth-Century North-Italian Drawings From Budapest: From Leonardo to Tintoretto
Approximately 50 works.

Through April
Focus on an Artist: Kenojuak
Contemporary Inuit art by Kenojuak Ashevak.

February 1–May 5
Gathie Falk
More than 75 works, dating from the artist's 1970's ceramic sculptures to her recent mixed-media installations.

February 1–May 12
No Man's Land: The Photographs of Lynne Cohen
Nearly 70 images of people's living and working
environments, from the mid-1970's to the present.

May 31–September 2
Betty Goodwin Prints
Works produced between 1969 and 1976, including a series of
images featuring vests and shirts.

June 7–September 8
Tom Thomson
A retrospective featuring approximately 125 paintings.

September 27–January 5, 2003
Printmaking in Italy
Prints of all types from the middle of the 16th century to the
1620's, a period that saw a massive increase in the volume of
print production. Includes examples by Agostino and Annibale
Carraci. Explores the relationship between printmakers,
designers, printers and distributors.

October–January 2003
David Rabinowitch
Works by the self-taught Canadian sculptor.

October 4–January 5, 2003
Chinese Jade: The Ultimate Treasure of Ancient China
Approximately 120 carvings, dating from the Neolithic Age to
the Qing Dynasty.

October 4–January 5, 2003
The Expressionist Portrait, 1905–1935
Photographs by Hugo Erfuth, Helmar Lerski, Lisette Model,
Umbo and others; paintings by Erich Heckel, Ernst Ludwig
Kirchner, Oskar Kokoschka, Emil Nolde and others; sculpture;
and drawings.

October 11–January 12, 2003
Marion Tuu'luq
Nearly 50 wall hangings.

PERMANENT COLLECTION

Canadian art; European art, including Gothic, Renaissance,
Baroque and 19th- and 20th-century works; Inuit and
American art; international contemporary film and video.
Highlights: Canadian works by the Group of Seven painters

(1920–1932), Borduas, Colville and Riopelle; paintings and sculpture by Bacon, Bernini, Constable, Matisse, Moore, Murillo, Pollock, Poussin, Rembrandt, Rubens and Turner; photography by Arbus, Atget, Cameron and Sander. **Architecture:** 1988 building by Moshe Safdie.

Admission: Free. Fee for special exhibitions.
Hours: Daily, 10 a.m.–6 p.m.; Thursday, until 8 p.m. During the winter, open until 5 p.m. and closed Monday and Tuesday.

The Civilization Museum
(Le Musée de la Civilisation)

85 Rue Dalhousie, C.P. 155 succursale B, Quebec City,
 Quebec G1K 7A6, Canada
(418) 673-2158
www.mcq.org

2002 EXHIBITIONS

Through January 6
The Body Takes Shape
In a sculpture workshop, visitors can explore the mechanics of the human body.

Through January 6
Diamonds
Nearly 400 objects tracing the history of the gem.

Through March 31
Turning the Tables
An exhibition with a humorous twist: What happens beneath a proper dining-room table?

Through April 7
KEO: Prelude to Its Flight
A collection of items that a rocket is scheduled to put into orbit around the Earth, to be returned to the planet in 50,000 years so it can deliver its messages to our distant descendants. Visitors are invited to contribute a message.

Through September 2
Xi'an, Eternal Capital
A collection of treasures from the Chinese city.

Through September 2
Today's Xi'an
Photographs of the city's inhabitants by Michel Boulianne.

Through September 9
Head Over Heels
Footwear from around the world.

Opening March 27
On the Road to Country and Western
A look at the country-and-western lifestyle and its effect on modern culture.

Continuing
Memories
Objects, stagecraft and personal testimonials help explain Quebec's history.

PERMANENT COLLECTION

More than 200,000 objects reflecting Quebec history, with four broad sections: ethnology, science, the fine arts and archaeology. The museum comprises three unlinked pavilions: the Musée de la Civilisation (at 85 Rue Dalhousie), which features exhibitions on historical and contemporary subjects; the Musée de l'Amérique Française (2 Côte de la Fabrique), a history museum that reflects the establishment of French culture in North America; and the Centre d'Interprétation de Place-Royale (27 Rue Notre-Dame), which offers a multimedia show, exhibitions and other activities.

Admission: Adults, $7 (Canadian dollars); seniors, $6, students, $4; children, $2; under 12, free.
Hours: Daily, 10 a.m.–7 p.m. During the winter, open until 5 p.m., and closed Monday.

Quebec Museum
(Musée du Québec)

Parc des Champs-de-Bataille, Quebec City, Quebec G1R
 5H3, Canada
(418) 643-2150
www.mdq.org

2002 EXHIBITIONS

Through January 6
Bill Vazan: Cosmological Shades
Large-scale photographs of Egypt and Quebec, plus slide shows
crossing Quebec landscapes with Egyptian monuments.

Through March 3
Seeking the Ideal: The Athletic Sculptures of R. Tait McKenzie
Approximately 40 works.

Through March 17
*The Geniuses of the Ocean: Masterpieces of Ship Carving From the
National Marine Museum in Paris*
French carvings from the 17th to the late 19th century,
including rare wax models and depictions of Charlemagne,
Henri IV, Napoleon and other historical figures.

Through April 7
Denis Juneau
More than 100 works by the contemporary artist, who is
known for geometric abstraction.

February 7–May 5
Impressionist Masterworks From the National Gallery of Canada
Thirteen paintings produced between 1873 and 1903,
including three by Camille Pissarro and two each by Paul
Cézanne and Claude Monet.

March 28–May 19
Greg Curnoe and Serge Lemoyne: Two Nationalisms
Works by a pair of artists who debated national issues.

May 2–September 15
Antoine Bourdelle
A retrospective of the French artist's work, featuring more than
70 bronzes, embossings, drawings and photographs.

June 6–November 3
Embroidered Art From the Ursulines of Quebec Collection
Approximately 40 17th- and 18th-century altar covers, chasubles and stoles.

Opening June 6
I Remember: When Art Depicts History
Modern and ancient works that focus on people and events in Quebec's history.

October 10–January 5, 2003
Suzor-Coté: Matter and Light
A retrospective featuring paintings and sculpture by Marc-Aurèle de Foy Suzor-Coté.

December 12–March 16, 2003
Videographers and Photographers in Church
Contemporary works inspired by churches.

PERMANENT COLLECTION

More than 20,000 works, produced mainly in Quebec since the beginning of the colony. **Architecture:** Situated in Battlefields Park overlooking the St. Lawrence River, the museum comprises three linked pavilions: the Gérard-Morisset Pavilion, a neo-Classical structure; the Great Hall, a new central building crowned with a cross of skylights; and the Charles Baillairgé Pavilion, which was built between 1861 and 1871 and served as the Quebec City prison for nearly a century.

Admission: Adults, $7 (Canadian dollars); seniors, $6; students, $2.75; children, $2; under 12, free.
Hours: Tuesday through Sunday, 10 a.m.–5 p.m.; Wednesday, until 9 p.m. Closed Monday. June through August: daily, 10 a.m.–6 p.m.; Wednesday, until 9 p.m.

The Art Gallery of Ontario

317 Dundas Street West, Toronto, Ontario M5T 1G4, Canada
(416) 979-6648
www.ago.net

2002 EXHIBITIONS

Through January 6
Canvas of War: Masterpieces From the Canadian War Museum
More than 65 paintings from the two world wars.

Through January 13
Video Primer: Masquerade
Ten video works, by Colin Campbell, Yudi Sewraj and others.

Through January 27
House Guests: Contemporary Artists in The Grange
Works by Rebecca Belmore, Robert Fones, Luis Jacob, Josiah McElheny, Elaine Reichek, Christy Thompson and others on display with the historic art in The Grange.

Through March 17
Celebrating the Centennial: Recent Acquisitions of European Prints and Drawings

January 15–March 24
Video Primer: Language
Ten video works, by Benny Nemerofsky Ramsay, Vera Frenkel and others.

March 30–June 23
Celebrating the Centennial: David Blackwood's Fire Down on the Labrador
Working proofs, drawings and the original plate for the 1980 etching and aquatint.

Continuing
Treasures of a Collector: European Works of Art, 1100–1800, From the Thomson Collection
More than 350 objects, including ceramics, metalwork, enamel, gold, silver, ivory, crystal and boxwood.

PERMANENT COLLECTION

More than 20,000 works of European, American and Canadian art since the Renaissance, including Impressionist, Post-Impressionist, Modernist and contemporary works; Inuit art. Works by Hals, Rembrandt, Rubens, Chardin, Gainsborough, Degas and Pissarro; the world's largest public collection of sculpture by Henry Moore. **Architecture:** The Grange, an 1817 brick Georgian private home, fully restored to the 1830's period; 1936 expansion, Walker Memorial Sculpture Court;

1974 Henry Moore Sculpture Center, and Sam and Alaya Zacks Wing; 1977 Canadian Wing and Gallery School; 1993 additions by Marton Myers, in joint venture with Kuwabara Payne McKenna Blumberg Architects.

Admission: $6 suggested donation (Canadian dollars). Fee for certain exhibitions.

Hours: Tuesday through Friday, 11 a.m.–6 p.m.; Wednesday, until 8:30 p.m.; Saturday and Sunday, 10 a.m.–5:30 p.m. Closed Monday.

Royal Ontario Museum

100 Queen's Park, Toronto, Ontario M5S 2C6, Canada
(416) 586-8000; (416) 586-5550 (for the deaf)
www.rom.on.ca

2002 EXHIBITIONS

Through January 20
Papiers á la Mode: Illusions of Fashion by Isabelle de Borchgrave and Rita Brown
A celebration of fashion history through a collection of more than 30 elaborate costumes, re-created in paper.

Through April 28
More Than Keeping Cool: Chinese Fans and Fan Paintings
Examples from the museum's collection.

Opening in February
The Underground Railroad
Film, archival materials and artifacts tell the story of the activists who worked together to help enslaved African-Americans escape to freedom before the U.S. Civil War.

June–August
Images of Salvation: Masterpieces From the Vatican and other Italian Collections
Includes items from the Vatican's papal sacristy.

June–September
Covering the World
Works from the museum's textile and costume collections.

June–December
Chinese Shadows: Stone Rubbings
Art made in China's Shandong Province during the Hang Dynasty (A.D. 0–200).

June 21–October 13
Across Borders: Beadwork in Iroquois Life
Historical pieces and some contemporary works. (Travels)

August 3–November 10
Treasures From a Lost Civilization: Ancient Chinese Art From Sichuan
Artifacts from an archaeological site in Sanxingdui, excavated in the 1980's from two sacrificial pits. (Travels)

Opening in November
Elite Elegance: Couture in the Feminine Fifties
Original designer sketches and archival film footage present a peek at haute couture in Toronto during the 1950's.

PERMANENT COLLECTION

Canada's largest museum of natural and human history, with 5 million objects and 45 galleries of art, archaeology and science, including the Samuel European Galleries, The Ancient World, the Sigmund Samuel Canadiana Gallery and the T.T. Tsui Galleries of Chinese Art.

Admission: Adults, $12 (Canadian dollars); seniors and students, $7; children, $6; under 5, free; families, $25. Free on Friday after 4:30 p.m. Different fees during certain exhibitions.
Hours: Monday through Saturday, 10 a.m.–6 p.m.; Friday, until 9:30 p.m.; Sunday, 11 a.m.–6 p.m. Closed New Year's Day and Christmas Day.

The Power Plant Contemporary Art Gallery at Harbourfront Centre

231 Queens Quay West, Toronto, Ontario M5J 2G8,
Canada
(416) 973-4949
www.thepowerplant.org

2002 EXHIBITIONS

Through February 17
Peter Doig
Paintings with Canadian themes by the Toronto-born British artist.

Through February 17
Yabu Pushelberg
Interior space created by the Canadian design firm of George Yabu and Glenn Pushelberg.

March 23–May 23
Evan Penny
Recent sculpture and photography by the Toronto artist.

March 23–May 23
Magnetic North: Canadian Experimental Video
Independent video by 47 artists.

Architecture: 1926 power plant; 1980's renovations by Peter Smith with restored smokestack and industrial facade.

Admission: $4 (Canadian dollars); students and seniors, $2; under 13, free. Free on Wednesday, 5–8 p.m.
Hours: Tuesday through Sunday, noon–6 p.m.; Wednesday, until 8 p.m. Closed Monday, except on holidays.

The Vancouver Art Gallery

750 Hornby Street, Vancouver, British Columbia V6Z
 2H7, Canada
(604) 662-4700; (604) 662-4719 (recording)
www.vanartgallery.bc.ca

2002 EXHIBITIONS

Through April 28
Long Time
More than 75 works from the gallery's collection on the theme
of time, from 17th-century still life meditations on mortality
to contemporary reflections on speed.

February 9–May 26
The Uncanny: Experiments in Cyborg Culture
Explores the representation of the cybernetic body — part
human, part machine — in the visual arts and popular culture.
Includes works by Duchamp, Léger, Picabia and Picasso.

Continuing
Emily Carr
Works by the early-20th-century Canadian painter.

PERMANENT COLLECTION

Nearly 7,000 works of contemporary and international art,
including examples by British Columbia artists and other
Canadians. American and British prints; British and Dutch
paintings; Emily Carr paintings. **Architecture:** 1910 neo-
Classical courthouse building by F.M. Rattenbury, renovated in
the 1980's by Arthur Erickson and Associates; Robson annex
by Thomas Hooper.

Admission: $12.50 (Canadian dollars); seniors, $9; students,
$7; under 13, free; family, $30; Thursday evening, $6
suggested donation.
Hours: Daily, 10 a.m.–5:30 p.m.; Thursday, until 9 p.m.
Closed Monday during the winter.

Czech Republic

Brno Moravian Gallery
(Moravska Galerie v Brne)
www.moravska-galerie.cz

Prazakus Palace
(Prazakuv Palác)

18 Husova, Brno 662 26, Czech Republic
(420-54) 221-5753

PERMANENT COLLECTION

Czech art from the 20th century, including works by members of the Osma group and the Group of 42. **Architecture:** Neo-Renaissance structure created by the Austrian architect Theophil von Hansen by connecting two buildings.

Governor's Palace
(Mistodrzitelsky Palác)

1a Moravske Namesti, Brno 662 26, Czech Republic
(420-54) 232-1100

Closed for renovations.

Architecture: Building dates from the 14th century, with reconstructions in the 17th and 18th centuries.

Museum of Applied Arts
(Umeleckoprumyslove muzeum)

14 Husova, Brno 66226, Czech Republic
(420-53) 216-9111

PERMANENT COLLECTION

Glass, ceramics, porcelain, metals, textiles, furniture,
photography and graphics from antiquity to the 20th century.
Architecture: Neo-Renaissance building by the Austrian
architect Johan G. Schon. Reopening in 2002 after a three-year
reconstruction.

2002 EXHIBITIONS

Through January (Prazakus Palace)
Promethean Fire

Through March (Prazakus Palace or Governor's Palace)
Austrian Paintings in Moravian Collections
Paintings from the 19th century.

June 6–September 30 (Prazakus Palace)
Antonin Prochazka
Twentieth-century works.

**June 18–October 20 (Prazakus Palace and Applied Arts
Museum)**
Biennial of Graphic Design

**November–February 2003 (Prazakus Palace and Applied
Arts Museum)**
Light
A look at the use of light in Czech art, from the Gothic and
Baroque periods through Romanticism and 20th-century
trends.

Admission: 70 koruna.
Hours: Wednesday through Sunday, 10 a.m.–6 p.m.;
Thursday, until 7 p.m. Closed Monday and Tuesday.

Egon Schiele Art Center

(Egon Schiele Art Centrum)

70-72 Siroka, 38101 Cesky Krumlov, Czech Republic
(420-33) 770-4011

PERMANENT COLLECTION

Drawings and paintings by the Austrian Expressionist Egon
Schiele (1890–1918). **Architecture:** Renovated 16th-century
Baroque and Renaissance brewery building, with Baroque and
industrial additions.

Admission: 120 koruna.
Hours: Daily, 10 a.m.–6 p.m.

City Gallery of Prague
(Galerie Hlavniho Mesta Prahy)

3 Mickiewiczova, Praha 6, Hradcany, 16000, Czech
 Republic
(420-23) 332-1200
www.citygalleryprague.cz

Gallery headquarters. No exhibition space.

House at the Stone Bell
(Dum u Kamenneho Zvonu)

13 Staromestske Namesti, Prague 1, 11000, Czech
 Republic
(420-22) 482-7526

2002 EXHIBITIONS

February–March
Fourth Prague Biennial
Annual show of works by young artists from the Czech
Republic, Slovakia, Austria, Hungary and Poland.

March–May
Otto Piene
Works by an experimental artist of the 1960's who was the
founder of the group Zero.

Fall
Adolf Hoffmeister (1902–1973)

Works by the Czech painter, illustrator, caricaturist, poet and author.

Architecture: 14th-century Gothic house.

Admission: Varies.
Hours: Tuesday through Sunday, 10 a.m.–6 p.m. Closed Monday.

City Library
(Mestska Knihovna)

1 Marianske Namesti, Prague 1, 11000, Czech Republic
(420-22) 231-0489

March–June
Karel Malich
Retrospective featuring works by the 20th-century Czech painter and graphic artist.

July–August
German Photography
Traces the medium's development in the 20th century.

Opening in September
Stano Filko
Retrospective of works by the Slovak artist.

Architecture: Functionalist building constructed 1925–28.

Admission: Varies.

House at the Golden Ring
(Dum u Zlateho Prstenu)

6 Tynska, Prague 1, Ungelt, 11000, Czech Republic
(420-22) 482-7022

PERMANENT COLLECTION

Twentieth-century Czech art. **Architecture:** Gothic palace with late Renaissance reconstruction.

Admission: 60 koruna; students and seniors, 30 koruna.

Troja Castle
(Trojsky Zámek)

1 U Trojskeho Zamku, 17000, Prague 7, Czech Republic (420-28) 385-1614

PERMANENT COLLECTION

Czech paintings from the 19th century. **Architecture:** Baroque castle.

Admission: 120 koruna; students and seniors, 60 koruna.

Hours: Tuesday through Sunday, 10 a.m.–6 p.m. Closed Monday. November through March: Saturday and Sunday, 10 a.m.–5 p.m. Closed Monday through Friday.

Villa Bilek
(B'lkova Vila)

1 Michiewiczova 1, 16000, Prague 6, Czech Republic (420-22) 432-2021

PERMANENT COLLECTION

Sculpture, drawings and prints by the Czech Art Nouveau artist Frantisek Bilek (1872–1941). **Architecture:** 1911 villa built based on Bilek's plans.

Admission: 120 koruna; students and seniors, 60 koruna.

Hours: Tuesday through Sunday, 10 a.m.–6 p.m. Closed Monday. November through March: Saturday and Sunday, 10 a.m.–5 p.m. Closed Monday through Friday.

Czech Museum of Fine Arts
(Ceske Muzeum Vytvarnych Umeni)

19-21 Husova, Prague 1, Stare Mesto, 11000, Czech
 Republic
(420-22) 222-0218
www.cmvu.cz

2002 EXHIBITIONS

Through February 3
Zdenůk Seydl
A retrospective featuring drawings, prints and paintings from the 1930's to 1978, plus illustrations, book covers, typography, posters, costume designs, fabric designs, glass, ceramics and films made with animation and puppets.

February 13–April 7
Monochrome
Geometric abstracts in Czech art.

April 24–June 9
Svatopluk Slovencik
Works by a contemporary Czech artist.

June 27–September 15
On Engineering
Works from the museum's collection.

October 2–December 1
Landscape
Contemporary British paintings.

December 18–January 2, 2003
Czech Comics

PERMANENT COLLECTION

Painting and sculpture from the early period of Czech Modernism; works from the 1930's and 40's.

Admission: 35 koruna.
Hours: Tuesday through Sunday, 10 a.m.–noon and 1–6 p.m. Closed Monday.

Rudolfinum Gallery
(Galerie Rudolfinum)

12 Alsovo Nabrezi, Prague 1 11000, Czech Republic
(420-22) 489-3205
www.galerierudolfinum.cz

2002 EXHIBITIONS

Through March 17
Michael Biberstein: Landscapes
Contemporary works by the Swiss painter.

April 25–August 18
Mikulas Medeks
Angst-ridden works by the 20th-century Czech painter.

August 25–November 24
I: Body, Heart, Soul
Explores the theme of identity through works from the late 19th century and early 20th century.

Admission: 100 koruna; seniors, students and the disabled, 50 koruna; under 15, free.
Hours: Tuesday through Sunday, 10 a.m.–6 p.m. Closed Monday.

Mucha Museum

7 Panska, Prague 1 11000, Czech Republic
(420-22) 145-1333
www.mucha.cz

PERMANENT COLLECTION

Paintings, lithographs and personal effects of the Czech Art Nouveau artist Alphonse Mucha (1860–1939), known for the posters he created for the actress Sarah Bernhardt.
Architecture: 18th-century Kaunitz Palace.

Admission: 120 koruna; seniors and students, 60 koruna.
Hours: Daily, 10 a.m.–6 p.m.

Prague National Gallery
(Národní Galerie v Praze)
www.ngprague.cz

Kinsky Palace
(Palác Kinskych)

12 Staromestske Namesti, Prague 1, Stare Mesto 11000, Czech Republic
(420-22) 481-0758

2002 EXHIBITIONS

March 28–June 30
Jan Autengruber: Thirty-Six Last Drawings
Works by the Central European painter.

March 28–June 30
L. Novak

July 25–October 27
New Trends in Graphic Design

September 20–October 28
Japanese Postcards
Works dating back to the seventh century from the National Museum in Kyoto, including paintings, wooden sculptures, ceramics, lacquer works, weapons and kimonos.

November–February 2003
German Drawings From the 14th to the 16th Century

PERMANENT COLLECTION

Prints and drawings. **Architecture:** 1755–1765 late Baroque-Classical-style building by Anselmo Lurago.

Sternberg Palace
(Sternbersky Palác)

15 Hradcanske Namesti, Prague 1, Hradcany 11000
 Czech Republic
(420-22) 051-4634; (420-23) 335-7332

2002 EXHIBITIONS

March 28–June 30
Jan Kupecky: Master of Baroque Portraits

PERMANENT COLLECTION

Fourteenth- and 15th-century Italian art; 15th- and 16th-century Dutch art, Cretan-Venetian art; Russian icons; German paintings from the 15th, 16th and 17th centuries. Works by Dürer, Van Dyck, El Greco, Rembrandt and Rubens. **Architecture:** Baroque palace built 1697–1707.

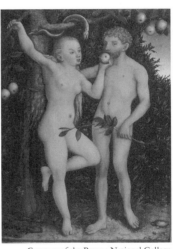

Courtesy of the Prague National Gallery. Lucas Cranach, *Adam and Eve.*

St. Agnes Convent
(Kláster Sv. Anezky Ceské)

17 U Milosrdnych, Prague 1, Stare Mesto, 11000, Czech
 Republic
(420-22) 481-0628

PERMANENT COLLECTION

Medieval art from Bohemia and Central Europe. **Highlights:** 14th-century altars. **Architecture:** 13th-century structure in the Cisterian-Burgundian Gothic style.

Veletrzni Palace
(Veletrzní Palác)

Dukelskych, 47 Hrdinu, Prague 7, Holosovice, Czech
 Republic
(420-22) 430-1024

2002 EXHIBITIONS

January 10–March 17
Andy Warhol: Retrospective

February 7–April 28
Kneubuhler

February 7–April 28
Josef Koudelka
Retrospective of the career of the Czech photographer, who has
been a member of Magnum Photos since 1977.

February 7–September 1
New Painters

June 15–September 29
Kunisada — Japanese Art

September 19–March 2003
Ladislav Sutnar
Works by a Czech-American painter and designer.

October 20–March 2003
J. Preissler

Opening in October
International Art

PERMANENT COLLECTION

Nineteenth- and 20th-century art, including works by Czech
artists and French Impressionists. Works by Braque, Bonnard,
Cézanne, Chagall, Corot, Coubert, Delacroix, Gauguin and
Picasso. **Architecture:** 1925–29 Functionalist building by
Oldrich Tyl and Josef Fuchs; renovated and opened in 1995.

Zbraslav Chateau
(Zámek Zbraslav)

15600 Prague 5, Zbraslav, Czech Republic
(420-25) 792-1638

2002 EXHIBITIONS

March 2–June 2
The Carpet and Its Context
Turkish, Persian, Central Asian and Caucasian examples.

October 19–March 1, 2003
Isnik Ceramics
Turkish works from the 15th century to the 17th.

PERMANENT COLLECTION

Asian art, including bronzes, funerary sculpture, ceramics, painting, lacquer art and metalwork; Japanese art; Chinese holdings, including works from the Han dynasty (207 B.C.-A.D. 220). **Highlights:** Chinese tomb figures; Tibetan thangkas; Koran manuscript. **Architecture:** Cistercian monastery, founded in 1292 by Wenceslas II; rebuilt in the 18th century by Giovanni Santini Aichl and Frantisek Maxmilian Kanka.

FOR ALL MUSEUMS
Hours: Daily, 10 a.m.–6 p.m.

Admission: 180 koruna; students and seniors, 90 koruna; under 10, free.

Denmark

Louisiana Museum of Modern Art

13 Gammel Strandvej, Humlebaek, DK-3050, Denmark
(454) 919-0719; (454) 919-0791 (recording)
www.louisiana.dk

2002 EXHIBITIONS

Through January 27
David Hockney: Paintings, 1960–2000

February 8–May 20
O'Keeffe's O'Keeffes: The Artist's Collection
Paintings.

May 3–August 4
Doug Aitken
Video installation and photography.

September 6–January 12, 2003
Arne Jacobsen

October 4–January 19, 2003
Wolfgang Tillmanns
Photography.

PERMANENT COLLECTION

Works by Francis Bacon, Baselitz, Giacometti, Johns, Kiefer, Klein, Picasso, Warhol and others. Sculpture garden featuring works by Calder, Henry Moore and others. **Architecture:** 1958 building designed by Jergen Bo and Vilhe Im Wohlert; several expansions.

Admission: Adults, 60 kroner; children, 20 kroner; under 4, free. Fee for special exhibitions.
Hours: Daily, 10 a.m.–5 p.m.; Wednesday, until 10 p.m. Closed New Year's Day, Christmas Eve and Christmas Day.

Egypt

The Museum of Mohammed Mahmoud Khalil and His Wife

1 Kafour Street, Orman Post Office, Giza, Egypt
(20-2) 336-2376; (20-2) 336-2379; (20-2) 336-2358
www.mkhalilmuseum.gov.eg

PERMANENT COLLECTION

Nineteenth- and early-20th-century European art, including works by Constable, Gauguin, van Gogh, Rodin and Rubens; Egyptian art; vases; Chinese miniatures. **Architecture:** 1915 Art Nouveau and neo-Classical style palace inaugurated as a museum in 1962 and remodeled in the early 1990's.

Admission: 25 Egyptian pounds; students, 12 pounds.
Hours: Tuesday through Sunday, 10 a.m.–6 p.m. Closed Monday.

England

Ikon Gallery

1 Oozells Square, Brindleyplace, Birmingham B1 2HS,
 England
(44-121) 248-0708
www.ikon-gallery.co.uk/ikon

2002 EXHIBITIONS

Through January 20
Braco Dimitrijevic and Richard Hamilton

February 12–April 7
Katharina Grosse and Santiago Sierra

April 16–June 2
Graham Gussin

June 12–July 21
Jean Frederic Schnyder

July 30–September 8
Vladimir Arkhipov

Architecture: Victorian school building refurbished and extended in the 1980's by Levitt Bernstein Associates.

Admission: Free.
Hours: Tuesday through Sunday, 11 a.m.–6 p.m. Closed Monday except holidays.

Fitzwilliam Museum

Trumpington Street, Cambridge CB2 1RB, England
(44-122) 333-2900
www.fitzmuseum.cam.ac.uk

During a courtyard development project through 2004, only
the Founder's Building will be open, with selections from the
permanent collection.

PERMANENT COLLECTION

Antiquities from Ancient Egypt, Greece and Rome; Roman,
Romano-Egyptian, Western Asiatic and Cypriot art; pottery;
glass; furniture; clocks; fans; armor; Chinese, Japanese and
Korean art, rugs and samplers; coins and medals; illuminated
literary and music manuscripts and rare printed books;
paintings, including works by Titian, Veronese, Rubens, Van
Dyck, Hals, Canaletto, Hogarth, Gainsborough, Constable,
Monet, Degas, Renoir, Cézanne and Picasso; miniatures;
drawings, watercolors and prints.

Admission: Free.
Hours: Tuesday through Saturday, 10 a.m.–5 p.m.; Wednesday,
until 7 p.m.; Sunday, noon–5 p.m. Closed Monday except
holidays. Closed December 16, 2002, through January 5, 2003.

Kettle's Yard

Castle Street, Cambridge CB3 0AQ, England
(44-122) 335-2124
www.kettlesyard.co.uk

2002 EXHIBITIONS

Through January 6
Benjamin Britten's Landscape

January 12–March 3
Flights of Reality
Showcases the work of artists who explore parallel worlds.

July 27–October 2
Ben Nicholson

PERMANENT COLLECTION

Early 20th-century art, including paintings by David Jones, Joan Miró, Ben Nicholson and Alfred Wallis, along with sculpture by Constantin Brancusi, Henri Gaudier-Brzeska, Barbara Hepworth and Henry Moore.

Admission: Free.
Hours: House: Tuesday through Sunday, 2–4 p.m. from September to Good Friday, and 1:30–4:30 p.m. from Easter Saturday through August. Exhibition gallery: Tuesday through Sunday, 11:30 a.m.–5 p.m. Closed Monday.

Tate Liverpool

Albert Dock, Liverpool L3 4BB, England
(44-151) 702-7400
www.tate.org.uk

2002 EXHIBITIONS

Through January 13
Paul McCarthy
Film, video, sculpture and installation works produced during the past 30 years. (Travels)

Through February 24
Emotional Ties
Paintings, sculptures and photographs from the Tate collection, featuring subjects who were close to the artists: family members, friends and lovers. Includes works by Pierre Bonnard, David Hockney and Thomas Struth.

Through March 10
Project Space: Richard Wright

Courtesy of the Tate Liverpool.
William Strang, *Bank Holiday*, 1912.

373

Wright's painting, right on the surface of the gallery walls, employs improvised motifs drawn from sources as diverse as illuminated manuscripts, computer graphics and tattoos.

Through August
Telling Tales
An international selection of works that employ narrative techniques, including examples by Sophie Calle, Nan Goldin, Cindy Sherman and Gillian Wearing.

February 1–April 21
Marc Quinn
New drawings, paintings and sculpture.

March 9–August 18
Philip Guston
Works from the Tate collection, including Abstract Expressionism and figurative painting by the American artist.

May 24–August 25
Remix: Pop and Art, 1977–2002
Explores the cultural collisions between music and art. Works by Rodney Graham, Gary Hume, Chris Ofili, Gavin Turk and other visual artists are juxtaposed with videos by David Bowie, Madonna, Prodigy and other musicians.

September 14–November 24
Liverpool Biennial of Contemporary Art
Works by some 40 artists from around the world.

December 20–March 23, 2003
Shopping: Art and Consumer Culture
Tracking art's creative dialogue with commercial display, distribution and presentation techniques. Includes works by artists, architects, designers, filmmakers and musicians.

Continuing
Modern British Art
Painting, sculpture and photography by a range of artists, including L.S. Lowry, Ben Nicholson and Stanley Spencer.

PERMANENT COLLECTION

Part of the Tate family of galleries, including Tate Britain and Tate Modern in London and Tate St. Ives. **Architecture:** Historic Albert Dock warehouse converted for gallery use by James Stirling and Michael Wilford.

Admission: Free. Fee for special exhibitions.

Hours: Tuesday through Sunday, 10 a.m.–5:50 p.m. Closed Monday (except public holidays), New Year's Day, January 2, December 24–26 and December 31.

Walker Art Gallery

William Brown Street, Liverpool L3 8EL, England
(44-151) 478-4199
www.nmgm.org.uk

PERMANENT COLLECTION

Holdings span the 12th to 20th centuries; Dutch, pre-Raphaelite and Victorian British art; works by Cézanne, Constable, Degas, Hockney, Rembrandt and Turner.
Highlights: Gibson, *The Tinted Venus;* Martini, *Christ Discovered in the Temple;* Rossetti, *Dante's Dream;* Hockney, *Peter Getting Out of Nick's Pool.* **Architecture:** Opened in 1877 and expanded in the 1930's.

Admission: Adults, £3; seniors and children, free.
Hours: Monday through Saturday, 10 a.m.–5 p.m.; Sunday, noon–5 p.m.

Barbican Art Gallery

Silk Street, London EC2Y 8DS, England
(44-207) 638-8891
www.barbican.org.uk

2002 EXHIBITIONS

January 31–April 14
Transition: The London Art Scene in the 1950's
Some 80 paintings and sculptures, along with photographs, books and magazines, representing the visual culture of the decade.

January 31–April 14
Martin Parr
Works by the British documentary photographer and Magnum member who took a wry look at everyday life.

February 20–April 7 (Curve)
Barbican: This Was Tomorrow
Examines the concepts behind the Barbican.

May 16–September 15
Game On
Interactive exhibition exploring the past, present and future of the games industry. (Travels)

Through January 5, 2003
Dressing Down: Contemporary Art, Fashion and Photography
A look at the relationship between art and fashion during the last three decades.

Architecture: Barbican, designed by Chamberlin, Powell and Bon and opened in 1982, includes two art galleries — the Barbican Gallery and Curve — as well as a concert hall, theaters, a library and exhibition halls.

Admission: Varies.
Hours: Monday through Saturday, 10 a.m.–6 p.m.; Wednesday, until 8 p.m.; Sunday and bank holidays, noon–6 p.m. Closed Christmas Eve and Christmas Day.

National Maritime Museum and Royal Observatory Greenwich

Greenwich, London, SE10 9NF, England
(44-208) 858-4422; (44-208) 312-6565
www.nmm.ac.uk

Through May
A Sea of Faces
About 150 portraits from the museum's collection of maritime art, including works by Gainsborough, Hogarth, Reynolds and Van Dyck.

April–October
Tattooing
Tracing the history of tattoos from the day of Captain James Cook to the present.

August–October
America's Cup
Presents the story of the prestigious sailing competition.

PERMANENT COLLECTION

British and 17th-century Dutch maritime art; cartography, manuscripts; ship models and plans; scientific and navigational instruments. British portraits. Maritime reference library, including books dating to the 15th century. **Highlights:** Admiral Horatio Nelson's bloodstained uniform from the Battle of Trafalgar and John Harrison's famous chronometer. **Architecture:** 17th-century Queen's House by Inigo Jones, with museum redevelopment completed in 1999; Flamsteed House (1675–76), the original part of the Royal Observatory, designed by Christopher Wren.

Admission: Free.
Hours: Daily, 10 a.m.–5 p.m.; June through September, until 6 p.m.

British Museum

Great Russell Street, London, WC1B 3DG, England
(44-207) 323-8299
www.thebritishmuseum.ac.uk

2002 EXHIBITIONS

Through January 6
Country Views: Place and Identity on British Paper Money
Three centuries of currency images.

Through January 6
The Print in Italy, 1550–1620
Works by Federico Barocci, the Carracci and others.

Through January 13
The Prints of Stanley William Hayter (1901–88)
Works produced from 1926 to 1960.

Through March 3
Light Motifs: An Aomori Float and Japanese Kites
Kites from the museum's collection, hung from the ceiling above a newly crafted Nebuta lantern.

Through March 24
Agatha Christie and Archaeology: Mystery in Mesopotamia
Archaeological finds from the sites on which the writer worked with her husband, Max Mallowan. Includes artifacts, archives, photographs and films made by Christie herself, as well as first-edition novels, a compartment from an Orient Express passenger car and other memorabilia.

Through March
European Decorated Porcelain
Works from the 17th and 18th centuries, including examples of Chinese porcelain decorated in Europe as well as European copies of Chinese and Japanese decorative styles.

Through April 1
Unknown Amazon: Culture and Nature in Ancient Brazil
More than 200 objects, including pottery and works made of stone, wood and feathers.

January 10–May
Coins of the Princely States of India

January 17–May 19
Japanese Prints From the Occupation

January 31–May 19
The Art of Calligraphy in Modern China

February 2–May 19
Imaging Ulysses: Richard Hamilton's Illustrations to James Joyce

May–September
European Coinage

May 17–September 15
The Hunt for Paradise: Court Arts of Safavid Iran, 1501–1576

June 7–October 13
The Queen of Sheba: Treasures From the Yemen

June 13–September 22
From Bruegel to Rembrandt: The George Abrams Collection

June 13–September 22
Behind the Lines: Vietnamese Images of War

June 20–September 22
Japanese Swords From the Peter Moores Project

September–January 2003
Charles Masson: Collections in Afghanistan

November 15–January 12, 2003
Antony Gormley's Field for the British Isles
An installation featuring 40,000 miniature clay figures, which were handmade by 100 people, ages 7 to 70, from a small British town.

December 6–March 23, 2003
Albrecht Dürer and His Influence: The Graphic Work of a Renaissance Artist

Continuing
Islamic Works on Paper: Recent Acquisitions
Paintings, calligraphy, bound manuscripts and drawings from the Islamic world, as well as contemporary graphics by artists from the Middle East, North Africa and Britain.

Continuing
Master European Prints From the 15th to the Early 19th Century
Examples of woodcuts, engravings, etchings and aquatints by Canaletto, Eugéne Delacroix, Albrecht Dürer, Adam Elsheimer, Hendrick Goltzius, Francisco José de Goya, Rembrandt and others.

Continuing
The Salcombe Cannon Site Treasure
More than 400 gold coins and related artifacts produced by the dynasty of the Sa'dian Sharifs, who ruled Morocco during the 16th and 17th centuries. The items were recovered in 1995 from a shipwreck off the Devon coast.

PERMANENT COLLECTION

More than six million objects, including antiquities from Egypt, Western Asia, Greece and Rome; prehistoric and Romano-British, medieval, Renaissance, Modern and Oriental collections; prints and drawings; coins and medals.
Highlights: Parthenon sculptures; the Rosetta Stone; Sutton Hoo treasures; Portland vase. **Architecture:** Neo-Classical mid-19th-century buildings by Robert and Sidney Smirke.

Admission: Free. Fee for some exhibitions.
Hours: Daily, 10 a.m.–5:30 p.m.; Thursday and Friday, until
8:30 p.m.

Courtauld Institute of Art

Somerset House, Strand, London WC2R 0RN, England
(44-207) 848-2526
www.courtauld.ac.uk

Through January 20
Art on the Line: The Royal Academy Exhibitions at Somerset House,
1780–1836
Some 300 works that the Royal Academy first exhibited to
the public at Somerset House, presented in the manner of
the original displays. Includes works by Thomas
Gainsborough, Thomas Lawrence, John Opie and Joshua
Reynolds.

PERMANENT COLLECTION

Impressionist and Post-Impressionist paintings, including
works by Cézanne, Degas, Manet, Monet, Pissarro, Renoir,
Seurat and Toulouse-Lautrec; 14th- to 20th-century works,
including paintings by Rubens and Tiepolo; early Flemish and
Italian paintings; 34,000 Old Master drawings and prints.
Highlights: Master of Flémalle, *Entombment;* Cranach, *Adam*
and Eve; Rubens, *Moonlight Landscape and Deposition;* Tiepolo oil
sketches. **Architecture:** 1786 neo-Classical Somerset House by
William Chambers.

Admission: Adults, £4; annual ticket, £7.50; children, free.
Free on Monday, 10 a.m.–2 p.m., except bank holidays.
Hours: Monday to Saturday, 10 a.m.–6 p.m.; Sunday and bank
holiday Mondays, noon–6 p.m.

The Dulwich Picture Gallery

Gallery Road, London SE21 7AD, England
(44-0208) 693-5254
www.dulwichpicturegallery.org.uk

2002 EXHIBITIONS

Through January 6
The Golden Age of Watercolors: The Hickman Bacon Collection
Works by Joseph Mallord William Turner, as well as examples
by Richard Parkes Bonington, John Sell Cotman, David Cox,
Thomas Gainsborough, Thomas Girtin and others.

February 6–April 14
William Beckford
Furniture and pictures from the collections of Beckford
(1760–1844), a writer and hedonist whose father was
considered the richest man in England.

May 22–August 26
The Dutch Italianates, 1600–1700
Paintings by Aelbert Cuyp, Jan Baptist Weenix, Philips
Wouwermans and Wynants that are idyllic landscapes of places
they never saw.

September 11–December 1
David Wilkie
Paintings.

Opening December 18
Arthur Rackham
Works by the children's book illustrator (1867–1939).

PERMANENT COLLECTION

England's oldest public art gallery, designed in 1811. Old
Master paintings from the 17th and 18th centuries; works by
Canaletto, Van Dyck, Gainsborough, Murillo, Poussin,
Rembrandt, Rubens, Tiepolo and Watteau. **Architecture:**
Neo-Classical building by John Soane; 2000 wing by Rick
Mather Architects.

Admission: Adults, £4; seniors, £3; students and children,
free. Free on Friday. Fee for some exhibitions.

Hours: Tuesday through Friday, 10 a.m.–5 p.m.; Saturday and Sunday, 11 a.m.–5 p.m. Closed Monday (except bank holidays), New Year's Day, Good Friday and December 24–26.

Hayward Gallery

Belvedere Road, London SE1 8XZ, England
(44-207) 960-4242
www.haywardgallery.org.uk

2002 EXHIBITIONS

January 17–April 1
Paul Klee

July–September
Ansel Adams

Autumn
Douglas Gordon

PERMANENT COLLECTION

The gallery manages the Arts Council Collection on behalf of the Arts Council of England. The collection is not normally displayed at the Hayward but travels. **Architecture:** Opened in 1968, the Hayward is considered a classic example of 1960's "brutalist" architecture; neon tower on the roof designed by Philip Vaughan and Roger Dainton.

Admission: Varies.
Hours: Daily, 10 a.m.–6 p.m.; Tuesday and Wednesday, until 8 p.m.

The Imperial War Museum

Lambeth Road, London, SE1 6HZ, England
(44-207) 416-5000
www.iwm.org.uk

2002 EXHIBITIONS

Through April 2

Memory Becomes History

Works from the museum's collection inspired by memories of World War I.

PERMANENT COLLECTION

The largest collection of 20th-century British art after the Tate galleries; photographic archive with more than six million images; national collection of airplanes, tanks, memorabilia and other items relating to 20th-century military conflicts.

Branches: HMS Belfast, Morgan's Lane, Tooley Street, London, SE1 6HZ, (44-0207) 940-6328; Cabinet War Rooms, Clive Steps, King Charles Street, London, SW1A 2AQ, (44-207) 930-6961; Imperial War Museum — Duxford, Duxford, Cambridgeshire, CB2 4QR, (44-122) 383-5000.

Admission: Free.

Hours: Daily, 10 a.m.–6 p.m. Closed December 24–26.

Institute of Contemporary Arts

The Mall, London SW1Y 5AH, England

(44-207) 930-3647

www.ica.org.uk

Admission: Monday through Friday, £1.50; Saturday and Sunday, £2.50.

Hours: Tuesday through Saturday, noon–1 a.m.; Sunday, until 10:30 p.m.; Monday, until 11 p.m.; galleries close at 7:30 p.m.

Museum of London

150 London Wall, London EC2Y 5HN, England

(44-207) 600-3699; (44-207) 600-0807 (recording)

www.museumoflondon.org.uk

2002 EXHIBITIONS

June
Queen's Jubilee
Memorabilia from Jubilee celebrations.

PERMANENT COLLECTION

More than one million objects that chart the history of London from prehistoric times to the present. Includes displays of recent archaeological discoveries in the city.

Admission: Adults, £5 for annual ticket; seniors and students, £3; under 17, free.

Hours: Monday through Saturday, 10 a.m.–5:50 p.m., Sunday, noon–5:50 p.m. Closed New Year's Day and December 24–26.

The National Gallery

Trafalgar Square, London WC2N 5DN, England
(44-0207) 747-2885
www.nationalgallery.org.uk

2002 EXHIBITIONS

Through January 13
Pisanello
Two 15th-century panel paintings, *The Vision of Saint Eustace* and *The Virgin and Child With Saints George and Anthony Abbot*, plus preparatory drawings, medals, manuscript illuminations, tapestries and paintings by the Italian artist, including a portrait of his patron and a group of nature studies.

Through February 10
Kitaj: In the Aura of Cézanne and Other Masters
Seven new paintings by R.B. Kitaj inspired by Cézanne's *Bathers*, plus older works that reveal the American artist's interest in Degas, Duccio and Velazquez.

Through March 3
Goya: The Family of the Infante Don Luis
One of Goya's largest works. Created in 1784, it marked the beginning of his career as painter to the Spanish royal family.

February 13–May 12
Aelbert Cuyp
A retrospective featuring the landscapes for which the 17th-century Dutch painter is most known, as well as biblical scenes, portraits and the fanciful works he created in the latter part of his career. (Travels)

March 13–June 16
Baroque Painting in Genoa
An assortment of 17th-century works by Giovanni Benedetto Castiglione, Bernardo Strozzi and other Genoa residents and by Peter Paul Rubens, Anthony Van Dyck and others who traveled to the Italian city to paint portraits of its aristocrats.

June 19–September 8
Fabric of Vision: Dress and Drapery in Painting
A look at how artists have used clothing and drapery to emphasize their figures. Includes works by Eugène Delacroix, Anthony Van Dyck, Pablo Picasso, Joshua Reynolds, James Tissot, Édouard Vuillard and Rogier van der Weyden.

October 16–January 12, 2003
Madame de Pompadour: Images of a Mistress
Paintings and sculptures of Louis XV's official mistress. Includes a portrait by François-Hubert Drouais.

PERMANENT COLLECTION

Western European painting from 1260 to 1900. Founded in 1824. Works by Botticelli, Leonardo, Raphael, Michelangelo, Holbein, Titian, El Greco, Rubens, Rembrandt, Vermeer, Gainsborough, Constable, Turner, Monet, Renoir, Cézanne, van Gogh and Seurat. **Architecture:** 1838 neo-Classical building by William Wilkins; 1975 northern expansion by PSA; 1991 Sainsbury Wing.

Admission: Free. Fee for special exhibitions.
Hours: Daily, 10 a.m.–6 p.m.; Wednesday, until 9 p.m.
Closed New Year's Day, Good Friday and December 24–26.

National Portrait Gallery

St. Martin's Place, London WC2H 0HE, England
(44-0207) 306-0055
www.npg.org.uk

2002 EXHIBITIONS

Through January 6
Painted Ladies: Women at the Court of Charles II

Through January 20
John Kobal Photographic Portrait Award
Annual award exhibition in memory of Kobal, a film and
photography archivist.

Through February 10
Mirror Mirror: Self-Portraits by Female Artists
Paintings, drawings, photographs, sculpture and prints by 40
women from the past four centuries, including 20th-century
works by Eileen Agar and Barbara Hepworth.

February 14–May
Mario Testino: Portraits
Some 150 prints by the fashion photographer.

February 27–June
Saving Faces: Portraits by Mark Gilbert
Paintings of patients before, after and, occasionally, during
surgery, conveying their changing emotions.

May 30–August 18
George Romney, 1734–1802

June–September
Once Upon a Time: Beatrix Potter to Harry Potter
Paintings, drawings, photographs and portrait busts of 20th-
century British children's book authors, including Enid
Blyton, Raymond Briggs, Roald Dahl and Kenneth Grahame.

Opening October 4
*Americans: Portraits From the National Portrait Gallery,
Washington, D.C.*
Views of John Singleton Copley, James Whistler and other
artists; Mark Twain, John Updike and other writers; and Davy
Crockett, Benjamin Franklin, Lena Horne and other notables.

Opening in October
Byronism

A look at how portraits of Lord Byron helped fuel his literary fame and create an indelible public image.

PERMANENT COLLECTION

More than 10,000 portraits of famous Britons, including paintings, drawings, sculptures, miniatures, caricatures, silhouettes, photographs and electronic media; photography and document archive. **Highlights:** G. L. Brockelhurst, *The Duchess of Windsor*; Terence Donovan, *Diana, Princess of Wales*. **Architecture:** 1896 building designed by Ewan Christian; 1933 Duveen wing by Richard Allison and J.G. West; 1980's alterations by Roderick Gradidge and Christopher Boulter; a 2000 wing, designed by the Dixon-Jones Partnership, that includes the new Tudor Gallery.

Admission: Free. Fee for special exhibitions.
Hours: Daily, 10 a.m.–6 p.m.; Thursday and Friday, until 9 p.m.

Royal Academy of Arts

Burlington House, Piccadilly, London, W1J 0BD, England
(44-207) 300-8000; (44-207) 300-5760 (recording)
www.royalacademy.org.uk

2002 EXHIBITIONS

Through February 17
The Dawn of the Floating World, 1650–1765
Exhibition of Japanese prints known as ukiyo-e, showing daily Japanese life.

January 26–April 12
Paris: Capital of the Arts, 1900–1968
Explores the major art movements that emerged from the social, political and economic scene, featuring works by Marcel Duchamp, Fernand Léger, Henri Matisse, Pablo Picasso and others. (Travels)

April–June
Chinese Buddhist Sculpture

June 11–August 19
Summer Exhibition
Annual contemporary art show.

July–September
Merzbacher: The Joy of Color

September 27–February 16, 2003
The Aztecs
Survey of cultural riches.

PERMANENT COLLECTION

Founded in 1768, the Royal Academy is the oldest fine arts institution in Britain. Examples of British art from the 18th century to the present, including paintings, sculpture, plaster casts, artists' memorabilia, prints and drawings. A small selection of paintings and sculpture can be viewed as part of the Burlington House tour; others can be viewed by making an appointment with the curator.

Admission: Varies. Tickets: boxoffice@royalacademy.org.uk.
Hours: Daily, 10 a.m.–6 p.m.; Friday, until 10 p.m.

The Saatchi Gallery

98a Boundary Road, London NW8 ORH, England
(44-207) 624-8299

PERMANENT COLLECTION

More than 2,000 contemporary paintings, sculptures and installations, focusing on young British artists. **Architecture:** Former paint factory converted into almost 30,000 square feet of gallery space by Max Gordon.

Admission: Adults, £5; seniors and students, £3.
Hours: Thursday through Sunday, noon–6 p.m.

The Serpentine Gallery

Kensington Gardens, London, W2 3XA, England
(44-207) 402-6075; (44-207) 298-1515 (recording)
www.serpentinegallery.org

Architecture: 1934 tea pavilion opened as a gallery in 1970; renovations completed in 1998.

Admission: Free.
Hours: Daily, 10 a.m.–6 p.m.

Tate Britain

Millbank, London SW1P 4RG, England
(44-207) 887-8000; (44-207) 887-8008 (recording)
www.tate.org.uk

2002 EXHIBITIONS

Through January 20
Turner Prize
The annual award, established in 1984 by the Tate, is given to a British artist under 50. The exhibition features works by the four finalists: Richard Billingham, Martin Creed, Isaac Julien and Mike Nelson.

Through January 27
Exposed: The Victorian Nude
Survey of male and female nudes in painting, drawing and sculpture, including works by Edward Burne-Jones, Gwen John, Dante Gabriel Rossetti, John Singer Sargent, Walter Sickert and James Abbott McNeill Whistler.

Through March 2
Medieval Sculpture
Works from the 14th and 15th centuries, including architectural ornaments and funerary monuments.

PERMANENT COLLECTION

Part of the Tate family of galleries, including the Tate Modern in London, Tate Liverpool and Tate St. Ives. The Tate Britain houses the national collection of British art from the 16th century to the present, including works by Blake, Constable, Hogarth and Spencer.

Admission: Free. Fee for special exhibitions.
Hours: Daily, 10 a.m.–5:50 p.m. Closed December 24–26.

Tate Modern

Bankside, London SE1 9TG, England
(44-207) 887-8000; (44-207) 887-8008 (recording)
www.tate.org.uk

2002 EXHIBITIONS

Through January 1
Surrealism: Desire Unbound
Paintings, films and photographs, by Georgio de Chirico,
Salvador Dalí, Max Ernst, Man Ray and others. (Travels)

Through March 10
The Unilever Series: Juan Muñoz
Installation titled *Double Bind* by the Spanish artist,
commissioned by the museum for its Turbine Hall.

September 19–January 5, 2003
Barnett Newman

PERMANENT COLLECTION

Twentieth-century art, including works by Picasso, Matisse,
Dalí, Duchamp, Moore, Bacon, Gado, Giacometti and Warhol.
Architecture: Power plant by Giles Gilbert Scott converted to
gallery space by the Swiss architects Herzog and de Meuron.

Admission: Free.
Hours: Sunday through Thursday, 10 a.m.–6 p.m.; Friday and
Saturday, until 10 p.m.

Victoria and Albert Museum

Cromwell Road, South Kensington, London SW7 2RL,
 England
(44-207) 942-2000
www.vam.ac.uk

2002 EXHIBITIONS

Through January 6
Radical Fashion
Works by today's avant-garde fashion designers.

Through February 3
Out of Japan
Images by three photographers working in Japan: the Anglo-Italian Felice Beato's hand-colored prints from the 1960's; Masahisa Fukiase's *Ravens* series from 1975–85; and Naoya Hatakeyama's *Underground* project.

February 20–August
Seeing Things: Photographing Objects
Traces still photography from its beginnings. Features works by Henri Cartier-Bresson, Man Ray, Henry Talbot and others.

March 21–July
The Tiara Today
More than 150 tiaras from the mid-18th century to the present, by Fabergé, Cartier, Tiffany and others.

March 14–July
Earth and Fire: Italian Terra-Cotta Sculpture From Donatello to Canova
Includes reliefs by Donatello and Luca della Robbia and sculpture by Gian Lorenzo Bernini and Antonio Canova.

October 3–January 26, 2003
Dresser

PERMANENT COLLECTION

Decorative arts dating from 3000 B.C. to the present. Some four million items. Newly opened British Galleries, 1500–1900, with 3,000 examples of British design and art; Raphael Gallery, with seven prized cartoons by Raphael; John Constable paintings; national collection of watercolors; Devonshire Hunting Tapestries; Dress Collection showing fashion from 1500 to the present; Asian collection; medieval treasures; Renaissance sculpture; Victorian plasters; Jewelry Gallery; 20th-Century Gallery; National Art Library.
Architecture: 1891 building by Captain Francis Fawke; 1899-1909 south front by Aston Webb.

Admission: Adults, £5; seniors, students and children, free.
Hours: Daily, 10 a.m.–5:45 p.m.; Wednesday and the last Friday of the month, until 10 p.m. Closed December 24–26.

Wallace Collection

Hertford House, Manchester Square, London W1M
 6BN, England
(44-207) 563-9500
www.wallace-collection.com

2002 EXHIBITIONS

January 16–April 7
Poussin to Cézanne: French Drawings From the Ashmolean Museum
Fifty-two drawings from the 17th century to the 19th,
including works by François Boucher, Jean-Auguste-
Dominique Ingres, Édouard Manet and Jean-Antoine Watteau.

June 6–September 22
Armour as Art: Treasures of the Wallace Collection

October 10–January 5, 2003
Louis XV and Madame de Pompadour

PERMANENT COLLECTION

Fine and decorative arts, including 18th-century French
pictures, porcelain and furniture; Old Masters; armory.
Architecture: Late–18th-century town house; new floor by
Rick Mather.

Admission: Free.
Hours: Monday through Saturday, 10 a.m.–5 p.m.; Sunday,
noon–5 p.m.

Whitechapel Art Gallery

80-82 Whitechapel High Street, London E1 7QX,
 England
(44-0207) 522-7888; (44-0207) 522-7878 (recording)
www.whitechapel.org

2002 EXHIBITIONS

Through January 13
Mark Wallinger

Videos, photographs and sculptures exploring religious, mythological and popular iconography. *Prometheus* installation.

January 25–March 31
Nan Goldin
Photography retrospective. Admission fee.

Admission: Free. Fee for some exhibitions.
Hours: Tuesday through Sunday, 11 a.m.–5 p.m.; Wednesday, until 8 p.m. Closed Monday.

The Lowry

Pier 8, Salford Quays, Manchester M5 2AZ, England
(44-0161) 876-2000
www.thelowry.com

2002 EXHIBITIONS

Through January 3
Open City: Street Photographs Since 1950
More than 100 images by 19 international artists.

PERMANENT COLLECTION

Opened in 2000 as a visual and performing arts center, the Lowry has more than 300 paintings and drawings by the 20th-century British artist L. S. Lowry, the largest collection of his work in the world. **Architecture:** Designed by Michael Wilford and Partners.

Admission: Free.
Hours: Daily, 11 a.m.–5 p.m.; Thursday, Saturday and Sunday, until 8 p.m.; Friday, until 10 p.m.

Museum of Modern Art

30 Pembroke Street, Oxford OX1 1BP, England
(44-0186) 572-2733; (44-0186) 581-3830 (recording)
www.moma.org.uk

2002 EXHIBITIONS

Through January 13
Ed Ruscha
Paintings and drawings from the 1960's to the present.

February 10–April 14
Trauma
Works in a variety of media, including drawing, painting, sculpture, photography, video and film.

Admission: Adults, £2.50; students and seniors, £1.50; under 16, free. Wednesday 11 a.m.–1 p.m. and Thursday 6–9 p.m., free.
Hours: Tuesday through Sunday, 11 a.m.–6 p.m.; Thursday, until 9 p.m. Closed Monday.

Tate St. Ives

Porthmeor Beach, St. Ives, Cornwall TR26 1TG, England
(44-0173) 679-6226
www.tate.org.uk

2002 EXHIBITIONS

Through February 17
Sandra Blow, 1969–2000
Paintings by the St. Ives resident.

Through March 3
Vicken Parsons: Paintings

March 11–June 2
Hussein Chalayan
Photography.

March 11–June 2
Naum Gabo
Sculpture.

March 11–June 2
Ian Hamilton Finlay: Maritime Works

March 11–June 2
Simon Starling

March 11–June 2
St. Ives International: Ceramicforum

June 10–September 1
Richard Long

PERMANENT COLLECTION

Part of the Tate family of galleries, including the Tate Britain and Tate Modern in London and the Tate Liverpool.

Admission: Adults, £3.95; students, £2.50; children and seniors; free.
Hours: Daily, 10 a.m.–5:30 p.m. November through February, Tuesday through Sunday, 10 a.m.–4:30 p.m.; closed Monday. Closed New Year's Day and December 24–26.

The New Art Gallery Walsall

Gallery Square, Walsall WS2 8LG, West Midlands, England
(44-01922) 654-400
www.artatwalsall.org.uk

2002 EXHIBITIONS

Through January 13
By Janet Cardiff
Installation by the Canadian artist based on the motet *Spem in Alium* by the English Renaissance composer Thomas Tallis.

Through January 13
Walsall Society of Artists
Annual exhibition.

Through January 13
Gifts to Walsall
Recent acquisitions.

January 31–March 13
Harry Wingfield: Ladybird Illustrations
Paintings used to illustrate the Ladybird books of the 1960's and 70's by a Walsall-based artist.

March 28–June 9
Vivencias: Dialogues Between the Works of Brazilian Artists From the 1960's to 2002
Includes works by two artists, Lygia Clark and Helio Oiticica, who revolutionized art in Brazil in the 1960's.

Courtesy of the New Art Gallery Walsall.

Jacob Epstein, *Sunflowers*, 1943

June 27–September 1
Gavin Turk
Works by the British artist who often addresses issues of
authorship, history and current affairs.

June 27–September 1
Borders and Boundaries
Paintings, drawings and prints challenging the view of Walsall
as an industrial area.

September 19–November 24
Tate Partnership Project
An exhibition from the Tate Collections selected by the artist
Anish Kapoor.

December 12–January 2003
Walsall Society of Artists

PERMANENT COLLECTION

European art in the Garman Ryan Collection, which was
donated to the people of Walsall by Kathleen Garman, widow
of the sculptor Jacob Epstein. **Highlights:** The Discovery
Gallery, which includes an artist's studio and activity room
with interactive elements for children. **Architecture:** 1999
Caruso St. John building in the town's shopping district.

Admission: Free.
Hours: Tuesday through Saturday, 10 a.m.–5 p.m.; Sunday,
noon–5 p.m. Closed Monday except bank holidays.

France

Centre National d'Art Contemporain

155 Cours Berriat, Grenoble 38028, France
(33-4) 76-21-95-84
www.magasin-cnac.org

2002 EXHIBITIONS

February 10–April 21
Jack Goldstein
Works by this conceptual artist.

Architecture: A 1900 industrial building with the word
"Magasin" on the facade. Because of that, and in honor of the
Magasin exhibition of Russian Dadaism held in Moscow in
1916, the museum is often referred to as "The Magasin."

Admission: Adults, 20 francs; reduced admission, 10 francs;
under 10, free.
Hours: Tuesday through Sunday, noon–7 p.m. Closed Monday.

Musée de Grenoble

5 Place de Lavalette, Grenoble 38000, France
(33-4) 76-63-44-44
www.ville-grenoble.fr/musee-de-grenoble

2002 EXHIBITIONS

Through January 6
Purism in Paris
Works by Fernand Léger, Le Corbusier and Amédée Ozenfant.

January–April
Exhibition of Drawings

May–July
Architectural Photographs

May–July
Berto Lardera

May–July
Karl Gerstner, Drawings

October–December
Bustamente

PERMANENT COLLECTION

Italian art; 17th-century French paintings; 19th-century Romantic and Realist paintings; modern and contemporary art. **Highlights:** Works by Rubens and Zurbarán; outdoor sculpture garden. **Architecture:** On the Isère River overlooking the Alps.

Admission: Adults, 25 francs; students, 15 francs.
Hours: Thursday through Monday, 11 a.m.–7 p.m. (6 p.m. in summer); Wednesday, until 10 p.m. Closed Tuesday.

Musée des Beaux Arts de Lyon

Palais St. Pierre, 20 Place Terreaux, Lyon 79001, France
(33-4) 72-10-17-40
www.mairie-lyon.fr

PERMANENT COLLECTION

Works from antiquity to the present. **Highlights:** French and Flemish painting from the 14th to the 18th centuries. **Architecture:** 17th-century convent converted into a museum in 1803.

Admission: Adults, 25 francs; students, 13 francs; under 18, free.
Hours: Wednesday through Monday, 10:30 a.m.–7 p.m. Closed Tuesday.

Musée d'Art Moderne et d'Art Contemporain

Promenade des Artistes, Nice 06300, France
(33-4) 93-62-61-62
www.mamoc-nice.org

PERMANENT COLLECTION

French and American works since 1969. Collection of Pop art.
Architecture: Four polyhedrons by Yves Bayard and Henri Vidal, built in 1990.

Admission: Adults, 25 francs; reduced admission, 15 francs.
Hours: Wednesday through Monday, 10 a.m.–6 p.m. Closed Tuesday and holidays.

Musée des Art Asiatiques

405 Promenade des Anglais, Nice 06200, France
(33-4) 92-29-37-00
www.arts-asiatiques.com

PERMANENT COLLECTION

Japanese, Chinese, Korean and Cambodian art. **Highlights:** The paths of Buddhism; furniture collection. **Architecture:** Modern marble building by the Japanese architect Kenzo Tange.

Admission: Adults, 35 francs; reduced rate, 25 francs; under 7, free.
Hours: Wednesday through Monday, 10 p.m.–5 p.m.; May through September, until 6 p.m. Closed Tuesday and holidays.

Musée des Beaux Arts, Nice

33 Avenue des Baumettes, Nice 06000, France
(33-4) 92-15-28-28
www.nice-coteazur.org

PERMANENT COLLECTION

Painting and sculpture from the 15th through the early 20th
centuries. **Architecture:** Late 19th-century mansion built in
the 17th-century Mannerist style for a Ukrainian princess;
opened as a museum in 1928.

Admission: Adults, 25 francs; reduced admission, 15 francs; 17
and under and disabled, free. Free on first Sunday of the month.

Hours: Tuesday through Sunday, 10 a.m.–noon, 2–6 p.m.
Closed Monday and holidays.

Musée Matisse

164 Avenue des Arènes-de-Cimiez, Nice 06000, France
(33-4) 93-81-08-08
www.musee-matisse-nice.org

PERMANENT COLLECTION

Works donated by Matisse and his family. Oil paintings from
all periods; paper cutouts; Vence Chapel Chasubles. **High-
lights:** *Portrait of Mme. Matisse,* 1905; *Odalisque au Cofret Rouge,*
1926; *Fauteuil Rocaille,* 1946; *Nature Morte aux Grenades,* 1947.
Architecture: 17th-century Italian villa on the Cimiez Hill
near the hotel where Matisse lived and died.

Admission: Adults, 25 francs; reduced admission, 15 francs;
17 and under and the disabled, free.
Hours: Wednesday through Monday, 10 a.m.–6 p.m. Slightly
shorter hours from October to March.

Musée National Marc Chagall

16 Avenue du Docteur Ménard, Nice 06000, France
(33-4) 93-53-87-20
www.nice-coteazure.org

2002 EXHIBITIONS

Through January 7
Chagall: Dream Images
About 50 works evoking Chagall's ties to Surrealism.

Fall
The Della Robbias
Glazed sculptures and ceramics created by the Della Robbias workshop in the 15th and 16th century.

PERMANENT COLLECTION

More than 700 works by Marc Chagall. **Highlights:** 17 large biblically themed paintings, executed between 1954 and 1967; 39 gouaches and 105 engravings designed as illustrations for a bible.

Admission: Adults, 36 francs; reduced admission, 26 francs; under 18, free.

Courtesy of the Musée National Marc Chagall.
Marc Chagall, *Adam and Eve.*

Hours: Wednesday through Monday, 10 a.m.–5 p.m.; July through September, until 6 p.m. Closed Tuesday, New Year's Day, May 1 and Christmas Day.

Centre National d'Art et de Culture Georges Pompidou

Rue Rambuteau and Rue St. Merri, Paris 75001, France
(33-1) 44-78-12-33
www.centrepompidou.fr

2002 EXHIBITIONS

March 13–May 8
Andreas Gursky
Large color digitally altered photographs.

PERMANENT COLLECTION

Major collection of 20th-century art, including Impressionism, Cubism, abstract art, Surrealism, Pop Art. Artists include Brancusi, Braque, Chagall, Dalí, Dubuffet, Léger, Kandinsky, Matisse, Mondrian, Picasso, Pollock, Warhol. **Highlights:** Niki de Saint-Phalle courtyard fountain sculptures; Braque, *Woman With Guitar*; Matisse, *The Sadness of the King*; Picasso, *Harlequin*. **Architecture:** 1977 building by Renzo Piano and Richard Rogers recently reopened after extensive renovation.

Admission: 30 to 50 francs for combination tickets including the permanent collection and temporary exhibitions; reduced admission, 20 to 40 francs; 17 and under, free for the permanent collection; 12 and under, free for temporary exhibitions and permanent collection. Free on first Sunday of the month.
Hours: Wednesday through Monday, 11 a.m.–9 p.m. Closed Tuesday.

Galerie Nationale du Jeu de Paume

Jardin des Tuleries (entry from Place de la Concorde),
 Paris 75001, France
(33-1) 47-03-12-50
www.paris.org/Musees/JeudePaume

Admission: Adults, 38 francs; reduced admission, 28 francs; under 13, free.
Hours: Tuesday, noon–9:30 p.m.; Wednesday through Friday, noon–7 p.m.; Saturday and Sunday, 10 a.m.–7 p.m. Closed Monday.

Galeries Nationales du Grand Palais

3 Avenue du General Eisenhower, Paris 75008, France
(33-1) 44-13-17-17
www.rmn.fr

Architecture: Built for the 1900 World's Fair based on a design by Deglane, Louvet & Thomas.

Admission: 45–50 francs.
Hours: Thursday through Monday, 1–8 p.m.; Wednesday, until 10 p.m. Closed Tuesday. Entrance by reservation only until 1 p.m.

Louvre

34-36 Quai du Louvre, Paris 75001, France
(33-1) 40-20-50-50; (33-1) 40-20-51-51 (recording, in
 five languages)
www.louvre.fr

2002 EXHIBITIONS

Through January
Painting as Crime, or "the Accursed Share" of Modernity

Exhibition inspired by a comment by the Viennese artist
Rudolf Schwarzkogler.

Through March
The Treasury of Conques at the Louvre
Relics and gold from the treasury of Conques, one of the last
great religious treasuries in Roman Europe.

January 18–April 15
The Honor of Curiosity: Drawings From Jabach's "Second" Collection
Works by Dürer, da Vinci, Titian, Van Dyck and others from
the collection of Everhard Jabach, a 17th-century collector.

February 8–May 27
*Beautiful and Unknown Terra Cotta Sculptures From the Maine
Workshops (16th–17th Century)*
Religious art from ateliers in the Le Mans region.

April 19–July 15
The Pharaoh's Artists: Deir el-Médineh and the Valley of the Kings
Approximately 350 pieces excavated at the Deir el-Médinah
site, reflecting life in ancient Egypt.

May 24–August 19
Ingres's Models of Stained Glass
Models for windows made between 1842 and 1844 for the
chapel Saint-Ferdinand and the Basilique de Dreux.

PERMANENT COLLECTION

Major collection of Western art from the Middle Ages to
1848; Oriental antiquities and arts of Islam; Egyptian antiq-
uities; Greek, Etruscan and Roman antiquities; paintings,
sculptures, objets d'art, prints and drawings. **Highlights:** Da
Vinci, *Mona Lisa; Venus de Milo; Winged Victory of Samothrace;*
Géricault, *Raft of the Medusa;* Millet, *The Gleaners;* David,
Coronation of Napoleon. **Architecture:** An 800-year-old former
palace of the French kings, which has undergone almost con-
tinuous expansion; 1989 glass pyramid by I. M. Pei.

Admission: Adults, 46 francs until 3 p.m.; 30 francs after
3 p.m. and on Sunday; free for age 17 and under. Free on
the first Sunday of each month. Combined and multiple-day
packages available. Advance ticket purchase is recom-
mended (by Internet or by calling 0803 808 803 within
France).

Hours: Wednesday through Monday, 9 a.m.–6 p.m.; Monday and Wednesday, until 9:45 p.m. Closed Tuesday and major holidays.

Musée d'Art Moderne de la Ville de Paris

11 Avenue du President Wilson, Paris 75116, France
(33-1) 53-67-40-00
www.mairie-paris.fr

2002 EXHIBITIONS

October–February 2003
Francis Picabia, Retrospective

PERMANENT COLLECTION

Work from all modern periods, from Fauvism and Cubism to the present. **Highlights:** Several large Robert Delaunay paintings; Matisse, *La Danse*; Raoul Dufy, *La Fée Éléctrique,* a 6,500-square-foot painting that occupies a room of its own.

Admission: 30 francs; reduced admission, 20 francs; free for under 26. Free on Sunday, 10 a.m.–1 p.m.
Hours: Tuesday through Friday, 10 a.m.–5:30 p.m.; Saturday and Sunday, until 6:45 p.m. Closed Monday.

Musée de l'Orangerie

Place de la Concorde, Paris 75001, France
(33-1) 40-20-67-71

Closed for renovation until end of 2003.

PERMANENT COLLECTION

Impressionists and modern art. Includes Monet's *Waterlilies* and works by Cézanne, Renoir, Matisse, Picasso, Rousseau and Modigliani. **Architecture:** 18th-century mansion.

Musée d'Orsay

62 Rue de Lille, Paris 75007, France
(33-1) 40-49-48-14
www.musee-orsay.fr

2002 EXHIBITIONS

Through January 14
Arnold Böcklin
Paintings by the artist (1827–1901).

Through January 27
August Strindberg
Paintings and photographs.

Through February 10
A *Fleur de Peau*
Nineteenth-century plaster reliefs with nature motifs.

Through February 17
France at the Table in the 19th Century
Paintings and objects.

February 3–May 12
Thomas Eakins
Paintings by the 19th-century American artist.

March–June
Piet Mondrian

PERMANENT COLLECTION

Significant painting, sculptural and decorative work from 1848 to 1914; noted Impressionist collection. Works by Degas, Manet, Monet, Cézanne, van Gogh, Gauguin, Toulouse-Lautrec and Rodin. **Architecture:** Converted late–19th-century railway station.

Admission: Adults, 45 francs; reduced admission, 33 francs; age Free the first Sunday of each month.
Hours: Tuesday through Saturday, 10 a.m.–6 p.m.; Thursday, until 9:45 p.m.; Sunday, 9 a.m.–6 p.m. Closed Monday.

Musée du Petit Palais

Avenue Winston Churchill, Paris 75008, France
(33-1) 42-65-12-73

Closed for renovation until 2003.

PERMANENT COLLECTION

Nineteenth-century art and works from the medieval period
through the 17th century from the collection of Dutuit and
Edward Tuck. Works by Gros, Géricault and Delacroix.
Architecture: Built for the Universal Exhibition of 1900.

Musée Guimet

6 Place d'Iena, 75116 Paris, France
(33-1) 56-52-53-39
www.museeguimet.fr

PERMANENT COLLECTION

One of the world's leading museums of Asian art. Comprehen-
sive collection of art from Afghanistan, Pakistan, the
Himalayas, Indian subcontinent, Southeast Asia, Central Asia,
China, Korea and Japan. Collection of Khmer sculpture.
Admission: Adults, 35 francs; students, 23 francs; under 18,
free. Reduced admission on Sunday for everyone. Free on first
Sunday of the month. Includes admission to the Buddhist Pan-
theon next door at 16 Avenue d'Iéna.
Hours: Wednesday–Monday, 10 a.m.–6 p.m. Closed Tuesday.

Musée Jacquemart André

158 Boulevard Haussmann, Paris 75008, France
(33-1) 42-89-04-91
www.musee-jacquemart-andre.com

PERMANENT COLLECTION

Italian Renaissance and 15th- to 17th-century French paint-
ings collected by Nilie and André Jacquemart, the former resi-

dents of the mansion that now houses the museum. Decorative art, furniture, textile art and sculpture.

Admission: Adults, 50 francs; students, 38 francs; under 7, free.
Hours: Daily, 10 a.m.–6 p.m.

Musée Marmottan Monet

2 Rue Louis-Boilly, Paris 75016, France
(33-1) 42-24-07-02
www.marmottan.com

PERMANENT COLLECTION

Hundreds of Impressionist and Post-Impressionist works, including paintings by Monet, Caillebotte, Carrière, Guillaumin, Manet, Morisot, Pissarro and Renoir; medieval illuminations; works by German, Flemish and Italian primitive painters, including Renaissance tapestries. **Architecture:** 19th-century mansion donated to the state by Paul Marmottan.

Admission: 40 francs; students, 25 francs; under 8, free.
Hours: Tuesday through Sunday, 10 a.m.–5:30 p.m. Closed Monday, May 1 and Christmas Day.

Musée Picasso

5 Rue de Thorigny, Paris 75003, France
(33-1) 42-71-25-21

2002 EXHIBITIONS
Through March 4
Picasso Under the Sun of Mithra
Works inspired by bullfights.

PERMANENT COLLECTION

Works by Picasso from every period, beginning in his adolescence; works by contemporaries, including Corot, Cézanne,

Giacometti and Braque. Picasso's private collection, including primitive art. **Architecture:** Housed in Picasso's private mansion in the Marais area, built by Jean Boullier de Bourges at the end of the 17th century.

Admission: Permanent collection and temporary exhibitions: Adults, 38 francs; students, 28 francs; under 18, free. 28 francs for all on Sunday and free for all the first Sunday of each month. Permanent collection only: Adults, 30 francs; students, 20 francs.
Hours: Wednesday through Monday, 9:30 a.m.–5:30 p.m. (until 6 p.m. April–September); Thursday, until 8 p.m. Closed Tuesday.

Musée Rodin

77 Rue de Varenne, Paris 75007, France
(33-1) 44-18-61-10
www.musee-rodin.fr

PERMANENT COLLECTION

Large collection of work by Auguste Rodin. **Highlights:** Large sculpture garden; *The Thinker*; *Door to Hell*; *The Kiss*; a room dedicated to the work of Camille Claudel, Rodin's companion and student. **Architecture:** 18th-century mansion.

Admission: Adults, 28 francs; students, 18 francs; 17 and under, free. Entrance to the park, 5 francs.
Hours: Tuesday through Sunday, 9:30 a.m.–5:45 p.m. (until 4:45 p.m. October–March). Slightly shorter hours during the winter. Closed Monday.

Union Centrale des Arts Décoratifs

107 Rue de Rivoli, Paris 75001, France
(33-1) 44-55-57-50
www.ucad.fr

Musée des Arts Décoratifs
(Decorative Arts Museum)

PERMANENT COLLECTION

Medieval and Renaissance art, including altarpieces, tapestries and sculptures. **Architecture:** In the Marsan wing of the Louvre Palace.

Musée de la Publicité
(Museum of Advertising)

PERMANENT COLLECTION

Posters, objects, television and film commercials and print advertisements from around the world. **Architecture:** Designed by Jean Nouvel to resemble a city.

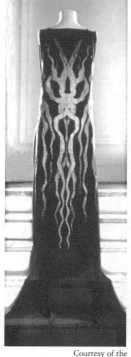

Musée de la Mode et du Textile
(Fashion and Textile Museum)

PERMANENT COLLECTION

Textiles and clothing from the 18th century to the present; about 40 "wardrobes" donated by prominent people, including the Duchess of Windsor and Fina Gomez.

Musée Nissim de Camondo

63 Rue de Monceau, Paris 75008, France
(33-1) 53-89-06-50

Courtesy of the Musée de la Mode et du Textile. Madeline Vionet, *robe*, 1924.

PERMANENT COLLECTION

Collection of 18th-century furniture displayed in a villa inspired by Petit Trianon in Versailles. Collection of Count Moise de Camondo.

Admission: For Musée Nissim de Camondo: Adults, 35 francs; students, 25 francs; under 18, free. For other three museums: Adults, 35 francs; students, 25 francs; under 18, free.

Hours: For Musée Nissim de Camondo: Wednesday–Sunday, 10 a.m.–5 p.m. Closed Monday and Tuesday. For other three museums: Tuesday through Friday, 11 a.m.–6 p.m.; Wednesday, until 9 p.m.; Saturday and Sunday, 10 a.m.–6 p.m. Closed Monday.

Fondation Maeght

623 Che Gartettes, Saint-Paul 06570, France
(33-4) 93-32-81-63
www.fondation-maeght.com

PERMANENT COLLECTION

Modern art, including works by Kandinsky, Chagall, Braque and Giacometti. **Highlights:** *The Labyrinth of Dreams,* a series of monumental sculptures that Joan Miró made for the foundation's gardens. **Architecture:** 1960's José Luis Sert building, built in collaboration with many of the artists whose works are displayed there, including Giacometti, Miró and Braque.

Admission: Adults, 50 francs; students, 40 francs; under 10, free.

Hours: 10 a.m.–7 p.m., July–September; 10 a.m.–12:30 p.m. and 2:30-6 p.m., October–June.

Bauhaus-Archiv Museum für Gestaltung

(Bauhaus Archive and Museum of Design)

14 Klingelhöferstrasse, Berlin 10785, Germany
(49-30) 254-0020
www.bauhaus.de

PERMANENT COLLECTION

Materials related to the activities and ideas of the Bauhaus, the influential art school that flourished between 1919 and 1933. Includes architectural models, furniture, metalware, ceramics, weavings, murals, paintings, drawings, sculpture and photography. **Highlights:** Klee, *Neues im Oktober*; Kandinsky, *Meinem Lieben Galston*; Schlemmer, *Abstrakter*; Brandt, *Tea and Coffee Set*; architectural models by Bayer, Feininger, Itten, Moholy-Nagy. **Architecture:** 1979 structure built from plans by Walter Gropius, founder and director of the Bauhaus.

Admission: Adults, Euro 4; reduced admission, Euro 2.
Hours: Wednesday through Monday, 10 a.m.–5 p.m. Closed Tuesday.

Deutsche Guggenheim Berlin

13-15 Unter den Linden, Berlin 10117, Germany
(49-30) 20-20930
www.deutsche-guggenheim-berlin.de

2002 EXHIBITIONS

Through January 13
Rachel Whiteread: Transient Spaces

February 2–April 28
Bill Viola
Work commissioned by the museum.

May 11–June 30
Kara Walker
Works from the Deutsche Bank collection.

July 13–October 6
Commissioned Work for the Deutsche Guggenheim

PERMANENT COLLECTION

Architecture: Gallery designed by Richard Gluckman on the ground floor of a 1910 sandstone Deutsche Bank building.

Admission: Adults, Euro 2.56; students, Euro 1.53. Free on Monday. Additional fees for special exhibitions.
Hours: Daily, 11 a.m.–8 p.m.; Thursday, until 10 p.m.

Jüdisches Museum Berlin
(Jewish Museum Berlin)

9-14 Lindenstrasse, Berlin 10969, Germany
(49-30) 25-993-410
www.jmberlin.de

2002 EXHIBITIONS

Continuing
Jews in Germany
Exhibition tracing the 2,000-year history of Jews in Germany.

PERMANENT COLLECTION

Historical archives. Herbert Sonnenfeld's photos on Jewish life in Berlin, 1933–38; paintings by Max Liebermann, Ludwig Meidner, Lesser Ury, Hermann Struck, Jakob Steinhardt, Felix Nussbaum and Arthur Segal; the Loewenhardt-Hirsch Palestine Collection; Zvi Shofer's Judaica Collection. **Architecture:** Zinc-clad building by Daniel Libeskind.

Admission: Adults, Euro 5; seniors and students, Euro 2.50; under 6, free
Hours: Daily, 10 a.m.–8 p.m. Closed on Rosh Hashanah, Yom Kippur and December 24.

Kunst- und Ausstellungshalle der Bundesrepublik Deutschland

(Federal Republic of Germany Art and Exhibition Hall)

4 Friedrich Ebert Allee, Bonn 53113, Germany
(49-228) 917-1200
www.Bundeskunsthalle.de

2002 EXHIBITIONS

Through January 6
7000 Years of Persian Art
Masterpieces from the Iranian National Museum, including Islamic painted ceramics, clay figures and gold and silver vessels, many never before exhibited abroad.

Through February 7
Troy: Dream and Reality
Includes major finds from archeological explorations at Troy.

January 18–April 28
The People of 1,000 Gods: The Hittites
Stone reliefs, clay tablets, bronze statuettes, ceramics and gold from the Hittite civilization of Anatolia.

April 26–August 11
Alex Katz

June 14–October 6
Art From Venetian Palaces

Admission: Adults, Euro 6.50; reduced admission, Euro 3.50; families, Euro 10.50. Discounts for two-day admission and for groups.

Hours: Tuesday and Wednesday, 10 a.m.–9 p.m.; Thursday and Saturday-Sunday, 10 a.m.–7 p.m.; Friday, 9 a.m.–7 p.m. Closed Monday, except on holidays.

Kunstmuseum Bonn

2 Friedrich Ebert-Allee, Bonn 53113, Germany
(49-228) 77-6260
www.bonn.de/kunstmuseum

2002 EXHIBITIONS

Through February 10
Im Zwischenreich
Works by Paul Klee, Max Ernst and others.

Through February 17
Contemporary Art From Turkey

March 7–May 26
Dunja Evers
Photography.

March 14–June 2
August Macke

April 21–July 21
Franz Erhardt Walther
Exhibition for children.

June
10 Years Museum Mile

June 20–September 8
Ulrich Ruckreim
Drawings.

August
Arts Award of the City of Bonn 2001

September 26–February 2003
The Bridge

Masterpieces from the Brucke-Museum, Berlin.

October 3–November 24
Dorothea Von Stetten Arts Award 2002

December 19–February 2003
Ernst Wilheim Nay

PERMANENT COLLECTION

Twentieth-century works by German and international artists, with an emphasis on works from the 1950's to 1990's; works by the Rhineland Expressionists. **Architecture:** Opened in 1992, the museum building was designed by Axel Schultes and drew international attention.

Admission: Adults, Euro 5; reduced admission, Euro 2.50. Discounts for two-day visit and for families.
Hours: Tuesday through Sunday, 10 a.m.–6 p.m.; Wednesday, until 9 p.m. Closed Monday, Christmas Eve, Christmas Day and New Year's Eve.

Museum Ludwig

1 Bischofsgartenstrasse, Cologne 50667, Germany
(49-221) 221-16165
www.museenkoeln.de

2002 EXHIBITIONS

Through February
Photography/Sculpture
Works by Isa Genzken of Berlin and Wolfgang Tillmanns of London.

Through February
Photography
Works by Thomas Bayrie of Frankfurt and Bodys Isek Kingelez of Kinshasa.

Through April
Museum of Our Wishes

March–May
Economy of Time
Video, objects, photography and installations.

June 8–September
Matthew Barney

PERMANENT COLLECTION

German Expressionist, Russian avant-garde and Surrealist works; works by Picasso; Pop Art; contemporary art; prints; photography. **Highlights:** 80 works by Robert Rauschenberg; video art. **Architecture:** Complex designed by Busman and Haberer; piazza by Dani Karavan.

Admission: Adults, Euro 5.62; students, Euro 3.58.
Hours: Tuesday, 10 a.m.–8 p.m.; Wednesday through Friday, 10 a.m.–6 p.m.; Saturday and Sunday, 11 a.m.–6 p.m. Closed Monday.

Museum für Moderne Kunst

10 Domstrasse, Frankfurt 60311, Germany
(49-69) 212-304-47
www.mmk-frankfurt.de

2002 EXHIBITIONS

Through March 3
Change of Scene XX
Works by about 20 artists.

PERMANENT COLLECTION

Extensive collection of contemporary art, including the 60's Collection (Jasper Johns, Roy Lichtenstein, Andy Warhol, Claes Oldenburg, Robert Rauschenberg, George Segal) and works by young German artists. **Architecture:** Triangular 1983 building by Hans Hollein.

Courtesy of the Museum für Moderne Kunst. Museum für Moderne Kunst, photo by Axel Schneider.

Admission: Adults, Euro 5; children and students, Euro 2.50.
Free on Wednesday.
Hours: Tuesday through Sunday, 10 a.m.- 5 p.m.; Wednesday,
until 8 p.m. Closed Monday and major holidays.

Hamburger Kunsthalle

Glockengiesserwall, Hamburg 20095, Germany
(49-40) 42854-2612
www.hamburger-kunsthalle.de

2002 EXHIBITIONS

Through January 27
Edouard Vuillard: Les Tasses Noires

Through February 10
Hilka Nordhausen

January 18–April 1
Jacob van Ruisdael: The Revolution of Landscape

February 15–May 12
In Focus: Wols, Composition, 1947

March 1–May 19
Edvard Munch: The Sick Child

March 15–May 30
Andres Zorn

March 29–June 16
Vincent van Gogh
Paris drawings.

April 24–August 4
Jurgen Klauke Retrospective

PERMANENT COLLECTION

Gothic to contemporary paintings; 19th- and 20th-century
sculpture, drawings and graphics. **Highlights:** Meister
Bertram, *The Creation of the Animals*; Rembrandt, *Simeon and
Anna Recognize Jesus as the Lord*; Beckmann, *Ulysses and Calypso*;
Friedrich, *The Sea of Ice, Runge Morning*; Hockney, *Doll Boy*.

Architecture: 1869 building by Hude and Schirrmacher; 1919 annex; building by Oswald Mathias Ungers opened in 1997.

Admission: Adults, Euro 7; students and under 16, Euro 5; handicapped, free.
Hours: Tuesday through Sunday, 10 a.m.–6 p.m.; Thursday, until 9 p.m. Closed Monday.

Alte Pinakothek

Barer Strasse 27, 80333 Munich, Germany
(49-0) 89-23805-26

PERMANENT COLLECTION

One of the oldest galleries in the world, with art from the Middle Ages to the end of the Rococo period. Italian art by Giotto, Botticelli, da Vinci, Paphael, Titian and Tintoretto; Dutch Baroque art by Rembrandt and Hals; early German painting by Holbein the Elder, Dürer, Lochner and Altdorfer. **Highlights:** One of the world's largest collections of works by Rubens; Dürer's self-portrait from 1500 and *Four Apostles*. **Architecture:** Designed by Leo von Klenze and completed in 1836; extensive interior renovation in 1998.

Admission: DM 9; reduced admission: DM 6.
Hours: Tuesday through Sunday, 10 a.m.–5 p.m.; Thursday, until 10 p.m. Closed Monday.

Neue Pinakothek

Barer Strasse 29, 80333 Munich, Germany
(49-0) 89-23805-195

PERMANENT COLLECTION

European art and sculpture from the late 18th century to the beginning of the 20th century, particularly German art of the

19th century, French Impressionist works, portrait and land-scape painters from England, France and Spain.

Admission: DM 9; reduced admission: DM 6.
Hours: Wednesday through Monday, 10 a.m.–5 p.m.; Thursday, until 10 p.m. Closed Tuesday.

Staatsgalerie Stuttgart

30-32 Konrad Adenauer Strasse, Stuttgart 70174,
 Germany
(49-711) 212-4050
www.staatsgalerie.de

2002 EXHIBITIONS

September 21–February 9, 2003
Manet and the Impressionists

PERMANENT COLLECTION

Early German, Dutch and Italian painting; 19th-century
French painting; Swabian classicism; European modern art,
including Fauvist, Expressionist and Constructivist works;

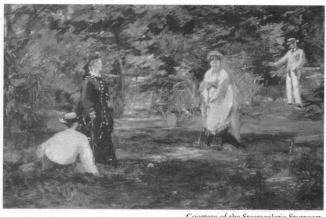

Courtesy of the Staatsgalerie Stuttgart.

Edouard Manet, *The Croquet Party*, 1873.

American Abstract Expressionism; Pop Art and Minimalism; drawings; watercolors; collages; prints; illustrated books; posters; photographs. **Architecture:** Old building by G.G. Barth, 1843; new building by James Stirling, 1984.

Admission: Adults, Euro 4.50; children, Euro 2.50. **Hours:** Tuesday through Sunday, 10 a.m.–6 p.m.; Thursday, until 9 p.m. Closed Monday.

Hong Kong

Art Museum, The Chinese University of Hong Kong

Shatin, New Territories, Hong Kong
(852) 2609-7416
www.cuhk.edu.hk/ics/amm

2002 EXHIBITIONS

Opening April 3
Double Beauty: Chinese Calligraphy Couplets From the Lok Tsai Hsien Collection

Opening May 5
Graduation Exhibition 2002: Fine Arts

Opening September 7
Yuan and Ming Blue and White Ware From Jiangxi

Opening December 10
Inkplay Within a Bottle: Inside Painted Snuff Bottles

PERMANENT COLLECTION

More than 7,000 items, including Chinese paintings, calligraphy, rubbings, sculpture, ceramics, jades, bronzes, seals and other decorative arts.

Admission: Free.

Hours: Monday through Saturday, 10 a.m.–4:45 p.m.; Sunday, 12:30–5:30 p.m. Closed public holidays.

The University Museum and Art Gallery

University of Hong Kong, Pokfulam, Hong Kong
(852) 2241-5500
www.hku.hk/hkumag

2002 EXHIBITIONS

Through January 8
Ancient Chinese Musical Instruments
More than 100 instruments from the Bronze Age onwards.

Through January 20
South Africa: A Photographic Odyssey by Ho Lok-tian
Works by a Hong Kong photographer who was commissioned by the South African government to document South African life and culture.

March–June
Chaozhou Folk Art
Folk art dating to the Ming and Qing dynasties, including textiles, embroidery, carving and ceramics.

May–June
French May Exhibition
Annual exhibition in cooperation with the Consulate General of France as part of a festival celebrating French culture.

June–July
Artworks by Ren Rong
Multimedia works that include cutouts and photomontage techniques by the Germany-based Chinese artist.

September–November
Contemporary Chinese Prints
Works by 25 contemporary Chinese printmakers.

November–January 2003
Oil Paintings by Chinese Masters

PERMANENT COLLECTION

Chinese antiquities, including ceramics, bronzes and paintings; contemporary Chinese paintings. **Highlights:** Nestorian bronze crosses of the Yuan dynasty; underglaze blue water pot of the Tang dynasty.

Admission: Free.
Hours: Monday through Saturday, 9:30 a.m.–6 p.m.; Sunday, 1:30–5:30 p.m. Closed holidays.

India

Asutosh Museum of Indian Art

Centenary Building, University of Calcutta, College Street, Calcutta 700012, India
(91-33) 241-0071; (91-33) 241-4984

PERMANENT COLLECTION

More than 25,000 objects of Indian art and antiquity, with an emphasis on Eastern India and Bengal, including sculpture, paintings, folk art, textiles and terra cotta. **Highlights:** Ancient Indian and Ceylonese mural paintings; banner paintings from Tibet and Nepal; Mughal, Rajasthani, Pahari and local paintings; pats (scroll paintings); pata (painted manuscript covers); kantha (embroidered textiles).

Courtesy of the Asutosh Museum of Indian Art. West Bengal, Kirtan Scene, *Chaitanya and His Disciples*, 19th century.

Admission: Free.
Hours: Monday through Friday, 11 a.m.–4:45 p.m. Closed Saturday, Sunday and national and state holidays.

Baroda (Vadodara) Museum and Picture Gallery

Sayaji Baug (Park), Baroda, Gujarat 390005, India
(91-26) 579-3801

PERMANENT COLLECTION

Art, archaeology, natural history, geology and ethnology; 11th-century Shiva Natraj; ninth-century ivory; miniatures from Razm Nama; a Persian version of the Hindu epic Mahabharata commissioned by Emperor Akbar; European art from early Greek times to the 20th century. The Picture Gallery features European art from the 15th, 18th and 19th centuries; works by Veronese, Giordano and Zurbarán; Flemish and Dutch school paintings; Turner and Constable; Mughal miniatures; palm-leaf manuscripts of Buddhist and Jain origin. **Architecture:** Two buildings connected by a covered bridge, modeled on the Victoria and Albert and Science Museums of London; designed by Maj. R.N. Mant and R.F. Chisholm in 1897.

Admission: Adults, 5 rupees; under 12, free.
Hours: Daily, 10:30 a.m.–5:30 p.m. Closed national holidays.

National Gallery of Modern Art

Jaipur House, near India Gate, New Delhi 110003, India
(91-11) 338-8853
www.ngma-india.com

PERMANENT COLLECTION

More than 14,000 works of Indian and Western modern art,
including Indian works from the Company School (1857) and
from the Bengal School of the early 20th century (Jamini Roy,
Rabindranath Tagore, Nandalal Bose).

Admission: 150 rupees.
Hours: Tuesday through Sunday, 10 a.m.–5 p.m. Closed
Monday and national holidays.

National Museum

Janpath, New Delhi 110001, India
(91-11) 301-9272
www.nationalmuseumindia.org

PERMANENT COLLECTION

Works that span 5,000 years; pre-history gallery; Indus Valley
civilization; Maurya, Satvahana and Shunga art; late medieval
art; Indian bronzes; Central Asian art; Chamba Rangmahal;
Indian miniature paintings; manuscripts; pre-Columbian and
Western art; Indian coins and copper plates; wood carvings;
musical instruments; arms and armor; Buddhist art, including
Buddha's relics from Kapilavastu and life scenes from the fifth
century B.C.; decorative arts; paintings from South India, Tan-
jore and Mysore; Indian textiles and jewelry.

Admission: 150 rupees; camera fee, 300 rupees.
Hours: Tuesday through Sunday, 10 a.m.–5 p.m. Closed Mon-
day and national holidays.

Sanskriti Museum of Everyday Art and Indian Terracotta

Sanskriti Kendra, Anandgram, Qutab-Mehrauli-Gugaon
 Road, New Delhi 110047, India
(91-11) 650-1796
www.sanskritifoundation.org

PERMANENT COLLECTION

Museum of Everyday Art: Collection of about 2,500 objects from everyday life in traditional India, including folk and tribal sacred images, ritual accessories, lamps, incense burners, writing materials and kitchen implements. Museum of Indian Terracotta: About 1,500 objects of terracotta, including earthenware pots and ritual figures.

Admission: Free.
Hours: Tuesday through Sunday, 10 a.m.–5 p.m. Closed Monday and national holidays.

Ireland

Hugh Lane Municipal Gallery of Modern Art

Charlemont House, Parnell Square North, Dublin 1,
 Ireland
(353-1) 874-1903
www.hughlane.ie

PERMANENT COLLECTION

Twentieth-century Irish art, including works by Jack B. Yeats and contemporary artists such as Willie Doherty, Dorothy Cross, Sean Scully and Kathy Prendergast; paintings by Degas, Manet, Monet and other Impressionists; modern art by Albers, Christo, Beuys, Agnes Martin, Francis Bacon and others.
Architecture: Georgian building.

Admission: £6 for Francis Bacon Studio; free for rest of gallery.
Hours: Tuesday to Thursday, 9.30 a.m.–6 p.m.; Friday and Saturday, 9.30 a.m.–5 p.m.; Sunday, 11 a.m.–5 p.m.

Irish Museum of Modern Art

Royal Hospital, Military Road, Kilmainham, Dublin 8, Ireland
(353-1) 612-9900
www.modernart.ie

2002 EXHIBITIONS

Through January
Sol LeWitt: New Wall Drawings
A series of cube-based color drawings.

Through January
Shirin Neshat
A new work by the Iranian filmmaker and photographer, plus her first major film work, *Turbulent*.

Through January
Tony O'Malley: Paintings and Gouaches From the McClelland Collection
Works produced during the 1960's and 70's.

PERMANENT COLLECTION

Some 4,000 works of 20th-century Irish and international art; paintings by Sean Scully and others; sculpture; photography; video work; an installation by Ilya and Amelia Kabakov.
Architecture: The former Royal Hospital Kilmainham, built in the 17th century as a home for retired soldiers.

Admission: Free.
Hours: Tuesday through Saturday, 10 a.m.–5:30 p.m.; Sunday and holidays, noon–5:30 p.m. Closed Monday, Good Friday, December 24–26 and New Year's Eve.

National Gallery of Ireland

Merrion Square (West), Dublin 2, Ireland
(353-1) 661-5133
www.nationalgallery.ie

2002 EXHIBITIONS

Through January 31
The Turner Watercolors
Nearly three dozen works by the English-born Joseph Mallord
William Turner (1775-1851), featuring scenic views of the
Alps, Venice, English coastal towns and the sea.

Mid-January–April 14
Monet, Renoir and the Impressionist Landscape
A look at the Impressionists and their influences, as well as the
artists they in turn influenced. Nearly 70 works.

February–May
Terbrugghen's Crucifixion

June 12–September 1
*American Beauty: Painting and Sculpture From the Detroit Institute
of Arts, 1770–1920*
Some 90 works, from Colonial times until the late 19th
century. (Travels)

June 19–August 11
Anthony Van Dyck: Ecce Homo *and* The Mocking of Christ

September 23–December 15
Jules Breton
A retrospective featuring approximately 100 works by the
19th-century Realist painter.

PERMANENT COLLECTION

Some 13,000 works of art, more than 2,500 of which are oil
paintings. Irish art from the 17th century to the 20th,
including works by Barry, O'Connor, Orpen and Yeats;
European art, including works by Canova, Caravaggio,
Gainsborough, Goya, Poussin, Rembrandt and Vermeer.
Highlights: Yeats Museum dedicated to the work of the Irish
artist and writer as well as his father and other members of the
family; National Portrait Collection. **Architecture:** 1864
Dargan Wing by Francis Fowke; Milltown Wing by Thomas

N. Deane; 1968 North Wing, refurbished in 1996; just-completed wing by Benson and Forsyth.

Admission: Free.
Hours: Monday through Saturday, 9:30 a.m.–5:30 p.m.;
Thursday, until 8:30 p.m.; Sunday, noon–5:30 p.m. Closed
Good Friday and December 24–26.

Israel

Israel Museum

Givat Ram (Ruppin Road, across from Knesset),
 Jerusalem 91710, Israel
(972-2) 670-8811
www.imj.org.il

2002 EXHIBITIONS

Through January 15
Treasures of China
Exhibition of bronzes, porcelains and paintings from the past
5,000 years, being shown for the first time in Israel.

Through February
Mapping the Holy Land
Examples of maps illuminating scientific, religious and artistic
perspectives of the world over the past 2,000 years.

Through April
Moshe Kupferman Retrospective
Some 100 paintings and works on paper from the 1950's to the
present by the Israeli artist.

Through September
Hands
Interactive exhibition about hands featuring works of art,
musical objects and activities for the whole family.

Through October
Mountain Jews: Customs and Daily Life in the Caucasus
Tenth in a series of exhibitions about the disparate Jewish communities around the world.

March
North African Lights
Display of 120 Hanukkah lamps from North Africa.

May–October
Raffi Lavie Retrospective
Works by an influential Israeli artist, teacher and art critic.

July–November
In the Beginning There Was the Palette: The Paintings of Mordechai Ardon
Landscapes and portraits by the Israeli artist (1896–1992).

December
A Personal Journey: Central African Art From the Collection of Lawrence Gussman
More than 75 items of African art.

PERMANENT COLLECTION

Israel's largest museum, containing archaeological and fine arts collections of the Holy Land from antiquity to the present day.
Highlights: The Dead Sea Scrolls; noted collection of Judaica and the ethnology of the Jewish people around the world; fine art holdings from European Old Masters through international contemporary art.

Admission: Adults, NIS 37 (New Israeli shekels); seniors, students and the handicapped, NIS 30; ages 3–17, NIS 20.
Hours: Monday, Wednesday and Saturday, 10 a.m.–4 p.m.; Tuesday, 4–9 p.m.; Thursday, 10 a.m.–9 p.m.; Friday, 10 a.m.–2 p.m. Closed Sunday and Yom Kippur Eve and Yom Kippur.

Italy

Galleria dell'Accademia

58-60 Via Ricasoli, Florence 50122, Italy
(39-055) 238-8609
www.sbas.firenze.it/accademia

PERMANENT COLLECTION

Michelangelo sculptures; paintings, mostly dating between the 13th and 15th centuries. **Highlights:** Michelangelo, *David*, *St. Matthew*, *Pietà di Palestrina* and *The Four Slaves*, created for the tomb of Pope Julius II. **Architecture:** 16th-century building, restored in the 18th and 19th centuries.

Admission: 15,000 lire. Advance ticket purchase recommended, at reduced rate; contact the Florence Museum reservation office at (39-05) 529-4883.
Hours: Tuesday through Sunday, 8:15 a.m.–7 p.m. Closed Monday, New Year's Day, May 1 and Christmas Day.

Galleria degli Uffizi

5 Via della Ninna, Florence 50122, Italy
(39-055) 238-8651
www.sbas.firenze.it/uffizi

PERMANENT COLLECTION

Italian Renaissance art. **Highlights:** Botticelli room; paintings by Caravaggio, Giotto, Leonardo da Vinci, Michelangelo and Titian. **Architecture:** Designed by Giorgio Vasari for the Medici family in 1560.

Admission: 15,000 lire. Advance ticket purchase recommended; contact the Florence Museum reservation office at (39-05) 529-4883.
Hours: Tuesday through Sunday, 8:30 a.m.–7 p.m. Closed Monday, New Year's Day, May 1 and Christmas Day.

Museo Nazionale del Bargello

4 Via del Proconsolo, Florence 50122, Italy
(39-055) 238-8606
www.sbas.firenze.it/bargello

2002 EXHIBITIONS

Fall
Acquisitions From the Last Five Years

PERMANENT COLLECTION

Major collection of Renaissance sculpture. Works by
Donatello, Della Robbia and Michelangelo; base of Benvenuto
Cellini's *Perseus;* decorative arts. **Architecture:** 14th-century
Gothic Podestà Palace.

Admission: 8,000 lire. Advance ticket purchase
recommended; contact the Florence Museum reservation office
at (39-05) 529-4883.
Hours: Daily, 8:15 a.m.–1:50 p.m. Closed New Year's Day,
May 1 and Christmas Day. Closed the second and fourth
Sunday and first, third and fifth Monday of each month.

Museo Poldi Pezzoli

12 Via Manzoni, Milan 20121, Italy
(39-0) 279-6334
www.museopoldipezzoli.it

PERMANENT COLLECTION

Paintings, sculpture, works of gold, arms and armor, fabric, clocks
and bronzes. **Highlights:** Paintings by Giovanni Bellini, Botticelli,
Piero della Francesca, Pollaiuolo and Raphael. **Architecture:** 17th-
century mansion of a 19th-century art collector.

Admission: 10,000 lire; slightly higher for some exhibitions.
Hours: Tuesday through Sunday, 10 a.m.–6 p.m. Closed
Monday, New Year's Day, Easter Sunday, April 25, May 1,
August 15, November 1 and December 8, 25 and 26.

Pinacoteca di Brera
(Brera Picture Gallery)

28 Via Brera, Milan 20121, Italy
(39) 02-8942-1146
www.rcs.it/mimu/musei/brera/presentazione.htm

PERMANENT COLLECTION

Mostly paintings from churches and cloisters closed during the
Napoleonic period; Lombard and Venetian school works.
Highlights: Caravaggio, *Supper at Emaus*; Tintoretto, *Finding of
the Body of St. Mark*; Mantegna, *Dead Christ*; Luini, *Madonna of the
Rose Hedge*; Raphael, *The Betrothal of the Virgin*; Piero della
Francesca, Montefeltro altarpiece. **Architecture:** Begun in the
12th century as a cloister; additional construction in the early 17th
century by Francesco Maria Richini; 18th-century alterations by
Giuseppe Piermarini. Opened as a museum in 1809.

Admission: 10,000 lire.
Hours: Tuesday through Sunday, 8:30 a.m.–7:30 p.m. Slightly
shorter hours during the winter. Closed Monday, New Year's
Day, May 1 and Christmas Day.

Veneranda Biblioteca Ambrosiana, Pinacoteca Ambrosiana
(Ambrosiana Library and Picture Gallery)

2 Piazza Pio XI, Milan 20123, Italy
(39-0) 280-6921
www.ambrosiana.it

PERMANENT COLLECTION

Founded in 1609 with a bequest by Cardinal Federico
Borromeo. **Highlights:** Sketches for Raphael's *School of Athens*;
works by Flemish, Lombard and Venetian masters, including

Caravaggio, Leonardo da Vinci, Luini and Titian.
Architecture: Part of a palace built for Cardinal Borromeo, begun in 1603 and finished in 1630. Restored in 1997.

Admission: 14,000 lire.
Hours: Tuesday through Sunday, 10 a.m.–5:30 p.m. Closed Monday, New Year's Day, Easter Sunday, May 1 and Christmas Day. The library is closed on weekends from December 24 to January 7 and in August.

Museo Archeologico Nazionale Napoli

(Naples Archaeological Museum)

19 Piazza Museo, Naples 80135, Italy
(39-08) 144-0166
www.marketplace.it/museo.nazionale

Permanent Collection

Classical antiquities from the 18th-century excavations of Pompeii, Herculaneum and Stabiae. **Highlights:** Roman wall frescoes from the Vesuvius region; statue of the Farnese *Hercules*; sculptural group of the Farnese bull; mosaic of Alexander from the House of the Faun in Pompeii; frescoes and sculpture from the Villa of the Papyri in Herculaneum and the Temple of Isis in Pompeii. **Architecture:** Built at the end of the 16th century; reconstructed at the beginning of the 17th century, when it became the University of Naples, and expanded at the end of the 18th century to become the Royal Bourbon Museum.

Admission: Adults, 12,000 lire; European Union citizens over 65 or under 18, free.
Hours: Wednesday through Monday, 9 a.m.–7:30 p.m. Hours may be shorter during the winter. Closed Tuesday, New Year's Day, May 1 and Christmas Day.

Museo di Capodimonte

1 Via Miano, Naples 80137, Italy
(39-081) 749-9111
capodimonte.selfin.net/capodim/home.htm

PERMANENT COLLECTION

Works from the Borgia, Bourbon and Farnese collections; contemporary art. **Highlights:** Works by Bruegel the Elder, Caravaggio, Mantegna, Martini, Masaccio and Titian; 18th-century porcelain. **Architecture:** Former royal estate, begun in 1738 by Antonio Medrano and completed a century later.

Admission: 14,000 lire.
Hours: Tuesday through Sunday, 8:30 a.m.–8 p.m.; holidays, 9 a.m.–8 p.m. Closed Monday, New Year's Day, May 1 and Christmas Day.

Galleria Nazionale dell'Umbria

Palazzo dei Priori, 1 Corso Vannucci, Perugia 06100,
 Italy
(39-075) 574-1257

PERMANENT COLLECTION

Central Italian art, with emphasis given to artists working in Umbria.
Highlights: Sculptures from a fountain by Arnolfo di Cambio; paintings by Duccio di Buoninsegna, Gentile and Piero della Francesca; works by Perugino.

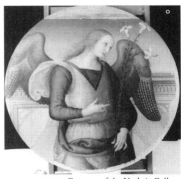

Courtesy of the Umbria Gallery.
Pietro Vanucci detto il Perugino, *Archangel Gabriel*.

435

Architecture: 13th-century palace, recently restored and expanded.

Admission: 12,000 lire.
Hours: Daily, 8:30 a.m.–7:30 p.m. Closed the first Monday of the month.

Galleria Borghese

5 Piazza Scipione Borghese, Rome 00197, Italy
(39-06) 854-8577
www.galleriaborghese.it

PERMANENT COLLECTION

Italian art, especially Roman, Venetian and Emilian works.
Highlights: Caravaggio paintings; Bernini sculptures;
Raphael, *Deposition*; Canova, *Pauline Bonaparte*. **Architecture:**
Designed by Jan van Santen in the early 17th century for
Cardinal Scipione Borghese; recently restored.

Admission: 14,000 lire plus mandatory 2,000-lire reservation
fee; call (39) 063-2810 for reservations.
Hours: Tuesday through Sunday, 9 a.m.–7 p.m. Closed
Monday, New Year's Day, May 1 and Christmas Day.

Galleria Nazionale d'Arte Antica, Palazzo Barberini

13 Via Barberini, Rome 00184, Italy
(39-06) 481-4591
www.galleriaborghese.it

PERMANENT COLLECTION

Art dating from the 13th century to the 18th. **Highlights:**
Fresco in the Grand Salon by Pietro da Cortona; Raphael,
Fornarina; Caravaggio, *Judith and Holofernes*; Hans Holbein the

Younger, *Portrait of Henry VIII*. **Architecture:** 17th-century palace built for Pope Urban VIII by Carlo Maderno, Gian Lorenzo Bernini and Francesco Borromini.

Admission: 12,000 lire; reservations can be made by calling (39) 063-2810 (for a 2,000-lire fee), but are not required.
Hours: Tuesday through Thursday and Sunday, 9 a.m.–8 p.m.; Friday and Saturday, 9 a.m.–10 p.m. Closed Monday, New Year's Day, May 1 and Christmas Day.

Galleria Nazionale d'Arte Moderna

131 Viale delle Belle Arti, Rome 00196, Italy
(39-063) 229-8225
www.gnam.arti.beniculturali.it

Museo Mario Praz

Palazzo Primoli, 1 Via Zanardelli
(39-06) 686-1089
www.gnam.arti.beniculturali.it/prazco.htm

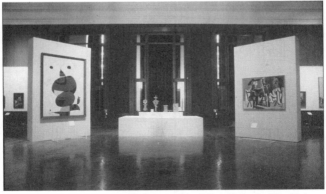

Courtesy of the Galleria Nazionale d'Arte Moderna.
Spanish vanguard room.

437

Museo Boncompagni Ludovisi

18 Via Boncompagni
(39-064) 282-4074
www.gnam.arti.beniculturali.it/boncco.htm

Manzù Collection

1 Via Sant'Antonio, Ardea
(39-06) 913-5022
www.gnam.arti.beniculturali.it/manzco.htm

Museo Hendrik C. Andersen

24 Via Pasquale Stanislao Mancini
(39-06) 321-9089
www.gnam.arti.beniculturali.it/andeco.htm.

PERMANENT COLLECTION

Paintings and sculpture, mostly Italian, from 1780 to the present; works by Balla, Boccioni and other Futurists; paintings by Burri, Fontana and Morandi. **Highlights:** Canova, *Hercules and Lychas*; Giulio Aristide Sartorio, *Gorgon and the Heroes*. **Architecture:** Built in 1911; since expanded.

Admission: 12,000 lire; European Union citizens over 65 or under 18, free.
Hours: Tuesday through Sunday, 8:30 a.m.–7:30 p.m. Closed Monday, New Year's Day and May 1.

Musei Capitolini

Piazza del Campidoglio, Rome 00186
(39-063) 996-7800
www.comune.roma.it/cultura/italiano/
 musei_spazi_espositivi/musei/musei_capitolini

PERMANENT COLLECTION

Divided into two buildings: One houses a collection of ancient sculpture; the other, frescoes and a picture gallery. Ancient Roman busts of emperors and philosophers; paintings by Caravaggio, Guercino, Pietro da Cortona, Reni and Rubens. **Highlights:** Equestrian statue of Marcus Aurelius; the Capitoline Venus. **Architecture:** The Palazzo dei Conservatori was built in the 15th century, the Palazzo Nuovo in the 17th. The square between the two palaces was designed by Michelangelo. The museums were recently expanded to include new exhibition spaces as well as a gallery overlooking the Roman Forum.

Admission: 12,000 lire.
Hours: Tuesday through Sunday, 9:30 a.m.–7 p.m. Closed Monday.

Museo Nazionale Romano, Palazzo Altemps

8 Piazza di Sant'Apollinare, Rome 00186, Italy
(39-06) 683-3759
www.archeorm.arti.beniculturali.it/sar2000/altemps/
 pal_altemps.htm

PERMANENT COLLECTION

Antique statuary, including the 15 statues remaining from the original Altemps collection; works from the Boncompagni-Ludovisi, Mattei, Del Drago and Brancaccio collections. **Highlights:** *Ludovisi Throne* and *Ares Ludovisi*. **Architecture:** Built from the 15th to the 18th century by the architects Antonio da Sangallo, Baldassare Peruzzi, Martino Longhi the Elder and others.

Admission: 10,000 lire.
Hours: Tuesday through Sunday, 9 a.m.–7 p.m. Closed Monday, New Year's Day, May 1 and Christmas Day.

Museo Nazionale Romano, Palazzo Massimo alle Terme

1 Largo di Villa Peretti, Rome 00185, Italy
(39-064) 890-3500
www.archeorm.arti.beniculturali.it/sar2000/
museo_romano/pal_massimo.htm

PERMANENT COLLECTION

Ancient Roman art, including mosaics, frescoes, sculpture and bronzes. Some Greek originals. Underground vault with a coin collection spanning the origins of currency to the present. **Highlights:** Series of frescoes from the Roman Villa of the Farnesina and the triclinium of Livia's Villa on the Via Flaminia. **Architecture:** 19th-century structure.

Admission: 12,000 lire.
Hours: Tuesday through Sunday, 9 a.m.–7:45 p.m. Closed Monday, New Year's Day, May 1 and Christmas Day.

Museo Egizio

(Egyptian Museum)

6 Via Accademia delle Scienze, Turin 10123, Italy
(39-011) 561-7776
www.museoegizio.it

PERMANENT COLLECTION

Founded in 1824. Statues, mummies, sarcophagi, papyri rolls and tomb jewels. **Highlights:** Complete set of funerary objects from the tomb of the architect Kha and his wife, Merit (1430 B.C.); statue of Ramses II (1299-1233 B.C.); Rock Temple of Thutmose III (circa 1430 B.C.) from Ellessya. **Architecture:** 17th-century Palazzo dell'Accademia delle Scienze, designed by Guarino Guarini.

Admission: 12,000 lire.

Hours: Tuesday through Sunday, 8:30 a.m.–7:30 p.m. Closed Monday, New Year's Day, May 1 and Christmas Day.

Gallerie dell'Accademia
(Academy of Fine Arts)

1050 Dorsoduro, Campo di Carità, Venice 30100, Italy
(39-041) 522-2247
www.gallerieaccademia.org

PERMANENT COLLECTION

Venetian paintings; works by Lotto, Mantegna, Tiepolo, Tintoretto and Veronese. **Highlights:** Giorgione, *Tempest*; Titian, *Pietà*; Carpaccio, *Legend of Saint Ursula*. **Architecture:** 15th-century school and church, and 16th-century monastery designed by Andrea Palladio.

Admission: 12,000 lire; European Union citizens over 60 or under 18, free.
Hours: Tuesday through Sunday, 8:15 a.m.–7:15 p.m.; Monday, until 2 p.m.

Museo Nazionale di Palazzo Venezia

Via del Plebiscito, Venice 30118, Italy
(39-06) 679-8865

2002 EXHIBITIONS

January
Medieval Ceramics From Orvieto

March 16–June 15
Giovanni Lanfranco
Paintings.

Opening in October
Roman Miniatures
Works from the 12th century through the 17th.

Fall
The Family in Italy: Historical Moments and Images From the 20th Century

Fall
Orazio Amato (1879–1952)
Paintings.

PERMANENT COLLECTION

Decorative arts, including Romanesque and 14th-century ivory, majolica, church silver and terra cotta; sculpture; paintings. **Architecture:** Palace built in the mid-15th century for Cardinal Pietro Barbo, who became Pope Paul II; attributed to Francesco del Borgo.

Admission: 8,000 lire. Reservations recommended for exhibitions.
Hours: Tuesday through Sunday, 8:30 a.m.–7:30 p.m. Slightly later hours for exhibitions. Closed Monday, New Year's Day, May 1 and Christmas Day.

Palazzo Grassi

3231 San Samuele, Venice 30134, Italy
(39-041) 523-1680
www.palazzograssi.it

2002 EXHIBITIONS

Through January 6
Balthus
A retrospective featuring more than 250 works.

Architecture: Built 1740–1760 by Giorgio Massari for the Grassi family.

Admission: 15,000 lire.
Hours: Daily, 10 a.m.–7 p.m.

Peggy Guggenheim Collection

701 Dorsoduro, Venice 30123, Italy
(39-041) 240-5411
www.guggenheim-venice.it

PERMANENT COLLECTION

European and American art, including Cubism, Futurism,
metaphysical painting, European abstraction, Surrealism and
American Abstract Expressionism. Works by Brancusi, Braque,
Calder, Duchamp, Ernst, Kandinsky, Mondrian and Picasso.
Highlights: Magritte, *Empire of Light.* **Architecture:** Mid-
18th-century mansion on the Grand Canal.

Admission: Adults, 12,000 lire; students, 8,000 lire; under
10 and members, free.
Hours: Wednesday through Monday, 10 a.m.–6 p.m. Slightly
longer hours during the summer. Closed Tuesday and Christmas
Day.

Monumenti Musei e Gallerie Pontificie
(Vatican Museums)

Vatican City, 00120
(39-066) 988-4466
www.vatican.va/museums

PERMANENT COLLECTION

Egyptian, Etruscan, Greek, Roman and Renaissance art;
contemporary religious art. Picture Gallery: Paintings by
Leonardo, Raphael, Caravaggio, Poussin, Van Dyck. Pio-
Clementino Museum: Greek and Roman sculptures. Pio-
Christian Museum: Christian sarcophagi from the second
century to the fifth. **Highlights:** Sistine Chapel; Raphael's
Rooms; the *Laocoon*; *Apollo Belvedere*; map gallery.
Architecture: The museums occupy the palaces built by the

popes from the 13th century onward. The long courtyards and galleries that connect the Belvedere Pavilion to other buildings were designed by Bramante in 1503. Most of the successive additions were made in the 18th century.

Admission: 18,000 lire; students, 12,000 lire.
Hours: Monday through Friday, 8:45 a.m.–4:45 p.m.; Saturday, 8:45 a.m.–1:45 p.m. Slightly shorter hours during the winter. Closed Sunday and Vatican holidays. Open the last Sunday of each month, unless it is a holiday.

Japan

Kyoto National Museum

527 Chayamachi, Higashiyama-ku, Kyoto 605-0931,
 Japan
(81-75) 541-1151
www.kyohaku.go.jp

2002 EXHIBITIONS

January 4–March 24
Lions and Lion-dogs
Works mainly from the early Heian and Kamakura periods.

January 12–February 17
Masterpieces of Japanese Fine Arts From the National Gallery in Prague
Wood-block prints and other works.

February 6–March 10
Hand-copied Buddhist Sutras of the Nara Period
Approximately 25 examples.

Late February–late March
Japanese Dolls

March 12–April 7
Sesshu
A retrospective of the painter's work.

Courtesy of the Kyoto National Museum.

Sesshu, *Amanohashidate*, 16th century.

PERMANENT COLLECTION

Approximately 5,500 works, including 170 designated by the
Japanese government as national treasures or "important
cultural properties." Archaeological items, ceramics, sculpture,
paintings, calligraphy, textiles, lacquerware and metalwork.
Architecture: 1895 Main Exhibition Hall, red-brick Main
Gate and adjoining ticket gate and fences are remains of the
former Imperial Museum of Kyoto; 1965 New Exhibition Hall
by Keiichi Morita.

Admission: Adults, 420 yen; students, 70–130 yen.
Discounts for groups of 20 or more. Additional fees for special
exhibitions.
Hours: Tuesday through Sunday, 9:30 a.m.–5 p.m.; Friday
until 8 p.m. Closed Monday and December 26 through
January 3. December through March, Friday until 5 p.m.

The National Museum of Western Art

7-7 Ueno-koen, Taito-ku, Tokyo 110–0007, Japan
(81-33) 828-5131
www.nmwa.go.jp

2002 EXHIBITIONS

March–June
Prado Museum Exhibition

PERMANENT COLLECTION

Art from the late medieval period through the early 20th century, including sculpture by Rodin and paintings by Courbet, Delacroix, Monet and Renoir. **Architecture:** 1958 main building by Le Corbusier; wings added in 1979, 1997.

Admission: Adults, 420 yen; students, 130 yen; children, 70 yen. Free on the second and fourth Saturday of each month. Discounts for groups of 20 or more. Additional fees for special exhibitions.

Hours: Tuesday through Sunday, 9:30 a.m.–5 p.m.; Friday, until 8 p.m. Closed Monday and December 28 through January 4.

The National Museum of Modern Art, Tokyo

3 Kitanomaru Koen, Chiyoda-ku, Tokyo 102-8322, Japan
(81-33) 561-1400
www.momat.go.jp

2002 EXHIBITIONS

Through February 11
Crafts in Kyoto, 1945–2000

Through February 24
Italian Cinema

January 16–March 10
The Unfinished Century: Legacies of 20th-Century Art
Approximately 350 works, including paintings, sculpture, prints and photographs.

February 6–March 10
Hand-Copied Buddhist Sutras of the Nara Period
Some 25 examples.

February 23–April 14
Modern Japanese Crafts

March 5–24
Films and the 20th Century

March 26–May 26
Wassily Kandinsky
Composition VII and other works.

June 18–August 4
Photographs at Present

August 20–October 6
Yuki Ogura
Works by this painter.

PERMANENT COLLECTION

More than 8,600 20th-century works, including paintings, prints, watercolors, drawings, sculpture and photographs.
Architecture: 1910 red-brick Crafts Gallery, originally built as the headquarters of the imperial guards. Rescued from ruin after World War II. An example of Meiji-era, Western-style architecture.

Admission: Adults, 420 yen; students, 130 yen; children, 70 yen. Free on the second and fourth Saturday of each month, free; November 3, free.
Hours: Tuesday through Sunday, 10 a.m.–5 p.m. Closed Monday and December 28 through January 4. The main building is to reopen January 16 following its renovation.

Tokyo National Museum

13-9 Ueno Park, Taito-ku, Tokyo 110-8712, Japan
(81-33) 822-1111
www.tnm.go.jp

2002 EXHIBITIONS

Through January 27
Recovering the Past Through Historical Materials, Art and Technology

February 19–March 24
Matsunaga Collection

February 19–March 24
Taikan Yokoyama

April 23–May 19
Sesshu: Master of Ink and Brush

April 23–May 19
Sesshu — Master of Ink and Brush: 500th Anniversary Exhibition
Sesshu, regarded as one of the greatest figures in Japanese painting, was active in the 15th and 16th centuries.

June 11–July 28
Masterpieces of Korean Art
Paintings, sculpture and applied art, exhibited under an exchange program with the National Museum of Korea.

July 30–August 25
Nashikawa Yasushi
Works by a leading calligrapher who studied in China, commemorating the 100th anniversary of his birth.

PERMANENT COLLECTION

More than 89,000 Asian works and archeological objects.
Highlights: Some 90 items registered by the Japanese government as national treasures and 575 items registered as "important cultural properties."

Admission: Adults, 420 yen; students, 130 yen; children, 70 yen; seniors, free; January 10 and September 15, free. Discounts for groups of 20 or more.
Hours: Tuesday through Sunday, 9:30 a.m.–5 p.m.; during the summer, until 8 p.m. Closed Monday and during the New Year's holidays.

Mexico

Museo de Arte Carrillo Gil

Avenida Revolución 1608, Colonia San Angel, Mexico
 City 01000, Mexico
(525) 550-1254; (525) 550-3983
www.macg.inba.gob.mx

PERMANENT COLLECTION

Created from the collection of Dr. Alvar Carrillo Gil, including
works by Orozco, Siqueiros, Rivera and Paalen; Japanese
stamps from the 17th to the 20th centuries.

Admission: Adults, 15 pesos; teachers and students, 9 pesos;
seniors, free. Free on Sunday.
Hours: Tuesday through Sunday, 10 a.m.–6 p.m. Closed
Monday.

Museo de Arte Contemporáneo Internacional Rufino Tamayo

Paseo de la Reforma y Gandhi, Bosque de Chapultepec,
 Mexico City 11580, Mexico
(525) 286-6519; (525) 286-6599
www.museotamayo.org

2002 EXHIBITIONS

Through March 17
Hiroshi Sugimoto

PERMANENT COLLECTION

More than 300 works of international contemporary art; works
by Mexican artists, including Francisco Toledo, Lilia Carrillo,

449

José Luis Cuevas and Rufino Tamayo. **Highlights:** Works by Picasso, Rothko, de Kooning, Miró, Dubuffet, Noguchi, Chadwick, Soulages and Francis Bacon.

Admission: Adults, 20 pesos; students, children and seniors, free. Free on Sunday.
Hours: Tuesday through Sunday, 10 a.m.–6 p.m. Closed Monday.

Museo de Arte Moderno

Paseo de la Reforma y Gandhi, Bosque de Chapultepec,
 Mexico City 11560, Mexico
(525) 553-6233
www.arts-history.mx/museos/mam/home.html

PERMANENT COLLECTION

Works by 20th-century Mexican artists, including Siqueiros, Orozco and Rivera. **Highlights:** Frida Kahlo, *The Two Fridas*.

Admission: Adults, 15 pesos; students, teachers, under 10 and seniors, free. Free on Sunday.
Hours: Tuesday through Sunday, 10 a.m.–6 p.m. Closed Monday.

Museo Dolores Olmedo

Avenida México 5843, Colonia la Noria, Xochimilco,
 Mexico City 16030, Mexico
(525) 676-1055
www.arts-history.mx/museos/mdo

PERMANENT COLLECTION

Olmedo collection of modern art; colonial objects and furniture; collection of Mexican folk art, with ceramics, glass, papier-mâché, masks and lacquers. **Highlights:** Some 135 works by Diego Rivera; 25 paintings by Frida Kahlo; 43 prints

by Angelina Beloff; more than 600 pre-Columbian pieces. **Architecture:** 17th-century Hacienda la Noria.

Admission: 25 pesos; students and teachers, 15 pesos; seniors and under 6 with an adult, free. Free on Tuesday.
Hours: Tuesday through Sunday, 10 a.m.–6 p.m. Closed Monday.

Museo Franz Mayer

Avenida Hidalgo 45, Colonia Guerrero, Mexico City
 063000, Mexico
(525) 518-2265; (525) 518-2266; (525) 518-2271
www.arts-history.mx/museos/franz/home.html

PERMANENT COLLECTION

Some 10,000 examples of Mexican furniture and household accessories, mostly from the 16th through the 19th centuries; Talavera pottery; gold and silver religious pieces; sculpture; tapestries; rare watches and clocks; Old Master paintings from Europe and Mexico; a library with books dating from 1484, including approximately 800 editions of *Don Quixote* in 15 languages. **Architecture:** A restored 16th-century building in the city's historic center.

Admission: Adults, 20 pesos; students and teachers, 10 pesos; under 12 and seniors, free. Free on Tuesday.
Hours: Tuesday through Sunday, 10 a.m.–5 p.m. Closed Monday.

Museo de Arte Contemporáneo de Monterrey

Gran Plaza at Zuazua and Jardon, Monterrey 64000,
 Mexico
(528) 342-4820; (528) 342-4830

PERMANENT COLLECTION

Art from Mexico and Latin America. **Architecture:** Designed by Ricardo Legorreta in the style of a Moorish palace.

Admission: Adults, 30 pesos; students and seniors, 18 pesos; under 5, free. Free on Wednesday.
Hours: Tuesday through Sunday, 10 a.m.–6 p.m.; Wednesday, until 8 p.m. Closed Monday.

Museo de Arte Contemporáneo de Oaxaca

Macedonio Alcala, Centro, Oaxaca 68000, Mexico
(529) 514-2228; (529) 514-1055

PERMANENT COLLECTION

Highlights: Works by artists from Oaxaca, including Rufino Tamayo, Francisco Gutiérrez, Rodolfo Morales and Francisco Toledo. **Architecture:** The Casa de Cortés, a building dating from the end of the 17th century.

Admission: Adults, 10 pesos; students, 5 pesos; seniors free. Free on Sunday.
Hours: Wednesday through Monday, 10:30 a.m.–8 p.m. Closed Tuesday.

The Netherlands

Rijksmuseum

42 Stadhouderskade, Amsterdam 1071 ZD, the
 Netherlands
(31-20) 674-7047
www.rijksmuseum.nl

2002 EXHIBITIONS

Through January 6
Acquisitions: Prints, Drawings and Photos

Through January 13
Document the Netherlands: Villa Vinex
Photographs by Bart Sorgedrager.

Through February 3
Rococo: A Riot of Ornament
A look at decorative arts in 18th-century Holland.

January 12–April 7
Photographs From Far Away Countries

March 8–May 12
Michiel Sweerts: Painter of Silence and Secrets

March 19–September 29
The Dutch Encounter With Asia, 1602–2002

April 13–July 14
The Gordon Atlas: South Africa on the Map

May 25–November 24
Costume Accessories

June 8–September 1
Aelbert Cuyp: Paintings and Drawings

October 5–January 5, 2003
The Hare and the Moon: Arita Porcelain From Japan

October 26–January 5, 2003
Document the Netherlands: Celebration!

November 2–February 2, 2003
The French Still Life in the 17th and 18th Century

PERMANENT COLLECTION

Major collection of 15th- to 19th-century Dutch paintings, including works by Rembrandt, Vermeer, Hals and Jan Steen; sculpture and applied arts; large collections of silver, delftware, prints and drawings; presentation on Dutch history. **Highlights:** 20 works by Rembrandt, including *The Night Watch*, *The Jewish Bride* and *The Draper's Guild*; Hals, *The Merry Drinker*; Vermeer, *Young Woman Reading a Letter* and *The Kitchen Maid*. **Architecture:** 1885 Renaissance Revival building by P.J.H. Cuypers.

Admission: Adults, 17.50 guilder; 18 and under, free; additional fees for some exhibitions.
Hours: Daily, 10 a.m.–5 p.m. Closed New Year's Day.

Stedelijk Museum

13 Paulus Potterstraat, Amsterdam 1071, the
 Netherlands
(31-20) 573-2911
www.stedelijk.nl

PERMANENT COLLECTION

Modern and contemporary paintings, sculptures, drawings, prints, photographs, graphic design and applied arts, with an emphasis on postwar artists, including Appel, de Kooning, Newman, Judd, Stella, Lichtenstein, Warhol and Nauman; extensive collection of Malevich paintings; works by Beckmann, Chagall, Cézanne, Kirchner, Matisse, Mondrian, Monet and Picasso. **Architecture:** 1895 neo-Renaissance building by A. W. Weissman; 1954 modern glass wing by J. Sargentini and F. A. Eschauzier.

Admission: Adults, 9 guilder; children, 4.50 guilder.
Hours: Daily, 11 a.m.–5 p.m. Closed New Year's Day.

Van Gogh Museum

Paulus Potterstraat 7, Amsterdam, the Netherlands
(31-20) 570-5252
www.vangoghmuseum.nl

2002 EXHIBITIONS

Through January 6
The Photograph and the American Dream: The Stephen White Collection, 1840–1940

Through January 6
Vincent Van Gogh Drawings: Antwerp and Paris, 1885–1888

February 9–June 2
Van Gogh and Gauguin: "The Studio of the South"

PERMANENT COLLECTION

World's largest collection of works by van Gogh, with more than 200 paintings, 500 drawings and 700 letters. Also works by artists van Gogh admired, including Seurat and Gauguin. **Architecture:** Original building designed by the Dutch architect Gerrit Rietveld (1888–1964) and partners, renovated by Martien van Goor, Greiner van Goor Architects (Amsterdam); new wing designed by the architect Kisho Kurokawa of Tokyo.

Admission: Adults, 15.50 guilder; under 17, 5 guilder; under 13, free.
Hours: Daily, 10 a.m.–6 p.m.

Mauritshuis

8 Korte Vijverberg, the Hague 2513, the Netherlands
(31-70) 302-3456
www.mauritshuis.nl

PERMANENT COLLECTION

Since 1822, the museum has housed the Royal Cabinet paintings. Masterpieces from the Dutch Golden Age, including paintings by Vermeer, Rembrandt, Jan Steen and Frans Hals, as well as a panorama of Dutch and Flemish art from the 15th to 17th century. **Highlights:** Vermeer, *View of Delft;* Rogier van der Weyden, *The Lamentation of Christ;* Frans Hals, *A Laughing Boy.* **Architecture:** Dutch classical-style mansion designed by Jacob van Campen and built around 1640.

Admission: Adults, 15 guilder; 18 and under, free.
Hours: Tuesday through Saturday, 10 a.m.–5 p.m.; Sundays and holidays, 11 a.m.–5 p.m. Closed Monday.

Kröller-Müller Museum

6 Houtkampweg, Otterlo 6730, the Netherlands
(31-31) 859-1241
www.kmm.nl

2002 EXHIBITIONS

Through January 13
Miroslaw Balka

Through February 10
Dan Graham

February 2–July 7
Odilon Redon

June 29–September 22
R.W. van de Wint

December 21–January 11, 2004
Van Gogh

PERMANENT COLLECTION

Opened in 1938 to house the collection of Helene Kröller-Müller, which she bequeathed to the state in 1935. Features art from the 19th and 20th centuries, including works by van Gogh, Seurat, Picasso, Léger and Mondrian, and one of Europe's largest sculpture parks, including works by Rodin, Moore, Serra and Oldenburg. **Architecture:** Designed by Henry van de Velde and Wim Quist and located in Huge Veluwe National Park.

Admission: Adults, 20 guilder; ages 6–12, 10 guilder; under 6, free. Discount for groups of 20 or more.
Hours: Tuesday through Sunday and bank holidays, 10 a.m.–5 p.m. Closed Monday, New Year's Day.

Kunsthal Rotterdam

Westzeedijk 341, 3015 Rotterdam, The Netherlands
(31-010) 44-00-300
www.kunsthal.nl

2002 EXHIBITIONS

January 12–April 14
Kees Maks (1876–1967)
Works by an influential and mostly forgotten 20th-century figurative artist who made his mark with his paintings of fashionable nightlife.

January 12–April 7
Irving Penn: Still Lifes
More than 80 large photos from 1939 to the present made for advertising campaigns.

February 16–April 28
Jewels of the Orient: The Van der Star Collection
About 450 pieces of jewelry, mostly from the 20th century, collected by René van der Star during his travels to Asia.

April 20–August 18
A Lasting Attraction: Dutch Artists in Italy, 1800–1940
Works by Dutch artists who traveled to Italy and often depicted romanticized images of Italian peasant life.

April 27–June 30
Highlights From 250 Programs of "Tussen Kunst & Kitsch"
Objects from the Dutch version of "Antiques Road Show" popular in Britain and the United States, to mark its 250th broadcast.

Courtesy of the Kunsthal Rotterdam.

Kunsthal Rotterdam

August 31–November 24
Master Drawings From Private Collections
About 120 drawings by Italian, Belgian, French and Dutch
artists from the 15th to 18th century, including Rubens,
Michelangelo, Fragonard and Poussin.

October 2–January 5, 2003
Wonderland: From Pietje Bell to Harry Potter
A hands-on exhibit for families to launch the 2002 Children's
Book Week in Rotterdam.

Architecture: Designed by a Rotterdam native, Rem Koolhaas.

Admission: Adults, 15 guilder/6.81 Euro; under 15, 7.50
guilder/3.40 Euro; under 6, free.
Hours: Tuesday through Saturday, 10 a.m.–5 p.m.; Sunday
and holidays, 11 a.m.–5 p.m. Closed Monday, New Year's Day,
April 30 and Christmas Day.

Museum Boijmans Van Beuningen

18-20 Museumpark, Rotterdam, the Netherlands
(31-10) 441-9400
www.boijmans.rotterdam.nl

PERMANENT COLLECTION

Art ranging from the Middle Ages to the present day: 15th- to
17th-century Dutch art, including works by van Eyck, Rubens
and Rembrandt; Surrealist art by Magritte, Dalí and others;
contemporary German and American art; contemporary sculp-
ture, including works by Bruce Nauman and Frank Stella.
Architecture: 1935 Expressionist building with sculpture
garden.

Admission: Adults, 10 guilder.
Hours: Tuesday through Saturday, 10 a.m.–5 p.m.; Sunday
and holidays, 11 a.m.–5 p.m. Closed Monday, New Year's Day,
April 30 and Christmas Day.

Norway

The Astrup Fearnley Museum of Modern Art

4 Dronningensgate, 0107 Oslo, Norway
(472) 293-6060
www.af-moma.no

2002 EXHIBITIONS

January 19–April 21
Passenger: The Viewer as a Participant
Including works by Mona Hatoum, Jasper Johns, Donald Judd, Bruce Nauman, Yoko Ono and Andy Warhol.

April–June
Anselm Kiefer

Summer
Museum 3
Works from the museum's collection.

PERMANENT COLLECTION

Works by Francis Bacon, R.B. Kitaj and others from the London School; Norwegian art, including works by Bjorn Carlsen and Knut Rose. **Highlights:** Anselm Kiefer, *The High Priestess/Zweistromland*; Damien Hirst, *Mother and Child Divided*; sculpture court.

Admission: Adults, 50 kroner; children, students, artists and senior citizens, 25 kroner; Tuesday, free.
Hours: Tuesday through Friday, 11 a.m.–5 p.m.; Thursday, until 7 p.m.; Saturday and Sunday, noon–5 p.m. Closed Monday.

The Munch Museum

Tøyengaten 53, 0608 Oslo, Norway
(472) 324-1400
www.munch.museum.no

PERMANENT COLLECTION

Some 1,000 paintings, 18,000 prints and 4,500 drawings by
Edvard Munch.

Admission: Adults, 60 kroner; children, seniors and students,
30 kroner. Discount for groups of 10 or more. Free admission
with Oslo Card.
Hours: Tuesday through Sunday, 10 a.m.–4 p.m.; Thursday
and Sunday, until 6 p.m. Closed Monday. June 1 through
September 15, daily, 10 a.m.–6 p.m.

National Gallery

13 Universitetsgaten, Oslo 0164, Norway
(472) 220-0404
www.museumsnett.no/nasjonalgalleriet

PERMANENT COLLECTION

Some 4,500 paintings, 900 original sculptures and 950 plaster
casts. Nineteenth- and 20th-century Norwegian art, featuring
romantic landscape painting, Realism, neo-Romanticism,
Impressionism, Post-Impressionism and Expressionism; works
from other Scandinavian countries; some Old Masters and Roman
sculptures and a collection of French art since Delacroix;
Norwegian and international drawings and graphic art; Russian
icons. **Highlights:** Some 58 paintings by Edvard Munch,
including *Frieze of Life*, *Moonlight*, *The Scream* and *The Dance of Life*.

Admission: Free.
Hours: Monday and Wednesday through Friday, 10 a.m.–6
p.m.; Thursday, until 8 p.m.; Saturday and Sunday, 11 a.m.–4
p.m. Closed Tuesday.

Philippines

The Metropolitan Museum of Manila

Bangko Sentral ng Pilipinas Complex, Roxas Boulevard, Manila 1004, Philippines
(632) 521-1517; (623) 523-7856

PERMANENT COLLECTION

Gold belts, rings, earrings and necklaces dating from the 10th to the 14th centuries; Philippine pottery from 200 B.C. to 900 A.D.

Admission: Adults, 50 pesos; children and students, 30 pesos.
Hours: Monday through Saturday, 10 a.m.–6 p.m. Closed Sunday and holidays.

Portugal

Evora Museum

Largo Conde de Vila Flor, Evora 7000, Portugal
(351-26) 670-2604

PERMANENT COLLECTION

Stone sculpture from the Middle Ages and the Renaissance; portraits from the Portuguese School; religious and domestic silver from the 14th century to the 19th. **Highlights:** 16th-century cenotaphs of Dom Alvaro da Costa and Bishop Afonso of Portugal; the Flemish polyptych *The Life of Virgin Mary*.
Architecture: 17th-century former archbishop's residence.

Admission: Adults, 300 escudos; students, 150 escudos.
Hours: Tuesday, 2–5 p.m.; Wednesday through Sunday, 9:30 a.m.–12:30 p.m. and 2–5:30 p.m. Closed Monday.

Calouste Gulbenkian Museum

45a Avenida de Berna, Lisbon 1067-001, Portugal
(351-21) 782-3000
www.gulbenkian.pt

2002 EXHIBITIONS

Through January 10
Exotica: The Discoveries and Renaissance Kunstkammer Collections
More than 100 items, including a lacquered Chinese wooden
chair that belonged to Philip II of Spain.

PERMANENT COLLECTION

Painting, sculpture and decorative arts; Oriental and Islamic
art; Greek coins; Egyptian art. **Highlights:** René Lalique
collection.

Admission: Adults, 600 escudos; museum directors and
curators, school groups, teachers, students and seniors, free.
Hours: Wednesday through Sunday, 10 a.m.–6 p.m.; Tuesday,
2–6 p.m. Closed Monday and public holidays.

National Museum of Ancient Art

Rua das Janelas Verdes, Lisbon 1249-017, Portugal
(351-21) 391-2800
www.ipmuseus.pt

PERMANENT COLLECTION

Portuguese and European paintings, sculpture and decorative
arts from the 12th through the 19th centuries; African and
Asian decorative arts that reflect relations with Portugal.

Admission: Adults, 600 escudos; seniors and children, 300
escudos; under 14, free; free on Sunday until 2 p.m.

Hours: Tuesday, 2–6 p.m.; Wednesday through Sunday, 10 a.m.–6 p.m. Closed Monday, New Year's Day, Easter Sunday, May 1 and Christmas Day.

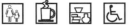

Russia

Pushkin Museum of Fine Arts

12 Volkhonka Street, Moscow 121019, Russia
(7-095) 203-7412
www.museum.ru/gmii

2002 EXHIBITIONS

Through January 15
Marcel Proust and Claude Monet
Monet paintings alongside Proust books, manuscripts and memorial objects, as well as portraits and photographs.

Through February
African Gold
Works from The Museum of Fine Arts in Houston.

February 2–April 7
Drawings of the Seventeenth and Eighteenth Centuries
Works by Dutch artists.

February 18–April 7
Biology in Art

August 26–November 17
Unknown French Painting
Works from the 17th to the early 19th century.

Opening in mid-November
Italian Painting
Works from the 15th century to the 20th.

PERMANENT COLLECTION

Ancient Greek and Roman sculpture, including the marble sarcophagus *Drunken Hercules* and a torso of Aphrodite; French

Barbizon and modern painting. **Highlights:** Botticelli, *The Annunciation*; San di Pietro, *Beheading of John the Baptist*; six Rembrandts, including *Portrait of an Old Woman*; five Poussins; Picassos from the Blue period; Cézanne, *Pierrot and Harlequin*; van Gogh, *Landscape at Auvers After the Rain* and *Red Vineyards*; Monet, *Rouen Cathedral at Sunset*; Renoir, *Bathing on the Seine* and *Nude on a Couch*; 10 Gauguins. **Architecture:** Neo-Classical Roman Klein building (1898–1912) with a large colonnade and glass roof.

Admission: Adults, 160 rubles; children and students, 60 rubles. **Hours:** Tuesday through Sunday, 10 a.m.–6 p.m. Closed Monday.

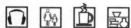

Tretyakov Gallery

12 Lavrushinsky Pereulok, Moscow, Russia
(7-095) 951-1362; (7-095) 953-5223 (tours)
10 Krymsky Val, Moscow, Russia
(7-095) 238-1378; (7-095) 238-2054 (tours)
www.tretyakov.ru

2002 EXHIBITIONS

Through February
Andrei Drevin
Figurative paintings and avant-garde compositions.

May–June
Vladimir Baranov-Rossine
Avant-garde works.

June–September
Sound and Image
Works of Russian art from the 12th century to the 20th, united by the theme of music and harmony. Concerts are planned in coordination with the exhibition.

September–October
Dionisy
Copies of monumental frescoes, icons and book miniatures, as well as needlework created by the Russian iconographer and his apprentices.

October
Mikhail Roginsky
A retrospective of the
contemporary painter's
work.

Continuing
Golden Map of Russia
Works from the
collections of regional
Russian museums.

PERMANENT
COLLECTION

More than 100,000 works
of Russian art. Ancient
works; icons; classical
18th- and 19th-century
works. Works by Chagall,
Kandinsky, Malevich and
other 20th-century artists
in the Krymsky Val
building. Original

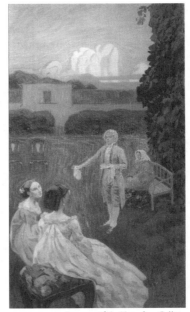

Courtesy of the Tretyakov Gallery.
V. Polenov, *Moscow Courtyard*.

collection donated by Tretyakov brothers in 1895.
Architecture: 1900 Lavrushinsky Pereulok building in early
Art Nouveau style; facade by Viktor Vasnetsov.

Admission: Adults, 210 rubles; children and students, 120
rubles.
Hours: Tuesday through Sunday, 10 a.m.–7:30 p.m.; last
admission at 6:30. Closed Monday.

The State Hermitage
Museum

35 Dvortsovaya Naberezhnaya, St. Petersburg 190000,
 Russia
(7-812) 110-9079; (7-812) 219-4751 (tours)
www.hermitage.ru

PERMANENT COLLECTION

More than three million works of art, including antiquities
from Egypt, Babylon, Byzantium, Greece, Rome and Asia;
prehistoric Russian artifacts; medals and decoration; Old
Masters of Western Art; French Impressionist, Post-
Impressionist and Barbizon School works. **Highlights:** The
Jordan staircase; Michelangelo's *Crouching Boy* sculpture;
works by Leonardo and Raphael; eight Titians; works by El
Greco, Velázquez, Zurbaran and Goya; 40 works by Rubens;
25 Rembrandts; Matisse, *Dance*; Cézanne, *Banks of the
Marne*; Picassos from the Blue, Pink and Cubist periods.
Architecture: Built in the 1750's as a retreat for Catherine
the Great by architect Bartolomeo Rastrelli in the Imperial
Russian style; 1850's renovations by Andrei
Stakenschneider.

Admission: Adults, 300 rubles; students and under 17, free.
Hours: Tuesday through Saturday, 10:30 a.m.–6 p.m.; Sunday,
10:30 a.m.–5 p.m. Closed Monday.

The State Russian Museum

4 Inzhenernaya Street, St. Petersburg 191011, Russia
(7-812) 219-1608; (7-812) 314-8368
www.rusmuseum.ru

2002 EXHIBITIONS

Through February
Abstractionism in Russia
More than 200 20th-century paintings and sculptures from the
museum's collection, including a number of works by Vassily
Kandinsky.

Through February
Russian Drawings of the 18th Century

Through February
Russian Portraits of the 20th Century

February–March
Vladimir Izdebsky
Works from the *Return* cycle.

Spring
Master and Apprentice: Marc Chagall and Yehuda Pen

Summer
Vladimir Baranov-Rossine
Avant-garde works.

Fall
Boris Yermolayev
Works from the *Forgotten Names* series.

Opening in November
Russian Lithography: From Orlovsky to the Present

Opening in December
The Sacred Sixties
Works from the 1860's.

PERMANENT COLLECTION

Some 400,000 examples of Russian art from the 10th century to the 20th, including works by Aivazovsky, Chagall, Ivanov, Levitan, Repin, Serov, Surikov and Vrubel; Russian avant-garde works; sculpture; graphics; decorative and applied arts.
Highlights: Works by Dionisy, Kandinsky, Malevich and Rublev. **Architecture:** Empire-style Mikhailovsky Palace (1819–25) designed by Carlo Rossi; Benois Wing (1914–20) by L.N. Benois; neo-Classsical Marble Palace (1768–1785) by Antonio Rinaldi and St. Michael's Castle (1791–1801) by Vasily Bazhenov and Vincenzo Brenna; Baroque-style Stroganoff Palace (1750's) by Francesco Bartolomeo Rastrelli.

Admission: Adults, 240 rubles; students and children, 120 rubles.
Hours: Wednesday through Sunday, 10 a.m.–6 p.m.; Monday, until 5 p.m. Closed Tuesday.

Scotland

Dundee Contemporary Arts

152 Nethergate, Dundee DD1 4DY, Scotland
(44-13) 82-432-000
www.dca.org.uk

PERMANENT COLLECTION

Opened in March 1999, this center for contemporary art and
film has two galleries, two screening rooms and a print studio.

Admission: Free to galleries.
Hours: Galleries, Tuesday through Sunday, 10:30 a.m.–5:30
p.m.; Thursday and Friday, until 8 p.m. Closed Monday
(except for Dundee public holidays).

National Galleries of Scotland

(44-131) 624-6200
www.natgalscot.ac.uk

National Gallery of Scotland

The Mound, Edinburgh EH4 3DS, Scotland

PERMANENT COLLECTION

Masterpieces from the Renaissance to Post-Impressionism,
including works by Constable, van Gogh, El Greco, Monet,
Rembrandt, Turner, Velázquez and Vermeer; Scottish paintings
by Raeburn, Ramsay, Wilkie and others; Italian and
Netherlandish drawings. **Architecture:** 1895 neo-Classical
building by William Playfair.

Sandro Botticelli, *The Virgin Adoring the Sleeping Christ Child*, ca. 1490-1500

Courtesy of the National Gallery of Scotland.

Scottish National Portrait Gallery

1 Queen Street, Edinburgh EH2 1JD, Scotland

2002 EXHIBITIONS

Through January 13
The Fine Art of Photography
Approximately 200 works from the Scottish National
Photography Collection, including pioneering examples by
Hill and Adamson, 19th-century James Craig Annan prints
and 20th-century images by Eve Arnold, Bill Brandt, Annie
Leibovitz and Alfred Stieglitz.

Through February 3
A Tribute to Edwin Morgan
A multimedia portrait of the Scottish literary figure by Steven
Campbell and Ron O'Donnell, teaming up for the first time.

PERMANENT COLLECTION

Subjects include Mary, Queen of Scots; Robert Burns; Sir
Walter Scott; Jimmy Shand; and Sean Connery. Photography,

sculpture, miniatures, coins and medallions. **Architecture:** 1880's red sandstone neo-Gothic building designed by Robert Rowand Anderson.

Scottish National Gallery of Modern Art

Belford Road, Edinburgh EH4 3DR, Scotland

PERMANENT COLLECTION

Twentieth-century paintings, sculpture and graphic art, including works by Bacon, Bonnard, Baselitz, Kirchner, Léger, Lichtenstein, Matisse, Moore and Picasso. Works by Scottish artists, including the Colorists. **Architecture:** 1820's neo-Classical former school building designed by William Burn.

Dean Gallery

Belford Road, Edinburgh EH4 3DR, Scotland

2002 EXHIBITIONS

Through January 13
Beuys to Hirst: Art Works at Deutsche Bank
Contemporary works by British and German artists, including Joseph Beuys, Tony Cragg, Richard Hamilton, Damien Hirst, David Hockney, Jörg Immendorf, Anselm Kiefer, Martin Kippenberger and Gerhard Richter.

PERMANENT COLLECTION

Dada and Surrealist works; prints, drawings, plaster maquettes and moulds by Eduardo Paolozzi, as well as the contents of his studio. **Architecture:** 1830's hospital building converted to a gallery in the 1990's by Terry Farrell and Partners.

FOR ALL FOUR MUSEUMS:

Admission: Free. Fees for some exhibitions.
Hours: Monday through Saturday, 10 a.m.–5 p.m.; Sunday, noon–5 p.m.

Hunterian Art Gallery

University of Glasgow, 22 Hillhead Street, Glasgow G12
 8QQ, Scotland
(44-41) 330-5431
www.hunterian.gla.ac.uk

PERMANENT COLLECTION

Paintings by Rembrandt, Koninck, Stubbs and Chardin;
18th-century portraits by Ramsay and Reynolds; 19th- and
20th-century Scottish paintings, including works by McTag-
gart, Guthrie and Fergusson; 19th-century French art,
including works by Pissarro and Rodin; some 70 paintings
and personal items of James McNeill Whistler; the world's
largest collection of the Scottish architect and designer
Charles Rennie Mackintosh, including some 80 pieces of fur-
niture and more than 700 drawings, watercolors and designs;
print collection.

Admission: Free.
Hours: Monday through Saturday, 9:30 a.m.–5:30 p.m.
Closed Sunday and some public holidays.

South Africa

South African National Gallery

Government Avenue, Cape Town 8000, South Africa
(27-21) 465-1628
www.museums.org.za/sang

PERMANENT COLLECTION

Southern African and international art.

Admission: Adults, 5 rand; seniors, students and children,
free. Free on Sunday.

Hours: Tuesday through Sunday, 10 a.m.–5 p.m. Closed Monday and May 1.

Johannesburg Art Gallery

Klein Street, Joubert Park, Johannesburg 2044, South
 Africa
(27-11) 725-3130
www.johannesburgart.org

PERMANENT COLLECTION

Nineteenth- to early-20th-century French and British art; 17th-century Dutch art; 19th- and 20th-century traditional art from the subcontinent; Modern art, including South African; print collection from Dürer and Rembrandt to the present day; small collection of lace, ceramics, furniture, textiles; sculpture, including large-scale works on the gallery grounds and in the park. **Architecture:** 1913–1915 Classical building designed by Sir Edwin Lutyens; construction and 1940 wings supervised by Robert Howden; 1980's expansion by Meyer Pienaar and Partners.

Admission: Free.
Hours: Tuesday through Sunday, 10 a.m.–5 p.m. Closed Monday, Good Friday and Christmas Day.

Spain

Fundació Antoni Tàpies

255 Aragó, Barcelona 08007, Spain
(34-93) 487-0315

PERMANENT COLLECTION

Examples from every period of Tàpies's career.

Admission: 700 pesetas; seniors and students, 350 pesetas; under 16, free.
Hours: Tuesday through Sunday, 10 a.m.–8 p.m. Closed Monday.

Fundació Joan Miró

Parc de Montjuïc, Barcelona 08038, Spain
(34-93) 443-9470

PERMANENT COLLECTION

Nearly 300 paintings, 150 sculptures and 7,000 drawings and prints by Miró, from every period of his career. **Architecture:** Building by Josep Lluís Sert in the Parc de Montjuïc.

Admission: 1,200 pesetas; students and seniors, 650 pesetas; under 14, free. Discounts for groups.
Hours: Tuesday through Saturday, 10 a.m.–7 p.m.; Thursday, until 9:30 p.m.; Sunday and public holidays, 10 a.m.–2:30 p.m. Slightly longer hours during the summer. Closed Monday.

Museu d'Art Contemporaneo de Barcelona

1 Plaça dels Àngels, Barcelona 08001, Spain
(34-93) 412-0810
www.macba.es

PERMANENT COLLECTION

More than 1,600 works by Spanish and international artists, including Dubuffet, Kiefer, Klee, Long, Manzoni, Merz, Rauschenberg and Tàpies. **Architecture:** 1995 Richard Meier building.

Admission: 800 pesetas; students, 550 pesetas; under 16, free; Wednesday, 400 pesetas.
Hours: Monday and Wednesday through Friday, 11 a.m.–7:30 p.m; Saturday, 10 a.m.–8 p.m.; Sunday, 10 a.m.–3 p.m. Slightly longer hours during the summer. Closed Tuesday.

Museo Picasso

15-23 Carrer de Montcada, Barcelona 08003, Spain
(34-93) 319-6310

2002 EXHIBITIONS

Through January 25
Erotic Picasso
More than 300 paintings, drawings, etchings, sculptures and ceramic pieces reflecting Pablo Picasso's interest in the erotic.

February 28–May 26
Paris-Barcelona
An illustration of the artistic links between the two cities, from the late 19th century to the mid-20th, featuring works by Salvador Dalí, Joan Miró, Picasso and others.

PERMANENT COLLECTION

More than 3,500 works from Picasso's formative years, including paintings, drawings, engravings, ceramics and graphics. **Architecture:** Three 13th-century palaces.

Admission: 800 pesetas; seniors, students and the unemployed, 400 pesetas; under 12, free. Additional fees for special exhibitions.
Hours: Tuesday through Saturday, and holidays, 10 a.m.–8 p.m.; Sunday, 10 a.m.–3 p.m. Closed Monday, New Year's Day, Good Friday, May 1, June 24, Christmas Day and December 26.

Guggenheim Bilbao

2 Abandoibarra, Bilbao 48001, Spain
(34-94) 435-9080
www.guggenheim-bilbao.es

2002 EXHIBITIONS

Opening in September
Paris: Capital of the Arts, 1900–1968
Explores the major art movements that emerged from the
social, political and economic scene, featuring works by
Picasso, Matisse, Léger, Duchamp and others. (Travels)

PERMANENT COLLECTION

Modern and contemporary art, including works by Klein, de
Kooning, Motherwell, Rauschenberg, Rosenquist, Still, Tàpies
and Warhol. **Highlights:** Mark Rothko, *Untitled (1952),* the
oldest work in the collection; works by Francesco Clemente,
Jenny Holzer, Sol LeWitt and Richard Serra, designed for
specific exhibition areas in the museum. **Architecture:** 1997
titanium-and-limestone building by Frank O. Gehry.

Admission: 1,200 pesetas; students and seniors, 600 pesetas;
under 12 accompanied by an adult, free. Discounts for groups
of more than 20. Advance tickets recommended.
Hours: Tuesday through Sunday, 10 a.m.–8 p.m. Closed
Monday, New Year's Day and Christmas Day. July and August,
daily, 9 a.m.–9 p.m.

Teatre-Museu Dalí

5 Plaça Gala i Salvador Dalí, Figueres 17600, Spain
(34-97) 267-7500
www.dali-estate.org

PERMANENT COLLECTION

A broad range of works by Salvador Dalí, from his earliest
works and his Surrealist period up to the last years of his life;
jewelry the artist designed between 1932 and 1970,
illustrating the evolution of his style.

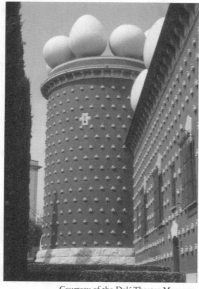

Dalí Theater Museum

Courtesy of the Dalí Theater Museum.

Admission: 1,200 pesetas; students, 800 pesetas; under 8, free.
Hours: Tuesday through Sunday, 10:30 a.m.–5:45 p.m. Closed
Monday, New Year's Day and Christmas Day. July through
September, daily, 9 a.m–7:45 p.m.

Museo del Prado

Paseo del Prado, Madrid 28014, Spain
(34-91) 330-2800; (34-91) 330-2900
museoprado.mcu.es

2002 EXHIBITIONS

Through January 27
Goya: Images of Women

PERMANENT COLLECTION

Master paintings from the Italian Renaissance; Northern
European and Spanish court painters, collected by the royal
family since the 15th century; works by Velázquez, Murillo,
Rubens, van Dyck, Raphael, Botticelli, Titian and Dürer;

sculpture, from Greco-Roman pieces to 18th-century works; drawings, etchings, coins and medals; decorative arts.
Highlights: Fra Angelico, *The Annunciation*; Titian, *Danae*; Bosch, *The Garden of Delights*; Bruegel, *The Triumph of Death*; El Greco, *The Nobleman With His Hand on His Chest*; Velázquez, *The Surrender of Breda*; Goya, *Nude Maja, Clothed Maja, Third of May.* **Architecture:** 1819 neo-Classical building by Juan de Villanueva.

Admission: Adults, 500 pesetas; students, 250 pesetas; seniors and under 18, free; Sunday, free; Saturday, 2:30 p.m.–7 p.m., free.
Hours: Tuesday through Saturday, 9 a.m.–7 p.m.; Sunday and holidays, 9 a.m.–2 p.m. Closed Monday, New Year's Day, Good Friday, May 1 and Christmas Day.

Museo Reina Sofía

Santa Isabel 52, Madrid 28012, Spain
(34-91) 467-5062; (34-91) 467-5161
museoreinasofia.mcu.es

2002 Exhibitions

Through January 7
Julio Antonio

Through January 14
Gerardo Rueda

Through January 21
Pipilotti Rist

Through January 21
Cartel Moderno Francés

Permanent Collection

More than 10,000 works of European modern and contemporary art; works by the Spanish artists Gris, Dalí, Picasso, Miró and González, as well as artists influenced by the Modernist movement; sculpture, including works by Gargallo, Alfaro and Serrano; more than 4,500 drawings and engravings.

477

Highlights: Picasso, *La Naguese*, *Guernica*; Kapoor, *1,000 Names*. **Architecture:** Former hospital building designed by Sabatini in 1788; 1980 restoration by Antonio Fernández Alba; 1988 renovation and expansion by José Luis Iñíguez de Onzoño and Antonio Vázquez de Castro.

Admission: Adults, 500 pesetas; students, 250 pesetas; seniors and under 18, free; Saturday and Sunday, free.
Hours: Monday and Wednesday through Saturday, 10 a.m.–9 p.m.; Sunday, 10 a.m.–2:30 p.m. Closed Tuesday.

Museo Thyssen-Bornemisza

8 Paseo del Prado, Madrid 28014, Spain
(34-91) 420-3944
www.museothyssen.org

2002 EXHIBITIONS

February 5–May 19
Georges Braque
A representative selection of works by the French painter.

June 6–September 15
Alfred Sisley: A Poet of Impressionism
Retrospective.

PERMANENT COLLECTION

Some 800 paintings, including works by Italian Primitives; Renaissance and Baroque art; 17th-century Dutch landscapes; 19th-century American School; Impressionism; German Expressionism; avant-garde; Surrealism; Pop Art.
Architecture: Villahermosa Palace, renovated from 1989 to 1992 by Rafael Moneo.

Admission: 1,100 pesetas; seniors and students, 600 pesetas; under 12 accompanied by an adult, free.
Hours: Tuesday through Sunday, 10 a.m.–7 p.m. Slightly longer hours during the summer. Closed Monday, New Year's Day, May 1 and Christmas Day.

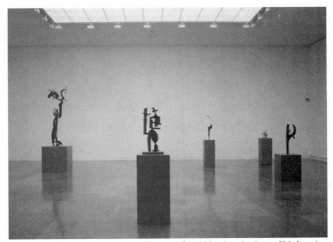

Courtesy of the Valenciano Institute of Modern Art.

Sculptures of Julio González.

Instituto Valenciano de Arte Moderno

118 Guillem de Castro, Valencia 46003, Spain
(34-96) 386-3000
www.ivam.es

PERMANENT COLLECTION

Sculpture by Julio González; avant-garde works, focusing on the development of abstraction, typographical montage and photomontage; European Informalism; Pop Art; New Figuration. **Architecture:** 1989 Centre Julio González and the historic Centre del Carme.

Admission: Centre Julio González, 350 pesetas; students, 175 pesetas; seniors and children, free; Sunday, free. Centre del Carme, free.
Hours: Tuesday through Sunday, 10 a.m.–7 p.m. Closed Monday.

Sweden

Modern Museum

Skeppsholmen, Stockholm 10327, Sweden
(46-85) 195-5200; (46-85) 195-5282 (recording)
www.modernamuseet.se

2002 EXHIBITIONS

Through January 6
Times of Aberration: Sketches and Drawings by Vera Nilsson, 1910–1970

Through January 13
Fernando Botero
Paintings by the contemporary Colombian artist. (Travels)

PERMANENT COLLECTION

Swedish and foreign art, including works by Matisse and Munch; German Expressionists; Dadaism; Cubism; Surrealism; Picasso; works produced between 1945 and 1970 by Kelly, Klein, Newman and others; Pop Art, with works by Rosenquist, Warhol and contemporaries; Minimalism and conceptual art, including works by Flavin, Judd and Kawara.

Admission: 75 kronor; students and seniors, 50 kronor; under 16, free. Reduced rate for groups.
Hours: Tuesday through Thursday, 11 a.m.–8 p.m.; Friday through Sunday, 11 a.m.–6 p.m. Closed Monday, New Year's Day, Christmas Eve, Christmas Day and New Year's Eve.

National Museum

Sodra Blasieholmshamnen, Stockholm, Sweden
(46-85) 195-4300
www.nationalmuseum.se

2002 EXHIBITIONS

Through January 27
Face to Face: Portraits From Five Centuries

More than 450 European works, including paintings, drawings and sculpture, from the 16th century to the 20th.

January 30–August 11
Selling Brands
A look at corporate logos and brand identities.

March 21–May 26
Elsa Beskow
More than 100 works by the children's-book illustrator.

September 20–January 6, 2003
Nicodemus Tessin the Younger

September 27–January 12, 2003
Impressionism and Scandinavia
Paintings by French Impressionists and Post-Impressionists, along with canvases by Nordic artists who were influenced by them. More than 150 works in all.

Continuing
Design, 1900–2000

PERMANENT COLLECTION

Some 16,000 works of painting and sculpture, from the Middle Ages to the 20th century; 500,000 prints and drawings, from the 15th century to the turn of the 20th century; Swedish 18th- and 19th-century painting; 17th-century Dutch art; 18th-century French art; about 30,000 decorative-arts objects from six centuries, including china, glass, Swedish silver and furniture; tapestries from the 15th to the 17th centuries; 20th-century design and applied arts.
Architecture: In the Florentine and Venetian Renaissance style.

Admission: 75 kronor; students and groups, 60 kronor; under 16, free; Wednesday, 60 kronor.
Hours: Tuesday through Sunday, 11 a.m.–5 p.m.; Tuesday, until 8 p.m.; Thursday from September through May, until 8 p.m. Closed Monday.

Switzerland

Kunstmuseum Basel

16 St. Alban-Graben, Basel 4010, Switzerland
(41-61) 206-6262
www.kunstmuseumbasel.ch

2002 EXHIBITIONS

Through March 3
Urs Graf, 1485–1528
Works by this goldsmith and painter.

March 23–July 28
Paul Klee

August 9–November 3
Aspects of Life in Paris
French color lithographs from around 1900.

September 28–December 31
Louis Soutter and the Moderns

PERMANENT COLLECTION

Paintings and drawings from the Swiss Upper Rhine area and the Netherlands from the 15th and 16th centuries; 19th- and 20th-century art; works by Holbein, Böcklin, Picasso, Braque and Gris; German Expressionism; Abstract Expressionism; Pop Art.

Admission: Adults, 10 francs; students and groups, 8 francs; 15 and under, free. Includes admission to the Museum of Contemporary Art.

Hours: Tuesday through Sunday, 10 a.m–5 p.m. Closed Monday, February 22–24, May 1, Christmas Eve, Christmas Day and December 31.

Museum für Gegenwartskunst

60 St. Alban-Rheinweg, Basel 4010, Switzerland
www.mgkbasel.ch

2002 EXHIBITIONS

Through February 24
Richard Prince: Photographs

Through February 24
From Baselitz to Warhol

March 15–May 12
Manor Arts Award Basel

PERMANENT COLLECTION

Art made since 1960; minimal art; conceptual art; "Die Neuen Wilden"; works by Joseph Beuys and Frank Stella. **Architecture:** Built in 1980 by Katharina and Wilfried Steib, the extension of a late 19th-century factory building with creek running beneath it.

Admission: Adults, 10 francs; students and groups, 8 francs; 15 and under, free. Includes admission to the Kunstmuseum.
Hours: Tuesday through Sunday, 11 a.m.–5 p.m. Closed Monday.

Kunstmuseum Bern

8-12 Hodlerstrasse, Bern 3000, Switzerland
(41-31) 311-0944; (41-31) 312-0955
www.kunstmuseumbern.ch

PERMANENT COLLECTION

More than 3,000 paintings and sculptures and 40,000 works on paper. Italian Trecento; Swiss art from the 15th century, including Manuel, Anker and Hodler; works by Delacroix, Courbet, Dalí, Masson, Kirchner, Klee, Pollock and contemporary artists.

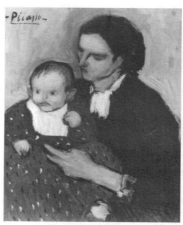

Pablo Picasso, *Mother and Child*, 1901.

Courtesy of the Kunstmuseum Bern.

Admission: Adults, 7 francs; students and groups, 5 francs. Higher fees for special exhibitions.
Hours: Tuesday, 10 a.m.–9 p.m.; Wednesday through Sunday, 10 a.m.–5 p.m. Closed Monday, Good Friday, Easter Sunday, Pentecost Sunday, Chistmas Eve and Christmas Day.

Museum Barbier-Mueller

10 Rue Calvin, 1204 Geneva, Switzerland
(41-22) 312-0270
www.barbier-mueller.ch

PERMANENT COLLECTION

Founded in 1977 by Jean Paul and Monique Barbier-Mueller. Some 8,000 works of art, mainly sculptures, but also masks, textiles and personal ornaments. Works from Africa, Indonesia, Oceania, America and Asia as well as from ancient civilizations, including Greece, Italy and Japan.

Admission: Adults, 5 francs; students, groups and the handicapped, 3 francs; 11 and under, free.
Hours: Daily, 11 a.m.–5 p.m.

Fondation de l'Hermitage

2 Route du Signal, Lausanne 1000, Switzerland
(41-21) 320-5001
www.fondation-hermitage.ch

2002 EXHIBITIONS

February 1–May 12
Alberto Giacometti
Sculptures, paintings and drawings from the collection of
Robert and Lisa Sainsburg, as well as major works created
between 1935 and 1965 from public and private collections.

June 7–October 20
The American Impressionists (1880–1915)
More than 100 paintings, watercolors and drawings by Cassatt,
Chase, Hassam, Homer, Robinson, Sargent, Twachtman and
others.

PERMANENT COLLECTION

Space restrictions prevent the regular display of the permanent
collection, which includes paintings by Boudin, Bosshard,
Magritte, Sisley and Vallotton as well as sculptures, drawings
and prints. **Architecture:** Country villa designed by Louis
Wenger and built for Charles-Juste Bugnion between 1842
and 1850; restoration in 1976.

Admission: Adults, 13 francs; children, free.
Hours: Tuesday through Sunday, 10 a.m.–6 p.m.; Thursday,
until 9 p.m. Closed Monday.

Museo dell'Arte Moderna

Riva Caccia 5, Lugano 6900, Switzerland
(41-91) 800-7214
www.mdam.ch

Admission: Adults, 8 francs; students and groups, 5 francs;
children, 3 francs.
Hours: Tuesday through Sunday, 9 a.m.–7 p.m. Closed Monday.

Fondation Pierre Gianadda

29 Rue de Forum, Martigny 1920, Switzerland
(41-27) 722-3978
www.gianadda.ch

2002 EXHIBITIONS

January 25–June 9
Van Dongen

June 20–November 19
Berthe Morisot

PERMANENT COLLECTION

Franck Collection, with paintings by Cézanne, van Gogh,
James Ensor, Toulouse-Lautrec, Kees van Dongen and Picasso;
automobile museum, with about 50 antique cars from 1897 to
1939; sculpture park, with works by Rodin, Brancusi, Miró,
Arp, Moore, Ernst and others.

Admission: Families, 30 francs; adults, 14 francs; seniors, 12
francs; students, 7 francs.
Hours: Daily, 10 a.m.–6 p.m. (Extended hours in the spring
and summer.)

Kunstmuseum Winterthur

52 Museumstrasse, Winterthur 8402, Switzerland
(41-52) 267-5162
www.kmw.ch

2002 EXHIBITIONS

March 23–June 16
Bruno Goller, 1901–1998

June 29–August 18
Bram Bogart, Jef Verheyen, Englebert Von Anderlecht
Three painters from Belgium and the Netherlands.

August 31–November 24
Richard Hamilton
Works from the museum's collection.

PERMANENT COLLECTION

Paintings and sculptures from the late 19th century to the present by van Gogh, Klee, Mondrian, Giacometti, Richter, Kounellis, Marden, Kelly. **Architecture:** 1915 Art Nouveau building by Rittmeyer/Furrer with extension built in 1995 by Annette Gigon and Mike Guyer, which is completely framed in glass.

Admission: Adults, 10 francs; seniors, students and groups, 7 francs. Fees vary with exhibitions.

Hours: Tuesday, 10 a.m.–8 p.m.; Wednesday through Sunday, 10 a.m.–5 p.m. Closed Monday, New Year's Day, Mardi Gras, Good Friday, Easter Sunday, May 1, Pentecost Sunday, Albani Festival (last Sunday in June) and Christmas Day.

Kunsthaus Zürich

1 Heimplatz, Zürich 8024, Switzerland
(41-1) 251-6765
www.kunsthaus.ch

2002 EXHIBITIONS

February 1–May 30
William Turner

PERMANENT COLLECTION

Medieval art; Baroque art; Venetian art; Swiss art; 19th- and 20th-century French painting; Modern Croatian art; Dada; Modern American art. **Highlights:** Rodin sculptures; works by Alberto Giacometti, Ferdinand Hodler, Matisse and Chagall.

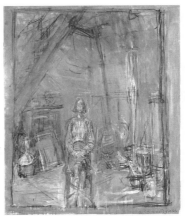

Courtesy of the Kunsthaus Zurich.
Alberto Giacometti, *Annette*, 1951.

Admission: Adults, 10 francs; students and groups, 6 francs. Additional fees for special exhibitions.

Hours: Tuesday through Thursday, 10 a.m.–9 p.m.; Friday through Sunday, 10 a.m.–5 p.m. Closed Monday.

Thailand

The National Gallery

Chao-Fa Road, Bangkok 10200, Thailand
(66-2) 282-2639; (66-2) 281-2224

PERMANENT COLLECTION

Works by Thai artists from various periods, including works of King Rama VI and King Rama IX; traditional Thai paintings; contemporary Thai art. **Architecture:** Built during the reign of King Rama V for the Royal Mint, which used the building from 1902–72.

Admission: Adults, 30 baht; children and students, free.
Hours: Wednesday through Sunday, 9 a.m.–4 p.m. Closed Monday, Tuesday and national holidays.

Wales

National Museum and Gallery of Wales

Cathays Park, Cardiff, CF1 3NP, Wales
(44-292) 039-7951
www.nmgw.ac.uk

PERMANENT COLLECTION

Medieval and Renaissance art; 17th-century French and Italian art; British art from the Pre-Raphaelites to the 20th century; 18th- and 19th-century Welsh landscapes and portraits; Gwendoline and Margaret Davies collection, which includes paintings by Old Masters, established British artists and French Impressionists; ceramics.

Admission: Adults, £4.50; students and the disabled, £2.65; seniors, unemployed, under 18, free.
Hours: Tuesday through Sunday, and bank holiday Mondays, 10 a.m.–5 p.m.

Index